STARTING YOUR CAREER AS A FREELANCE PHOTOGRAPHER

TAD CRAWFORD

ALLWORTH PRESS
NEW YORK

asmp

AMERICAN SOCIETY OF
MEDIA PHOTOGRAPHERS

08 07 06 05 04 03 5 4 3 2 1

Published by Allworth Press
An imprint of Allworth Communications, Inc.
10 East 23rd Street, New York, NY 10010

Cover design by Derek Bacchus

Interior page design by Jennifer Moore, Brooklyn, NY

Page composition/typography by Rosanne Pignone, Pro Production

Library of Congress Cataloging-in-Publication Data

Crawford, Tad, 1946–
 Starting your career as a freelance photographer / Tad Crawford.
 p. cm.
Includes bibliographical references and index.
 ISBN 1-58115-280-9
 1. Freelance photography. 2. Photography—Business methods.
3. Photography—Vocational guidance. I. Title.

TR690.2.C73 2003
770'.23'2—dc21 2003011639

Printed in Canada

Introduction

To start a career in photography is an exciting step. Photography offers an unusual blend of challenges, from the creation of effective images to the management of a business. Photography gives you the chance to succeed on your own terms, but you also have to shoulder the responsibility of being on your own. This book is designed to help you make informed and intelligent choices about a photography career. In particular, it maps out the business practices that are important to your future success. To gather excellent advice from across a broad spectrum of areas, I asked many experts to contribute chapters to *Starting Your Career as a Freelance Photographer.*

"Getting Started" is discussed in part I. What is a career in photography? That's the first question you have to consider, and it is addressed in chapter 1. Should you go to college for a degree in photography? This choice is considered in chapter 2. What about becoming a photographer's assistant, whether or not you go to school? Chapter 3 explores the value of assisting. What specialty should you develop—or can you succeed as a generalist? An overview of photographic specialties is given in chapter 4. And chapter 5 reviews what equipment you will need to start your photographic career.

Part II is titled "Building and Protecting Your Business." Chapter 6 discusses how you should plan your business to give it a firm foundation from which to succeed. If you're going to have a studio, chapter 7 examines the key considerations with respect to location and leases. Some of the important steps to get your business up and running are scrutinized in chapter 8. Then, studio management, with a special look at software and automation, is the focus of chapter 9. Insurance protection against both business and personal risks is reviewed in chapter 10. Health hazards—and how to anticipate and protect against them—form the subject matter of chapter 11.

No business can succeed without clients, so part III, "Marketing Your Photography," is a topic that must be understood and mastered. Chapter 12 deals with markets, promotion, and clients. Building a portfolio, a crucial step, is detailed in chapter 13. And the use of a Web site for marketing is explored in chapter 14.

As your business finds clients and you start making sales, you have to feel at ease "Negotiating Contracts and Prices," which is the title of part IV. This starts with an overview of how to negotiate a contract, in chapter 15. Then chapter 16 gives specific contract forms that can be adapted for use or serve as checklists in evaluating forms offered by clients. Proper pricing, a necessity for profitability, is explored in chapter 17.

The final topic is "Photography and the Law," which is part V. Chapter 18 covers ways in which the photographer can protect and benefit from copyrights. Taxes, including potential tax breaks, are examined in chapter 19. Anyone taking photographs has to be concerned about invading people's privacy and has to know when releases should be obtained, which is elaborated in chapter 20. Chapter 21 highlights other legal areas to make sure the photographer does not run into difficulties. Finally, chapter 22 explains how to settle disputes or, if necessary, find a good attorney.

The appendices include the Code of Ethics of the American Society of Media Photographers and a list of organizations that photographers might join or be interested in. The Selected Bibliography includes many books that belong in your bookcase if you want to succeed in the creative business you have selected for your career.

The road you are about to take has its challenges, but certainly it has great potential rewards—not only financial, but artistic and personal as well. I hope that *Starting Your Career as a Freelance Photographer* helps ensure that the road ahead will always rise up to meet you.

TAD CRAWFORD
NEW YORK CITY
APRIL 2003

CONTENTS

Foreword

ASMP is pleased to work in conjunction with Allworth Press to offer *Starting Your Career as a Freelance Photographer.* For almost sixty years, the American Society of Media Photographers has been the premier trade association for promoting and protecting the interests of working publication photographers. Membership in ASMP continues to be recognized worldwide as a commitment to professionalism, quality, good ethics, and as a sign of proven experience. ASMP is built on the cornerstones of education, information and advocacy. This publication is an invaluable tool for educating the emerging photographer. From your business plan, to pricing, negotiating, marketing, and protecting your copyright, this book covers it all. Written and edited by a collection of experts, *Starting Your Career As a Freelance Photographer* advances the educational mission of ASMP. It provides part of the foundation needed to conduct business in a professional manner and become a successful working publication photographer. Visit *www.asmp.org* for more information on ASMP and its mission. Good luck and much success with your new career.

EUGENE MOPSIK
EXECUTIVE DIRECTOR, ASMP

PART I
GETTING STARTED

CAREERS IN PHOTOGRAPHY

by Chuck DeLaney

This chapter is adapted from *Photography Your Way* by Chuck DeLaney, the dean of the New York Institute of Photography *(www.nyip.com),* America's oldest and largest photography school. A freelance photographer and writer based in New York City, he is a frequent speaker at professional photography seminars across the country.

IN MY LIBRARY, I have a number of books that are traditional career guides in photography. Most of these books survey various fields—portraiture, medical photography, photojournalism, commercial and industrial photography—and discuss the requirements, job opportunities, and financial prospects of each area.

That's not my approach. I firmly believe that photography is a passion and that during one photographer's lifetime the career activities are likely to meld into one another. If you were going to be a doctor, you would need to choose a specialty, such as cardiology or nephrology or psychiatry, and probably devote many years of training to that specialty. In all likelihood, you would practice that specialty for the rest of your life.

Similarly, if you want to make a lot of money, you might go to business school or law school, but probably not both. After that training, you would go out and have a career "in business" or "in law." Then you'd (hopefully) get old, retire, and then die.

PHOTOGRAPHY IS DIFFERENT

To me, that's not what a lifetime in photography is about. Sure, it can be a way to make money, but there's also a lot of fun and adventure to be had, a lot of opportunities to express yourself and your unique point of view, and the chance to change what you do as you go along. Why do one thing all your life? If you want to do that, it's fine, but even if you train to become, say, a medical photographer, and then work in hospitals for your entire work life, that's no reason you cannot involve yourself with all sorts of other photographic endeavors at night, on weekends, and on vacation.

That's the beauty of photography—the vocational goals are hazy, and the training in photography technique and technology doesn't need to be that extensive in most fields. You can be a medical photographer during the workweek and pursue fine art or animal photography on the weekend. Try being a lawyer during the week and a brain surgeon on weekends—it won't work. The requirements, and limits, of many fields are set in stone.

To that end, I view photography more as a lifestyle than as a career. There's no sense of either/or. You can be a medical photographer and a wedding photographer. You can be a photojournalist and a child photographer. It's up to you.

PHOTOGRAPHY AS A CREATIVE OUTLET

And, let's not write off all those doctors, lawyers, and MBAs either. There are lots of professionals in a host of fields who turn to photography to get the creative and expressive satisfaction that their "profession" may not be able to deliver. At the New York Institute of Photography, some of our most excited students are professionals in other fields, who turn to photography to relax and enjoy the freedom it offers.

So let's start with the basics. We're photographers and we're involved with a very powerful force—photography. And we have the opportunity to shape our careers as we go along. But before you can bask in the potential of photography and locate your interests and find success in one or more fields, it is essential to address three things: (1) the nature of this magical medium; (2) what you really want to get out of photography and what skills you bring to the table; and (3) what holds you back—as a photographer and as a human being—the negative emotions that may confuse and inhibit you.

THE NATURE OF PHOTOGRAPHY

I love photography. I make images almost every day, and I respect the power, science, art, and magic of the medium. I once took a Christmas-greeting portrait on Polaroid film for a young man who was in prison. It took me three minutes at most. Six weeks later the prisoner told me that he had sent it to his deathly ill grandmother who hadn't seen him in the ten years he'd been in prison. Shortly after the photo arrived, she died. Among her last requests was to be buried with the portrait I made of her grandson.

To me, that's powerful. I make images. I show people things. I capture their emotions and expressions, their memories, their past, the things they love. Sometimes I try to express my emotions in my photographs. Maybe one of my photos will help change something in the world for the better.

And people pay me to do this!

Another key part of what I love about photography is that it is so democratic and accessible. The equipment isn't that expensive, and lots of equipment isn't necessary anyway. There are lots of ways to get the training you need, and there's opportunity for you regardless of sex, race, or physical ability.

I know photographers who work from wheelchairs. There are photographers who are legally blind. At the New York Institute of Photography, we always have students in our course who are recovering from serious illness or injuries and who turned to photography as a second career, or as a way to reconstruct their lives. Photography can help you grow. And, I know from experience, it can help you heal.

And people looking at your photos won't necessarily know if you're black or white, female or male, or whether you used a Canon or a Nikon.

I recall a television interview with the late Danny Kaye, a performer with many talents. In talking about his interests, he made a very simple but profound statement: "If you can find the form of self-expression that's best for you, then you've got it made."

A CAREER TO THE END

There's one other great aspect of photography. There's no need to retire. Opera singers, supermodels, athletes—even the sharks and traders on Wall Street—all have a prime, and when they can no longer take the rigors or hit the high notes, or when the "new (and younger) face" retires the supermodel who may be "over the hill" in her mid-twenties, it's time to move on.

Not so with photography. You can take great photos while leaning on a cane. Photography will never desert you. How many of us are lucky enough to find a lifelong friend?

For me, that's photography. My guess is, it's photography for you, too. Now that you've found your method of expression, the trick is to move forward and stay optimistic. Perhaps, as you grow, you may find photography is not for you, or that there's something better. Then the trick is to move on to that better something. This is not unheard of in creative professions. The great artist Marcel Duchamp, for example, gave up making art altogether and turned his passion to chess in his later years. The wonderful French photographer Jacques Lartigue turned to painting in midlife. Not long ago I read the obituary of Myron "Scottie" Scott, who started out as a news photographer and happened to take a few feature photographs of some kids who had made a toy car out of a soapbox and a set of buggy wheels. He went on to become the founder and guiding light of the Soapbox Derby.

WHAT DO YOU WANT FROM PHOTOGRAPHY?

Knowing what areas of photography are of interest to you isn't always that easy. One problem is that the world of photographic specialties and professional practitioners is very segmented, particularly in the way photography is taught. There isn't a lot of crossover. For the most part, those in fashion know of their predecessors and peers, but are clueless in the history of photojournalists or portraitists. The couple who runs a portrait studio in Des Moines probably don't know the names of the hotshot fine art photographers from New York and Los Angeles.

The key to learning about what possibilities exist out there is to look at the lives and work of lots of photographers. There's no career guide better than looking at the lives and works of others who devoted their lives to the pursuit of photography.

Michelangelo, known to most of us for his skills as a sculptor and painter, also wrote poetry. One of his sonnets muses on the potential in a block of

marble. Every sculpture is contained within that block; the sculptor need only remove the bits of marble that aren't part of the sculpture!

Photography is like that block of marble. It offers everything you could possibly desire. Sometimes it may be easier to determine what you don't want, and then make your way toward the areas that are left.

THE NEGATIVE STUFF

We're all susceptible to negative feelings, but until those emotions are examined and either eradicated or put in their place, the good stuff is hard to access in a sustained, trustworthy way. And those despairing gremlins do have a way of popping up again and again, for all of us.

That's important to remember. There may be a few enlightened souls who have put the dark stuff behind them forever, conclusively, and with no hitches. But for most of us, those negative feelings are like houseflies—you never get rid of every single one of them, you just keep them under control.

Over the course of my career, I've slowly come to realize how many people—not just photographers, but all kinds of people—take themselves off the playing field, fold their hand, and ask to be dealt out of the game. They end up bitter, befuddled, or beaten. Or, if they're lucky, just depressed. And they did it to themselves! Well, the hell with that!

A lot of our emotions come out as anger when dealing with customers and suppliers. As you'll see, there are a few situations where you can go ahead and blow your top, and other times when you have to take it easy. There are times to talk, and times when the trick is to stay silent.

Occasionally, as you go along, you may find yourself thrown to the ground. Maybe you can pull this book out and reread a few sections and get up, brush yourself off, get back in the game, and get even with those that threw you.

This discussion of negative stuff is written with the wish that it will help you stay in play right up to the end, that it will help you absorb the bumps and learn to analyze the self-inflicted ones so as to keep them to a minimum, and figure out how to handle those dealt you by others.

FIGHTING THE "IF ONLYS"

Photography is an elusive undertaking. As a form of self-expression, it can fool lots of people. It's easy to get good, to take technically okay photographs—to get a sharp, well-exposed image of something on film.

But it's a lot harder to get really good, and, for the gifted, even harder to get great. It's hard to get other people to take your photography seriously. There are business and finances involved. There are lots of rejections along the way. Any of these factors can lead to distracted, depressed thinking, a lot of "if onlys":

- If only I had better equipment
- If only I had her contacts
- If only I had his sales technique

- If only I had gone to that school
- If only I could be published in that magazine

And one of the worst:

- If only I hadn't screwed up that job

You can fritter away an entire lifetime dealing with the "if onlys," but this seduction must be avoided. It's not that hard once you see them for what they are, but it's also one of the reasons that, if you're not careful, photography can make you crazy.

IT'S ATTITUDE, NOT SUCCESS, THAT COUNTS

In fact, I know lots of successful photographers who are still hounded by "if onlys"—what they haven't accomplished, or the people who don't respect them—rather than basking in their considerable achievements. And these aren't just run-of-the-mill photographers. I know of one fabulously successful commercial and editorial photographer who is obsessed with getting major shows for his work in recognized fine art museums. He won't rest until he's secured that reputation. I've also met a very successful nature photographer who expressed to me his need to prove himself to his colleagues although he has legions of admirers. "They still think I'm a techno-geek," he told me.

I believe that there is no one way of being. If that's what these photographers want to do, if those are goals of their choosing, and as long as it is a choice and not an obsession, then that's okay.

And, while it can be obsessive at the top, it can be lonely when you're starting out. Photographers spend a lot of time alone—working, traveling, in the darkroom or in front of a computer screen. The world is usually on one side of your lens and you're on the other. You need to make certain that you have enough input from the outside world. It's dangerous to get too isolated.

The fact that photography is a democratic medium, with accessibility for all, does have some drawbacks. There's a real potential for deluding yourself, pretending to be a photographer, thinking you're better than you are, or obsessing that you're not as good as you actually are.

Other forms of art and expression are much quicker to discourage people who seek to master them. For example, the performing arts can be downright cruel. If you wish to make your mark as a singer, musician, dancer, actor, or comedian, but have little or no talent, your limitations are likely to be made painfully clear very quickly. Maybe that's good, because then you can move on.

After all, it's your lifetime, and, as it passes, you'll realize a lifetime isn't a long time; it's a short time. There's no benefit in wasting any of it.

Like the performing arts, the traditional visual arts—the "fine arts" of painting, sculpture, and architecture—also require talent that many of us lack. You're not likely to paint for very long if you have no skill at all.

If lack of talent weren't a big enough obstacle, many art forms impose financial barriers as well. Authors, poets, and playwrights can curse the lack of interest from publishers. All filmmakers can lament the high cost of producing a motion picture. Worst off may be architects, some of whom must kiss up to the likes of developers such as Donald Trump to get their works realized.

But film is cheap, and anyone can push that shutter. That's a blessing and a possible drawback. You'll have to trust the honest feedback of the people whose opinion you value most to determine whether your sense of your work is on target.

ANYONE CAN TAKE A PICTURE

In the last two decades, technology has made photography even easier. It used to be that you had to have a modicum of understanding of exposure calibration to get the image properly exposed, and you needed sufficient eyesight and a steady hand or tripod to get a sharp image. Now even those requirements are gone—computer chips assist with exposure and focus. *Anyone* can take a photograph.

I remember, years ago, there was a chimpanzee that lived on Manhattan's Upper West Side and took Polaroid photographs at parties, if you hired him and his trainer. Not only could he take photographs, he was a pro!

My daughter started taking photographs when she was eighteen months old. Now that she's nearly three, I'm comfortable putting the strap of an expensive SLR—or, better still, a digital camera—around her neck. She's still a little puzzled by the LCD viewfinder on my digital camera, but I'm sure she'll figure it out soon.

Make sure that you have a reasonably accurate estimation of your weaknesses and your strengths. That can require a rigorous self-examination. Is it worth it? It is if you want to be a photographer.

LET'S END WITH THE POSITIVES

One last point. It is fair for the reader to ask, "What are the benefits of the effort to banish those negative emotions? If the goal is photography *without* negatives, then photography *with* what?"

The answer is multidimensional:

- Photography with choice, with a sense of play, with assignments, with confidence, and with a plan of roughly defined goals that work for you.
- Photography with freedom, with a respect for the tradition, and with an eye on the pitfalls that come with that tradition. Photography with no regrets, with the right to experiment, and *with the right to make mistakes.*

There's another difference between photography and brain surgery or rocket science—it's okay to make mistakes. Sometimes, mistakes are part of the discovery and excitement. Mistakes can show you the way.

CHAPTER 2 · THE VALUE OF A PHOTOGRAPHIC EDUCATION

by Bill Kennedy

Bill Kennedy has been a professional photographer for over twenty-five years. His commercial business specializes in portraiture and location photography for editorial, corporate, and advertising clients. He has received an NEA/M-AAA Fellowship in Photography, among other grants and awards, and has exhibited widely. An associate professor of photography at St. Edward's University in Austin, Texas, he is also a member of the Santa Fe Workshops Board of Advisors.

THERE ARE TWO TRADITIONAL and respected approaches to an education in photography. One option is to enroll in a structured academic program that offers a degree or certification of some kind. These programs, ranging from trade schools to community colleges and four-year universities, can vary considerably in their curriculum. Understanding the differences and choices afforded by these programs is the main focus of this chapter.

An alternative is to forgo a formal education and choose instead the "School of Hard Knocks." The advantage of Hard Knocks is open enrollment. You can come and go as you will, learning at your own pace. A Hard Knocks education is a viable alternative to structured academic programs because freelance photography is an unlicensed profession in America. It is possible to work as a photographer without a formal education, certification, or license of any kind. In fact, if you are successful—if you can find the clientele to generate a sustainable profit from your freelance business—your claim to be a "professional" is as legitimate as that of someone with a four-year university degree.

By default, becoming a self-employed professional photographer is determined less by formal education and more by how quickly you learn what is essential to survive and prosper economically. In other words, business acumen will be at least as important as your creativity and photographic ability.

THE LEARNING CURVE

One way or the other—formal education or Hard Knocks—both the photography and business learning curves must be mastered for you to survive ethically and prosper economically as a freelance photographer. Regardless of pedigree, smart freelancers also realize that an education in photography is never complete. The realities of the marketplace make education a lifelong process. There is always something new to learn as tastes change and new technologies appear (just ask, for example, the studio photographer compelled to learn prepress color management and workflow because they moved from analog to digital photography). The need

to learn explains, at least in part, why photography workshops have become increasingly popular.

PHOTOGRAPHY WORKSHOPS

Workshops are intensive experiences usually structured around learning a set of skills (platinum printing, studio techniques, and digital imaging, for example) or the experience and reputation of the instructor. It is remarkable what can be accomplished, and how far a motivated person can travel, when surrounded—twenty-four hours a day—by people committed to the same pursuit. Workshops typically last a short week (five or six days), but come in a wide variety of flavors and configurations. You may be able to find workshops in your area (check local art schools and museums, the learning extension programs at larger schools and universities, and any local photography groups or professional organizations). Some of the larger and better-known workshop programs include Anderson Ranch, Santa Fe Workshops, Palm Beach, and the Maine Photographic Workshops. Information on these, and many others, can be found on the Web. Incidentally, workshops are an excellent way to explore the idea of becoming a freelance photographer. You can take a class with a working professional and benefit from their experience and point of view.

One lesson you may learn from attending a workshop is that the desire to become a freelance photographer—intoxicating and compelling as it may be—is inevitably tempered by a career decision: what kind of photographer do you want to be and what kind of small business should you create to support this decision? In short, becoming a successful freelance photographer means you want to own and operate a small business fueled by your ability and passion to make images. What kind of image making do you want to specialize in?

CHOICES

For the sake of simplicity, we can organize the myriad of freelance choices into a few large categories: commercial photography, retail photography, and fine art photography. These categories differ mainly in the way images are marketed and sold, by the way, and less by image content, talent, or skill. Examples of commercial photography include annual reports, freelance editorial, advertising, fashion and lifestyle, and product illustration. It is a very diversified field. Photographers who choose a commercial photography career do not usually deal with the general public. They most often market and sell their work to art buyers and art directors, graphic designers, and editors.

Retail photographers, on the other hand, do market and sell directly to the public. This would include portrait studios and event and wedding photography, for example. Fine art photographers also sell to the public but generally try to work with galleries or agents to market their work (and will pay a commission that could approach 50 percent, for the privilege).

To further complicate matters, boundaries are fluid and there are no hard and fast rules, save those that govern commerce in general (a benefit of photography

being an unlicensed profession). Commercial photographers can shoot weddings or sell work through fine art galleries, for example. Retail photographers can shoot commercial assignments and exhibit their work in galleries and museums. Fine art photographers often accept commercial assignments and traditionally may supplement their photography careers by teaching. All may work with stock agencies to sell their work to wider markets. In other words, freelance photographers independently define their business; if they operate within the law, they are free to "behave" any way they wish.

Keep in mind, though, that these categories—commercial, retail, or fine art—simply reflect the choices photographers make about their work and how they choose to market what they do. The Internal Revenue Service does not care about the aesthetic decisions, distinctions, labels, or ego that lead photographers to define what they do. The IRS view of commercial photography is simple and direct: If freelancers earn money from making photographs, they are a business and have entered the world of taxation and regulation. Fine art photographers declaring their earnings from print sales must use the same IRS forms and procedures as an editorial photographer working for international magazines or a commercial photographer shooting automobiles or annual reports. In fact, if there is a "Grand Unifying Theory" of freelance photography, it exists only within the byzantine business code of the IRS.

CHOOSING A PROGRAM

Obviously, the decision to become a freelance photographer is more complex and interesting than it may at first seem. In fact, one strong argument for a structured academic education in photography is the time it affords a photographer to comprehend, appreciate, and find reliable answers to important career questions and issues. School provides time to examine what kind of images you want to make (and learn how to make them). There is time to explore, experiment, grow, change, and refine your thinking and career ambition—ideally, with the help and guidance of good teachers. You are looking for an education that will fuel your ambitions by challenging assumptions, refining technique and aesthetic judgment, strengthening your work ethic, and establishing a critical dialogue about photography that will mature over the long and sustained arc of your career.

The first decision about a formal education in photography is to determine what kind of program is best for you. The way photography education is organized, especially at four-year colleges and universities, rarely reflects the way commercial photography as a business is organized (traditionally, the *art* rather than the *commerce* of photography has been emphasized in higher education).

This means you need to evaluate and compare programs carefully. There often are considerable and important differences, and it is easy to mistakenly compare apples to oranges. The following is a checklist to help you structure your investigation. Fortunately, most of the information you need can be

found on Web sites or by contacting the admissions office of the schools that interest you. Almost all schools will send enrollment information free of charge (but most will charge a fee to apply).

A Photography Education Checklist:

1. What kind of program is it? Is it a trade school certification, an institute, a two-year associate's degree, or a four-year bachelor's degree?

■ If it is a trade-school certification program or an institute, does it award academic credit that will transfer to a college or university program (an important consideration if you eventually want to enroll in a college or university degree program)? A trade-school education could be an excellent fit, but it is often considered to be vocational training and may not transfer to colleges or universities. If it is an associate's or bachelor's degree, what kind? Associate degrees can vary considerably, depending on what department the photography program is located in. It may be a science or technology degree, or it could be a fine art degree. Traditionally, four-year degree programs come in two variations: fine art (bachelor of fine arts, or BFA) and photojournalism (bachelor of journalism, or BJ). The fine art approach is a studio education that will include art history and coursework in design, drawing, and art theory, for example. Photojournalism programs tend to be majors within schools of either journalism or communication. PJ programs prepare students for careers in journalism. Both, by the way, feed graduates into freelance photography, usually with little or no practical business training (but more about that later).

2. How is the program structured within the school?

■ How many hours in your degree plan are dedicated to studying photography?

■ When can you begin taking photography coursework? Some schools, including most universities, do not allow students to begin study in their major until late in the sophomore or junior year. There are exceptions to this, but it is an important consideration if you want to get started on your photography education quickly. This can be especially important to older-than-average students.

3. What classes are taught in the program? Always look for a complete list of classes. This will give you valuable insight into how a program's curriculum is structured. For example, what is the balance between traditional and digital imaging, or production classes (where you are expected to shoot and process images) and history or theory classes (where you are expected to do research and write)? Are only still imaging courses taught, or does the curriculum include video or multimedia, for example?

4. Who teaches in the program? How many full-time versus part-time instructors are there? This can help predict how much time you can expect to spend with core faculty. Good adjunct faculty can bring depth and vitality to a program that has a sound core faculty, but beware of programs that seem

to lack full-time faculty. You want to select a program because of its focus and strength, not the lack of it. Another important indicator of a program's strength, by the way, is the professional involvement and expertise of the faculty. Ideally, you want to study photography with people who are passionately and professionally involved in the medium.

5. What kind of facilities and equipment can you expect to have access to? You may be able to gain an informed opinion from printed or Web material, but this is one area that is best informed by a campus visit. If that is impossible, try corresponding with a faculty member (e-mail addresses can sometimes be found on school Web sites). Does the school have an equipment bank that you can use to borrow equipment that you don't have? This is especially important if you will be required to take courses that use specialized or expensive equipment that you may not own (or want to buy). You want to gauge the "tool kit" you will be paying to use. By the way, remember to ask about the hardware/software used in digital imaging labs. Because of the expense involved in maintaining digital equipment and purchasing software upgrades, some schools' technology may not be as current as others' is.

6. What financial aid programs exist? Are there scholarships or grants that you are eligible for? This kind of information can be found on school campuses. In fact, good schools have specialists who will work with you to arrange any financing needed to attend school.

GATHERING INFORMATION

Gathering this information will help you understand the differences between programs and between the schools where the programs are located. Essentially, what matters most are the people you will spend time with (students, staff, and faculty) and the curriculum (what is actually being taught and learned). After applying and being accepted, registering and paying tuition, buying supplies, and arranging your life to accommodate a class schedule, what can you look forward to? What are the experiences and learning milestones you can expect and want to seek out?

LEARNING COMMUNITIES

Exceptional academic photography programs are more than the sum of their parts. They generate a strong sense of community. In part, people bind together and learn from each other through their mutual commitment and the sheer effort a thorough and demanding photography program requires. If a program does its job properly, classmates become colleagues as they study and learn photography together.

In other words, if a program is a good fit for you, there will be a *process* at work that extends learning well beyond the classroom. It is the process of *learning how to think* in an ordered, disciplined, and joyous way. Yvon Chouinard, adventurer and founder of Patagonia, Inc. (considered by many to be a model ethical business), understands the value of process. He identifies it as a core

value in the way his company operates. "It's all about process," explains Chouinard. "Part of the process of life is to question how you live it . . . and it's the same in business. If you focus on the goal and not the process, you inevitably compromise. Businessmen who focus on the profits wind up in the hole. For me, profit is what happens when you do everything else right."

The process of learning how to "do everything else right" that Chouinard refers to is a simple but powerful description of the training and experience a good education can provide a freelance photographer. Learning communities generate and sustain a critical dialogue—essentially, a disciplined conversation—that lasts for years and extends beyond graduation. This dialogue inevitably reflects one's education and values. Students, discovering that they belong to a group sharing a common agenda and goals, stimulate and challenge each other. It is empowering to be surrounded by people dedicated to learning the same craft, technique, and language of light that you are. From working through a common agenda, students find their own unique and irreplaceable voice. They develop a personal aesthetic and acquire the technical skills to express their vision through the images they make.

This is particularly valuable to a freelance photographer. A freelancer is constantly faced with the challenge of breaking through the visual clutter of our mediated society in general, as well as the piles of promos sitting on a typical art director's desk. Being able to convincingly express a mature personal aesthetic is paramount to survival in the market. Learning what kind of images you are capable of making is a substantial and concrete part of learning how to think. In fact, this method, or way of thinking, can be understood in three parts:

1. Seeing a problem or issue;
2. Understanding it; and
3. Exercising sound reasoning toward its resolution.

Learning to see clearly and incisively, to perceive, is the first step. It involves training the mind to scan broadly and discriminate precisely. Reaching understanding requires an intellectual "tool kit" that enables and conditions one's inquiry. This can include being familiar and conversant with subjects across disciplines. It also includes the confidence that rewards curiosity informed by research. Lastly, reasoning toward resolution is a learned ability—but also the expression of a desire—to struggle toward reliable conclusions rather than settling for convenient and simple opinion. This is the foundation of a liberal arts education and it is also a very adept description of the process of making good photographs.

Ansel Adams believed that young photographers were best served by earning a degree before beginning a career in photography. He understood that the process of educating the mind—of learning how to think—was precisely the kind of training photographers need in order to make successful images. (A champion of technique, Adams nonetheless placed technique at the service of one's creativity and intellect.)

School has the "silent" benefit of structuring not only time but priorities as well. A degree program mandates a structure for time to be wisely and purposefully used. This structuring of priorities can be achieved on your own (if you are highly motivated and disciplined), but for most it will be much more difficult to accomplish. Without the structure of school, you may find that life issues—jobs and family, for example—demand attention and compete for your resources. For many, this can be one of the hardest issues to control in the School of Hard Knocks.

If an academic program encourages student membership in professional organizations—the ASMP, NPPA, and PPA, for example—there will be opportunities to extend your education beyond the classroom. Learning about fair trade practices and ethical conduct from working photographers, who struggle with these issues every day, can be a powerful extension of classroom learning. Belonging to professional organizations and attending local meetings can open a window from the classroom to the real world. It allows students the opportunity to benefit from real-world experience while working toward a degree.

It is also an excellent way to begin networking and finding mentors. Mentors are seasoned professionals willing to share their success with students. They take special interest in a student's ambition and career. Mentors share and guide, providing access to information, experience, and opinion that can help a student photographer make good career decisions. Most importantly, they can help you negotiate the inevitable transition from academia to the real world.

Some photography programs include (or require) internships, which can be another way of learning about business issues and of finding mentors. An internship is essentially a temporary job placement for which you can earn academic credit. It is similar to the student-teaching experience that education majors typically go through. It is real-world learning while in school. You may intern with a working photographer, for example, although excellent internships can also include nonprofit organizations, fine art institutions, media providers (like television stations or video production houses), graphic designers, agencies, print publications, and so forth. Good internship programs place students in real-world situations and allow them an opportunity to explore career options firsthand. This is often very helpful when one is managing the transition from academia to the real world.

Entering the market is the final piece of the education puzzle. In hand with an active internship program, there is one more element that a good program should offer to help substantially with the transition from academia to the real world. It should emphasize the importance of a *graduation portfolio.* Many programs leave portfolio development up to the individual student. Consider instead a program that begins portfolio development early on, preferably in the freshman or sophomore year. This approach stresses continual reevaluation and editing. With the help of their teachers, students will, ideally, review and change their portfolio many times before they graduate. With each edit, the

portfolio becomes a stronger and more persuasive statement about the student's skills and vision. An exceptional portfolio translates into a competitive advantage, and that is one thing a freelance photographer should always be interested in learning more about.

© BILL KENNEDY 2003

CHAPTER 3 THE BENEFITS OF APPRENTICESHIP

by John Kieffer

This chapter is adapted from *The Photographer's Assistant* by John Kieffer, a photographer and writer based in Boulder, Colorado, who spends the majority of his time photographing the natural places of the American West and marketing his and other stock photographers' work through Kieffer Nature Stock.

MANY OF US EXPERIENCED a special fascination with photography from our earliest encounter, and we continue to nurture the dream of being a professional photographer. Unfortunately, one of the first and greatest stumbling blocks is just getting your foot in the door. The best approach to getting started as a professional photographer is to become a professional photographic assistant.

THE PHOTOGRAPHIC ASSISTANT

Just what is a professional photographic assistant? In general, it's an individual with both photographic and related skills, who assists a professional photographer. Being a photographic assistant can be both a transitional period and a learning experience. It can allow the advanced amateur or recent photography school graduate to turn professional more smoothly. A good assistant has marketable photographic skills, but also performs as an apprentice.

Before you can appreciate the importance and responsibilities of the assistant, it's necessary to dispel some *common myths* regarding professional photographers, especially those photographers most likely to hire assistants. Photographers who regularly utilize assistants receive photographic assignments that have budgets for an assistant. They get the better jobs because of their ability to consistently produce a technically excellent photographic product, regardless of the subject or shooting conditions.

Many aspects of high-level photography must be approached very precisely. What is almost perfect is unacceptable. Being a little out of focus, seeing only the edge of a piece of double-stick tape, or overlooking a speck of errant dust on the set is intolerable. Imagine several professionals viewing a 4 x 5 inch color transparency with a magnifying loupe. There's no place to hide mistakes.

Photography is a process where the production of the final image, whether it's a piece of film or a digital file, is the result of many small steps. Failure to perform any one of these steps satisfactorily can render the outcome useless. Consistently sustaining this high level of output requires both technical and

creative skills. It also necessitates a certain fastidious nature, attentiveness to detail, and overall organization by photographer and assistant alike.

Photography is often mistakenly perceived as a fairly laid-back, almost casual occupation. This is largely untrue for professional photography as a whole, and even more so when assistants are utilized. An acceptable product must be delivered on schedule, often by the end of the day.

Besides the assistant, others might be involved with the day's work, perhaps an art director, a client, a stylist, or a model. Either their schedules or the budget may not allow for extending the shoot. A photographic assistant is an integral part of this creative effort and can be a tremendous asset. Conversely, mistakes can cost thousands of dollars and damage the photographer's credibility.

The bottom line is, the most successful photographers are those who won't let something go out the door until they're satisfied that the work is the best it can be. These are the photographers assistants want to work for the most. Keep in mind, as the day grows longer and the take-out pizza gets colder, there are likely to be only two people left in the studio—the photographer and the assistant. As an assistant, you should expect long days and demanding work. The rewards are financial, educational, and an active involvement with a high-quality photographic experience.

THE ASSISTANT'S RESPONSIBILITIES

A clearer view of the photographer's working environment makes it easier to appreciate why the successful photographer needs a competent assistant. Well, what are an assistant's responsibilities? In general terms, the assistant is hired to free the photographer from many lesser tasks. This allows the photographer to concentrate on what's in the camera frame, and ultimately on film.

The best assistants integrate a variety of skills into many different kinds of photographic situations. Besides receiving instructions from the photographer, a good assistant anticipates the progression of the shoot and takes the initiative regarding assisting duties. Finally, the assistant must be in tune with the photographer . . . a sort of mind reader.

More specifically, assistants work with *photographic equipment.* However, this equipment is rarely the kind mentioned in the popular photography magazines. The 35 mm, single-lens reflex camera (SLR), so familiar to amateur photographers, is often the format encountered least by the assistant. The 35 mm SLR is likely to be replaced by medium-format cameras (6 x 6 cm and 6 x 7 cm), and large-format view cameras (4 x 5"). These often have digital backs, completely bypassing film.

The need to produce on schedule requires the photographer to control as many variables as possible. Hence, the use of constructed shooting environments. *Artificial lighting* is a big part of this controlled environment. The small flash units that attach to 35 mm SLR cameras are replaced by more powerful, electronic flash systems. These lighting systems consist of large power supplies and individual flash heads.

In addition, stands and numerous *light-modifying devices* are used to control this raw light. Some of the assistant's responsibilities are to set up the lighting system, subtly change its position and character, and to tear it down. Reliance on artificial lighting greatly increases the need for an assistant.

Artificial lighting also necessitates the use of Polaroid instant film, and Polaroid film means more work for the assistant. Generally, a photographer won't go to film until all that can be done is done. Polaroid helps confirm important aspects ranging from composition and lighting to focus and exposure. Everything must be just right to avoid unwanted surprises. Today's assistant is just as likely to encounter some form of *digital capture*, thereby forgoing film entirely. Here, the set might be reviewed on the computer monitor.

Like an artist, the photographer often starts with only a general idea and a blank camera frame. This means a background or location must be chosen or even specifically constructed.

Both the subject and all props must be selected and everything must then be precisely positioned, by whatever means necessary. The solution may dictate the simple use of a clamp, but frequently demands real ingenuity. It's imperative that everything stays together, at least until the last exposure is made.

A key to being a *good assistant* is the ability to prioritize your responsibilities and be efficient in accomplishing them. At the same time, you keep one ear dedicated to the photographer. There's more to professional photography than what's visible in the final image. To be a successful assistant, you need many skills. Not all are thought of as photographic, but they're still essential in creating successful photography.

BENEFITS FROM ASSISTING

The benefits you receive by being a professional photographic assistant are almost too numerous to list. In simple terms, it's an incomparable *learning experience . . .* and you get paid for it. You work with the better photographers, and in the process you're exposed to a vast array of photographic challenges and creative solutions.

By assisting different photographers on countless photographic assignments, the day-to-day tasks of photography gradually become routine. As a result, you'll be far less likely to have difficulties when making the transition from assistant to professional photographer.

Perhaps of greatest value is the knowledge you gain regarding every aspect of light. As your photographic eye evolves, you learn to appreciate its subtleties. If you're perceptive, techniques used to control light can become invaluable tools for use later on. Assisting also gives you a familiarity with a range of photographic equipment that's impossible to obtain any other way. This hands-on experience makes the inevitable purchase of costly photographic equipment less of a gamble.

The assistant is part of a creative team, commonly working with models, stylists, set builders, and other assistants. Working with these people imparts valuable knowledge. Later in your career, many of these same individuals may

even be of service to you. When you are assisting, your daily routine is likely to include running errands. These will consist of stops at film-processing labs, repair shops, and other photo-related resources. Support services are essential to virtually all areas of professional photography, and many times aren't readily located in the phone directory.

Finally, assisting provides a unique avenue for becoming part of the local photographic community and for building a *network* of relationships. As a successful assistant, the transition to professional photographer will be more fluid. Gradually, your employers become your peers.

THE PROFESSIONAL PHOTOGRAPHIC COMMUNITY

The field of professional photography is extremely diverse, so it's critical to know which areas of photography require assistants and why. The following list discusses areas with the greatest potential to utilize photographic assistants. It's fair to say that several categories might apply to a photographer over the course of a busy year.

Commercial Photography

Commercial photographers use assistants, more than any other group of photographers. These photographers commonly obtain work from advertising agencies, graphic design firms, and larger companies. The resulting image is then used in some form of commercial endeavor, such as a magazine advertisement, brochure, Web site, or annual report.

The field of commercial photography isn't precisely defined and holds the potential to expose the assistant to every kind of shooting experience. Commercial work differs from wedding and portrait photography, where the general public is buying the product. Editorial photography and photojournalism aren't considered commercial work because the photography is not directly involved with selling something.

Product Photography

Product photography is a branch of commercial photography, essential to many businesses and photographers alike. When the objects are small, it's often referred to as tabletop or still-life photography. Whatever you call it, you take pictures of things, usually things that are sold. Ideally, this work is performed in the studio, where photographic control can be maximized. Proper lighting is critical, not only to show the product most favorably, but also to elicit a response or convey an idea. Utilizing view cameras, professional lighting systems, and every type of related equipment is the routine.

Architectural Photography

Architectural photographers also depend on assistants. Whether shooting interiors or exteriors, they are often called on to illuminate large areas. This translates

into lots of lighting equipment. Photographers often need to be in two places at once and, when large spaces are involved, what's better than a good assistant? As you'd expect, it's always a location job and everything must be transported to and from the site; strong backs are required.

With much of product and architectural photography, capturing the final image is often anticlimactic and almost a formality. Lighting and composition problems have been solved and verified with Polaroid instant film or by viewing a monitor. Unless an important variable cannot be precisely controlled, like the pouring of a beverage or rapidly changing natural light, a limited number of exposures are made.

People and Fashion Photography

For some subjects, going to film signals a higher level of activity. This is true when photographing people, especially in fashion. Here the fast-handling 35 mm and medium-format cameras are most useful, with electronic flash helping to freeze the action. Due to a model's movements, the photographer cannot control the final outcome, and a certain level of tension exists on the set.

This uncertainty means many more exposures are made to assure the photographer gets the shot. For the assistant, it becomes more important than ever to be attentive to the photographer's needs and to what's happening around the set. If there's a delay in the action, it'd better not be because of you.

Editorial Photography and Photojournalism

Editorial photography and photojournalism are the noncommercial photography found in magazines and newspapers. The photographers producing this work tend to use assistants less frequently than commercial photographers do. Unfortunately, many editorial budgets just don't have any extra money for an assistant.

Besides budget, there is a fundamental difference in the subject matter. In most instances, the editorial subject possesses an inherent quality that makes it interesting to the viewer. A commercial product or idea doesn't have this advantage. It's a box, a thing, and the public often has little interest in it. The commercial photographer has to work hard to evoke any kind of response . . . that's part of the challenge. On the other hand, the very nature of editorial photography and photojournalism requires a less contrived approach, which means less need for an assistant.

Wedding and Portrait Photography

When the lay person envisions professional photography, both weddings and portrait studios quickly come to mind. From an assistant's viewpoint, both share some common traits. First, they draw their livelihood from the general public. This usually translates into a restricted budget. In addition, shooting situations and lighting solutions are less complex. The result is less need for an assistant. It's important to realize, though, that there's still tremendous

opportunity to photograph people, although it's usually related to a commercial job.

FREELANCING AND FULL-TIME ASSISTING

Another aspect of assisting must be addressed. This is whether to be a freelance or full-time assistant. As a full-time assistant you are like an employee of any small business, except that the job is with a photographer who owns an independent studio. As a freelance assistant, you provide services to many photographers on an as-needed basis.

Before deciding if one position is best, it's important to examine the city where you intend to work. There may not be a choice to make. Larger, economically healthy, metropolitan areas have larger photographic communities. These markets hold the greatest potential in finding a full-time position. Metropolitan areas with less than half a million people may have only a handful of full-time positions. Wherever the market, there are always more freelancers than full-time assistants.

If given the opportunity to pursue either, understanding how the two positions differ will help you make an informed decision. The word that best describes freelance assisting is "diversity." One day you're on location, involved with a fashion shoot. You're working with a medium-format camera, strobe, models, and a stylist. On another, you'll spend the day in the studio, fine-tuning a single product shot. Here the photographer utilizes a view camera, different lighting equipment, and, more importantly, a different viewpoint.

No matter how skilled, no single photographer practices every type of photography or utilizes every valid approach. Freelancing allows you to explore the widest range of photographic experiences. You may become more familiar with those areas you think you want to pursue professionally. But it is just as likely that you will become sidetracked by areas you never even knew existed. Try it; you might like it. If it doesn't hold your interest, don't worry; your next assisting job will probably be quite different.

Working with different photographers means different equipment. Freelance assistants get hands-on experience with a vast array of equipment. This helps you decide which style of photography or particular camera format feels right for you.

Don't conclude that freelance assisting is all pluses. As a freelance assistant, you are essentially running your own business. Freelancers don't find one job and then stop looking. They build a clientele and work at keeping it. This means you don't receive a steady paycheck. You bill your clients and wait for payment.

When you are pursuing a full-time position, it's important to evaluate both the photographer and the kind of work he or she performs. The assistant works very closely with the photographer, and a certain degree of compatibility is essential. Does the kind of work the photographer shoots day in and day out fit into your learning and career goals?

GETTING THE MOST FROM ASSISTING

Besides providing a service, assisting is also the best opportunity to learn about all aspects of photography. However, little can be gained by passively observing what's happening on the set. Certainly, you'll learn which processing labs are best and the preferred types of equipment. But there's much more. Realizing this potential takes a conscious and directed effort.

BE A GOOD ASSISTANT

One of the most basic ways to learn is to work hard at being a good assistant. By concentrating on the photographer and the progress of the shoot, you not only sense the photographer's needs, you begin to think like a professional photographer.

In addition, the repetition of basic photographic tasks is a tremendous benefit to learning. Eventually, you become proficient at the many photographic processes that, if not done correctly, can subtract from the final image. With consistency comes the ability to improvise and create new solutions.

It's important to remember that assisting isn't one continuous question-and-answer session. Rather than asking numerous questions, try to think of the answer yourself. If you remain perplexed, approach the photographer at a less hectic moment or at the end of the day.

Lighting is one of the most critical aspects of good photography. Here, much can be learned by following the evolution of the lighting arrangement and reviewing the resulting series of Polaroid prints. Since these prints are sequentially numbered, they can be examined later in the day.

On your way home from the job, reflect on the day's activities. This will make you a better assistant, and technical or creative aspects of the shot are more likely to be remembered. Consider keeping a notebook. In it you can record information, such as filter combinations for mixed-lighting conditions or perhaps the name of a unique light-modifying device.

Review the discussion on *freelance* versus *full-time assisting*. Your decision, and how you market your services, can profoundly influence whom you work for and the type of photography you encounter. Ultimately, this affects what you learn.

KEEP SHOOTING

Assisting is so beneficial because you learn by doing. You'll find that your own photography will progress at a faster rate if you continue to shoot frequently while assisting. This is partly because you can employ recently learned techniques, but you'll also become more critical of your own work, and consequently more demanding.

Unfortunately, your progress can be hindered by a lack of equipment or studio space. If this is the case, consider trading your services for the use of these items. With time, you'll know which photographers might be receptive to your proposal, and they'll know they can trust you with their equipment. If they didn't, they wouldn't continue to hire you.

THINK BEYOND PHOTOGRAPHY

When you're first learning photography and assisting, it's easy to get too focused on photography. I feel that, even though you're a photographer first, it's essential to keep an open mind, not only to grow artistically but also to take advantage of new opportunities.

1. *Keep up with business and current events,* so you can get the broader picture. You need to know where the world is going and how your industry fits into it. It's the only way to keep ahead of the curve.

When I began assisting, most photographers had never thought of their images as "content." The Web as we know it today was virtually nonexistent. And who'd have thought that a couple of corporations could end up controlling so much of the fragmented stock industry in just a matter of five years?

2. *Acquire computer skills.* Although I'm best described as a landscape photographer and stock agency owner, it's the computer that has really allowed me to do much of what I want, which is take pictures. That's because it has allowed me to market my photography using CD-ROMs. Without it, I'd surely be out of business, considering the stock industry today. Besides being necessary, computer skills have a much higher perceived value.

3. *Develop graphic design skills.* Since so much can be done on the Web, it pays to have some basic graphic design skills. This can not only save you money, but can also make you a better photographer. The more design work I do, the more I learn why some photos are easier to work with than others.

4. *Write down your ideas into what's traditionally called a business plan.* Edit it until you feel it can be presented to someone. This is a great way to consolidate your ideas, but, even more importantly, the very process of writing opens you up to new ideas.

TAKE ADVANTAGE OF WHAT'S AVAILABLE

Many photographers continue to learn and build valuable business relationships by being involved with *professional organizations.* Local branches of the American Society of Media Photographers (ASMP) and Advertising Photographers of America (APA) have regular meetings, which are open to nonmembers for a small charge. These expose you to a variety of topics, while introducing you to the local photographic community. Try volunteering.

There are also courses, workshops, and seminars available. These cover many aspects of photography, but don't limit yourself. Consider gaining more expertise on computers, multimedia, graphic design, and business. And, finally, immerse yourself into the stream of *information* that's readily available. This includes books, professional magazines, Web sites, galleries, and equipment catalogs.

© John Kieffer 2001, 2003

CHAPTER 4 — PHOTOGRAPHY: A MANY-FACETED FIELD

by Susan McCartney

Susan McCartney started taking pictures at age twelve, with a plastic camera. A lifelong photojournalist specializing in people and travel, she has shot all over the world and is the author of *Mastering the Basics of Photography, Photographic Lighting Simplified, Mastering Flash Photography,* and *How to Shoot Great Travel Photos.*

YOU ARE CONSIDERING A CAREER in photography. That's good. There are plenty of opportunities for talented and motivated newcomers—advanced-level photographers who can successfully handle the pressure of shooting paid assignments.

Be aware that, except in the smaller markets, most photographers eventually specialize. Good reasons for specialization are preference, opportunity, and any contacts that can help you get work. Your area of residence and willingness to relocate are factors, too—it's just not possible to be a celebrity photographer and live in a small town. Another reason for specialization is that equipment suited to one type of photography may not be useful for another. Most importantly, it is easier for a potential client to offer work if they can see that you have experience in photographing what is needed. Finally, when you become known for excellence in a particular area, you can charge premium fees.

It's okay to have more than one specialty—many photographers do just that—but then they show different portfolios, geared to the interests of prospective clients.

Photographic specialties are listed below with general requirements, in alphabetical order. This list is not written in stone—quite a few photographers, including myself, have more than one specialty. To learn more, visit Web sites for the organizations mentioned. Find them under *http://www.(initials or name of the organization).org* unless otherwise noted in the text below. Find helpful books on the Internet, too.

ARCHITECTURE AND INTERIORS

Architecture is a well-paid specialty in an uncrowded area of photography. Opportunities exist just about everywhere. Start small, working for local real-estate firms, builders, contractors, architects, homeowners, and interior decorators and designers. Move up to shooting for nationally and internationally known architects and construction firms who give out many commissions. So do corporations, architectural publications, and decorating magazines. Top specialists, like Norman McGrath, the author of the now-classic *Photographing Buildings Inside and Out,* travel all over the world on assignment.

Good architectural and interior photography requires patience and technical knowledge of how to use medium- and large-format cameras with "swings," "tilts," and "shifts"—camera adjustments that control subject perspective and depth of field. Also needed is expertise in photographic lighting. Color must be rendered correctly and the architect/designers' lighting effects must be reproduced exactly. This may require long exposures, switching lights on and off, and the use of several color- and light-balancing filters, all in one photograph. Today you will also need a good knowledge of Adobe Photoshop retouching program. Many technical corrections previously made with the camera or filters are now made on the computer.

BABIES AND CHILDREN

It's possible to start part-time with minimal equipment—any user-adjustable 35 mm film or digital camera plus a moderate-focal length telephoto or tele-zoom lens is fine. Add a portable silver/white fabric reflector if you like to work outdoors, or use a flash off-camera and you are in business. (Later you may want studio lights, too.) Find clients everywhere, including the birth announcement columns in local newspapers. This specialty is emphatically *not* just for women or small-time photographers. Yes, you could shoot for an hourly wage at the local Wal-Mart studio, but if you love kids and have energy, ambition, and talent, think about all the baby products advertised in national women's magazines and all those ads and editorial shots of babies that run in parenting magazines. If you have access to cute babies, children, and teens, photograph them often, and attractive parents and grandparents, too. Be sure to get model releases, because baby and family pictures are big stock sellers.

At the highest level of child photography, specialists include Jack Reznicki, an acquaintance who does very well indeed shooting Toys R Us catalogs and advertising-related kid pix. Or think about Ann Geddes from New Zealand, whose highly original baby picture books have sold millions of copies all over the world and made her famous and rich.

CATALOG

Catalog photographers may work on the staff of large corporations that do high-end product advertising, for instance of automobile or furniture, or they may shoot for a big department store, or a mail-order/Web merchandiser. Alternately, he or she may work for a specialist "catalog house"—a fair-sized, independent photo studio specializing in shooting products for companies that don't have full-time staff.

Most catalog specialists like the security and steady work they get despite the fact that catalog work is not usually highly creative. Technical lighting ability and the love of detail required of all still-life photographers is important. Much catalog work is shot with large- or medium-format digital equipment today. It's safe to say that most corporations recruit catalog staffers who are graduates of photo schools with a reputation for technical excellence.

CELEBRITIES

You must start close to where the celebrities are, which, in the United States, pretty much means Los Angeles, Las Vegas, New York, and top resorts. You also need a lot of chutzpah! I know three celebrity photographers. All have excellent social skills. If you have the charm and persistence needed to be a successful telemarketer, you can probably also make it as a celebrity photographer.

Two former students of mine with excellent flash photography technique started out as freelance "paparazzi," finding photo ops by subscribing to commercial celebrity listing services and selling to supermarket tabloids. One now shoots far-flung assignments for *Us, People,* and similar publications; the other successfully made the transition to fashion photography. A longtime friend, Ken Regan, first shot sports, then features on sports stars. He cofounded a celebrity stock agency and has published several great picture books. He now spends a good percentage of his time shooting movie stills for Clint Eastwood, Sean Connery, and other top stars.

COMPUTER PROGRAMS AND SKILLS, AND
COMPUTER MANIPULATED IMAGERY/MONTAGES

All but fine art photographers today require at least some computer skills. Especially important is a good knowledge of the industry standard, Adobe Photoshop software. Photoshop is excellent for retouching minor flaws in a scanned image, or for correcting color balance or removing the odd dust spot in digital images, as I do. If you want to make your own promo sheets, business cards, and more, you will need to know either the Adobe PageMaker or QuarkXPress program, too.

Specialists use Photoshop to manipulate photographs as a basis for elaborate computer montages. This obviously requires expert computer skills, and many practitioners have degrees in computer science as well as a good knowledge of photography. Some digital imaging specialists work with their own photographs, whether film or digital originals, while some work with photographs taken by others. See *Digital Imaging* and similar magazines for examples. Purely photographic montages are as old as photography itself.

CORPORATE/INDUSTRIAL PHOTOGRAPHY

This specialty requires excellent people skills, and a strong, even elegant, sense of composition. High-paying annual report assignments are often given out by top graphic design firms. For success in this field, you must be flexible: You may shoot in a boardroom one day, on top of a coal car the next—it has happened to me. In both cases you interfere with the workday of busy people, so you must be able to get what you want fast. Most such assignments are shot with 35 mm equipment; increasingly, it's digital. There are many ways to learn this specialty—the skills of a photojournalist are transferable. Assisting a good specialist for a while is ideal. Entry-level corporate staff photographers are usually hired from top photo schools.

EDITORIAL/PHOTOJOURNALISM

Some people would separate these categories, but I do not. Photojournalists all photograph picture stories documenting actual events and real people's lives. Good reflexes and graphic sense are paramount skills.

"Soft" editorial photographers like myself shoot for consumer magazines and books, most often photographing people and noncontroversial stories, and may on occasion "set up" or recreate situations. "Pure" photojournalists often cover much tougher stuff, including wars and social problems, and, in theory anyway, never set anything up. In terms of equipment, 35 mm is the norm—again, it's increasingly digital equipment. Good lighting skills are a plus, but some "photo-j's" never use any lighting beyond an occasional flash pop. See books by Brazilian Sabastiao Salgado to view the work of a graphic master and socially committed true photojournalist, who, of all the photographers in the world, is the one I would be most proud to be. Many photojournalists and editorial specialists belong to the ASMP (American Society of Media Photographers), which has regional chapters.

FASHION AND BEAUTY

Top fashion and beauty photographers work almost exclusively for the clothing and cosmetic industries and related fashion magazines. In the United States most have studios in New York or Los Angeles, traveling to fashion capitals like Paris, Milan, and London for spring and fall shows and special events. Some specialists shoot mostly men, others children; the majority, though, concentrate on women's wear, by far the largest fashion category. Quite obviously, a sense of style and elegance, a love of beautiful people and things, and a respect for the business is required. You need to be able to work well with models, clients, designers, stylists, and makeup artists, too.

Learn basics by assisting a fashion or beauty specialist—many graduates of photo schools come to New York each September to find assisting jobs. Editorial fashion photography can be free and fun and is often shot with 35 mm equipment outdoors or in beautiful indoor locations. Fashion/beauty advertising has a more studied, or formal, "look" than editorial, and is done in studios, most often with medium-format equipment and strobe lighting. European fashion magazines are worth studying to preview future trends in both clothing and fashion photography. Specialist magazine stores and Web sites are places to view them.

FINE ART

Any photograph can be labeled as fine art, and some are. You are free to express yourself in any way you want. For you to be able to sell prints, the craft aspect of your work should be impeccable. Sadly, fine art pictures are most valuable after the artist is dead! If you shoot highly personal work but do not have a nice spouse or comfortable trust fund to support your living, you might want to consider teaching. Today, minimum requirements for teaching photography at a good art school or college are an MFA in photography, some history of having

work published and/or exhibited in recognized galleries, and excellent communication skills. If you are interested in teaching, the SPE (Society for Photographic Education) can provide some information. It has mostly college teacher members. Their Web address is *www.spenational.org.*

GENERALISTS

Some photographers are generalists, either because they live in smaller towns or rural areas, or because they like variety. They probably shoot portraits, parties, weddings, products when called for, and may do some work for the local newspaper, too. This generalization does not mean they are bad photographers—they probably need to be excellent to make a good living! Some generalists have a storefront studio; others work out of home. Space to shoot, a good camera or two, several lenses, a set of strobe lights and stands, and a flash meter are essential to begin. Having a good Web site can extend your advertising reach, and the many Internet newsgroups aimed at photographers can keep you current on trends.

ILLUSTRATION/PEOPLE FOR ADVERTISING

Top advertising photographers who can shoot models in elaborate setups convincingly are highly paid. Individuals have widely differing styles and favorite subject matter. See their work in national magazines and, of course, also in "sourcebooks" such as the *Workbook,* published in Los Angeles, which can be found in libraries. These days, you don't have to live in New York or L.A. or Chicago to work for great ad agencies, because many highly creative shops are now located in Atlanta, Dallas, Minneapolis, Seattle, and other major cities around the United States and the world. Advertising is an image-conscious business; you will need a great portfolio, an attractive studio, good equipment, and at least one assistant to be convincing. Almost everyone works up to this level gradually. Learn by working for an established advertising specialist. Mostly, these folks are choosy about assistants, and hire graduates of good photo schools. A computer whiz has a good chance landing a job with a veteran ad photographer who may not want to do computer work him- or herself. APA (the Advertising Photographers of America) is a national organization with a few local chapters. Their Web address is *www.apanational.org.*

MEDICAL/SCIENTIFIC

Almost all specialists in this field work on the staff of private, government, or police agencies, at research labs, hospitals, or universities. Most have scientific training as well as knowledge of photo microscopy. A specialist acquaintance told me that there are good full-time employment prospects. Check out technically oriented photo schools for training opportunities.

NATURE/WILDLIFE/LANDSCAPE

All wonderful specialties, but all ones with which it is hard to make a full-time living. Many photographers, like myself, combine their love of nature with travel

and other types of photojournalism and even with writing or teaching. While 35 mm equipment is the norm for wildlife, landscapists may use any camera format. View books by Frans Lanting, Jim Brandenburg, and Art Wolfe to see the finest animal and bird photography. Heather Angel shoots beautiful nature photographs and also writes excellent how-to books. My favorite landscapists include John Shaw, Richard Misrach, and the great Ansel Adams. Many specialists belong to NANPA (North American Nature Photographers Association).

NEWS/SPORTS

I group these specialties because many photojournalists shoot both breaking news and sports. The smallest of small town papers use photographs, so almost anyone with a love of a fast-paced life and good photo skills and great reflexes has a chance of breaking in. Show a portfolio with people and local sport examples to the news or photo editor. Major newspapers employ staffers. The NPPA (National Press Photographers Association) may have information on employment opportunities. At a high level, top news specialists work for magazines like *Time* and *Newsweek*—both good to study. Top sports specialists know a lot about the games they shoot. Many are former players or participants. See *Sports Illustrated.* Specialized magazines cover auto racing, baseball, basketball, bicycling, football, golf, running, skating, soccer, swimming, tennis, and more.

STILL LIFE AND FOOD

While catalog and commercial photographers—even travel specialists like myself—tackle still-life subjects on occasion, the true specialist can make the most mundane of objects look gorgeous. Someone with this talent, training, lighting expertise, eye for detail, and patience can make a lot of money photographing cans and bottles, watches and jewelry, electronic and household gadgets, cars, tubes of toothpaste, liquor, wine and beer, and canned and packaged foods. A still-life specialist photographs just about any product advertised in magazines or newspapers, or on posters and billboards. There is plenty of work out there: Still life is one of the most in-demand of advertising photography categories. Much product/object imagery today is created with large-format cameras incorporating swings, tilts, and digital backs.

Food is one of the subspecialties of still life, and may be photographed with much detail for advertising, or in a looser editorial style for food, lifestyle, and travel magazines. I have shot food as part of editorial travel coverage. Then superfine detail is not critical, and I use 35 mm equipment. To work for a still-life specialist is great training; most hire assistants out of good photo schools.

STOCK

I have made a respectable amount of money from my stock images, which are almost exclusively "outtakes" from travel assignments. That makes me an amateur to today's specialists, who work closely with one or more stock agencies, shooting on demand. Now, serious stock shooters function as production houses,

some setting up elaborate situations using top models while fronting the expenses. This obviously excludes many younger shooters without access to capital. However, a new development in the industry is that some of the largest stock houses are giving paid assignments to photographers whose style they like, and allowing them some residual income from resulting sales. If you can work out an arrangement with a stock house to do this, it may be a good way to make money and gain exposure.

The biggest-selling stock category is called "lifestyle"—model-released pictures of attractive people, families, and business situations, with the "look" of much advertising illustration. There is a market for unposed, editorial-style travel, nature, and people stock, if the images look fresh and the subject matter is current. Sadly, however, stock prices in most categories have remained static because of the large number of royalty-free images now available on CD-ROM disc.

Most stock shoots are still financed by photographers, so you would be well advised to work closely with an established stock agent if you want to specialize in this area. PACA (the Picture Archive Council of America) is the umbrella organization of stock agencies, sometimes called picture libraries. Members subscribe to a code of ethics regarding payment terms and many other important matters. Find them on the Web at *www.stockindustry.org*.

STUDIO PORTRAITURE

Top studio portraitists may work for advertising and magazines, but most in smaller markets shoot for individuals, local businesses, and corporations. Executives everywhere need portraits, and so do would-be actors and models, families and schools, and high school and college students. Start small, with a home studio and simple lighting equipment. If you get on well with people and can photograph them so they look their best, your reputation will grow. Who knows where that will take you? Many towns and smaller cities have portrait studios, whose owners do excellent work; perhaps you can assist to get experience. The Professional Photographers of America (PPA) organization has many studio-portrait photographers as members. Their Web address is *www.ppa.org*. Also see WPPI, under "Weddings."

TRAVEL/LOCATION

Travel specialists like myself are photojournalists who love a wide variety of subjects. We photograph sports, interiors, landscapes, still life, wildlife, churches, offices, castles, gardens, food, nightlife, festivals, and all kinds of people. I have made images of actors, artists, aristocrats, chefs, farmers, jockeys, mayors, ministers, and notables all over the world, for advertising, commercial, and editorial travel clients.

You need great curiosity about the world. If you have that, you will make opportunities to travel. You also must be flexible, have a sense of humor, and be well organized, or the little (sometimes big) dramas that occur on all trips

may overwhelm you and prevent you from getting needed coverage. Begin by traveling and building a portfolio. Travel photography is a crowded specialty, so adding a few other strings to your photographic bow will add to your income.

Location photography is done outside a studio, and uses the same skills as travel photography. Annual reports, business meetings, conferences, audiovisuals, stock, and more are often shot on location. See my book *Travel Photography* for much more.

WEDDINGS/EVENTS

Wedding photography is practiced at many levels, from the part-timer with a day job who shoots occasional low-budget weddings to the specialist with an international reputation who flies to glamorous locales to cover celebrity nuptials. The average professional wedding photographer is full-time, experienced, and reliable—to shoot a wedding is a big responsibility—and may work out of a home office or studio. He or she may be the owner or a staffer of a big operation employing receptionists, salespeople, other photographers, and assistants.

Wedding photographers' styles can be formal, or editorial, so-called "photojournalistic." Break into the business by working for an experienced wedding specialist. Locate wedding shooters in the Yellow Pages. Many wedding photographers also cover business and social events. The PPA (see page 31) has many wedding specialist members. So does the Wedding and Portrait Photographers International (WPPI), whose Web address is *www.wppinow.com*.

© Susan McCartney 2003

CHAPTER 5

EQUIPMENT FOR THE FREELANCE PHOTOGRAPHER

by Chuck DeLaney

This chapter is adapted from *Photography Your Way* by Chuck DeLaney, the dean of the New York Institute of Photography *(www.nyip.com)*, America's oldest and largest photography school, and a freelance photographer and writer based in New York City. He is a frequent speaker at professional photography seminars across the country.

THE TYPE OF EQUIPMENT a photographer will need to get started will vary with the type of freelance assignments that are being sought. It stands to reason that a photographer specializing in weddings needs different lighting equipment from that required for a news photographer who specializes in high school sports.

But it all begins with the camera. And that's where we'll start this chapter. It's a testament to the viability of film in the emerging digital era that camera manufacturers are still introducing 35 mm film SLRs with new features. There has never been better photo equipment available than today, and for the most part the cost of professional-grade equipment is very reasonable compared to what cameras cost twenty-five or thirty years ago. You get a lot for your money.

That said, it's important to put equipment in perspective. At the New York Institute of Photography, we have a saying that we repeat frequently to all students: "It's not the violin, it's the violinist." A good photographer can handle most assignments with almost any equipment. If you have a reasonable sense of the exposure range of your favorite film, you should be able to get good results with a thirty-year-old, all-manual camera without a light meter.

Still, particularly when the number of dollars you have in your pocket is limited, and especially when you're getting started, what you need, which brands to select, and how to shop can raise lots of questions. I hope this chapter will address your most pressing questions.

Technology has made tremendous improvements in everything—cameras, lenses, and film—in the past two decades. There's fierce competition for market share, and every major manufacturer puts a lot of effort into quality control. And it shows. There's hardly a piece of equipment out there that is a "lemon."

CAMERAS

To understand the cameras that are available to you, you have to know a bit about the photo industry.

Over the past twenty years, the pattern of camera sales has changed drastically. Only a few camera manufacturers have a big stake in producing top-quality professional equipment. The numbers explain why.

For the past few years, annual sales of single-use cameras have soared way past 100 million units in the United States alone. Point-and-shoot sales hover near 10 million units per year, and American annual sales of 35 mm SLRs have crawled back toward 1 million units after bottoming out at about 700,000 in the early 1990s.

Some companies that used to put a lot of effort into producing professional gear have realigned their efforts to make and sell point-and-shoot models, both film and digital versions. That's where the market and the big profits reside.

Consumer digital cameras are already selling millions of units a year. Current estimates are that one quarter of American households own a digital camera. Experts predict sales of digital models will continue to climb.

For serious photographers who use SLRs, technological developments in professional-level cameras have been staggering since Minolta brought out the first auto-focus Maxum in 1985. SLRs now automatically solve many complicated problems. For example, fill flash used to require balancing the natural light with the power of a flash unit to find an aperture size that would allow the ambient light to provide the principal exposure for the scene, and a matching shutter speed slow enough to synchronize with the flash, but not so slow as to blur the subject.

That used to be a higher math problem for a lot of photographers, but the dedicated flash, TTL (through-the-lens) flash metering, and the auto-exposure camera have made fill flash a simple technique. The chips do it all.

For years, our approach at NYIP was to advise students to start with an inexpensive, all-manual SLR, such as the venerable Pentax K-1000 or the Minolta X-700. Both had production runs for twenty years or more, and both gave the student an opportunity to experiment with the full range of exposure options.

The Proper Violin for the Beginner

I've changed my thinking recently and feel that beginners are best off with one of the lower-priced auto-exposure, auto-focus models offered by the key SLR manufacturers.

There is a danger that the photographer will fail to use the extremes of aperture size to exploit narrow depth-of-field and maximum depth-of-field to their best advantage in a variety of photographic situations, since auto-exposure software will tend to use mid-range shutter speeds and apertures unless a program mode of some sort is used to force the auto exposure to behave in a way that the photographer desires.

However, the awareness of these essential creative photographic options can be learned in other ways, and today's fully-automated SLR can enable the

beginner to capture a variety of types of images that would be tough to grab with that all-manual K-1000.

I'm particularly enamored of the SLR models that have a small, built-in, pop-up flash. While for professional applications I prefer a more powerful add-on dedicated unit, there are lots of situations where that little flash will provide just enough "pop" to make a portrait in shade look much better, or illuminate a small floral subject in deep shadow.

Turning to brands, Canon and Nikon are the two manufacturers that offer the most extensive range of professional camera accessories, and, certainly, if you're considering building an elaborate system of 35 mm lenses and accessories for an SLR, you're probably going to end up using one or the other. The working pros seem to be about evenly divided at this point.

Pentax and Minolta also make great SLRs, and, if you're the type of photographer who needs just one or two camera bodies and a few lenses, both these lines have models worth considering. They just aren't as extensive in lens offerings and other accessories.

There are other manufacturers, such as Leica and Contax, that produce precision instruments and whose SLRs still have passionate devotees.

For the most part, your final decision boils down to personal preference. What feels better in your hands? The new Canon models tend to operate very quietly. Does that matter in the work you plan to do?

I should add that there are excellent 35 mm range-finder cameras as well. Sebastio Salgado uses a range-finder Leica. Others swear by Contax. Particularly for situations where it's essential to use a quiet camera, range-finder models have a place in the professional's arsenal.

Medium-Format Cameras

Here there are fewer manufacturers, and the number of units sold in America each year is estimated to be somewhere around thirty thousand to forty thousand.

As for brands, we all know that the Hasselblad was the first camera on the moon, but the popular view that the Hasselblad is the choice of discerning professionals has been challenged in recent years by Mamiya. While sales figures are elusive, the consensus of observers is that these two cameras dominate the marketplace. However, I know lots of working pros who swear by their Bronica, Pentax, or Rollei. In recent years, Fuji has taken the lead in introducing some interesting medium-format designs and concepts.

There's also a lot of innovation in the medium-format field right now. The twin lens reflex, long a staple of models made by Rollei and Mamiya, is nearly extinct. Only Rollei and the Seagull TLR, a Rollei knockoff made in China, are still in production. Several manufacturers, including Fuji and Mamiya, have brought out range-finder medium-format models that function almost like overgrown point-and-shoot cameras with the benefit of a giant negative. They're pretty tempting—I find myself playing with them at the trade shows. Auto-focus and auto-exposure features are turning up in more models. We'll

discuss buying used equipment later in this chapter, but I want to point out that there is a lot of good used medium-format equipment available.

I think using a medium-format camera can add a great deal to your photography. For one thing, those additional billions of silver-halide grains can record a lot more information about your subject. For wedding and portrait photographers, the medium-format negative makes mechanical retouching by the lab feasible.

Certainly one question you should ponder is whether you're interested in either a 6 x 4.5 cm or a 6 x 7 cm model, rather than the traditional, square, 6 x 6 cm images produced by the Hasselblad. The variables are pretty straightforward. With any 6 x 6 cm camera, you never have to think about turning the camera. With a 6 x 7 cm model you get an even bigger image, but fewer frames on a roll of film. And with the 6 x 4.5 cm you get a little less image size but more frames on a roll. However, with either format you have a camera that makes a rectangular image in your hand, and there will be times when you will have to turn the camera to match the frame aspect ratio to your subject matter. Depending on the viewing system in the camera, this can be unwieldy.

Large-Format Cameras

Whether in the commercial studio or out in the field, there will always be photographers who enjoy making an image on 4 x 5 or 8 x 10 sheet film. The slow and contemplative pace is appealing, and the potential for manipulation of the image using camera movements is almost exclusively reserved for the realm of the view camera. And the images have a richness and high resolution that is unmistakable and very pleasing to the eye.

The nature of the freelance work you seek will dictate whether it makes any sense for you to even consider working with a view camera. However, it is a wonderful experience and one I recommend you try. This might be the perfect reason to visit a rental shop to see what kind of rate you could get for a week or a month to rent a view camera, a lens or two, and a dozen film holders. Make sure to rent a proper tripod as well. The one you use with your 35 mm SLR won't support the weight and bulk of a view camera.

Digital Cameras

For the professional photographer, digital cameras have become simply another tool. When it makes sense to use that tool, pros will do that. Digital capture is ideal for breaking news and photojournalism, where often the speed with which a picture can be "moved" is paramount. Lots of catalog and other commercial work is shot digitally to save on the cost of film and processing.

While high-end digital cameras have been used for more and more applications by professionals over the past decade, and while the professional photographer has entered a world where it's necessary to master the computer-age electronic darkroom, for many photographers it still makes sense to capture the image on film and convert it to a digital file by scanning later on.

BUYING A NEW CAMERA

If you're considering buying a new camera, you can make the process a lot easier and guarantee that you'll get the right camera at a good price if you take just two simple steps.

First, take the time to answer five easy questions *before* you set foot in a camera store.

Second, obey the Cardinal Rule of Camera Shopping.

Here are the questions:

1. What type of camera do you want: a point-and-shoot model or an SLR? Or a medium-format camera?
2. How much are you willing to pay?
3. What brands interest you?
4. What type of store would you like to use to make your purchase, and what is a "good" price for the camera in which you are interested?
5. Do you care about a USA Warranty?

Why should you know the answer to these five questions *before* you enter a camera store?

Because the sad fact is that *almost* all the stores that sell cameras—and nowadays those range from photo specialty stores (which are dwindling in number) to department stores, consumer electronic stores, and mass discount stores—want to sell you a specific camera, one that's in stock and that has the fattest profit margin for them.

These desires are at the heart of the Cardinal Rule of Camera Shopping. It is: *Avoid the bait-and-switch.* For those of you who don't know, I'll explain what "bait-and-switch" is and how to avoid it in a moment.

First, back to the stores. While *almost* all stores want to sell you a specific camera based on *their* needs, there are some photo specialty stores that will sell you a camera based on listening to you and getting to know your needs. Stores of this type are rare. They are stores that cater to serious photographers, and therefore they want to make you a regular customer. This type of photo store requires salespeople who know about cameras and a management that has a good business plan. There are other photo specialty stores, which will "sell down your throat," like all the other outlets.

In most of the outlets, particularly mass merchandisers and department stores, you're likely to run into a staff that doesn't even care what you want, and wouldn't know enough to help you if they did care. They just want to move product.

Does this mean that you should only shop at a good photo specialty store? No, but that's not a bad idea. It does mean that, wherever you shop, you need to make some basic decisions based on the five questions I've listed above before you start hearing sales pitches.

Not that all sales pitches are bad. You may even change your mind about a few points if you get a thoughtful presentation from a good (and honest) salesperson.

However, you'll be a lot better off if you have a working plan in mind, and a lot less susceptible to the old "bait-and-switch" if you have a brand or model in mind.

What Is "Bait-and-Switch?"

The risk of bait-and-switch sales operations extends to electronics and computer sales as well. Here's what it's all about: You enter a store, or call a mail-order dealer, with a specific product in mind. Perhaps you were drawn to that seller because of an advertisement offering a great sale price on a particular item.

The advertisement has "baited" your interest, and you visit the store because you intend to buy that item. In a bait-and-switch, what happens next is that the salesperson "switches" you to a different product, one that will make the seller more profit and in all likelihood won't be as good as the product you originally sought to purchase.

If it's a great sale price that has drawn your attention, you'll be told you're too late, they're "sold out" of that model, but, lucky for you, they have something "just as good." It may even be a little cheaper than the item that caught your eye, but it won't be *as good,* and the seller's markup will be bigger.

That's the old bait-and-switch.

Here's an example. A while back, a friend of mine asked for my help in selecting a camera. She and her boyfriend were going to Africa for a wildlife safari. I met her at the local camera store, and she quickly decided she preferred a compact point-and-shoot over an SLR. At that time, I didn't know too much about point-and-shoots, but I suggested a couple of name brands that had garnered good reviews in the photo magazines.

The guy behind the counter strongly recommended a model by a smaller manufacturer. He told us that it performed as well as the others and showed us a feature that he said he liked. My friend bought the model he suggested.

Shortly after she came back from Africa, she called me to lament that her photographs came out poorly. Sure enough, after I inspected them, it was clear that the camera had consistently underexposed her images. I shrugged it off as a manufacturing problem and cautioned her that she shouldn't have waited until the last minute to purchase a camera. She should have bought it earlier and tested it.

Only years later, long after that store had closed, did I find out the truth. A former salesperson from that store explained to me that the store's owner pushed one manufacturer's line because he got a big rebate based on sales volume. The model that his associate had sold to my friend was well known to be a lemon. There had been a conscious choice to go for the fast buck and stick it to the customers!

The Five Questions for Camera Buyers

That's why it's important to know what you want before you start shopping. That brings us back to our five questions. Let's start at the top of our list, and work our way down:

1. WHAT TYPE OF CAMERA DO YOU WANT?
Point-and-Shoot Cameras
Don't think point-and-shoot cameras are only for amateurs. Not long ago, I read a profile of a celebrity paparazzo, who makes a handsome living crashing society events and photographing his subjects with a point-and-shoot when they least expect it. Since he is always clad in a tuxedo, his subjects think he's a harmless, well-to-do fan, not a working pro. An SLR would blow his cover. I sometimes use a high-quality point-and-shoot for street photography; my subjects think I'm a tourist.

Single Lens Reflex Cameras
As good as the new point-and-shoot models are, there are things that point-and-shoot cameras can't do. For example, you can't change lenses or use filters, you can't see for sure what you're getting in the frame, and you can't be absolutely certain that your subject is the object upon which the camera is focusing.

With an SLR, you can do all those things. SLRs remain the cameras used by most professionals, since they allow you to look through the lens that will take the picture to make sure the image is focused and composed correctly. There are lots of different lenses and accessories available. You can buy an entry-level SLR with a 28–70 mm or 28–80 mm zoom lens for under $400.

Medium Format
As I mentioned before, medium-format cameras are particularly appealing to professionals for several reasons. Most importantly, they have a lens with fine optics, which, when coupled with modern medium-format film, will yield an image that is "richer" to the eye than any that can be produced by a 35 mm camera. It's just better, and you can see the difference. It's also true that it's easier to perform conventional retouching on a medium-format piece of film, which is very important for portrait and wedding photographers.

There are some interesting models that work almost like point-and-shoots, and Fuji has a great panoramic model that I'm itching to try.

2. HOW MUCH ARE YOU WILLING TO PAY?
You can get a beginner's SLR with a medium-length (28–80 mm) zoom lens for under $400. But you can spend close to $2,000 on a point-and-shoot and perhaps twice that for a few of the top-of-the-line SLRs. And for lenses the sky's the limit. For a big telephoto zoom made by Nikon or Canon, you can expect to pay several times the cost of those manufacturers' top-of-the-line camera bodies.

Realize that very few photographers need a top-of-the-line camera with all sorts of bells and whistles. At the same time, if you're interested in a special feature and you spend a little more for a camera that offers that feature, don't feel bad. If you need that feature for the work you intend to do, it should pay for itself in short order.

When we get to where to shop, I'll suggest ways you can stretch your dollars if you need to do so. At this point, I recommend that you pick a dollar figure you're prepared to spend, in increments of $100, and a budget of no less than $400 and no more than $1,500. If you want to spend more than that, make sure you have a good reason to do so.

I suggest $1,500 as a top limit because you can buy a professional-quality SLR and zoom lens from one of the "big four" manufacturers for that much. You could even get a less expensive SLR body and two zoom lenses for that amount.

Don't be crestfallen. Remember: That's the top of the line. You can own a great SLR and lens from a famous maker for $400 or less. There will always be a better camera than you can afford right now, but don't let that bother you. Nitpickers will always tell you their lens is sharper or they really need the titanium shutter and the ten-frames-a-second capability, but the truth is most of us don't.

You get what you pay for. More expensive, professional models have more metal fittings and screws, and the features that professionals need. If possible, spend more rather than less on your camera. Chances are, you'll have it a long time and it will pay for itself many times over. If you buy a film SLR, the money you'll spend on film and processing will far exceed the cost of the camera. If you're weighing two models and one costs two hundred dollars more than the other, try to make the stretch. You won't regret it. Another possibility, if money is tight, is to buy the better model used.

3. WHAT BRANDS ARE YOU INTERESTED IN?
We've covered all the major manufacturers already. Again, I suggest examining all the models that interest you to see which ones feel the best in your hands.

4. WHAT TYPE OF STORE WOULD YOU LIKE TO USE?
This is a very important question. You have three basic choices—the photo specialty store, the discount store, or the mail-order or online dealer. There are advantages and drawbacks to each. Let's weigh them.

Photo Specialty Stores
Chances are, you will pay more if you buy a camera from a specialty store than you would for the same model if it is available at a discount house. But you may wish to form a good relationship with your local photo store, and it is certainly the place to go to handle the models they have in stock before you make your final decision about purchasing. However, because the specialty store is often a small independent business, it is likely to have to charge more than the discounters and mail-order outfits.

Discount Stores
If the brand you want is a popular one, you may be able to find it at the local discount store and get a great price.

You will find a limited selection and get little sales help. You're there to save money, but watch out—you don't always get such a good price. Here's why. Many discount stores and chains offer astoundingly low prices on just a *fraction* of the items they sell—perhaps one item in a hundred. They offer these big discounts on the so-called "price-sensitive" items—items for which most consumers have a sense of price—like cans of Coca-Cola, lightbulbs, potato chips, and the like. That means the big discount stores "seed" their offerings with a few really cheap items to lull you into thinking *everything* in the store is really cheap, when it isn't. When it comes to photographic or video equipment, you have to know prices. You may not be saving more than a penny or two!

Mail Order/Online

Now, what about mail order? Can mail-order dealers be trusted? The bad news is that you can't trust them all. The good news is that there are good ones that are trustworthy. Buying a camera by mail or online should be no less risky than buying an airline ticket or a sweater through the mail. Since you don't know who is who, when you call a mail-order dealer, be careful, as follows:

First, specify the exact piece of equipment you want, including the model number, and make sure you understand exactly what comes with it. Make it clear that you expect it to come in the manufacturer's original, unopened package, with all the accessories the manufacturer supplies—including an instruction book in English, lens, batteries, straps, and so on. Stress that you don't want a refurbished model. If the seller won't confirm this, don't order. You'll also want to ask about the warranty, which we will discuss next.

Second, if the seller confirms the points listed above, find out if the item is in stock and will be shipped within twenty-four hours. If it's temporarily out of stock and the company expects to get it in stock in a day or two, check back in two days and order if it's in stock. When you check back, if it's still out of stock—don't order. Go elsewhere. That dealer wants to sell the item to you and then buy it from someone else for a lower price. You don't need to pay someone in the middle. Go find a store that has the camera you want in stock and buy it for the better price.

Third, verify the mail-order house's refund policy and warranty. As to refund policy, make sure the firm will take back any item you get in less-than-perfect condition. You don't want to have to deal with the manufacturer under warranty on an item you got that was defective. You paid for a new working model. You should get a new working model.

If you decide to purchase from a mail-order outfit, don't forget to reconfirm all prices with the clerk and get the name of the clerk. Write it down. If possible, use a credit card rather than a check for the purchase; this will give you the option of disputing the charge if there's a problem. If possible, ask the mail-order company to fax you a copy of the sales receipt.

The last part of question four is: How do you determine what is a "good price"?

You can find this out just by using the Web or making one toll-free telephone call. The benchmark for pricing these days is how much B&H Photo-Video charges for any given product.

B&H is unique among photography stores in America. Located on the West Side of Manhattan, it is the single biggest photo retail store in America, and also has a very big mail-order operation. There are other good photo specialty stores in Manhattan and around the country, but none have the vast inventory that B&H maintains, and few can match the low prices that B&H can offer.

Visit *www.bhphoto.com* to check the B&H price on a specific make and model of camera. The phones are busy and the store is closed on Friday afternoon, all day Saturday, and on all Jewish holy days. But when you get through, the sales staff will tell you the store's price on virtually any piece of photo equipment that is made by anyone, anywhere.

Knowing what you could buy it for from B&H will give you an idea how much more you'll pay if you shop at a discount store or local photo retailer. Now you can make an informed decision about where to shop. There's just one last question.

5. DO YOU CARE ABOUT A USA WARRANTY?

This is a confusing point for many people. A camera that has a USA Warranty has been imported by the manufacturer and is qualified for any necessary repairs during the warranty period and for any rebate programs offered by the manufacturer. A camera that does not have a USA Warranty is part of the so-called "gray market" of hardware that was not necessarily intended for distribution in America by the manufacturer.

Some stores sell only USA Warranty items, others sell only gray market, and others stock both. As you might guess, the gray-market item is cheaper, but the risk is that if the camera is not perfect and needs repair, you'll have to pay the cost rather than have it covered under the warranty.

There are two points to stress. First, know what you're getting. Ask, "Does this camera have a USA Warranty?" and expect a direct answer. If the salesperson is vague, shop elsewhere.

Second, my advice is to get the USA Warranty on today's sophisticated auto-focus, auto-exposure cameras. Here's why: Even though today's cameras are uniformly well made, there's always the danger that a computer chip or other electronic part may not be perfect. In the old days, when cameras were all mechanical, it was easy for the technicians at the inspection bench to check each spring, lever, and gear before the camera was put in the box. With today's electronic gizmos, it's hard for even the most conscientious manufacturer to inspect each unit so thoroughly as to make certain that everything works perfectly on every unit. If you happen to have a problem, it can be very costly, and that's why I think it's worth a few extra bucks for the certainty of a USA Warranty.

Now you've answered all the questions, you've selected the model you want, and you know the price you should pay. I suggest that, before you buy, you visit

your local photo store and ask the owner or counter clerk if she can meet or beat the benchmark price. She may be able to do so, or at least she may be able to come very close. The worst that can happen is that the store will say no. The manager won't throw you out.

One more shopping tip—avoid packages. Generally, when a store offers a kit that includes a flash, filter, and cleaning kit—or what have you—the accessories are being marked up to compensate for a low profit margin on the camera. My advice: Get only the camera you want. You can always buy accessories later as you need them.

Okay. If your local photo store can match (or even come close to) the price in the mail-order ad or at the discount store, I suggest you buy from the neighborhood store. The local store usually has a wide selection, the staff offers knowledgeable advice, and if you ever need repairs, service, or special-order items, you're likely to end up there anyway. So it pays to support your local store and have a good relationship with the people there.

Congratulations, you've completed every step. Enjoy your new camera!

FILM AND HARDWARE

As dramatic as the advances in camera hardware (and software) have been, perhaps the innovations in film have had an even greater impact on the images that photographers can record. T-grain film structure, self-masking film layers, and other chemical and physical developments have resulted in color negative and transparency films with fine grain, improved latitude, and all kinds of other qualities. The chemists have also created high-speed color negative films in the ISO 800 to 1600 range that can even be pushed, if necessary.

Slide Film or Negative?

Among professionals, news, portrait, and wedding photographers are likely to shoot negatives in order to produce prints to sell to their customers. Slides (or transparencies—I use the terms interchangeably) are usually produced by photographers who shoot lots of scenic or nature photos, take commercial and still-life images, or make photos for stock agencies.

Years ago, all photographers who shot for publication used slides, because photo editors preferred them, owing to the nature of printing preproduction. Nowadays, most publications are comfortable using either slides or negatives or prints, and, actually, most images arrive in digital form, having been either scanned by the photographer prior to submission or captured digitally in the first place.

Black-and-White Film

Despite the number of new black-and-white film emulsions that have been introduced in recent years, I still use Tri-X principally, along with T-Max 3200 for low-light work. There are also legions of photographers who swear by Ilford's black-and-white films. I usually use black-and-white film only when

the client requests it. In certain fields, such as wedding photography, black-and-white photography has experienced a resurgence. I also use the chromogenic black-and-white films made by Ilford and Kodak when I want to make sepia-looking prints, which can be done by any good one-hour lab.

Light Meters

Although I'm comfortable with the meter in my camera most of the time, I own several handheld light meters. I think any serious photographer should own (and learn to use) either a good reflected light meter and a gray card, or an incident meter. My personal preference is for an incident meter, and the model I use doubles as a flash meter. Anyone trying to do studio lighting with electronic flash without using a good flash meter is in danger of driving himself nuts.

There is no better way to learn about lighting than to learn how to take accurate readings of light in a variety of situations.

Used Equipment

I buy a lot of equipment that is used, and I have had good luck doing so. Here's my advice for the photographer who would like to purchase good secondhand equipment.

In addition to cameras taken in trade, at a good photo store you may find used lenses, meters, and lighting equipment. Individuals may sell cameras via newspaper want ads, online, or at a flea market or garage sale. If the seller is an individual, chances are you're dealing with someone who has bought new equipment or who has lost interest in photography and wants to cash out.

Where to Find Used Equipment

There are six principal places you'll find used camera equipment—your local specialty store, mail-order dealers that advertise in magazines, pawnshops, flea markets and garage sales, newspaper classified ads, and online auction services. Each has its own possible benefits and potential pitfalls.

Obviously, you must be careful wherever you buy used equipment. If you buy from a specialty shop or a mail-order house, you will want to ascertain that you are dealing with a reputable merchant. If you buy from a pawnshop, flea market, or classified ad, you must scrutinize the equipment meticulously before you take it home. If you are interested in buying equipment through an online auction, you should probably get to know the particular service before you start bidding.

The online auction is a hot new growth area on the Internet. Online auction services—such as eBay—have attracted lots of people to the auction concept. Naturally, the problem with a virtual auction is that you, the buyer, haven't had the opportunity to physically examine the items that are being offered by the seller.

The online services are working hard to ensure that there are adequate safeguards to prevent abuse. For example, eBay offers an escrow service that allows

the purchaser to receive and inspect the equipment before payment is released to the seller. In addition, most services supply some reference information about sellers, so you can find out whether the person from whom you are buying an item has had favorable reviews or negative ratings from past customers.

My friends who are eBay addicts suggest asking as many questions as possible of the person offering the equipment. Obvious examples: How much have you used the camera? Has it ever been dropped? Has it ever been repaired? Also, specific questions about the camera's features will clue you in as to whether the buyer is legitimate and has the camera to sell.

Sizing Up Used Equipment

Assuming you can physically inspect the equipment you may purchase, first look closely at the exterior. Are there signs that the camera has been dropped or suffered severe physical shock? Don't be concerned about a few chips in the finish, or minor dents, although those do indicate that the camera has traveled quite a bit.

It's unreasonable to expect that the camera was owned by a collector who never used it. In fact, it's better if a camera had light use during its lifetime, since that tends to keep the lubricants spread over the mechanical parts. What you want to avoid is a camera that has been mistreated by a clumsy owner or used heavily by a professional. Sooner or later, every camera will experience failure of some system after heavy use.

Open the camera. Is it clean inside? Look at the chamber where the film cassette is placed (assuming it is a 35 mm or medium-format camera). Are there signs of wear? That suggests a lot of film was loaded into the camera.

Hold the camera to your ear and listen to the shutter mechanism while you discharge the shutter. Set the camera's shutter control to run at different speeds. How does the shutter sound at 1/4 second? At 1/60? At 1/500? If you hear rough noises or different sounds at different speeds, that's a reason to be suspicious.

When you inspect a camera lens, feel how the focusing mechanism responds as you run through it. Are there any rough spots? Hold the lens to your ear and listen while you adjust the focus. You shouldn't hear any strange noises. If you're looking at a zoom lens, run through the zoom range. Feel and listen for any abnormalities.

With enlargers and other darkroom equipment, I don't anticipate much damage from use. Check to make sure the enlarger head is aligned, that the enlarger lenses are clean, fit properly, and aren't scratched, and that the electrical system that runs the light doesn't have a short in it.

Terms of Purchase and Warranty

When you buy from an individual at a flea market or from your local newspaper's classifieds, you're not likely to get any guarantee or offer of warranty. Same from a pawnshop or an online auction service. In these instances, you

need to trust your own assessment of the equipment you are considering. If possible, ask if you can shoot a roll of film using the camera (or lens) and ask that the seller hold the item for twenty-four hours while you get the film processed. This will give you a chance to determine whether there is anything wrong with the camera.

If you do get a chance to shoot a test roll, make sure that you test the response of the built-in meter if the camera has one, and use a wide range of different shutter speeds and aperture sizes to test the full range of the camera's function.

If you purchase via mail order, many reputable dealers state their warranty policy. For example, the B&H monthly catalog and monthly advertisements state that all used equipment is guaranteed to work, regardless of cosmetic condition. Used photo items are guaranteed for ninety days, and there's a fourteen-day return period. B&H also states in writing that "mechanics and optics are assumed to be excellent." Most large sellers also offer some kind of rating service.

Many of these mail-order dealers have been in business for many years and value their reputations highly. Others can be less than satisfactory. I suggest that you ask for references of other customers, make sure you understand what warranty or guarantee is included, and pay with a credit card, if possible, so you have some protection if there is a problem.

When you buy from a photo retailer, you should make sure that you get a written confirmation of the terms. You should be able to expect a sixty- or ninety-day guarantee and possibly a short period when you can return the item if it does not meet your expectations.

If you follow the advice I've offered in this section, you should have no problem getting great value when you shop for used photo equipment.

Lighting Equipment

I own two 500-watt quartz hot lights that probably cost me $150, including stands, and I have probably billed $30,000 from jobs I shot using just those two lights, principally making slides for artists of their paintings and sculpture and various types of copy work.

When it comes to electronic flash units, my advice is that you shouldn't be put off by the high price tags on some units. Start simply with two or three lights and decent stands. I don't care whether you opt for heads that run off a power pack or select monolights that have their own charger. However, you want lights with slave capacity and good modeling lights. For me, a good modeling light is one that is bright enough to show clearly the highlight and shadow areas on your subject in regular room light.

Some models are more lightweight than others, which may be a consideration for you if you plan on much traveling. Lots of companies make low-cost units, but I can personally vouch for those made by Photogenic, White Lightning, and SP Studio Systems.

At NYIP, in addition to our saying that "It's not the violin, it's the violinist," we also say, "Light is light." When the shutter is tripped and the flash fires, the light put out by an inexpensive unit is essentially the same as that generated by the most expensive one. What counts is your ability to manipulate the light and place it properly. Naturally, bigger, more powerful units put out more light, but most of the time you won't need lots of power. For most people photos, a low- or medium-power head will suffice.

With many flash units, manufacturers have a tendency to overstate their power. That means that if you try to calculate exposure using guide numbers provided by the manufacturer, you may end up underexposing many subjects. That's another reason you'll need a flash meter.

Lenses

One of the great attractions of 35 mm SLRs, as well as most medium- and large-format cameras, is that you can use the camera body with a variety of lenses. Today, photographers have the ability to choose between a great variety of lenses, including those made by the camera's manufacturer as well as models made by companies that specialize in lenses for cameras that were manufactured by another company.

Renting Lenses

I would caution that you shouldn't go out and spend $1,000 or more on a telephoto lens or a perspective-control lens or any other special piece of gear if you need it for a single job. Under those circumstances, I suggest that you consider renting the lens. There are lots of rental houses in the big cities that will even ship a rental item to you. It is customary that you secure the value of the lens by letting the rental house put a hold for an agreed-upon amount on your credit card until the rental is completed and the lens (or other piece of equipment, for that matter) is returned to the rental house in good condition.

I've had good luck renting equipment and it has given me the opportunity to use a variety of gear that I would have never been able to purchase.

Lens Maximum Aperture

If, on the other hand, you know that you need to purchase a specific type of lens because it is essential to the type of work that you do, then you should do some research before you buy. One key question is whether you need a large-aperture lens, such as an f/2.8, or whether a lesser maximum aperture will do the job. Obviously, the two benefits to a lens with a maximum aperture of f/2.8 is that it will allow you to use higher shutter speeds in a given situation than an f/4 or an f/5.6 lens, and, using f/2.8, you'll be able to count on a shallow depth of field that will throw your background out of focus and enable you to isolate your subject. This is very helpful for sports and photojournalism subject matter. Naturally, faster lenses cost more. They generally have more complicated designs and use larger glass elements to enhance their light-gathering ability.

Compare, for example, the cost of any manufacturer's 80–200 mm zoom lens that has a constant maximum aperture of f/2.8 with the much lower cost of a model by the same manufacturer that might have an aperture range of f/4 to f/5.6.

Zoom Lenses

In today's zoom lens world, I still enjoy using a prime lens. I recently bought a used 105 mm 2.8 micro Nikon, and it got me back on a kick using prime lenses. I still think many of the sharpest images are made using a good prime lens and a camera on a tripod. Plus, you'll find most prime lenses have larger maximum apertures than zooms. This means you'll be able to work in lower light, and easily use selective focus.

Zoom Lenses with Varying Apertures

I frequently get questions from students with regard to why zoom lenses often have varying apertures. For example, you'll get a 28–70 mm zoom lens with your camera and the aperture reading on the lens barrel might be something like "28–80 mm 1:3.5–5.6," or "70–210 mm 1:4–5.6." Simply stated, most inexpensive zoom lens designs do not give a uniform light transmission at all focal lengths. In the first example above, the lens barrel notation tells you that when you have the zoom lens set at 28 mm, the maximum aperture is f/3.5, and that when the lens is at 80 mm, the maximum aperture has dropped to f/5.6. When you have the lens set to intermediate settings in between those two extremes, the maximum aperture will be somewhere in between.

Prior to the advent of auto-exposure cameras, this change in light transmission used to require compensation by the photographer. Now, under most circumstances, using either automatic exposure or shutter or aperture priority, the camera will compensate for the drop in light transmission at longer focal lengths automatically. That's one of the reasons that zoom lenses have become both popular and practical with today's automatic cameras.

Aftermarket Lenses

Not long ago, I got a call from a student who asked whether he should buy a 300 mm lens made by the manufacturer of his camera, or whether he should purchase a lens from one of the aftermarket manufacturers for about one-fifth the price of the "name" lens.

Particularly if you want a long telephoto lens or a zoom lens in the telephoto range, you will see that you can buy one from Canon, Nikon, or the other big manufacturers for several thousand dollars or more. The same focal-length lens, with the same aperture size, can be purchased from an "aftermarket" manufacturer such as Sigma, Tamron, or Tokina for less than $1,000.

Can a lens that costs a fraction as much be just as good? Put the other way around, what are you getting if you spend five times as much for a name lens? The answer to the first question is, "It depends." The answer to the second question is, "A few things." Let me explain.

In photography, the main aftermarket is in lenses for 35 mm SLR cameras. The three companies I named earlier—Tamron, Sigma, and Tokina—all make very good lenses. In fact, since the companies that make optical-quality glass in Japan sell to all the manufacturers, it's possible that the glass you purchase in a "name" lens is exactly the same as the glass in an aftermarket lens. The difference is that the major manufacturer may assemble the lens using higher-quality rings, fasteners, and lubricants. Quality control and testing at the major manufacturer may be more demanding.

The reason that "It depends" is the answer to whether the lens is just as good is that it depends on who you are and what you're going to do with that lens. If you need a long lens or a long zoom because you plan to photograph eagles three times a year when the weather is nice, you'll be fine with an aftermarket lens. If, on the other hand, you're going to use that lens seventy-five times a year in lots of nasty weather, and it will be traveling in the luggage compartment of a lot of airplanes, then you'll probably be better off with the lens that has been assembled by the name manufacturer with professional wear-and-tear in mind.

I have been very satisfied with the aftermarket lenses I've used and owned. They are very well made and I've seen them stand up under heavy use. For more money, with the name lens, you will get a product that is a bit "better" in some respects, but the truth of the matter is that the aftermarket lenses by the major manufacturers I've mentioned are in most respects "good enough."

Tripods

I own half a dozen low- and medium-cost tripods. One resides in my car at all times, and others are at the ready at the office and in my studio. To an extent, I've changed my thinking about tripods. My advice used to be to use the sturdiest model you could handle. The problem with that is that too often I found I was leaving that sturdy model behind. Instead, I've decided that, when you need a tripod, any tripod is better than none. That's why I try to carry a flimsy one with me most of the time. When I know I've got a job that will require a good one, I pack a heavier model.

Cleaning Equipment

When I clean cameras and lenses, I try to keep it simple. I've heard too many stories about people damaging their camera by cleaning it. Most of the time, I use just three tools to clean my camera—an artist's sable brush, a rubber squeeze bulb to blow dust off the lens and out of the inside of the camera, and a microfiber cloth to remove dust, grit, and even the oil left by fingerprints. I avoid solvents, treated lens tissues of the type sold to eyeglass wearers, and compressed air blowers of all types, whether they are powered by propellants or not.

Solvents I find risky and likely to spill. Treated lens tissues I find unreliable in terms of quality, and compressed air is often too strong, particularly for today's very delicate shutter mechanisms. In addition, some types of "canned

air" use a propellant that, if you turn the can upside down, shoots out a burst of frozen, solid stuff. Who needs that in your camera or on your lens?

In addition to a general cleaning of the camera body, viewfinder, and lens with a microfiber cloth, I'll use the sable brush to flick off any particularly stubborn bit of dust, and I use the blower to clean out the inside of the camera. The type of blower squeeze bulb that I use is the Hakuba "Hurricane" Blower. The bulb is about two or three inches in diameter and tapers down to a tiny opening. It provides a concentrated "puff" of air, but not the overly powerful gush that some types of canned air provide. The little blowers sold in camera stores, with the brush on one end, are useless as far as I'm concerned.

In a pinch, if I don't have a microfiber cloth handy, I'll use a well-worn cotton T-shirt or an often-washed cotton handkerchief to clean a lens. The more used the piece of cotton, the more likely it is to be soft and lint-free. Occasionally, if there's a really stubborn fingerprint, I'll breathe gently on the lens to let a little of the moisture from my breath settle on the lens.

When I was very young and just getting started, I was overly nervous about my equipment. Sure, your camera and lenses are precision equipment, but it's not as if they're parts of a pacemaker that you're going to implant in a human chest. They need to be clean, but not sterile. If you use the gentle types of equipment I've described and some common sense, you'll keep your gear clean and you won't damage it.

CAMERA REPAIR

Since I've let my daughter use my cameras from the time she was a toddler, she knows to put the strap over her neck. One day, while I am completing a job in the studio, she is attracted to the sound of the auto-rewind system of the camera I am using. She watches as I open the back of the camera. I show her the rewound roll of exposed film. I say, "Will you take it out for me?" Her two-and-a-half-year-old hand reaches steadily for the film, her thumb and index finger outstretched. Mimicking the movement I have just shown her, she reaches in and firmly grabs the 35 mm film cassette. As she plucks it out, she gives a twist of the wrist, and, with a flourish, removes the film as her middle and ring fingers accidentally twist and bend the metal-hinged shutter. She holds out the roll of film and smiles. I close the camera and congratulate her on the job she has done well. I do not mention the shutter she has mutilated, since that was entirely my fault.

It cost me $300 to repair the shutter of the Nikon N-90s I had been using. I learned a lesson—modern shutters really are as fragile as the instruction book says.

In New York City, there are some good camera-repair shops. I take a lot of equipment directly to an outfit that is an authorized service center for many major manufacturers and that also takes work directly from the public. I have also had reasonable luck with work performed by the manufacturer's technicians. There are some good repair shops that will take items sent by mail. You should ask professionals that you know whom they have used and would recommend.

TWO SECURITY TIPS

In closing, I have two important tips regarding your equipment. When I first fell in love with photography and owned one camera body and a few lenses and a light meter, I kept everything together in my camera bag, at the ready, so I could just grab it and go. Great idea. The problem was that a burglar grabbed it and went. Now, when I have a lot more equipment, I keep a body and a few lenses here, my view camera in another room, and other odds and ends in a variety of locations. I might lose some stuff, but no one but me could find everything. Don't make it too easy for a burglar.

In the same vein, I work with a nondescript, dark, cloth camera bag. I shudder at the thought of carrying around gear in a bright metal case. To me, those shout, "Steal me!" If you want to protect your gear from bumps and bruises, line your bag with high-density foam rubber or some other cushioning material. When it comes to bags, when you work on the street or have to travel in rough neighborhoods, the funkier, the better.

TWO PACKING TIPS

I always keep two small flashlights in each camera bag that I use. There are lots of times when I find myself in the dark, or working in low light, and I need to see what I'm doing. This way, when you're on location and there's a power failure, you'll be able to find a flashlight quickly.

In addition to a flashlight, I always keep a large plastic garbage bag in my gear. I don't carry waterproof cases unless I really think they're necessary, but a heavy rainstorm can crop up anywhere, any time. When it does, there's nothing like having a large garbage bag big enough to contain all your gear to prevent equipment from getting ruined as you wait out a torrential downpour.

PART II

BUILDING AND PROTECTING

YOUR BUSINESS

CHAPTER 6 YOUR BUSINESS PLAN

STARTING A BUSINESS REQUIRES PLANNING. You have to estimate your expenses and your income, not just for the first year but for as many years into the future as you can reasonably project. Some expenses only happen once, while others recur each year.

For starting costs you may only have to pay once, consider the following list:

- Fixtures and equipment
- Installation of fixtures and equipment
- Decorating and remodeling
- Legal and other professional fees
- Advertising and promotion for opening

Of course, you must realistically think through the outlays you are going to have to make. Daydreaming can be pleasant, but in business it can easily become a nightmare.

What about the outlays that you'll have to make every month? Here's a partial list:

- Your own salary
- Any other salaries
- Rent
- Advertising
- Materials and supplies, insurance premiums, maintenance
- Legal and other professional fees
- Taxes (often paid in installments during the year or in full with the return)
- Miscellaneous

Maybe the last category is the most important, because it's the unexpected need for cash that leads to trouble for most photographers. If you can plan properly, you will ensure that you can meet all your needed outlays. And don't leave out your own salary. Martyrs don't make the most successful business owners. If you worked for someone else, you'd get a salary. To see realistically whether your business is making a profit, you must compute a salary for yourself. If you can't pay yourself a salary, you have to consider whether you'd be doing better working for someone else.

Your income is the next consideration. What sort of track record do you have? Are you easing from one field of photography into another field, in

which you're likely to have success? Or are you striking out toward an unknown horizon, a brave new world? You have to assess, in a fairly conservative way, how much income you're likely to have. If you just don't know, an assessment of zero is certainly safe.

What we're talking about is *cash flow*. It should probably be the most important word in the photographer's business lexicon, although *bottom line* is also a crucial term. *Cash flow* is the relationship between the influx of cash into your business and the outflow of cash from your business. If you don't plan to invest enough money in your business initially, you are likely to be *undercapitalized*. This simply means that you don't have enough money. Each month, you find yourself falling a little further behind in paying your bills.

Maybe this means your business is going to fail. But it may mean that you just didn't plan very well. You have to realize that almost all businesses go through an initial startup period during which they lose money. Even the Internal Revenue Service recognizes this. So, after you plan for your startup expenses and your monthly expenses (with an extra amount added in to cover contingencies you can't think of at the moment), you can see how much cash you're going to need to carry the business until it becomes profitable. Your investment should be enough to carry the business through at least one year without cash flow problems. If possible, you should plan to make a cash investment that will carry the business even beyond one year. Be realistic. If you know that you're going to have a profit in the first year, that's wonderful. But if it may take you a year or two before you have a profit, plan for it. It's easy to work out the numbers so you'll be a millionaire overnight, yet it's not realistic. In fact, it's a direct path to bankruptcy. But once you realize you need money to avoid being undercapitalized when you start or expand your business, where are you going to be able to find the amount you need?

SOURCES OF FUNDS

The most obvious source of funds is your own savings. You don't have to pay interest on it, and there's no due date when you'll have to give it back. But don't think it isn't costing you anything, because it is. Just calculate the current interest rate—for example, the rate on short-term United States Treasury notes—on what you've invested in your business. That's the amount you could earn by relaxing and not working at all.

What if you don't have any savings and your spouse isn't keen on donating part of his or her salary to support your studio? Of course, you can look for investors among family, friends, or people who simply believe you're going to create a profitable business. One problem with investors is that they're hard to find. Another problem is that they share in your profits if you succeed. And, after all, isn't it your talent that's making the business a success? But if you're going to have cash flow problems and are fortunate enough to find a willing investor, you'll be wise to take advantage of this source of funds.

The next source is your friendly banker. Banks are in the business of making money by lending money, so you'd think they'd be happy to have you as a client. You may be the lucky photographer who finds such a bank, but most loan officers know that the photography business carries high risks and is unpredictable. Conservatism is ingrained in their natures (otherwise, they'd be opening their own photographic studios). So, if you're going to have any chance of convincing the bank to make a loan, you must take the right approach. You should dress in a way that a banker can understand. You should know exactly how much money you want, because asking for too much or too little money is going to create a bad impression. It will show that you haven't done the planning necessary to succeed. You should be able to detail precisely how the money will be used. You should provide a history of your business—from a financial standpoint—and also give a forecast.

It's important to keep good business records in order to make an effective presentation to the bank. The loan officer must believe in the quality of management that you offer to your business. A helpful resource for keeping business records is *Photography: Focus on Profit* by Tom Zimberoff, a book that includes the PhotoByte business management software. One other point to keep in mind is the importance of building a relationship with your banker. If he or she comes to know and trust you, you're going to have a much better chance of getting a loan.

But, frankly, bank loans are going to be very difficult for many photographic businesses to obtain. Where can you turn next? The most likely source is borrowing from family and friends at a reasonable interest rate. Of course, if you give personal guarantees (and also to keep family harmony), you have to pay back these loans whether or not your business succeeds. (If you didn't have to pay back the money, you'd be dealing with investors rather than lenders.) Another possibility is borrowing against your life insurance policy if it has cash value. The interest rate is usually far below the current rate at which you would be borrowing from a bank. And, if you have been able to obtain credit cards that have a line of credit (that is, that permit you to borrow up to $2,500, $5,000, or more on each card), you can exercise your right to borrow. Depending on the number of cards you have and the amounts of the credit lines, you may be able to borrow thousands of dollars in this way. This is dangerous, however, and not an approach to be taken lightly. At the least, you should plan to repay credit-card cash advances promptly, to avoid the high interest rates imposed on money borrowed in this way.

Trade credit will undoubtedly be an important source of funds for you. It's invisible, but it greatly improves your cash flow. Trade credit is simply your right to be billed by your suppliers. The best way to build up trade credit is to be absolutely reliable. In this way, your suppliers come to trust you and are willing to let you owe greater and greater amounts. Of course, you must pay promptly, but you are paying roughly thirty days later than you would pay on a cash transaction.

The other side of the coin is your own extension of credit to your clients. This creates accounts receivable, which are an asset of your business in somewhat the same way that your cameras and your cash are assets of the business. But what is the magic formula by which you convert accounts receivable into cash when you desperately need it? You can *factor* your accounts receivable. This means that you sell your accounts receivable to another company—the factor—that collects the accounts receivable for you. What does the factor pay for the accounts receivable? The factor gives you the full amount of the accounts receivable, less a service charge. The effect of the service charge can be a very high annual interest rate. So take warning. Using factors isn't the magic trick it appears to be at first. In fact, it's inviting disaster. If your cash flow is bad, factoring is likely to make it much worse in the long run.

But, as the famed economist Lord Keynes said, none of us will be around in the long run. So let's put it another way: The long run may be in the immediate future if you factor. And the reason you would have to factor is poor planning in the first place. You were undercapitalized. Another possible avenue for securing funds is the Small Business Administration (SBA). While the SBA does not make direct loans, it will sometimes give a guaranty for a loan made by another party. The SBA guaranty might be as much as 85 percent for a loan up to $150,000 or 75 percent for a loan greater than $150,000, subject to a maximum guaranty of $1 million. It's certainly worth a visit to the SBA Web site at *www.sba.gov* and an exploratory telephone call to your local SBA office to find out what is possible.

The true message is *not* to borrow unless you know you're going to be able to repay the money from your business. There's no point in borrowing from one source after another as your business slides closer toward bankruptcy. Not only should you *not* factor your accounts receivable, but you should not borrow against your life insurance cash value or draw on your credit lines unless you definitely know that you will be doing the business necessary to pay back that money. Being adequately capitalized is a necessity if you are to have that wonderful feeling of confidence that comes from knowing that your business has the stamina to survive early losses and succeed.

EXPANSION

Expanding is much like starting a business. You must be adequately capitalized for the expansion to be successful. This means reviewing your expenses and your income so you can calculate exactly how the expansion will affect your overall business. Then you have to decide whether you have the cash flow to finance the expansion from the income of the business. If you don't, once again, you must consider sources of financing. If you're buying equipment, keep equipment-financing companies in mind as a potential credit source.

One of the most important reasons to expand is an economic one—the economies derived from larger-scale operations. For example, pooling with a

number of photographers may enable you to purchase equipment you couldn't otherwise afford, hire a receptionist that your business alone couldn't fully utilize, or purchase supplies in quantities sufficient to justify a discount. If you can hire an assistant who earns you enough money or saves you enough time to make more than the assistant's salary (and related overhead expenses), the hiring of the assistant may very well be justified.

On the other hand, expansion is hardly a panacea. In the first place, you'll probably have difficulty financing any major expansion from the cash flow of the business. Beyond this, expansion ties you into certain expenses. Suddenly, you have an assistant, a receptionist, a bookkeeper, a stylist. You need more space, and your rent increases. You're shooting more jobs, so your expenses increase for all your materials. You find that you must take more and more work in order to meet your overhead. You may even consider a rep, if you can get one, because you need to do a greater volume of business. But the rep will take 25 percent in commissions, so that's hardly going to solve your need for more productive jobs.

Suddenly, you realize that you've reached a very dangerous plateau, and that you're faced with a choice that will have lasting consequences for your career. You expanded because you wanted to earn more. But the more resources that you brought under your control—whether equipment, personnel, or studio space—the more time you had to spend managing these resources to make them productive. Now you must decide whether you are going to become a manager of a successful photographic business or cut back and be primarily a photographer. If you choose to be a manager, you had better be a very good one. If you go the expansion route, it's very painful to have to cut back if the business temporarily hits hard times—firing employees, giving up space you've labored to fix up, and so on. The alternative to being a manager is to aim for building a small business with highly productive accounts. You can be a photographer again without worrying so much about the overhead and the volume you're going to have to generate in order to meet it. Of course, you'll make your own decisions, but be certain that you're keeping the business headed in the direction that *you* want it to take.

SMALL BUSINESS ADMINISTRATION

The Small Business Administration was created in 1953 to help America's entrepreneurs build successful small enterprises. The SBA now has offices in every state, the District of Columbia, the Virgin Islands, and Puerto Rico to offer financing, training, and advocacy for small firms. This agency also works with thousands of lending, educational, and training institutions nationwide. Its Web site at *www.sba.gov* has an abundance of useful information, including advice on "Business Plans," "Frequent Startup Questions," "Expanding Your Business," and "Managing Your Business." Check the "Publications" link on the SBA Web site to get an overview of the extensive offerings available online.

In addition, if you have questions that you can't find answers for on the Web site, you can send an e-mail to the SBA at *answerdesk@sba.gov* or call your local SBA office and speak to or meet with a counselor who will help you with your specific problem. While these counselors are likely to have had limited contact with photographers, you may still get some helpful advice. The Service Corps of Retired Business Executives (SCORE) has been formed under the SBA and brings the experience and wisdom of successful businesspeople to the counseling program. SCORE offices can be found across the country and are listed on the SBA Web site.

CHAPTER 7 — LOCATION AND LEASES

THE LOCATION OF YOUR BUSINESS is extremely significant. If you run a photographic studio catering to the public, then you must be conveniently located for the public to come to your premises. The area must have a healthy economy with good prospects for the future, so you can count on a continuing flow of clients who are able to afford your services. If you work on assignment, then you must be able to reach the buyers with whom you'll be transacting business. You must consider the location not only from the marketing viewpoint, but also with respect to rent, amounts of available space (compared to your needs), competition, accessibility of facilities that you need (such as labs), and the terms under which you can obtain the space. Speak to other photographers and businesspeople in the area to find out all you can.

Since many photographers have their studios in their homes, it's worth considering this as the first option. You'll save on rent and gain in convenience. However, you may not be near your market, and you may also have trouble taking the fullest possible tax deductions for space that you use. The deduction of a studio at home is discussed in chapter 19, "Taxes."

ZONING

Another potential problem with having a studio at home is zoning. In many localities the zoning regulations will not permit commercial activity in districts zoned for residential use. If you didn't realize this, you could invest a great deal of money setting up a photographic studio, only to find you could not legally use it. But even when the zoning law says a home may not be used for commercial purposes, it is unlikely that you'll be prevented from conducting certain aspects of your photographic business, such as shooting and printing. Problems usually arise when your business requires a flow of people to and from the premises, whether they are clients or people making deliveries. The more visibly you do business, the more likely you are to face zoning difficulties. If you are considering setting up your studio in a residentially zoned area, you should definitely consult a local attorney for advice.

What happens if you rent a commercial space for your studio and decide to live there? This has become more and more common in urban centers where rents are high. You run the risk of eviction, since living in the studio will probably violate your lease as well as the zoning law. Some localities don't enforce commercial zoning regulations, but you must be wary if you are planning to sink a great deal of your money and time into fixing a commercial space with

the plan of living there. Especially in this situation, you should ask advice from an attorney who can then also advise you how to negotiate your lease.

NEGOTIATING YOUR LEASE

It's worth saying a few words of warning here about the risks involved in fixing up your studio. You can lay out thousands of dollars (many photographers have) to put up walls for your darkroom, reception area, and dressing room for models; to put in wiring and special plumbing for your darkroom; and to redecorate and refurbish your space in every way so that it's suitable for your special needs. What protects you when you do this?

If you're renting, your protection is your lease. The more you plan to invest in your space, the more protection you need under your lease. There are several crucial points to consider:

- Length of the lease
- Option to renew
- Right to sublet
- Ownership of fixtures
- Right to terminate
- Hidden lease costs

You have to know that you are going to be able to use your fixed-up space long enough to justify having spent so much money on it. A long lease term guarantees this for you. But what if you want to keep your options open? A more flexible device is an option to renew. For example, instead of taking a ten-year lease, you could take a five-year lease with a five-year option to renew. But you want to guarantee not only that you'll be able to stay in the space, but also that you can sell your fixtures when you leave. In most leases, the landlord owns all the fixtures when you leave, regardless of who put them in the space. If you want to own your fixtures and be able to resell them, a specific clause in the lease would be helpful.

The right to sublet your space—that is, to rent to someone else who pays rent to you—is also important. Most leases forbid this, but, if you are selling fixtures, it can be important who the new tenant is. Your power to sublet means you can choose the new tenant (who can then stay there for as much of your lease term as you want to allow). On the other hand, you may not be able to find a subtenant. If your business and the rental market are bad, you may simply want to get out of your lease regardless of the value of the fixtures you've put into the space. In this situation, the right to terminate your lease will enable you to end your obligations under the lease and leave whenever you want to. Remember that without a right of termination, your obligation to pay rent to the landlord will continue to the end of the lease term, even if you vacate the premises (unless the landlord is able to find a new tenant). In every lease you should look for hidden lease costs. These are likely to be escalators—automatic

increases in your rent based on various increasing costs. Many leases provide for increased rent if fuel prices increase. Others require you to pay a higher rent each year based on increases in the consumer price index. Of course, you want to know about all these hidden costs—whether to include them in your budget or to try to negotiate them out of the lease.

This is a very brief discussion of the negotiation of your lease. For a more extensive analysis, you can consult *Legal Guide for the Visual Artist* by Tad Crawford. Your attorney can aid you with the ins and outs of negotiating a lease.

CHAPTER **8** **THE GOING CONCERN**

MOST PEOPLE DON'T LEAP into a profession. They test and explore it first and gradually intensify their commitment. This is as true of photography as it is of any other entrepreneurial activity. Many photographers start part time while going to school or working at another job. For some it is a dream they work toward, even when supporting themselves with other work, and for others it is the extension of a beloved hobby. But once the photographer begins to market his or her work, questions inevitably arise as to the basics of operating a business. Should it be incorporated? Where can it be located? What kind of records do you need? What taxes will you have to pay?

Making decisions about these kinds of questions requires knowledge. Your knowledge can be gleaned from experience or from advisors with expertise in accounting, law, and business. The most important skill that you must have is that of problem recognition. Once you're aware that you face a problem, you can solve it—by yourself or with expert help.

FORMS OF DOING BUSINESS

You will probably start out in the world of business as a *sole proprietor.* That means that you own your business, are responsible for all its debts, and reap the rewards of all its profits. You file Schedule C, "Profit or Loss From Business (Sole Proprietorship)," with your Federal Tax Form 1040 each year and keep good business records for tax purposes. The advantages of being a sole proprietor are simplicity and a lack of expense in starting out.

However, you have to consider other possible forms in which your photography business can be conducted. Your expert advisors may decide that being a corporation, partnership, or limited liability company (LLC) will be better for you than being a sole proprietor. Naturally, you want to understand what each of these different choices would mean. One of the most important considerations in choosing between a sole proprietorship, partnership, corporation, and limited liability company is taxation. Another significant consideration is personal liability—whether you will personally have to pay for the debts of the business if it goes bankrupt.

As *sole proprietor* you are the business. Its income and expenses are your income and expenses. Its assets and liabilities are your assets and liabilities. If the business owns a Hasselblad and has taken a $1,000 loan from a bank, you owe the bank $1,000 and have a great camera. The business is you, because you have not created any other legal entity.

Why consider a *partnership?* Perhaps because it would be advantageous for you to join with other photographers so you can share certain expenses, facilities, and possibly clients. Sometimes two or more heads really are wiser than one. If you join a partnership, you'll want to protect yourself by having a partnership agreement drawn up before starting the business. As a partner you are liable for the debts of the partnership, even if one of the other partners incurs the debts. And creditors of the partnership can recover from you personally if the partnership doesn't have enough assets to pay the debts that it owes. So you want to make sure that none of your partners is going to run up big debts that you end up paying for from your own pocket. The profits and losses going to each partner are worked out in the partnership agreement. Your share of the profits and losses is taxed directly to you as an individual. In other words, the partnership files a tax return but does not pay a tax. Only the partners pay taxes based on their share of profit or loss.

A variation of the partnership is the *limited partnership.* If you have a lot of talent and no money, you may want to team up with someone who can bankroll the business. This investor would not take an active role in the business, so he or she could be a limited partner who would not have personal liability for the debts of the partnership. You, as photographer, would take an active role and be the general partner. You would have personal liability for the partnership's debts. You and the investor could agree to allocate the profits equally but to give a disproportionate share of any tax losses to the investor (such as 90 percent). This hedges the investor's risk, since the investor is presumably in a much higher tax bracket than you are and will benefit by having losses (although profits are naturally better than losses, no matter how much income the investor has).

The next avenue to consider is that of a *Subchapter S corporation.* This is a special type of corporation. It does provide limited liability for its shareholders, which is what you would be. However, there is basically no tax on corporate income. Instead, the profit or loss received by the corporation is divided among the shareholders, who are taxed individually as partners would be. The disadvantage of incorporating is the added expense and extra paperwork

What you normally think of as a corporation is not the Subchapter S corporation, but what we'll call the *regular corporation.* The regular corporation provides limited liability for its shareholders. Only the corporation is liable for its debts, not the shareholders. You should keep in mind, however, that many lenders will require shareholders to personally sign on a loan to the corporation. In such cases you do have personal liability, but it's probably the only way the corporation will be able to get a loan.

The key difference in creating a regular corporation is that it is taxed on its own taxable income. There is a federal corporate income tax with increasing rates as follows:

- 15 percent on taxable income up to $50,000
- 25 percent on taxable income from $50,000 to $75,000

- 34 percent on taxable income from $75,000 to $100,000
- 39 percent on taxable income from $100,000 to $335,000
- 34 percent on taxable income from $335,000 to $10,000,000
- 35 percent on taxable income from $10,000,000 to $15,000,000
- 38 percent on taxable income from $15,000,000 to $18,333,333
- 35 percent on all taxable income over $18,333,333

In addition, there may be state and local corporate income tax to pay. By paying yourself a salary, of course, you create a deduction for the corporation, which lowers its taxable income. You would then pay tax on your salary, as would any other employee. If, however, the corporation were to pay you dividends as a shareholder, two taxes would be paid on the same income. First, the corporation would pay tax on its taxable income, then it would distribute dividends and you would have to pay tax on the dividends.

The advantages of the regular corporation include the ability to make greater tax-deductible contributions to your retirement plan than you would be able to make as an individual. The disadvantages include, again, extra paperwork and the need for meetings, as well as the expenses of creating and, if necessary, dissolving the corporation.

Many states have recently legislated into existence a new form of business entity called a *limited liability company*, which combines the corporate advantage of limited liability for its owners while still being taxed for federal income tax purposes as a partnership. The limited liability company offers great flexibility in terms of the mode of ownership and the capital structure of the company, as well as what corporate formalities the company must observe. Its very newness suggests the need for caution when considering whether a limited liability company might be appropriate for a photographer.

In general, the tax law requires that a partnership, an S corporation, or a personal service corporation (which is a corporation whose principal activity is the performance of personal services by an employee-owner) use a calendar tax year, unless there is a business purpose for choosing a different fiscal year.

From this brief discussion, you can see why expert advice is a necessity if you're considering forming a partnership, corporation, or limited liability company. Such advice may seem costly in the short run, but in the long run it may not only save you money but also give you peace of mind.

BUSINESS LICENSING AND REGISTRATION

Photography is considered innocuous and not a danger to the public welfare. For this reason, state statutes requiring the licensing of photographers have generally been held unconstitutional. While a number of states require that a fee be paid in order to practice photography professionally, there is no examination to determine your proficiency as a photographer. Of course, states and localities can regulate photographers who sell their services from door-to-door or in public places. And if you're going to be shooting in a way that may disrupt

public activities, you should certainly consider whether you need a permit from the local government. A local attorney or photographers' society is obviously the best place to find out exactly which regulations apply in your area.

The registration of your business—or the name of your business—is also important. This is usually done with the county clerk in the county in which you have your studio. The purpose of this registration is to ensure that the public knows who is transacting business. Thus partnerships must file and disclose the names of the partners. Individuals doing business under an assumed name must disclose their true identity. But an individual photographer doing business under his or her own name might very well not be obligated to file with the county clerk. In any case, you should call the county clerk to find out whether you must comply with such requirements. The fee is usually not high.

SALES AND MISCELLANEOUS TAXES

Many states and cities have taxes that affect photographers. Included here are sales taxes, unincorporated business taxes, commercial occupancy taxes, and inventory taxes. You should check in your own state and locality to determine whether any such taxes exist and apply to you. By far the most common tax is the sales tax, however, and it deserves a more extensive discussion.

The sales tax is levied on sales of tangible personal property. If a book is sold by a bookstore, a sales tax must be paid. We will discuss the New York State sales tax, but sales taxes have many similarities from state to state. In New York State, the sale of reproduction rights is not considered to be a sale of tangible personal property. Reproduction rights are not tangible or physical; they are intangible. So no sales tax is charged on them.

Generally, no tax is charged on items that are going to be resold.

If a paper manufacturer sells paper to a printer who in turn manufactures books for a publisher who sells the books to a retailer, only the retailer should collect the sales tax and pay it to the State Sales Tax Bureau (which has local offices in many communities). Sales taxes are levied on the last sale when a product reaches the consumer, not on every step in the series of sales that are necessary to transform the finished product.

The photographer has a number of special considerations with respect to the sales tax. First, sale by the photographer of reproduction rights usually does not require the collection of the tax. (This particular exemption may not apply in some states. You should check the point carefully in your state.) But if the photographer also sells a physical object, such as a print, then sales tax must be collected on the full sale price. (You can't try to separate the price of the print from the price of the reproduction rights.) The photographer can hand over a print as long as it is returned—no sales tax has to be collected. But, if the client retouches the photograph, a sales tax will have to be paid because the client has acted like the owner of the physical object (as opposed to just a licensee of reproduction rights).

A common question is whether sales tax must be charged on those components of a bill that don't relate to materials. For example, if your bill lists services,

materials, and travel expenses, should you collect tax on the total bill or simply on parts of it? The Sales Tax Bureau insists that you collect and then pay tax on the entire bill. This is true despite the fact that your services would not be subject to sales tax if billed separately, because no tangible object is transferred. And some of the expenses you bill, such as models or travel, would not require collection of sales tax if billed separately. But when your bill relates to the transfer of a physical object, sales tax must be collected on the total billing. It also doesn't matter where the expenses were incurred. Whether they were incurred in or out of the state, the tax must still be collected on the total bill.

There is an exemption from collection of the tax for deliveries of tangible property sold to out-of-state clients. What often happens is that a client will have an office in state and out of state. If you in fact deliver out of state, you do not have to collect sales tax. However, you must be able to prove that the delivery was made out of state. Your proof should be a signed delivery receipt or a receipt from the common carrier taking your package to the client. This can be very important if you are audited.

Registering with the Sales Tax Bureau has one advantage. You receive a resale number. By presenting a resale form to stores that you buy materials from, you don't have to pay sales tax on materials going into taxable products that you will resell. If, for example, your client keeps the film and you charge the client sales tax, you may use the resale exemption when buying the film. If you don't deliver the film or it is not a taxable transaction, you should not use the resale exemption when you buy the film.

It's worth keeping in mind that certain organizations don't have to pay sales taxes. These are mainly charitable or religious organizations that have tax-exempt status. If you seek to collect sales tax from them, they will present you with their tax-exempt certificate entitling them not to pay sales tax.

Of course, your clients will frequently give you resale forms, because they are planning to reuse what you give them in the final product they are preparing. If you accept such a resale form in the reasonable belief that the client will incorporate your materials into a property for resale, you are saved from liability for not collecting the tax. But if your client has no resale number and you have any doubt about whether to collect the tax, collect it. If you don't collect it and the Sales Tax Bureau decides you should have, you're going to be liable for the tax. Your client is also liable, but imagine how embarrassing it would be to go back to a client several years later to try to collect the sales tax. And the client may have gone bankrupt, moved to another state, or merged into another corporation. When in doubt, collect the sales tax and remit it to the Sales Tax Bureau. You can't go wrong that way.

Contact your local Sales Tax Bureau to find out whether such a tax exists where you are and, if so, the exact nature of your obligations to collect and remit the tax to the Sales Tax Bureau.

CHAPTER 9 DIGITAL PHOTO STUDIO MANAGEMENT 101

by Sam Merrell

Digital photo consultant Sam Merrell solves imaging problems for photo agencies, photographers, and corporate "photo-intensives." He also writes and speaks on imaging at industry conferences and trade shows, and teaches digital photo at the School of Visual Arts in New York City. His company, Synthetic Imaging Inc., uses many of the techniques discussed in this chapter.

THE REWARDS OF A SUCCESSFUL BUSINESS are numerous and, unfortunately, pounding out paperwork is among them. Many photographers no longer have studios—but all have computers. Just as digital cameras are transforming the ways photographs are made, stored, sold, and delivered, another quiet revolution has already taken place. The desktop computer has transformed photo studio and business management into "digital document management."

Like any business, professional photographers—big or beginner—must create, organize, deliver, and manage many different kinds of information on paper. Even a low-budget photo project might require quite a bit of paperwork. Examples include an *estimate* that breaks down what the project will cost; a formal *proposal* to do the project; ongoing *project analysis* and *progress reports,* and, when the project is completed, an *invoice.*

Photographers also have to wrangle quite a few specialized documents: *Delivery memos* list the images being received by a client along with any delivery "conditions" (e.g., "presented for client review only, may not be reproduced without a separate license agreement"). Once a client decides which images they want to use, an *image license* sets out the specific usage rights granted to the client (along with the rights being retained by the photographer). The *model release* is an agreement between the photographer and people who appear in his or her images, which grants the photographer permission to use (i.e., sell) the person's likeness. *Property releases* are similar agreements between photographers and owners of any property appearing in commercial photographs. And *shoot logistics* documents might include agreements, scheduling, and summaries worked out between a photographer and *stylists, assistants,* or *studio, equipment,* and *location rentals.*

A BRIEF HISTORY OF PHOTO PAPERWORK

Estimates; proposals; analysis and progress reports; invoices and expense details; delivery memos; image licenses; model, property, and sensitive-issue releases; shoot logistics (agreements with stylists, assistants, studio, equipment, or location rentals, transportation, and other subcontractor companies) . . .

Twenty years ago, all that photo paperwork was pushed through typewriters: Someone hand-typed the invoices and expense forms, the agreements—every document a photographer needs to do business. Photo delivery and licensing paperwork improved dramatically in the early 1980s, when ASMP and APA (the professional photo trade organizations) prepared and distributed their preprinted delivery and license forms. Containing all the legal boilerplate—the information that never changes—the preprinted forms helped a great deal. But every time you made a mistake filling in one of the forms, you either reached for the whiteout or tossed the form out and began anew. And someone still had to type (or hand-print) all the necessary job information on each form. So a huge amount of a busy photographer's time was spent on office administration and business paperwork—which meant a lot of time not selling, not promoting, and not shooting—all far more essential to growing a photo operation than typing. The personal computer relegated preprinted forms and hand-typing to the junk heap. Over the course of the last ten years, almost every type of paperwork that photographers need to push has become computer-driven. Today's photo paperwork processor is perhaps $750 worth of relatively current software running on a recent $500–$1,000 desk- or laptop computer hooked up to a $99 inkjet or $300 laser printer.

EVERYDAY DOCUMENTS

When you finish almost every job, you need to prepare a client invoice. If the job is complex, you probably need to prepare additional documents that break out all the job expenses in excruciating detail. Then, when you deliver your film, prints, or image files to the client, you need to include a delivery memo and rights license.

That's five or six separate one- or two-page documents that you need to create for every billable project you work on. These are generic forms that you need to create and send out over and over and over.

Much as photographers in days past used typewriters and preprinted forms to increase efficiency and professionalism of their paperwork, today's photographers use word processing software—which comes out of the box with ready-to-use document "templates" for many kinds of business documents. Microsoft's Office software suite (which includes word processing, spreadsheet, e-mail, calendar, and contact management) has a basic invoice boilerplate entered and laid out—areas for the date and your business name and address, along with areas to enter project, job, invoice, and PO numbers, the client's name, project description, billing line items, and corresponding dollar amounts. With a business that's just getting off the ground, you would choose a template that contains most of what you need, add your logo and business information, and then save it as your custom invoice template. Each time you need to create an invoice, you duplicate your customized invoice template, rename the duplicate something appropriate to the project you are delivering, type in the information particular to the project, print it, and send it out to the client.

But because word processing is general-purpose software, and photo delivery and licensing is a specialized art, you will need to exercise great care when creating your delivery memo and image license templates. Plan to consult with a professional who has experience—or get legal advice from a photo-specialist attorney. Otherwise, the process is the same as with invoices; instead of pre-printed forms, you build electronic template forms . . . document templates that you use each time you need to create a delivery memo or a license.

You may still have to add up totals, calculate taxes, and type in the information, but good templates get you more than halfway through the paperwork drudge and help make the paperwork fly!

CRUNCHING THE NUMBERS

Speaking of math, once you learn your way around a spreadsheet program, you won't believe how you lived so long without such fabulous software. The things a spreadsheet program can do to simplify expense tracking and reporting! In the very same way that you use a word processing program to create and reuse templates for invoicing, delivery memos, releases, and licenses, spreadsheet software will make short work of the number-crunching and math side of your business.

As with your word processing template documents, an expense report template probably contains column headers (see the example below). Each time you need to draw up a new expense report, you open a copy of the template and start typing information about on-the-job expenses into the rows below your column header—food, batteries, transportation, messengers, etc.

After you've done the data entry comes the spreadsheet magic! Position the cursor at the bottom of the amount column, click a button, and voilà, the spreadsheet will automatically add up all the dollars and cents in the amount column and display the total. If you made a mistake when you entered any of the dollar amounts, you can move to the mistake, fix it, and the total down at the bottom is automatically refreshed with the correct sum. Forget an expense item? No problem; insert a row in the middle somewhere, type in the forgotten item, sort all the entries by date, and again the total at the bottom automatically updates with the correct math.

Spreadsheet software makes it faster and more accurate when you need to prepare and summarize any paperwork having to do with numbers and sums: expense reports, client or image sales histories, accounts payable and receivable summaries, and quarterly and year-end reports for your accountant to use during tax preparation.

You can even create a full—blown accounting system using spreadsheet software, but the task is more than a little daunting. Besides, someone has already invented the better mousetrap: What could be simpler than putting a checkbook into the computer with all the necessary math running automatically, hidden in the background? That's the metaphor used by both MYOB FirstEdge and Quicken ($99 and $59, respectively). Instead of writing with a pen onto a

	A	B	C	D
1	Date	Amount	Payee	Details
2	January 31, 2003	$43.58	The Set Shop	Roll of Seamless Backdrop for main set
3	January 31, 2003	$7.84	The Set Shop	Gaffers tape for seamless
4	February 1, 2003	$12.85	Maffai Restaurant	Lunch – Pizza and coke
5	February 1, 2003	$4.50	Taxi	Carfare to drop film at the lab
6	February 2, 2003	$4.50	Taxi	Carfare to pick up film at the lab
7				
8		$73.27	TOTAL	

In column B, row 8, the formula that does the math automatically is "=SUM(B2:B7)" which means, "equals the sum of the numbers in column B of rows 2–7."

paper checkbook, you type information about each transaction into your virtual checkbook—date, check number, dollar amount, and income or expense category).

Neither program will create full-blown accounts payable or receivables reports, or break out cash flow per job, or per client, Quicken, for example, will generate profit and loss statements for any period of time (very handy during the weeks leading up to April 15th), along with expense category reports, net-worth reports, or how much income you have received from a particular client during, say, the last forty-five days.

Together, word processing, spreadsheet, and small-business accounting software—three general-purpose business management programs—will handle almost all the paperwork a startup professional photography business needs. At most, $500 worth of software, which will trim hours off the time you spend keeping up with the paperwork.

THE HIGH-END ADVANTAGE

As your business expands, you will need to expand your office operations. Sooner or later, you will need to capture the advantages that high-end specialized software brings to the table. Obviously, as more cash flows through a business, managing that cash flow effectively becomes mission critical. For doing so, you cannot beat the reporting tools built into solid professional accounting software. Tracking your checking, savings, and line of credit bank accounts is just the tip of the iceberg: you really need a complete view of the financial shape of your business, which means double-entry credit-debit journal accounting. You need to keep track of receivables (how much you are owed) and payables (how much you owe), as well as sales tax, job expenses, and profitability, 1099 contractors, and on and on and on! Professional-level accounting and the software that supports it is a specialized world unto itself. Expect to need it and plan to migrate from whichever entry-level package you choose. And if you are doing

your own data entry, expect also that you will need to bone up on basic accounting principles and procedures.

That said, QuickBooks Pro (from Intuit, the same company that makes Quicken) will import the financial data files produced by Quicken, and has most of the bookkeeping power all but the largest photography business will ever need. If you choose MYOB as your entry-level bookkeeping software, you can upgrade to MYOB AccountEdge; for a small fee the software manufacturer will upgrade your data files. You can also buy software that converts QuickBooks files into MYOB files (but at press time you cannot convert in the other direction—from MYOB to QuickBooks). Not surprisingly, each of these grown-up accounting packages cost more than their entry-level cousins: $249 each (with additional charges if you need specialized versions that accommodate multiple concurrent users).

SPECIALIZED PHOTO MANAGEMENT SOFTWARE

Meeting the challenge of higher-volume image and client tracking documents and more complex delivery memos or licenses, a number of high-end programs are specifically designed for busy professional photography businesses.

Typically, all these high-end photo management programs require a somewhat deeper understanding of the workings of business. And, to use these powerful programs to fullest advantage, you will also need more computer savvy. However, the enhanced technologies brought to bear in these photo-powerhouse programs make them a compelling choice for the busy photo professional.

For wrangling the reams and reams of paperwork associated with a tremendously successful photo business, nothing beats having relational technology at your fingertips. Using general-purpose software, address information from one invoice is not automatically carried over onto, say, a delivery memo . . . nor are the images listed on a delivery memo automatically copied over to a follow-up image license form. The general-purpose workaround is to use the system's cut-and-paste functions to copy variable information from one document to another. But "type once and then cut-and-paste" becomes rather tedious at the end of the month when there is a load of documents to pound out.

Rather than working back and forth between several separate documents (e.g., a spreadsheet and a word processing document) to cut and paste information between each, high-end software consolidates your business information in one environment and automatically links it together; when you enter information onto a job estimate, the software automatically makes that information appear on expense statements, invoices, delivery memos, licenses, and other statements for that client or project.

This "relational" capability—a program's ability to use and link a central store of information to many different forms and documents—is what separates the high-end programs from general-purpose business software. Perhaps you enter a series of image ID numbers when you create a stock image delivery memo; a week later, when the client licenses some of those images, the relational

technology automatically carries those image numbers over to the delivery memo—and the license—together with the client's name, address, etc. In some cases, the software will automatically generate another form when it's time to ask the client to return unused film.

Part word processor, part spreadsheet, part database, the specialized high-end programs have software modules for all the mission critical tasks . . . billing, licensing, delivery, expense tracking, and so on—along with all the tools you need to work with it. All the functions you need are wrapped together in one software environment complete with all the preformatted templates you need. And the templates are almost always customizable—you can add your own graphics, for example—so that your paperwork carries your distinctive branding.

Available for Macintosh or Windows PC, PhotoByte (which you can download at no cost from *www.zimberoff.com* and which is explained in detail in the book *Photography: Focus on Profit* by Tom Zimberoff), links up information you enter on estimates to contracts— automatically—which in turn links to the follow-up job orders, expense reports, film and portfolio delivery memos, invoices, collection letters, etc. . . . relational data every step of the way. Even the more esoteric documents benefit from built-in legalese and other "boilerplate" text, including model releases, assignment confirmations, equipment manifests, indemnification agreements, agent/rep agreements, etc. PhotoByte also tracks image licensing and distribution; the exact disposition of film, print, or file submissions for each assignment or stock transaction is at your fingertips. You know how much revenue each image has earned, so you know exactly how much profit (to the penny) you earn on each job by margin percentage.

Another high-end software suite for Mac or Windows PC, HindSight Ltd.'s InView and StockView software, manages contacts, tracks events and jobs, and handles billing and bookkeeping tasks. StockView's tools track your image catalog and image submissions to clients, along with film and print labeling. (HindSight also publishes Pricing Guide and Caption Writer programs, which, as the names imply, help with pricing stock and assignment sales, and with labeling film and prints with proper caption and image identifiers.) Another HindSight software module, searchLynx, carries your StockView data and image files onto the World Wide Web, where clients can browse or search your collection. Together, InView and StockView cost $795 ($595 if you download from *www.hindsightltd.com*); separately, each program is $495.

Another easy-to-use photo paperwork program, fotoBiz from Cradoc Corporation, costs $299.95 and comes with Cradoc's fotoQuote, a photo pricing program that's become a ubiquitous industry standard for calculating prices for both stock and assignment sales. Mac or Windows PC versions are available along with additional information at *www.cradoc.com*. (At press time, Cradoc was offering a $100 rebate for first-time buyers.)

A Macintosh-only stock-photo management program, MacStock Express includes modules for client- and photo tracking, job invoicing, and delivery memos, along with word processing, mail merge, contact management, and

reporting tools. For Windows PC users, CameraBz includes invoicing, correspondence history, film and print labeling, image shipping and receiving, plus utilities for managing a stock collection.

THE ONLINE OFFICE

When you couple your office management system with a modem and a standard phone line—or with a cable or DSL broadband connection, all this paperwork automation gets even more interesting and capable. Not only can you send and receive e-mail messages (in itself a timesaver) . . . You can also send and receive faxes and digital documents, pay bills, check bank account balances, and transfer funds between bank accounts. In an increasing number of states, you can even file your local, state, and federal tax returns.

The online connection means you can also say good-bye to the post office—you can deliver your paperwork without printing a page! Just attach your document files to an e-mail message and then e-mail your message to whomever the document is intended for. You can also do your banking online: many major banks have transactional Web sites that let you track account balances, download transactions, transfer funds between accounts, and even pay bills—all in no-cost Web-browser software and the click of a mouse.

If you use Adobe Systems' Acrobat technology to make "digital paper" of your paperwork, you are virtually guaranteed that your documents will print on virtually any system your client might have. As long as they have a recent system (PC or Mac, Windows, Linux, Mac OS, whatever!) and a recent printer, your digital paperwork (saved as a PDF file) is universally readable and should print exactly the same on your clients' systems as your own.

A HARDWARE AND SOFTWARE SHOPPING LIST

So, what does it take? What kind of computer and software do you need to run a computer-enhanced office? For starters, it really doesn't matter much whether you use a Windows PC or a Macintosh. It's true that there are more software programs available for Windows systems, and they are usually less expensive to buy. Macintosh enthusiasts should not be discouraged, though; there are enough business programs for the Mac to get the job done. Use whichever machine feels more comfortable—Mac or PC. The main point is to spend as much time generating revenues, and as little time twiddling software to a computer, as possible.

That said, you want a reasonably current machine that's under a year old. Eligible PCs would have a Pentium III or 4 CPU, Macs a G3 or G4. You want lots of storage space (i.e., a large hard disk) together with as much memory (RAM) as you can afford. These days, that means at least a 10 gigabyte disk (40 gigs would be better) and 256 megabytes of RAM (512 is better). You will thank yourself if you have a good color monitor (1024 x 768), one you will feel comfortable looking at for ninety-minute spells. (More than ninety minutes staring at a computer monitor is decidedly bad for your eyes!)

Whatever machine you get should have a CD-ROM drive that lets you to read data from CDs (which is how software companies deliver most new software). A CD-RW disc drive and burner are an even better option, because you can burn data onto new blank CDs—essential for backing up your critical business, as well as delivering tax data to your accountant, or even an image file to a client.

And while we're on the hardware topic, don't forget a mouse, a very comfortable chair with good back and arm support, and a reasonably well-lit space for your workstation.

For software, you absolutely want your office computer to be running an up-to-date version of the operating system software. For PCs you want Windows 2000 or XP, and on the Macintosh either Mac OS 9 or (preferably) OS X. For most of what you will be doing at the beginning of your paperwork stage—generating "ad-hoc" documents—two types of programs are required: word processing and a spreadsheet. The pricey Microsoft Office Suite pretty much owns this category of software with the immensely capable MS Word and Excel. There are competitors (notably WordPerfect Quattro Pro from Corel Corporation). And Apple includes a "mini" software suite on all new Macintosh systems called AppleWorks, which has basic word processor and spreadsheet tools.

But even with all the progress the computer revolution has brought to office paperwork drudgery, one thing has not changed: Someone still has to type words and numbers. Whoever that person is, they still need to be consistent and accurate about typing your business data into your system. And one more thing—you still need a filing cabinet to organize and store your paperwork—hand typed or computer generated.

© SAM MERRELL 2003

CHAPTER 10 INSURANCE PROTECTION

by Arie Kopelman

Arie Kopelman is special counsel at the New York City law firm of Greenberg & Reicher, which specializes in the legal problems of photographers and other artists.

CONSIDER THIS SITUATION: *A photographer is informed by his physician that he needs an operation and will be unable to work for three to four months. Upon returning to his studio, he finds a "summons and complaint" (that is, notice of a legal action against him) to the effect that he is being sued for $25,000 for invasion of privacy. The claim is by a model who asserts that the photographer's client has made an unauthorized use of a photograph that the photographer had taken some five years ago.*

Undaunted, the photographer goes into his studio, accompanied by a former associate who trips over a tripod lying in front of the door and severely injures his head. Hearing this commotion, the studio assistant storms over to the doorway to inform the photographer that the person who had broken into the studio the night before had stolen most of their cameras and lenses, as well as the computer, which contained all of the photographer's tax and business records and client lists.

The photographer is relieved to find out that one of his prize portfolios has not been harmed in the turmoil, since his agent picked it up the day before to show it to a prospective ad agency client. Hours later, the agent duly reports the inevitable. The agency can't find the portfolio, which had been left for an overnight review.

Surprisingly, insurance coverages, many of them available at reasonable cost, would afford protection in most, if not all, of the situations referred to above.

FINDING THE RIGHT INSURANCE AGENT

The amount of insurance you will need in any category depends on your personal circumstances. If you add up the cost (or replacement value, where that is what the insurance covers) for all your equipment and it comes to $40,000, then that is the amount to cover.

Similarly, if you earn $50,000 per year, then the insurance to protect that income in case of sickness or an accident should provide for a benefit of about $800 to $1,000 per week. In each case, simply ask yourself what is at risk. What is the minimum amount needed to restore or maintain functionality? Then you will generally know how much coverage to secure.

When seeking insurance, try to deal with an agent whose clients are in business for themselves. That agent will have greater-than-usual exposure to your type of problems. Naturally, the best solution is to find an agent who is already dealing with a few of the other photographers in your area. If you are unable to

locate someone on your own, consult with one of the professional societies. For example:

- *American Society of Media Photographers (ASMP).* 150 North Second Street, Philadelphia, PA 19106, (215) 451-2767, e-mail: *membership@asmp.org.*
- *Advertising Photographers of America (APA).* 145 South Olive Street, Orange, CA 92866, (800) 272-6264, e-mail: *office@apanational.org.*
- *National Press Photographers Association (NPPA).* 3200 Croasdaile Drive, Suite 306, Durham, NC 27713, (800) 289-6772, e-mail: *info@nppa.org.*
- *Professional Photographers of America (PPA).* 229 Peachtree Street, Suite 2200, International Tower, Atlanta, GA 30303, (800) 786-6277, e-mail: *csc@ppa.com.*

If the national headquarters of the organization doesn't have the information, a local chapter or affiliate can probably help you. Be sure to ask the headquarters office for the organization's local contact or phone number.

Finally, when you are buying insurance, there are some crucial strategies you must employ to keep the total cost at a level you can afford. These are covered below.

STRATEGY FOR BUYING INSURANCE ECONOMICALLY

There are a few key points to bear in mind when buying professional insurance:

- **Package purchasing.** Get your insurance all at once, and all at the same place, if possible. Many business risks in this field are so unusual they might never be covered if you had to have a separate policy for each (such as invasion-of-privacy insurance, incorporated into "errors and omissions" coverage). But as part of a broad business package, the coverage can probably be secured, and, hopefully, at an affordable level.
- **High deductibles.** Look for policies in every area with high deductibles; that is, policies where you personally cover the first several hundred or even several thousand dollars of losses. A major cost for insurance companies is the administrative expenses of handling small claims. If you eliminate that problem for them on your policy, you may get a very substantial saving (often in the range of 20 percent to 40 percent). That approach will allow you to get more of the different coverages you need for your business. The money you save by self-insuring for small losses that you can afford allows you to pay for protecting against the really big risks that can kill you.
- **High limits.** Get the highest coverage you can where the risk is open-ended. For example, on "general liability" policies that cover personal physical injuries you (or your staff) might cause to innocent third parties, you should be covered up to about a million dollars, or possibly more. Jury awards of many hundreds of thousands of dollars and much more are commonplace today.
- **Focus on major risks.** Focus especially on a situation that could put all your personal or business assets, or your entire income, at risk. One would be the unlimited risks associated with injury to third parties, just men-

tioned above, that are covered by general liability insurance. Another would be a disabling injury or illness that kept you from working for many years (your income could be replaced by disability income insurance). Obviously, these situations are more fraught with danger than loss of a few cameras or your portfolio. As one New York insurance expert with roots in Iowa put it: "Imagine that your business operation was a farm with cows that give milk. You can afford to lose a lot of milk (your product) and even some of the cows (your tools), but you're completely wrecked without the farm."

BUSINESS PROTECTION

On the business side the basic coverages encompass the following:

1. **Injury to third parties.** General Commercial liability insurance covers claims of third parties for bodily injury and property damage incidents that occur inside or outside your studio. You need a specific extension to cover invasion of privacy, encompassing right of privacy and right of publicity claims, as well as plagiarism (including copyright violations), libel, and slander. Sometimes these coverages are obtained in the "errors and omissions" segment of a publishers' liability policy. You may also want to add to your general business insurance the specific use of nonowned cars that you rent in connection with jobs. This coverage will kick in when the insurance on the vehicle itself is exhausted.

2. **Injured or sick "employees."** Those freelance assistants and stylists you hire on a day-to-day basis may be classified as employees in many states for the purposes of claims arising from injury on the job and sickness off the job. Accordingly, you may well be required by law to have *workmen's compensation insurance* to protect freelance staffers in case of on-the-job injury and *disability benefits coverage* to provide income for employees who lose work time in the event of injury or sickness off the job. In any event, you absolutely must have workmen's compensation coverage for your regular staff employees, both full- and part-time.

In addition, with a large staff, you may consider the usual medical, retirement, and disability income benefits programs often made available to longer-term employees.

3. **Your business property.** At stake here are your studio and fixtures, equipment, photographs, business records, and cash accounts.

■ *Studio and office contents.* A package policy will cover studio and office contents against fire, theft, smoke, or water damage. Special improvements, such as a darkroom or other unique structure, should be specifically indicated in the coverage. If your studio or darkroom is part of your residential owner's or tenant's policy, it would cover these risks if the insurer is informed of the partial business use.

Additions to the package policy may be of interest to established professionals: a so-called extra expense or business interruption rider

will cover extra overhead expenses you incur, for example, if you temporarily rent another place in the event of fire or other destruction at your own studio. Similarly, you can get business overhead coverage to temporarily pay for ongoing studio expenses while you are disabled from sickness or accident.

■ *Cameras and equipment.* The most common coverage for photographers is the *camera floater,* which can encompass worldwide coverage for loss or damage to cameras, lenses, strobes, and other movable equipment. If you are just starting in business, you may have a nonbusiness floater policy that you use to cover personal property, including your cameras. As your business becomes significant, you must convert the camera coverage to a commercial policy to be sure that the insurance is in effect in the event a loss occurs. Floaters cover only the specific items named in the policy. Therefore, you must update the coverage list every six or twelve months with your new purchases during that period. Most policies insure only against losses up to the amount of your cost (less depreciation). That will not be enough to cover the cost of replacements, given the rapidly escalating price of equipment. Accordingly, you should consider getting "stated value" floaters, which will reimburse you for the current replacement cost in the event of loss. Of course, that increases the premium.

■ *Photographs and business records.* The package policy covering studio contents usually sharply limits recovery for loss of photographs or business records (often to as little as $500). To cover those items directly, you need *valuable papers coverage.* Its best use is for the time and effort that might have to be spent to replace business or computer records that are lost or damaged (in a fire, for example). Consider the problems that would arise if you lost the index to your picture file, or all your tax records. You can also use this coverage for negatives, transparencies, and prints. The problem is that these may be so numerous that the cost will be prohibitive. Many believe that the cheapest solution here is simply to store your best negatives and transparencies in the safe-deposit box of a bank vault. Of course, the rapid shift to all digital operations will eventually diminish the importance of these issues.

Films damaged in a lab present special problems. Virtually all labs waive liability for any loss or damage (except to supply replacement film). Your best defense here is to take all film from important shootings and break it into separate batches that are sent to the lab over several days. In addition, never have your film processed on the first day after long holiday weekends, when lab procedures may be slightly awry. Again, the rapid changeover to all digital operations will obviate these problems in the coming years.

■ *Cash accounts.* An established photographer may be jeopardized by the acts of a dishonest employee. While it happens very rarely indeed, an employee could forge your signature on studio checks or devise other means to secure unauthorized payments from the studio. Insurance for

such situations is referred to as fidelity coverage, which, in effect, is a bonding procedure for your employees.

On a related issue, bailee coverage is needed if you photograph valuable objects, such as jewelry or furs. Often, the client will pay for this if it is unique to a specific job.

PERSONAL PROTECTION

On the personal and family side a photographer's insurance needs are similar to those of most other members of the public and should encompass the following:

- *Sickness and injury.* Basic hospitalization or membership in an HMO (or other private plans) is essential but not enough. Extended hospitalization, intensive care, and major surgery make major medical coverage almost mandatory. Interestingly, once you have the basic hospitalization, the added expense of major medical is not great.
- *Disability.* Often overlooked, however, is what happens to your income in the event of long-term or permanent disability due to sickness or accident. Insurance coverage that provides income replacement is called *disability income* insurance and is generally considered essential for freelance people. If you elect a fairly long waiting period (say, sixty to ninety days of disability) before you start collecting, the cost can be quite reasonable.
- *Personal property.* The most common protection in this category is a homeowner's or tenant's policy.

These policies cover all of the property associated with your house, apartment, and personal possessions. These policies often have options to cover general liability for injury to third parties who visit your residence. For expensive property that you take out of the residence, such as cameras or other valuables, you need a floater, rider, or separate policy, which is an additional premium. Remember that business uses of your residence or property almost always require a separate commercial policy.

- *Automobiles.* Automobiles, of course, are covered separately for fire and theft under a comprehensive policy, and personal injury or property damage to third persons under a general liability auto policy.
- *Life insurance and accidental death benefits.* Life insurance is necessary only in cases where others are dependent on your income or services. That could include your family or business partner. Life insurance can be obtained either as *term insurance,* which is purely a death benefit without cash value, or as a form of savings combined with the death benefit, referred to as *whole life.* Since photographers tend to travel extensively, they may also see value in an *accidental death and dismemberment* (AD&D) policy, which in effect is basic term life insurance, covering only the limited situation of accidental death. On an annual basis it is quite inexpensive, covering all possible accident situations, including travel. For example, it is certainly far less expensive than taking out coverage at the airport for each trip. AD&D coverage should not,

however, be confused with medical coverage. AD&D pays only a death ben-efit and in certain cases pays for loss of sight or limbs.

- *Personal umbrella.* High net worth individuals may want additional coverage on top of the maximum coverage provided by a homeowner's policy or an automobile policy with respect to injuries to third parties. An umbrella policy can be used to increase the protection against recoveries that might exceed the maximum recoveries allowed under the homeowner's or auto-mobile policies.

© Arie Kopelman 2003

11

HEALTH AND ENVIRONMENTAL SAFETY IN PHOTOGRAPHY

by Monona Rossol

Monona Rossol is a chemist, artist, and industrial hygienist. She is the founder and president of ACTS (Arts, Crafts & Theater Safety), a not-for-profit corporation based in New York City dedicated to providing health and safety services to the arts. She is the coauthor of *Overexposure: Health Hazards in Photography* and the author of *The Artist's Complete Health* and *Safety Guide* and *The Film and Theater Health and Safety Guide.*

PHOTOGRAPHERS HAVE TO BE AWARE of environmental and health issues in photography. Many of the chemicals used in photography can be damaging to the environment if proper disposal techniques are not used. In addition, there can be serious health hazards to you and your family if proper precautions are not taken in designing and using your studio. This chapter will explore both the environmental and health issues that you must understand in practicing your profession.

ENVIRONMENTAL ISSUES

Setting up a photographic studio of your own used to mean finding a closet-size space and a sink. But today, you need to follow environmental and health laws. And if you hire someone to help you, you must comply with worker safety regulations.

LOCATING YOUR STUDIO

Unless you have switched to digital methods or send your exposed film out for processing, you are engaged in "light industry." That is, you use toxic substances to create your product. Your studio must be located in an area in which this activity is permitted by local zoning and building codes.

In addition, photochemicals smell. People around you may object. Many times, I have provided professional advice to groups of people who are taking legal action to shut down a studio whose odors are disturbing or sickening them. Even if you win the battle to stay in your studio, the legal actions are time consuming, expensive, and emotionally draining. And you probably will never be comfortable there.

If your studio is in your home, a loft, or a garage, it is important to tell your insurance agent all about it and pay any extra charges. I have seen insurance companies refuse to cover damages caused by fires, floods, toxic spills, and other accidents related to studio work when they were not fully apprised of the presence of the studio beforehand.

DOWN-THE-DRAIN WASTE

Most photographers know that the silver washed out of black-and-white prints is regulated by the Environmental Protection Agency (EPA) and, in turn, by your local publicly owned treatment works (POTW). Your local POTW will have stricter rules than the EPA.

For example, the small POTW in a town in which a well-known university is located can only handle household waste. They will not let the university art department that is located in their midst put any significant amount of chemical waste into their drains. All developers, toners, fix, stop, and other spent photochemicals must be picked up by a hazardous waste company. Even the water that is used to clean artists' acrylic-paint brushes must be collected.

In general, water waste rules in small communities are likely to be more restrictive than those in larger communities or areas zoned for industrial use. But wherever you are located, it is incumbent on you to find out what the discharge limits are in your area and figure out how to meet them. While many photographers get away with polluting, the fines imposed on those that get caught can break a small business.

In addition to silver, there are many other regulated photochemicals. These include chemicals that are strongly corrosive (e.g., glacial acetic acid), ignitable (e.g. solvents), toxic (many developers and toners), or reactive with other substances. You are considered a small-waste generator if you generate even one 55 gallon drum of these ordinary wastes over a period of a year, or generate one quart of extremely hazardous waste in a year. It is almost impossible for any active photo artist not to create this amount of waste.

Chemicals that can trigger the rules at even one quart include potassium and sodium ferricyanide and ferrocyanide compounds such as those used in old blueprints, Framer's reducer, carbo printing reducer, the cyanotype ferricyanide, and Prussian blue pigments. These chemicals release cyanide gas in the environment. Other highly toxic chemicals include: chromic acid bleaches; lead toners; mercury intensifiers and preservatives; and uranium nitrate toners.

If you are in a rural area and your waste goes into a septic system, you need to capture all your waste chemicals. While no one will stop you from putting chemicals into your land, years later, you can be held liable for having polluted a neighbor's land or water.

STORING CHEMICALS AND WASTE

Chemicals must not be stored in locations where they can even accidentally spill into sink or floor drains. Instead, spilled chemicals and wash water should be collected and picked up as toxic waste.

In one university, all the floor drains in the photography darkrooms and storerooms of a newly renovated building had to be capped so that spills or wash water could not go down the drains. University administrators were angry with the architect and engineers who put in all these expensive drains only to find out from local environmental authorities they could not be used.

All dispensers of chemicals, especially those with spigots, must not be over sinks into which the chemicals can flow if spigots are left open or break. Instead, all dispensers, Cubitainers, and other liquid chemical containers must be placed in containment rooms, inside pans, or in tubs so that accidental spills can be collected.

Once you have collected waste, there is a ninety-day storage limit on holding it. You will need to develop a relationship with a local toxic waste disposal company to come frequently to pick up your waste.

WASTE IN THE DUMPSTER

Do not put waste in the ordinary trash unless you are sure it will not release any of a number of regulated chemicals. Solid waste can be subjected to an acid leach test called the toxicity characteristic leach procedure, or TCLP test. Metals detected by the TCLP test that can render your waste "toxic" include antimony, arsenic, barium, beryllium, cadmium, chromium, copper, iron, lead, manganese, mercury, nickel, selenium, and zinc. Some of these metals are used toners, nonsilver process chemicals, art paints, and phototinting colors.

WHAT TO DO

If you have employees, you may want to consult with specialists to help you set up your systems. If you are self-employed and work alone, you can take the following minimum steps:

1. Obtain material safety data sheets (MSDSs) on all the products you use. These can be obtained by phone or fax request, or by downloading from the manufacturers' Web sites.

2. Check disposal advice on the MSDS if there is anything more than the usual "dispose of in accordance with local, state and federal regulations." Some MSDSs will have helpful information.

3. Use the MSDSs to create a list of all the chemicals in the materials you use.

4. Find out where your drains go.

 a. If you discharge to a treatment works, find out what their discharge limits are and make sure you do not discharge these chemicals in any significant amount.

 b. If you discharge to a septic system, collect all spent chemicals from photo processes.

5. If you are a business, register with your local Department of Environmental Protection as a small-waste generator and follow their rules.

6. If you create silver waste, purchase a recovery unit. They are sold in any catalog of photographic supplies.

7. Protect your sink and floor drains from accidental spills. Put containment tubs or trays under the silver unit and under all liquid-chemical and waste-holding containers.

8. Establish a relationship with a local hazardous waste company that can come periodically and pick up waste. Such companies also will usually provide good advice about local regulations.

9. Form alliances with other local photographers and share expertise and expenses. For example, if your waste pickup is coordinated with those of several other photographers in your area, the cost can be reduced. Getting a group together to rent a darkroom facility and pooling resources and distributing disposal costs also can be helpful.

HEALTH AND SAFETY ISSUES

Large numbers of substances, many of them very complex organic chemicals, are involved in photographic processes. Many of these are known to be hazardous, while the hazards of many others are unknown and unstudied. In addition, new photochemicals are continuously being developed, and their long-term hazards are unknown.

In practical terms, however, photochemicals are primarily associated with skin diseases and respiratory allergies. While skin diseases may be disfiguring and occasionally serious, they are not as likely to end your career as those affecting the respiratory system.

RESPIRATORY DISEASES

Photochemical baths emit substances that are recognized by their typical darkroom odor. These substances also may be responsible for many of the respiratory diseases associated with darkroom work. Table 1 lists some of these airborne substances and their hazards.

TABLE 1
COMMON DARKROOM AIR CONTAMINANTS

CHEMICAL	MAJOR SOURCES	PRIMARY HAZARDS
acetic acid	stop baths	Corrosive and irritating. Contact with glacial acetic and other high concentrations of this acid can cause severe burns and blindness.
formaldehyde	hardeners and preservatives	Sensitizer, irritant, and animal carcinogen. May be associated with nasal sinus cancer.
hydrogen sulfide	emissions by certain toners	Highly toxic to nervous system and irritant.
sulfur dioxide	breakdown of sulfites in baths, some toners	Respiratory irritant and sensitizer. Associated with asthma.
various solvents	color chemistry and film cleaners	Irritants, toxic to nervous system, liver, and other organ systems.
bromide compounds	restrainer, bleach	Moderately toxic by inhalation, but may cause birth defects.

LIVING SPACES VERSUS WORKING SPACES

Many photographers develop and print in unsafe locations, such as converted bathrooms, kitchens, basements, and other inadequate spaces in their own homes. Instead, studios must be planned so that chemicals—even microscopic amounts—cannot be tracked into living, eating, and sleeping areas. Even the air from the studio must not be contiguous with the air in living spaces. And sinks used for photographic activities must never also be used for bathing, washing, or food preparation.

If you have children, there must never be detectible odors of photochemicals in your home. The sulfur dioxide, acetic acid gases, and other photochemical pollutants can damage young lungs and cause permanent respiratory allergies and asthma. One way to have a studio in a home is to create barriers between the studio and living spaces. For example, one artist closed off any access from the rooms designated for the studios and created a door to the outside. This way, he can wash up, leave aprons and work shoes in the studio, and walk around his house to reenter living areas.

VENTILATION FOR BLACK-AND-WHITE PROCESSES

Straight black-and-white developing is one of the least toxic of the photoprocesses. In most cases, dilution ventilation systems can be used for this process. These systems consist of an air supply and an exhaust. However, the location of the supply and exhaust are crucial to its efficacy (See figure 1).

Figure 1

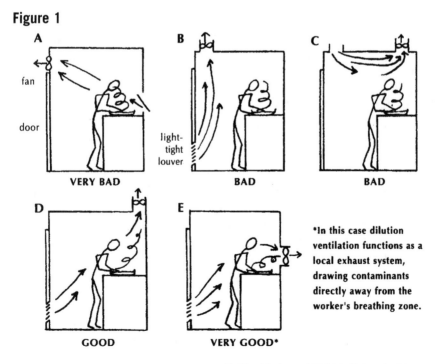

*In this case dilution ventilation functions as a local exhaust system, drawing contaminants directly away from the worker's breathing zone.

To select a fan that can draw the right amount of air for this system, the following formula can be used:

The fan's capacity in cubic feet per minute = ft3/min = CFM
The room's volume in cubic feet (height x length x width) = ft3
Air changes per hour = (AC/Hr)

$$\frac{(\text{room volume in ft3}) \times (\text{number of AC/Hr})}{60 \text{ minutes/hour}} = \text{CFM}$$

Example: For a darkroom that is 10 x 20 feet with a 10 foot ceiling, which requires about 15 air exchanges per hour, the fan's capacity should be:

$$\frac{10 \times 20 \times 10 \times 15}{60} = 500 \text{ CFM}$$

This formula assumes that the fan's performance is absolutely unhindered. This is true only if the fan encounters no resistances, such as some negative pressure in the room or an opposing breeze. For this reason, one should select fans that are capable of moving air against pressure. Most window exhaust-fans should be able to deliver the required CFM against 1/4" or 1/2" static pressure. Manufacturers should be able to provide this data on their fans' performance at specified static pressures.

If the fan must blow the air through a duct or a light trap, the resistance of the duct or trap must be compensated for in the calculations. In fact, an ordinary propeller exhaust fan may not be able to overcome such resistance. You may need the assistance of an industrial ventilation engineer to help you select the right centrifugal fan.

LOCAL EXHAUST VENTILATION

If toning, bleaching with highly toxic chemicals, color processing, mixing photochemicals from dry powders, or other hazardous processes are used, local exhaust systems are needed. These systems capture the contaminants at their source and exhaust them so that the worker has essentially no exposure to them. Such systems include slot vents or exhaust fans at the backs of sinks, spray booths, and chemistry fume hoods.

You will probably need an industrial ventilation engineer to design or select the appropriate systems for your space. You can contact Arts, Crafts & Theater Safety, Inc., at *ACTSNYC@cs.com* for recommendations. ACTS—181 Thompson St., #23, New York, NY 10012, (212) 777-0062—is a nonprofit corporation that does not benefit financially by recommending engineers or suppliers of equipment.

Be aware that there are a number of reasonably priced ventilation systems for darkrooms that *look* like they should work, but they don't. You can identify

these systems if you see square or rectangular ventilation ducts (round ones should be used), canopy hoods over sinks (which would draw contaminated air past your nose), or systems consisting of a fan and duct that connect at right angles to a horizontal pipe that has cut out portions at the bottom through which air is drawn.

Air purifiers also do not provide sufficient contaminant control for chemical darkrooms.

Automatic processors are easy to vent today because most new ones can be purchased with local exhaust ducts attached to them. However, many salespeople do not mention this fact unless you ask.

RESPIRATORS

Some photographers rely on air-purifying cartridge respirators for protection from photochemicals. The cartridges needed for most photoprocesses are a combination of organic vapor, acid gas, and particulate filter (if you mix dry chemicals). These are expensive cartridges that can only be counted on for about eight hours of use.

If masks or respirators are used in a workplace, the employer must provide medical certification, professional fit testing, and training for workers. This also is expensive, and usually ventilation is cheaper to install in the long run.

OSHA REGULATIONS

If you are self-employed and work alone, the Occupational Safety and Health Administration's (OSHA) rules do not apply to you. But if you employ even one worker, OSHA is now a factor. OSHA provides booklets of advice for small businesses and has a Web site and hotlines for advice. ACTS can also help.

GENERAL PRECAUTIONS

1. Replace dry chemicals with premixed chemicals when possible. When powders must be used, handle and mix them in local exhaust ventilation, such as a fume hood or with respiratory protection. Avoid skin contact and clean up powder spills scrupulously.

2. Dilute liquid chemicals in local exhaust ventilation, such as a fume hood. Always add acid to water, never the reverse.

3. Do not use or store glacial acetic acid. Concentrated acetic acid is both corrosive and flammable and must be stored alone. Splashes can cause severe skin injuries and blindness, and both an eyewash and an emergency shower are required. Instead, purchase acetic acid diluted to concentrations of 50 percent or less. Then it can be stored with other acids and only an eyewash is needed.

4. Provide eyewash stations in each room where chemicals are used. Flush the eyewash each week for three minutes. Provide an emergency shower if concentrated corrosive chemicals are used.

5. Obtain Material Safety Data Sheets on all photochemicals and select the safest materials. Do not use extremely toxic chemicals, such as those containing chromic acid, lead, mercury, uranium, or cyanide.

6. Use protective equipment, including gloves, chemical splash goggles, tongs, and aprons.

7. Gloves and tongs always should be used to transfer prints from baths. Barrier creams can replace gloves if only occasional splashes on the hands are expected. (Note: barrier creams may smudge prints if they are handled.)

8. Store photochemicals in the original containers when possible. Never store photochemicals in glass bottles, which can explode under pressure.

9. Place containment tubs and trays under liquid chemicals and prepare to handle spills and breakage with chemical absorbents. If spills could reach a floor drain, cap that drain. Special containment floors should be built into large darkrooms or chemical storerooms.

10. Floors should be made of material that is easily washed.

11. Set up silver recovery units for all silver-containing solutions, or else hold these solutions for commercial hazardous waste pickup.

12. Dispose of complex photochemicals, solvents, metal-containing toners, and other wastes in accordance with the manufacturer's recommendations and governmental regulations. Check with the local water treatment facility to determine which chemicals may be put down drains. Chemicals that may be released to drains should be diluted and flushed down with large amounts of water. Never flush chemicals into septic systems.

13. Contact a commercial toxic waste disposal service to set up regular removal of those chemicals that cannot be released to drains.

14. Practice good housekeeping. Clean up all spills immediately. Never work when floors or counters are wet with water or chemicals. Eliminate trip hazards and clutter.

15. Clean up and wash off all spills and splashes on the skin immediately. Do not allow splashes on clothing or skin to remain until dry. Instead, remove contaminated clothing and flush skin with copious amounts of water. After washing off caustic materials, use an acid-type cleanser.

16. Keep first-aid kits stocked and post emergency numbers by the phone.

17. Prevent electrical shocks by separating electrical equipment from sources of water as much as possible. Install ground fault circuit-interrupters on all darkroom outlets.

18. Keep chemicals in cool, dark places. Do not allow heat or ultraviolet (UV) light (from high-intensity light source or the sun) to affect or degrade stored photochemicals.

19. Follow all OSHA rules for storage and use of flammable and toxic solvents.

20. Always be prepared to provide your doctor with detailed information about the chemicals you use and your work environment.

PART III

MARKETING YOUR PHOTOGRAPHY

CHAPTER **MARKETS, PROMOTION, AND CLIENTS**

by Maria Piscopo

This chapter is adapted from *The Photographer's Guide to Marketing and Self-Promotion* by Maria Piscopo *(www.mpiscopo.com),* a photographers' rep for more than twenty years. She has consulted, lectured, and written extensively about the business of selling photography and is a frequent speaker at seminars and conferences. She is based in Costa Mesa, California.

MARKETS FOR YOUR PHOTOGRAPHY are divided into two types. One is the commercial client. The other is the consumer client.

This distinction is based on how the photography is used. A commercial client has a business reason for buying the use of your images. It could be a low level of commerce, for example, to communicate with their customers. It could be a high level of commerce, for example, to sell their products or services.

A consumer client (often called the wedding and portrait market) has a strictly personal reason for hiring you. There is no commerce or profit-making use of the images. If there is, then they become a commercial client.

Fine art photography can be either a consumer or commercial client! If the photography is for display in the home of an individual for noncommerce purposes, then it is a consumer client. If the photography is for display in the office and lobby of an individual's business, then it is a commercial client.

DIGITAL IMAGES

There are two distinct types of clients for digitally produced images. The first type of client hires you to create illustrations, images that no longer look like photographs. The second type of client hires you to create an image that still looks like a photograph. With digital technology both of these clients are still buying the use of images. How you get there (digital capture versus film and then scanning for digital enhancements) is not as important to the client as what it looks like when you are done!

For example, the client hires you as an illustrator, to create a unique, new expression—your personal style. Because this is style and not a subject-specific strategy, you would sell to a very broad audience of potential clients for this work. For any illustrator, advertising in a creative sourcebook (print or online) is probably the best marketing tool because it exposes the greatest number of clients to your style. They can then contact you through your Web page or ad when they have just the right job for your style.

The second kind of client hires you as a photographer using digital technology, to create something that still looks like a photograph, but you create the

final image instead of an outside service they previously used to put all the pieces together. The most likely client is the client you already have! This is the client that used to tell the photographer, "Shoot this so I can go have the photograph retouched or assembled later." Now, the photographer can do the image enhancement and assembly. The best marketing tools here are direct mail campaigns and sales calls. Since your studio will do the image enhancement and assembly, this expands your services and billings on jobs to existing and new clients. You can also expand your digital billings and business by working on supplied photos.

It is important to recognize that the subject matter is not at issue for your client. The determining factor is *how they will use the photos,* not the subject. A digitally produced portrait can be consumer client (family portrait to hang in the living room) or commercial client (executive portrait for an annual report).

STOCK PHOTOGRAPHY

Stock photography is a growing market and profit center for the traditional assignment photographer. Clients have become increasingly discerning and educated. It is hard to sell second-level quality images since clients have easy and quick access to so many first-level ones. You have the option of marketing stock on your own Web site or as a page on a Web site dedicated to stock sales. Try to avoid creating a complicated Web presence, one that is difficult for clients to navigate. To successfully compete as a photographer, be prepared to offer personal assistance in the client's search for the "perfect" stock image they have in mind. If you do go outside for representation by a stock agency, make certain they are not competing with you by selling their own images and that they have lots of expertise in rights-controlled e-commerce.

YOUR MARKETING MESSAGE

There are four ways to identify your "marketing message." They are style, subject, industry, and use of the images.

1. By a particular style of work, based on how you "see" the world. Selling style is your personal vision and tends to be used by high-end clients, or clients in cutting-edge industries, such as editorial or entertainment.
2. By naming a subject, based on what you are shooting. This is the most common approach to marketing and self-promotion of photography. Both consumer and commercial photographers use this successfully. It could be the photography of people, products, architecture, and nature—any subject you can name.
3. By a specific industry, based on who buys the photography. This is also a good marketing message because it is so easy to identify clients. It also helps the client to know you have experience with their product or service.
4. By the use of the images, based on how the photography is used. For example, annual report photography or catalog photography. This targeting works well because it also makes it easy to identify clients.

Once you have your marketing message, you will look for new clients in three steps: the primary research to build a database, the secondary research to upgrade and maintain new lead development, then turning each lead into the name of the true client you'll be selling to—your "prospect."

For commercial photography clients, it is very important to use all three steps. It is especially important to do your research so you can knock on the right doors. Trying to sell to a commercial client that does not buy the type of work you want to do is a waste of their time and your time. In addition, the rejection factor is sky high!

While commercial photographers go out and knock on *client's* doors (selling), the consumer photographer is more dependent on the reverse. Your wedding and portrait-marketing plan of advertising, Web sites, and direct mail must be designed to bring clients to *your* door, and then you can sell to them. For consumer photography clients, there are no precise directories of "people that want a family portrait," but you will certainly want to make the third step of turning a lead into a prospect.

PRIMARY MARKET RESEARCH

Most of this research for commercial photography clients will be done at your public library or online. The business reference section and librarians will be most helpful when you can tell them what you are looking for. From manufacturers to advertising agencies to book publishers, there is a directory for every market! Before you spend hours at the library copier with a pocketful of change, check with the publishers to see if the directory is available on CD or online. Then, you can download the information into your personal computer and use the information for making sales calls or mailing labels.

Another note: Watch for directories that have some kind of qualifier for a firm to be listed. When you are looking for new clients, you want to work with the highest level of information possible. For example, some directories will list book publishers simply because they exist, while others will list only book publishers that answer an annual survey of what kinds of photography assignments are available. The second is the better-qualified information!

Here are some commercial client research sources:

Advertising Agencies
1. Standard Directory of Advertising Agencies: *www.redbooks.com*
2. Adweek Directory: *www.adweek.com/directories*

When looking for advertising photography assignments, you must research an advertising agency based on the type of clients they represent, such as selling food photography to an agency with food clients. Even subject categories as broad as people or product photography can be broken down into specific client types. For leads on people photography, you will look at ad agencies that have "service" sector clients, such as healthcare, financial, or insurance. For

product photography, look at agencies with "manufacturing" clients, such as computers or electronics.

Corporate Clients (Also Called "Client Direct")
1. Standard Directory of Advertisers: *www.redbooks.com*
2. Chamber of Commerce Directory (check your local county chamber)
3. Brandweek Directory: *www.adweek.com/directories*
4. Business Journal, Book of Lists: *www.bizjournals.com*
5. Encyclopedia of Associations: *www.galegroup.com*

These are just a few of the dozens of directories that list the names of companies to develop into photography leads. Watch for qualified information, such as a Chamber of Commerce or an industry association directory (have to be a member to be listed). Again, the value of this level of information is that it "weeds" out the less aggressive companies and leaves you with firms that are actively promoting their products and services. What can you guess from this qualifier? They are probably doing more promotion and need more photography!

Direct Marketing
1. Directory of Major Mailers: *www.targetonline.com*

Direct marketing agencies are firms that are responsible for the design and production of promotions—primarily direct mail. Since so many companies have found direct mail more cost-effective than some forms of print or electronic advertising, millions of dollars in marketing budgets have been taken away from ad agencies and given over to direct marketing agencies. This is particularly good for catalog and other consumer photography projects. Books like *The Directory of Major Mailers* are available on a CD-ROM, so you can search by company name, industry category, or geographic area.

Editorial/Magazines/Publications
1. Standard Rate & Data Service: *www.srds.com*
2. *Photographer's Market* or *Writer's Market*: *www.writersdigest.com*

Though the photo fee rates are usually fixed by the publication at a "page rate," many photographers pursue editorial for the credibility of having published work and the creative freedom to pursue their personal style. When you pursue editorial clients, be sure you have thoroughly read and reviewed copies of the publication so that you are familiar with their own style—what they call their "focus"—and direction of their photography needs. Some are cutting edge; some are conservative—know whom you are selling to before you knock on their door!

Graphic Designers
 1. The Design Firm Directory: *www.wef.net/designsearch/dfd*
 2. *The Workbook* (Directory Section) or *www.workbook.com*

Design firms are wonderful clients for photographers and the better of two worlds. Like ad agencies, they work with client's projects for marketing and promotion. Like editorial clients, they work very collaboratively with their photographers and often use the photographer's perspective. Their photography projects often have extensive shot lists, such as an annual report or a Web site. Sometimes, their photo needs are regular and seasonal, such as catalogs.

Paper Products/Book Publishers/Record Album Producers
 1. *Photographer's Market and Writer's Market: www.writersdigest.com*
 2. ArtNetwork: *www.artmarketing.com*

Paper products are primarily a subject-specific market but are also great for style photography sales. This category includes publishers of calendars, greeting cards, posters, and other novelty products. In this market category, photography projects or assignments are often purchased on a small advance plus royalty payment plan. Be sure to have your personal attorney or a reliable agent look over any contract before you agree to the use of your work.

Buying Compiled Information
 1. *Target Marketing* magazine: *www.targetonline.com*
 2. Agency ComPile Web site: *www.agencycompile.com*
 3. ADBASE Creatives Web site: *www.adbase.com*

The above firms are just a few of the resources available for the purchase of names of potential clients compiled from surveys, credit card purchases, magazine subscriptions, and association memberships. Buying information is always more expensive than the purchase of a simple mailing list, but the quality of the sales lead is higher and more qualified.

SECONDARY MARKET RESEARCH
Once you have setup a primary database, here are some additional resources and new areas of communication and promotion for developing new leads in your photography business.

 1. *Daily Newspaper.* Every day in the business section, you will find news released by companies that includes new products, expanded services, and changes in personnel. Any of these are opportunities for you to get in the door with your photography services.

2. *Trade Magazines.* Check in the periodicals section of your library reference. You'll find magazines for every possible industry and trade. These publications, much like newspapers, include news releases that are specific to the area of photography you're interested in. You may even want to get the information to subscribe in print or online so that you can use them for contacting clients for photography services on a more regular basis.

3. *Trade Show Exhibitor's Guides.* Every industry also has some kind of annual trade show. The value of this research is that they are prequalified for buying photography. Many companies choose not to participate in their own industry trade shows. You can make a good guess the ones that do participate will need more photography for brochures and displays than their competitors that have stayed home!

4. *Editorial Calendars.* When researching any kind of publication for photography services, the editorial calendar identifies the issue-by-issue articles for the year. Keep in mind that magazines work three to six months ahead of publication date. When you approach the publication with the information from the editorial calendar, you will be able to reference your work to a specific need they will have for photography for an upcoming issue! You can get the editorial calendar by getting a media kit from the magazine or finding it on their Web site.

5. *Awards Annuals.* Finally, when you have a very strong visual style, you'll find that the clients that buy style tend to win the creative awards for their work. If a client used a strong photography style once, they are more likely to do it again. Research these clients by reviewing advertising and design industry award directories from trade associations and from publications such as *Communication Arts* and *STEP inside design* magazines.

QUALIFY LEADS TO PROSPECTS

In this final stage of research, your objective is simple. You will call to get the name of the true client, the person in charge of buying photography. Since this step is still research and not selling, it is very easy to delegate it to your marketing coordinator or studio manager.

You can start by using the below scripts to get the most information with the least amount of effort. It is very important to prepare ahead for even the simplest verbal interaction! You must not waste time or frustrate a potential client because you don't know what question to ask. Be sure to be specific as to the type of photography work you are looking for (your marketing message) so that you will get the correct contact name. You can use the variations depending on what kinds of company you are calling. You can even use job titles if you have the correct title information in advance.

Your phone call script for finding and qualifying new client leads:

"Hello, my name is Maria from Creative Services Studios and I'm just updating our files. Who is in charge of hiring for your (fill in with a specific type of work) photography?"

"Hello, my name is Maria from Creative Services Studios and I'm just updating our files. Who is the art director for the (fill in with a specific client name) photography?"

IN CONCLUSION

You will find a higher level of marketing success by simply separating the steps of identifying your marketing message, finding the clients that buy that type of work, then qualifying to get the name of your client prospect. With this information, you can now decide how to proceed. You can approach clients for an appointment to show your portfolio, or you can add their name to your mailing list—or both. The name of the prospective client that buys the photography you want to do is the key. With that key, you will open many new markets for your photography services.

© MARIA PISCOPO 2001, 2003

CHAPTER 13

BUILDING AND PRESENTING YOUR PORTFOLIO

by Maria Piscopo

This chapter is adapted from *The Photographer's Guide to Marketing and Self-Promotion* by Maria Piscopo *(www.mpiscopo.com),* a photographers' rep for more than twenty years. She has consulted, lectured, and written extensively about the business of selling photography and is a frequent speaker at seminars and conferences. She is based in Costa Mesa, California.

IF THIS IS YOUR FIRST ATTEMPT to put together a portfolio, congratulations! You will not be burdened with a lot of preconceptions of what works and what does not work in a portfolio. If you have been in the photography business any length of time, this is probably the part where you ask, "Who changed the rules and how come no one called me?"

For all photographers, your portfolio still provides the focus and direction for your photography business, but, because it is so personal, it is hard to be objective. Just because you are tired of looking at an image does not mean it will not do the job and stimulate the people that see it to give you work.

For most photographers, portfolio presentations do not work because they are not "packaged" or planned. Many show a collection of images they have done, and hope the consumer or commercial client will find something they want. This is not a multiple-choice test! You must show a portfolio that shouts out your marketing message so that any type of client can retain the visual information and remember when to hire you. As much as you may hate to be "pigeonholed" this way, there is simply too much visual information presented to most clients every day. They need your marketing message as the "hook" to hang you on and to find you when they need your type of work.

So let's start by redefining the term "portfolio." A mixed assortment of images is not a portfolio. All the images you have are not a portfolio. Your image files make up a body of work. Whether you are a consumer or commercial photographer, out of this body of work come various portfolios that are *customized by your marketing message* for viewing by a specific client. Each portfolio you pull out of the body of work must also target the level at which you want to work (not necessarily the level where you are now).

PLANNING FOR YOUR PORTFOLIO

There are two major areas to concentrate on when planning your portfolio presentations. First, what you show in your portfolios (image selection), and, second, how you show them (portfolio formats).

Before you do anything else, however, go to your planner or calendar and schedule the time to do this work. Overhauling your portfolios is not the kind of project you can just wait for the time to get around to it. You will be rushing around at the last minute every time you need a portfolio. That does not work! It should be treated like a real assignment and be given the proper budget, time, energy, and attention.

WHAT YOU SHOW

You have certainly heard that you get what you show in your portfolio. So, first you must look at the work you want to get. What kind of work do you want to do more of? Be specific as to the marketing message (style, subject, industry, use of the images) and to the type of client (consumer or commercial). Then you can select images and formats for your various portfolios considering both of these factors.

Often, the work you want to do is not the kind of work you have been getting from word of mouth or referrals from friends. Paid jobs may not even show your finest work. Photographers do work with budget or creative restrictions that keep them from doing the images they would be most proud to show. Basic rule is don't show this work! Never include a piece in your portfolio just because you got paid. It must reflect your best work and your passion for photography.

What if you don't have the images you want to show in your portfolios? What if you are making a transition and looking for different types of assignments or just starting out? What about the client that says, "But I want someone who has experience!" Your problem is the classic dilemma, "How do you get a job without experience when it takes experience to get the job?"

The answer is self-assignments. People hire you as a creative professional because of what you can do, not necessarily what you have done. So your portfolio work at this step is to pull out images from your portfolio that don't meet your marketing message and your highest level of creativity and technical ability. Retire them back into the body of work somewhere. Once that is done (be merciless), you can more clearly see where the holes are in your portfolios that need to be filled with self-assignments.

For example, if you want to do more annual reports, you need to create self-assignments built around the problems and solutions you would find in an annual report assignment. If you want to do more fashion assignments, select a fashion product and produce a portfolio of images to promote it. Self-assignment work is not always the same as personal work. Self-assignments must have a client in mind, with a problem/solution scenario. Personal work is just that, created for you. To come up with your self-assignments, either work with a client that can supply ideas, or collect samples of the kind of work you want to do. Then create your self-assignments from this "ideas file." Be careful of copyright violations! When looking at someone else's work, think in terms of adapting the idea with your own visual solution, not adopting their solution.

For further assistance, try checking with your local professional photography associations. Many of them sponsor annual "portfolio reviews," where you can get your photography portfolio critiqued and evaluated by reps or photography clients. Not being an official sales presentation, this review can be the most honest and open source of feedback you can find.

HOW YOU SHOW IT—COMMERCIAL PORTFOLIOS

Consider the target client. What format are they most familiar with? Don't format your portfolio and then decide on your target client. Target your client first, *and then* format your portfolio. This is not just about what you want to show; it is about what the client wants to see. The target client will influence both the format and the presentation.

How many different portfolio formats will you need for your target markets? Depending on what you are selling and whom you are selling your photography services to, you could create as many as four different portfolio formats. Keep in mind that any of these formats can be presented as any type—traditional print or transparency, or as a digitally produced format, such as a CD-ROM or Web site.

First, the "show" portfolio is your personal portfolio that goes with you to all your client presentations. Traditionally, this is the beautiful custom case you save to show in person. It does not get shipped out for clients to view. Many photographers have changed over to using their traveling portfolios instead, as they are making fewer in-person presentations.

Second, when you send a portfolio to an out-of-town client, you will need a "travel" portfolio. It is a duplicate of all the content in the "show" portfolio, but these "travel" portfolios are usually smaller and lighter for easy and less expensive shipping.

Third, sometimes a local client will ask that you "drop off" a portfolio, so they can easily evaluate whether they want to see you and the full "show" portfolio. This "drop-off book" is a partial portfolio designed to only give the client an idea of what you can do. It should take a small number of images (perhaps five or six) of images to help them make this decision, and the work should be bound into some kind of book so that nothing gets lost.

Fourth, many clients need a "mini-portfolio" of more than one or two promo pieces or mailers to remember what you do as a photographer and why they should hire you. They use this "mini-portfolio" so that they can keep you on file or to present your work to other people when you are not around. You can use this portfolio format to produce a distinctive combination of concept, design, copy, and photography, so that it becomes a unique piece for the client—or you can keep it simple. Most photographers start off with a simple presentation folder (with a logo on the cover) that holds a number of samples and printed promotional material and a business card that is easy for the client to keep on file. You can always get creative later!

WEDDING AND PORTRAIT PORTFOLIOS

Portfolios for consumer (wedding and portrait) clients are presented in the form most familiar to them—the album, but there is more to a successful consumer portfolio than your choice of album style. Many consumer photographers now combine traditional and digital portfolio presentations. The CD you make with special software for creating a portrait session album or wedding album is very popular with consumers and especially simple to ship to out-of-town clients for presentation or even for print sales.

For weddings, as the albums are most often the finished product, you should show two different albums. One album shows different people, locations, and poses, and a second album shows an entire wedding from start to finish.

You will also need to show prints, another important consumer photography sale item. Use the PPA standard competition format, 16 x 20 prints mounted on triple-weight art board. They have a great impact and are small enough to carry in a nice case for presentations at the client's home or office.

STEPS TO SHOWING YOUR PORTFOLIO

No matter how great you are as a photographer, at some point you have to talk to people. To get portfolio appointments, close a sale, follow up—all are verbal contacts with your clients you might not feel comfortable doing. You may have the greatest portfolio, promo piece, or direct-mail campaign, but you still have to talk with clients.

Talking to clients should be done with some preparation, because you want to make the best use of your time and their time, get more information about what the clients want, and have the best chance to get the work.

The best preparation for any kind of portfolio-related phone call or client meeting is called "scripting." This is simply a process of writing down the expected interaction between you and your client. You need to do a careful, thorough preparation, just as you would prepare before going out on any photo shoot. Preparing scripts to get portfolio appointments and do follow-up are the most useful portfolio tools you can develop.

Start by writing down the anticipated conversation, as you would like it to go. Be sure to plan for all variations. In other words, no matter what the client's response, you have anticipated your reply. Not only will this technique help you get more out of every call, but you will approach the entire chore of portfolio presentations with more motivation and inspiration. You may even get to like it!

STEPS FOR WRITING SCRIPTS

STEP #1. Open with a brief and specific introduction of your services. First, you get people's attention; then you tell them what you want. For example, "Hello, I am a food photographer and my name is _____. We are interested in the Daily Diner Restaurants account and would like to show our food portfolio to you this week—when would be a good time to come by?"

The first key phrase is "food photographer" and that allows the client to more accurately picture their need for your work than if you had just said, "I am a photographer."

The second key phrase is "when would be a good time," because it gives the client more options in terms of having a conversation than if you had asked the closed question, "May I come and show my portfolio?" (See step 4 below). The easy answer to the closed question is "No," and the client will not take the time to seriously consider your request and their specific photography needs if you ask a closed question.

STEP #2. Find out from your research what the client does or needs, and then decide what portfolio you will talk about. Talk food photography to food clients, portrait photography to portrait clients, corporate photography to corporate clients. What you do as a photographer depends on whom you are talking to. Clients can and will only care about what they need. Anything else is just entertaining them, and that may be fun but not a good use of your time.

STEP #3. Come up with something interesting. After all, you are most likely trying to replace another photographer that the client is already working with and feels secure with. Why should they switch? For example, "When would you like to see our digital background samples?" or "Our style of photography has helped our clients sell more of their products" or "We offer consultations for those clients making the switch to digital capture; when would you like to schedule your consultation?"

STEP #4. Always use open-ended questions that begin with "how," "who," "what," "when," "where," and "why" instead of closed questions that begin with "can," "could," "would," and "do." This will encourage your information gathering, save time, and reduce the rejection that comes with the "NO" you get when you ask a closed question. For example, when you are showing your portfolio, you could ask the following open questions to get information, confirm the information, and verify agreements you have reached:

"How often do you use different photographers?"
"What other photography needs do you have at this time?"
"When will you be looking at portfolios for your upcoming needs?"
"Who else in the office buys this type of photography?"

STEP # 5. Anticipate objections and questions about your services and have very specific information you want to acquire. Please, never hang up the phone without achieving some specific objective. Your objective to build and present your portfolio is to get either an appointment or a piece of information. Successfully accomplishing your objective keeps you motivated to do this day after day. For example, when you want more information from the client, you can ask:

"When would be a good time to check back on that job?"
"How do you feel about a follow-up call in three weeks?"
"What will you be looking for in the bids on that job?"
"Who will have final approval on the photography?"

STEP #6. The most important step and the entire reason you have built a portfolio and contacted this client. It is called the follow-up. The objective of follow-up is to find out what happens next. This step needs a good, strong script for you to get the information; you need to be in charge. Choose any of the below sample follow-up questions when you conclude the portfolio presentation or any contact with your clients. You want to always be the one in charge of the follow-up; it is not the client's job.

"When should we get together again?"

"What work would you like to see more of?"

"When should I call you back about that project?"

"How about a call next month?"

"How do you want to keep in touch?"

"When should I send more information on our services?"

IN CONCLUSION

Finally, portfolio scripts do not have to be elaborate, but they do have to be planned ahead and written down with all possible responses (yours and the client's) indicated. It is simply a matter of thinking through what you want to communicate and what you want to learn from the client so you can make the next move. With scripts, you will find your communications and portfolio presentations not only easier, but also more effective.

Don't expect these new techniques to feel comfortable at first. Anything not practiced regularly is quite uncomfortable. You will feel like you are being blunt and too aggressive. The truth is that you are not. What you are actually doing is "pulling" out the information you need to present your portfolio and create the follow-up instead of "pushing" yourself on a client who does not need you.

14 THE WEB SITE AS MARKETING TOOL

by John Kieffer

John Kieffer, author of *The Photographer's Assistant,* is a photographer and writer based in Boulder, Colorado, who spends the majority of his time photographing the natural places of the American West and marketing his and other stock photographers' work through Kieffer Nature Stock.

BESIDES SHOWING YOUR PHOTOGRAPHY, your Web site should be the culmination of lots of soul searching and market research. One of the first things to determine is exactly what you're selling and then who's buying. Are you a budding commercial photographer hoping to work with advertising agencies and graphic designers? Are you going after portrait and wedding jobs? Other important areas to consider are editorial or magazine assignments, selling fine art prints, school portraits, sports, and stock photography. Even though you don't want to be too specialized, there are some broad distinctions in the photo industry. Your average art director or designer isn't going to hire someone showing predominantly wedding or sports photography. Conversely, your general consumer isn't going to feel comfortable hiring a photographer after viewing a series of still lifes or annual report images. If you want to sell stock, call yourself a stock agency and list what subjects you have.

Even though the Internet has a worldwide reach, plan on most of your initial success coming locally. Therefore, design your Web site to appeal to local business. While cities like Los Angeles, Chicago, and New York can support a more specialized photographer, smaller markets will require you to be more of a generalist. You'll also have to get the right people to visit your Web site. It's more practical to market to a local audience than going national.

I suggest that even if your dream is to be a top fashion photographer, don't start out with a specialized Web site. In the beginning, you'll need to find work wherever you can. Plus, you never know how one experience or connection can lead to another. Additional photography can be sent to a prospective client via e-mail or downloaded to your Web site. This also provides you with an important second contact.

I began my photographic career in 1987 as a photo assistant and have gone from commercial assignments to running a stock photo agency. Besides learning that photography is a very difficult profession to earn a good living, I've observed that the photographers who have stayed in business over the years are both opportunistic and continuously evolving. They were the first ones to recognize stock and jump into it in its heyday. Others expanded or diversified into selling fine art prints, as film scanners and digital printers made it more practical.

Some honed their computer and graphic design skills, so more of the creative process stayed in their studio. One sure way to expand your skills is to build a Web site.

GENERAL CONSIDERATIONS FOR WEB SITES

Here are some general considerations for creating an effective Web site.

1. The simpler the site is to navigate, the more pleasant it is to use. If it's slow to load photos, and then the user gets lost, you've probably lost that individual for good.

2. Carefully consider the real need for sophisticated graphics and other elements that increase load time, reduce reliability, and possibly subtract from your message. Are you a photographer or Web master? This might be particularly important to wedding and portrait photographers, since your clients may have less powerful computers and slower Internet access, while art directors and graphic designers have more powerful computers, often with high-speed Internet access.

3. Not all photos translate equally to the Web. This is because many photos end up being small and pixelated. Therefore, small photos should have strong graphic elements and good colors. Don't rely on subtle details. Place the 35 mm slide on a light box. If it pops at you, it'll probably do well in a small size. If you need to use a loupe to appreciate it, then it might not work. Try a tight, graphic crop for the thumbnail and then show the entire photo full-screen.

4. Visit other Web sites, both to see how they're designed and to see what kind of photography is shown. Go to a major search engine like Google and type in "photographers." The top listings are the top professional photo organizations. One of the very best is the American Society of Media Photographers (*www.asmp.org*). Also try *www.apanational.org* (Advertising Photographers of America). Once there, you can search for photographers by location and specialty. There are active links directly to members' Web sites. This lets you look at many Web designs, see what established professionals show, and check out your competition.

5. Most computers come bundled with software that can be used for Web applications. Microsoft Publisher is supplied on Windows systems. This easy-to-use program lets you make print brochures and mailers, but there's more. Just about anything you can do in Publisher can be readily placed on your Web site. This is a simple and economical way to get a basic Web site up and running. Macintosh has a similar program called AppleWorks. High-end software programs include Macromedia's Dreamweaver and Flash and Adobe GoLive. Less sophisticated programs are Adobe PageMill, Microsoft FrontPage, and FileMaker Home Page.

6. Have your friends navigate your site, without your help. If they are confused about your message or how to get around, chances are others will be, too.

PLANNING YOUR LAYOUT

The Web offers many advantages, but in some ways the job of showing your photography has gotten bigger. A portfolio might have had ten to twenty carefully chosen photos, beautifully presented to show the kind of photography you've done and what you'd like to do. The Web is great for showing photography, but it also provides the opportunity to convey much more. Consequently, this also means more effort and thought.

There are two basic approaches to building a Web site. You can either do it yourself or hire a Web developer. The more you can do yourself, the better. Besides cost, this experience lets you update your Web site with new photography and text. Plus, learning how to make buttons, writing copy, and experimenting with different fonts and design schemes will broaden your marketable skills. I've come to appreciate how the design process has made me a better photographer. I've had photos that I've liked but found them difficult to work with in a design. I've learned to appreciate a solid blue sky versus one with wonderful clouds. The solid blue lets me use white or black text; plus, I can crop anywhere.

At the beginning design stages, it can be helpful to start on paper. This allows you to do some basic page layout while giving you an overview as to how the Web site flows from one page to the next. Screen resolution is 72 pixels per inch (ppi), and a common screen setting is 1024 pixels wide by 768 high. The smallest size you should encounter is 800 pixels wide by 600 pixels high. These have the same proportions as 8.5 x 11. You can always increase page height and let the viewer scroll down. Have your Home page sized to 1024 x 768 pixels and use the scrolling feature for photo pages. The upper left corner of your Web page will start loading first. Place a logo and some text here, so viewers know they're in the right place, especially if you have a slow-loading Web site.

I've viewed many stock submissions and Web sites, many from photographers with just a few years experience, and have concluded that less is often more. I'd much rather see a handful of excellent photos than be frustrated by wading through what appears to be unedited work. Showing photography that doesn't cut it tells the viewer not only that you have a limited selection and, hence, experience, but also that you aren't a good judge of photography. Try asking yourself, why am I showing this? As you develop a better selection of photography, it can be added to your Web site, or more-specific photos can be e-mailed to a prospective client. Most Web visitors have only so much patience when viewing photography on a slow Web site. I'm often done after about ten to fifteen photos.

PARTS OF YOUR WEB SITE

Care should be taken to make your Web site easy to navigate while clearly showing the viewer what you have to offer. Below are some main parts of most photographic Web sites. To facilitate navigating your site, place links at the bottom of each page to get to major sections. These could be *Home Page, Contact Us, Gallery, About.*

HOME PAGE

The *Home page* has several functions. As the first page of your Web site, it's used to deliver your *marketing message*. This will be done with a combination of photos, the names on your buttons, and descriptive text. Your Home page is also the *epicenter to navigating* your site, by directing viewers to the major sections. If someone gets lost, they often return to your Home page to start over. There are two basic ways to go to another page. You can have a button and a link embedded in text. For instance, to direct someone to your photography section, you might have a button labeled "Portfolio" or "Stock Catalog." You can also include some text with links to the same pages, giving the viewer two ways to get to an important part of your site.

However, the design also determines if *search engines* can find your Web site. Search engines look for text and keywords, not photos. A *title* and *block of text* loaded with carefully selected words will help search engines find you. Web sites are written in HTML (hypertext markup language). Two important portions of the code are <Keywords> and <Title>. Software for Web design will usually have the ability to include words into these two <Head> portions of the code. Many photographers make the mistake of not having text on their Home page and throughout their site. If possible, attach carefully chosen keywords to photos. For instance, a commercial photographer showing a bowl of fruit would do better using the words "still-life photograph" and "studio," while a stock shooter would use "stock photograph," "fruit," "apples," and "agriculture."

Also, having links to other sites moves you up some search lists. I'm often approached by photographers and organizations to exchange links. I'm hesitant because I don't want to send someone away from my site; visitors are hard to come by. And these might be competitors or a listing of other photographers.

Here's something for the technologically adventurous. While at your Web site, open one of these files stored on your computer: Index.html or Default.html. Below is some of the HTML you should see. The lowercase, descriptive words like "nature" and "john kieffer" are our keywords. "Kieffer Nature Stock . . ." are searchable words in our descriptive <TITLE>.

<HEAD>
<META NAME="Keywords" CONTENT="nature, john kieffer, john keefer, john keifer, kns, kieffernaturestock, colorado, american west, stock, images, creative, design, advertising, editorial, publishing, Web, photography, photos, colorado photographers, stock photography, photographs, images, lifestyles, recreation, nature, business, industry">
<TITLE>Kieffer Nature Stock Photographs, Nature, Lifestyles, Recreation, Business for Advertising, Publishing, . . .</TITLE>
<HEAD>

SHOWING YOUR PHOTOGRAPHY

While the Home page can make a great first impression, the heart of your Web site is your photography. On a simpler Web site, this section is often referred

to as a "Portfolio" or "Gallery." However, the number of sections showing photography can vary, depending on how much photography you have to offer or how diverse you want to be. Other photo sections that might be accessed from your Home page could be "Fine Art Prints," "Commercial Assignments," "Weddings," "Portraits," or "Stock Photos." "Commercial Assignments" could be further broken down into subsections, such as "Still-Lifes," "Hi-Tech," "Fashion," "Executive Portraits," "Location," or "Annual Reports."

One of the most common ways to navigate through photography is to first show a collection of related thumbnail photos, like executive portraits. Thumbnails load quickly and give the viewer a choice of photos. When clicked, a larger photo is shown. There is usually a Back button to return to the thumbnails. I make my full-screen photos about 300 x 450 pixels in size. Make sure the photo looks its best. After it's been cropped and sharpened, place it in a background that sets it off. This can be a drop shadow, a frame, or a colored background.

All artwork must be scanned, and scans usually come in file formats, like TIFF and PSD (Photoshop). These are relatively large files, so they are saved as JPEG file formats for use on your Web site or when sent by e-mail. An inexpensive flatbed scanner can handle Web applications and has an advantage of being able to scan both color transparencies (slides) or reflective material (prints). If you don't have a scanner, 35 mm slides are quite economical to have scanned at photo labs. You can get a 20 Mb file (TIFF) for a couple of dollars. This is usually a 2,000 x 3,000 pixel file, large enough to print 7 x 10 inches at 300 dpi (dots per inch). Scans should be in RGB (red, green, blue) color rather than CMYK.

PROTECTING YOUR PHOTOGRAPHY

When your photography goes on the Web, it's there for anyone to take and use. Legally, they must first have permission from you as the copyright owner to use it. However, there are people who are ignorant of copyright law or just ignore it. As you show more and better photography, your concern increases. A few words are in order, at least to educate newer photo users. Here are some things to try:

1. State that this is copyrighted photography and no image can be used without your express written permission, that it's not royalty-free, and it's not in the public domain.

2. Embed an identifying mark into the photo, such as your name, copyright symbol, or caption. I reduce the opacity of our logo and position it in the photo's corner. Don't go overboard; you want your photos to look good.

3. Before showing the photography section, make an intermediate page come up that requires the viewer to agree with a copyright statement.

4. The smaller the photo and the greater the JPEG compression, the lower the image quality to steal.

5. There are Web services that embed information into your photo. This allows the photo to be located on the Internet and, hopefully, catch unauthorized usages.

E-MAIL

Include an e-mail link, so visitors can contact you directly. Many people are more comfortable sending an e-mail than making a phone call. Try to determine if these responses are potential clients, fellow photographers, or just people cruising the Web. You need to be able to qualify these leads and, when appropriate, respond or add them to your database. If you're a commercial photographer, you want the responder to be with a company. An e-mail address of *smith@creativity.com* holds more potential than *cruiser@yahoo.com*. Thank them for visiting your site and, by asking a question, invite further contact. Ask how they found your Web site. This can be particularly important, if you've mailed out a postcard announcing your site, or if you have a Web address with your Yellow Pages listing. Do they hire commercial photographers, and are they located in your area? Would they like to see additional work via e-mail?

E-MAIL ATTACHMENTS

You can e-mail photos to someone by attaching a photo file to a text message. Don't send an unsolicited e-mail with attached files. Opening an attachment from an unknown source is a good way to get a computer virus, so many people don't do it.

1. Begin by writing an e-mail message and state that there's an attached file. In the standard "Write Mail" window there's a button, usually labeled "Attachments."

2. Click the Attachments button and in the next window click "Attach." You'll see the familiar Mac or PC file dialog box.

3. Select the file you want attached to your e-mail.

4. Make sure the file name for your attached file has the proper suffix. For JPEGs *filename.JPG,* and for Photoshop files *filename.PSD.*

5. When you go back to the standard "Write Mail" window, you see a confirmation as to which file was attached.

6. You can send multiple attached files by repeating these steps. Larger files take longer to send and download at their destination.

I really object to receiving a bunch of raw files from photographers. Take the time to crop rough edges and sharpen. Instead of sending five different files or photos, place the five photos in one file. While in Photoshop, use File > New and create a new file. Have it measure about 800 x 1,000 pixels. Next, reduce each scan to about 300 x 450 pixels and drag them into this new file. After you've arranged your photos, add your name, copyright notice, and phone number. Flatten the Photoshop file and save as a JPEG. For more important

responses, you can carry this technique further by designing the space as you would a nice promo piece.

THE "ABOUT" PAGE

This is your opportunity to tell something about you and why the viewer should feel comfortable hiring you. Depending on your experience, this can be an intimidating process. Start by mentioning something about yourself and your type of photography. How long have you been shooting? Did you graduate from a photo school or learn your craft by assisting established local photographers? Let people know if you have a studio and professional lighting equipment or shoot with a digital camera. For those with more experience, provide a list of clients or show some photography from actual assignments in your portfolio. Think of any awards or opportunities you've had to display your work.

Try to tell about any *nonphotographic interests* that help in producing your kind of photos. If you're at the early stages of portrait photography, can you honestly say you're great with kids and then provide an example or experience to back it up? Many people get into photography as a career change. Describe how your past experiences help in your current endeavor. This can also provide something for the viewer to personally identify with you.

Do you have any experience in a particular industry that might give you an edge over other photographers? I've assisted with more than one architectural photographer whose formal education was architecture, not photography. I know a retired military pilot who became an aerial photographer, and I know someone with an athletic background who began as a sports photographer and now gets assignments for *National Geographic.*

The "About" page is a good place to provide contact information. Some people and companies are leery of providing an address on the Web, but I'm leery of companies that don't. Remember, the Web has a global reach, but if you're going after commercial assignments, portrait, or wedding work, you'll be working directly with someone. If you're selling stock photography or fine art prints, then a physical location is less important.

This information can be presented as a paragraph or as a list of bulleted items. If it ends up as a dense paragraph, it's usually easier on the eyes to read black text on a white or very lightly tinted background. You might also try a ghosted photo (reduced opacity) as a background, or integrate some photography with the text.

GETTING VISITORS TO YOUR WEB SITE

Just like a portfolio resting in your studio, your Web site means very little if no one of value sees it. At first, you'll have to rely on your own ability to send people to it rather than hope for clients finding you through a search engine. This means you have to actively go after the business. Traditional marketing approaches can still work. This is usually some form of printed material, but now you'll prominently display your Web address. The new electronic approach

is to make sure your address appears on search engines and to send e-mail (spam) to prospects. Basically, you want to get your Web address wherever and on whatever you can. When it comes to photo credit, I ask to have our Web address follow the photographer's name. We've found photo users very agreeable to this idea. Again, your marketing approach will depend on whom you're trying to reach.

INTERNET ADVERTISING

Several design strategies that enable your site to be found by search engines were presented under the *Home Page* section. Use a search engine like Google or Yahoo and search for *Web + search engines.* This provides you with other search engines and companies offering e-commerce services. You may contact a search engine directly and register your site by following links from their Home page. Other search engines do the job for you, by constantly searching the Web for new sites and automatically adding them to their database. Your position on their list depends on how important they deem your Web site. Search engines will often tell you their criteria for making it higher up their list. There are companies that will increase your standing among the search engines, with a program involving proper keywording and resubmitting your name to search engines every few months. There are hundreds of search engines, so it can be impractical to do the job yourself. These are reasonably priced and worth investigating.

Another way is to send e-mail to prospective clients. Like direct mail, your e-mail must go to qualified people in your location or photographic specialty and it should be repeated every few months. One such database designed for photographers is *www.adbase.com*. Often, a database like this is best for larger metropolitan areas. I've found that even Denver gets little attention when compared to the database I've built over the years. Here, a database directed toward the general consumer might work for portrait and wedding photographers.

ORGANIZATIONS

There are many opportunities to list your Web address, but keep in mind, not just any traffic will do. Most jobs or assignments will come locally, so see what sites might be most used by your community. These can range from your local Better Business Bureau to photo and advertising organizations. Both the local ASMP chapters and national ASMP have valuable Web sites for members (the national Web site is *www.asmp.org*). ASMP has national name recognition to generate traffic and links to members' sites.

Inquire if your photo lab has a Web site. They're often asked for a reference, especially by people who don't hire professional photographers. Such a newcomer can be the perfect client for the relatively inexperienced shooter. Before the Internet, there used to be printed creative directories. These have been replaced by Web sites, such as *www.workbook.com*, which provide you with a free listing and a link to your site.

PRINTED MATERIAL

Mailing a *postcard* is a common approach for stock agencies and commercial assignment photographers. When you're announcing your new Web site, make the address a prominent part of the card. Postcards are most often targeted to art directors and graphic designers at ad agencies, to independent graphic design firms, and to companies with in-house departments that produce some form of advertising or internal communications. Postcards can also be effective when sent to photo editors at magazines. I wouldn't expect a postcard to attract much business for wedding or portrait photographers, unless you can get a mailing list for a demographic that you specialize in. Otherwise, the mailing would be prohibitively large for the return.

Even an inexpensive digital printer can make a great-looking promo piece, especially when using a sturdy photo paper. Consider mailing every couple of months to a very qualified audience, and see if you get any bites. Call ad agencies and ask for a *creative list*, a list of their creative staff. Also, try sending it to magazines you'd like to work with.

THE YELLOW PAGES

When I began advertising for commercial assignments, most of my budget went for a page or two in an expensive creative directory. Like most photographers, I had only a simple listing in the telephone Yellow Pages. Although I am now in the stock business, I'm getting more and more success through the Yellow Pages. I feel this is because, with the advent of desktop publishing, smaller businesses need photography of all kinds. Plus, we list our Web address. Potential clients go directly to our Web site, then call us. Checking the Denver 2003 Yellow Pages, I see very few commercial and stock photographers listing their Web address. I think this is a big mistake, and a Web listing could prove especially valuable for beginning photographers.

© JOHN KIEFFER 2003

NEGOTIATING CONTRACTS AND PRICES

15 NEGOTIATING CONTRACTS

by Richard Weisgrau

Richard Weisgrau followed his twenty years as a professional photographer by holding the post of executive director of ASMP, American Society of Media Photographers. He has written and lectured on many topics of the photography business with a strong specialty in negotiating.

YOU CAN'T BE IN BUSINESS without sooner or later being handed a contract to sign. It might be a contract to purchase goods or services or, even more likely, to provide them. Regardless of which it is, there is never any reason to assume that a contract is ready to be signed the second it is presented for your signature. In spite of that fact, many businesspeople are all too ready to sign on the bottom line without a critical examination of the contract and discussion of its terms, and without negotiating those terms to arrive at a more acceptable agreement. There seems to be an instinctive belief that a contract is a take-it-or-leave-it offer, and no negotiation is possible. The simple fact is that there are few contracts written that are not negotiable. The few that do exist are usually products of a negotiation that preceded the drafting of the contract. So let's learn how to negotiate a contract so that you have a say in the terms of what you are being asked to agree to.

DEVELOPING EXPERTISE IN CONTRACTS

Developing expertise in contract negotiating takes four things. First, you have to know what a contract is and is not. Expertise means specific knowledge, and you get that by study. Second, you have to have an understanding of language. You do not have to have the word skills of a writer, let alone a lawyer, but you do have to have a reasonable grasp on the language of the contract. If you don't have that, then get help before you try to negotiate. Third, you have to know the tactical means of negotiating. By that I mean knowing how to explain why your counterpart's demands are unacceptable and how to offer alternatives that are acceptable. If all you do is reject without offering alternatives, you are simply refusing and not negotiating. Fourth, you have to learn to keep the issue in perspective. Contracts are not enforceable until the parties sign them. There is no liability in negotiating. There may be some, if you do not.

WHAT IS A CONTRACT?

What is a contract? From a business perspective, a contract is a mutual understanding. Legally, a contract is an enforceable agreement. "Enforceable" is the keyword. We can enter into many agreements in life, but most of them are not

enforceable. Here's an example. A client asks you to do some work for him. His budget is low, and your price is high. He asks you for a price reduction on the work, and he says that he will make it up to you on the next job you do for him. You agree and give him the discounted price that he is looking for. A few weeks go by, and he calls you with the next job he has. Does he have to provide you with that extra payment he promised? No, he does not, because the agreement that you made with him is not an enforceable agreement. In short, it is not a contract. He made you an offer, and you accepted it, but the deal lacked one critical component, consideration. Consideration is something of value that the parties exchange to support the offer and acceptance made in the course of the deal. All your client did was to conditionally promise you a better deal. You accepted the promise. Both of you agreed, but you did not form a contract. A contract must have three things: offer, acceptance, and consideration. When all three are present, there is an enforceable agreement, a contract, on the table.

Contracts can be either written or spoken. Spoken contracts are sometimes referred to as "verbal" or "oral." Let's call the spoken contract "oral," since all contracts consist of words, the meaning of "verbal." While the principles of negotiating are applied to both written and oral contracts, if you are going to go to the trouble of negotiating a contract, you ought to have it written down when you are done. Bad memories of oral contract terms have probably led to more avoidable business disputes than any other cause. Avoid oral agreements in business. They are generally worthless in any subsequent dispute. That is why your client often presents you with a contract to sign when offering you work.

NEGOTIATING A CONTRACT
Negotiating a contract requires three important first steps. Skipping any one of these is almost a guarantee of failure. When you receive a contract, it is wise to make at least one photocopy of it. This is an editing copy. It allows you to mark up the contract with notes, crossouts, and additions without making the original unusable. Once that is done, you are ready to take the first three steps.

Step one is reading the proposed contract. I say "proposed," because it is not a contract until you agree to it. You are reading an offer from your client. Keep that mind-set. It is an offer, not a decree. As you read the document, make pencil notes on your photocopy. A few key words to jog your memory on what came to mind as you read that section will usually do. I also like to use a yellow highlighter to mark the parts that I know I will want to negotiate. Usually, those deal with fees, rights, and liability. I underline in red any word that I do not understand. There are many words in the dictionary, and, if the person who drafted the contract used words that you do not understand, you cannot have a "mutual understanding" until you understand those words.

Keep a dictionary at hand. Look up any word for which you do not have a clear understanding of the meaning. Misinterpretation of the meaning of a word can often lead to future problems, and sometimes those problems end up in the courtroom at great expense to the parties. One example of how a definition can

mean so much can be demonstrated by the word "advertising." A photographer signed a contract granting "advertising rights" to a client. The client placed ads in magazines and printed brochures to sell its product. The photographer protested the brochure use, claiming it to be promotional, not advertising, use. The case went to court. The photographer lost the case. The judge relied on the dictionary definition of the word "advertising," which is "the act of calling something to the public's attention." The judge said that the magazine ads and the brochures fit the definition perfectly. The judge rejected the photographer's argument that photographers had a different understanding of the word. He said people relied on dictionaries for meanings and not on photographers' interpretations. The lesson learned is to keep a dictionary nearby. A broadly defined word is exactly that. If you don't want to accept broad interpretations, then don't accept broadly defined words. Specifics are better than generalities in contracts.

Once you have edited the contract, you are ready to move on to step two. First, write down any words that are underlined in red. Then write the dictionary definition of the word next to it. You will refer to this list later on. Review your editing copy and make a list of each problematic clause in the same order as they appear in the contract. These should be highlighted in yellow and easy to find. Then think about possible alternatives to the clauses that you have listed. Maybe it means adding words, or deleting them. You might have to rewrite the entire clause. In the end, you should end up with a clause that you want to substitute in place of the one offered. These newly constructed clauses will be your counteroffer. Make sure that you have them spelled out exactly, word for word. You do not want to be formulating your position in your head in the middle of the negotiation, unless you have no alternative. Then make some notes about why you can't accept the clause as offered. A good negotiator has a reason for rejecting any word, clause, or contract, and at the same time has an alternative to offer. As a final step in this process, you should also write down the minimum you will accept for each of the clauses in dispute. This is what negotiators call the "bottom line." It is the point beyond which you refuse to concede. If you have no bottom line, there was no reason to begin the negotiation. Having no bottom line ultimately means that you will likely be accepting the offer as made to you in the first place.

So far, you have evaluated the offer and come up with a counteroffer. Now it is time to move on to step three, negotiating the contract. It is time to talk to your counterpart. Simple negotiations can often be handled with a brief phone call. Complex ones often require an exchange of written drafts commingled with phone calls to discuss the reasoning behind positions. Note that I said "reasoning." Negotiation is more about reasons that make sense than it is about power. You should never do something that does not make sense for you. Nor should your counterpart. A meeting of the minds results in a mutual understanding when the parties are reasonable. You cannot negotiate with an unreasonable party, and there are such people and companies. Sometimes, if the

situation permits, you will want to negotiate face to face. It is amazing how much more reasonable people can be when you can look them in the eye. By nature, most people want to be "seen" as "reasonable." I did not write the words "heard as reasonable." The most difficult negotiations are best handled face to face when the situation permits, because most people want to be "seen" as reasonable.

USING NEGOTIATION SKILLS

Once you have made the contact, it is time for you to employ your tactical negotiation skills. These skills can be learned by study and developed by practice. No one starts out as an expert. It takes time, trial, and (yes) error. Nobody scores 100 percent. Some people seem to think that negotiating is a mystical skill possessed by only a few who were given the gift. In fact, negotiating is something that most of us do regularly without even realizing it. A friend or spouse proposes dinner and a stage show for a night out. That is a sizeable bite of your budget. You suggest dinner and a movie as more affordable. Your counterpart really wants to see the stage show. You offer an alternative of a stage show and late-night snack. Agreed! You have just completed a successful negotiation. Negotiation is a process of reaching a meeting of the minds by exploring alternatives in an effort to resolve differences of opinion or position. When you apply that definition, you realize that even three-year-olds can negotiate, as parents learn this early on. If a three-year-old can do it, so can you. The advantage that they have is that they have not been intimidated by the mystique that has been built up about the process.

Successful negotiation requires common sense and an ability to set a "bottom line," the point beyond which you will not go. That line will usually be one of value. You won't take less than X amount for Y level of performance. You can become a better negotiator if you take some time to learn the principles of negotiating and the tactics used by expert negotiators. While common sense and a bottom line should protect you from making a bad deal for yourself, tactical knowledge will help you make a better deal. There are dozens of books on the topic of negotiating, but, if you want the basic course in negotiating for a photographer, you should read chapter 4 of the *ASMP Professional Business Practices in Photography* book. Titled "Negotiating Fees and Agreements," the chapter is a basic instructional manual to guide the photographer through the process of becoming a good negotiator. Oh, I almost forgot—I wrote it. Here are a few of the more useful tactics that negotiators use.

1. Asking the question *why* is a good tactic to use when you are concerned about an unreasonable demand. It can lead to one of two things. The other party explains why, and that helps you understand the objectives and frame an alternative to meet them. Or, they fail to be able to explain their reasons, and it becomes more difficult for them to hold on to an inexplicable position.

2. The red herring is a less important point at issue to which you assign a higher value in order to have it later when you need it. When negotiating, you often need to have something to concede, or trade, in order to match a concession by the other person. You trade the red herring. Maybe you ask for an advance on fees, knowing full well that you will not get it. Later, as you discuss expenses, you ask for an advance on them because they will be very high. Your counterpart balks. You reply that he is asking you to bankroll his work, which is like asking you to be a lender without interest, and your cash flow is important to you. You then offer to drop the demand for the advance on fees, if you get the advance on expenses. He wants to move the bigger obstacle off the table and agrees. You have just traded off your red herring for something that you wanted.

3. Silence, intentionally remaining quiet, is an important tactic of the successful negotiator. Listening is an art. You can't listen while you're talking. The person who asks a question and waits for an answer is in control. If they listen to the answer, the opportunity will arise to develop an option. Or, the silence will often compel your counterpart to keep talking. That can lead to new openings in a stalled dialogue. One time that you should always be silent is immediately after asking why. Do not explain the reason for asking *why*. You do not have to justify a perfectly reasonable question. The question *why* is always appropriate when you are trying to reach an understanding. It can often lead to a very productive dialogue.

4. Flinching is using a visual sign to let the other person know in a nonverbal way that you can't really accept what you are hearing. It can be unnerving to the other party. Think of it as a psychological tactic. Needless to say, a visual tactic can only be used in a face-to-face meeting. A flinch can be as simple as shaking your head from side to side just a tiny bit as someone is saying something that you know you will reject. It telegraphs the word "no" before he has all the words out of his mouth, but you never interrupted him. Never interrupt the other person. It is too adversarial and counterproductive. When your counterpart sees "no" as he is speaking, it has a way of putting him off balance. Maybe he will then be a bit more flexible on the point he is making.

5. The broken-record tactic is simply repeatedly asking for what you want until you get it. While it is unlikely to get you a major concession, it frequently works to get small ones as your counterpart just gives up from being tired of hearing it. One of my favorite broken-record lines was "But I have to have an advance on expenses." I could say it half a dozen times in a negotiation as our dialogue went on to cover the full scope of the agreement.

6. Nibbling is done after you've made the deal. You have completed a successful negotiation. Then you come back at the person and ask for one more point. If you don't get it, you have not undone the deal. If you do, you have expanded the deal. Let's say that you have wrapped up everything required to meet your bottom line. The deal is done, for all intents and

purposes. Then you nibble. You float the example in the "trial balloon" tactic below. If you get what you asked for, you have successfully "nibbled" a bit more for yourself.

7. The trial balloon is an excellent tactic. It is framed as a question. For example, "What would you say if I needed a $5,000 advance?" You haven't made a demand. You have tested the waters. If you get an answer like "Out of the question," you can drop the item, but if you get one like "I'd consider it," you can put it on the table for discussion.

8. Be direct in your statements. If you don't like what they offer, and you have an option, tell them. Say, "No, I can't accept that. Let me offer this as an alternative." Don't use three sentences to say "no." Just say "no" and offer your alternative.

9. When negotiating a contract, you will have to agree on each clause in dispute. Resolve the easiest ones first. This sets a tone for future agreement, and the word "yes" is easier to get if it's part of a pattern of "yeses." Prove that the two of you can agree on the easy ones, so it will be easier to reach agreement on the difficult ones.

If you have taken some time to understand the principles, psychology, and tactics of negotiating, you will soon find that negotiating a contract is simpler than you thought.

© Richard Weisgrau 2003

CHAPTER 16 CONTRACT FORMS

The contracts in this chapter are reproduced by permission from *Business and Legal Forms for Photographers* by Tad Crawford. *Business and Legal Forms for Photographers* has a large number of forms, all on CD-ROM for ease of use, as well as explanatory text and negotiation checklists. The forms selected for this chapter meet the basic needs of commercial photographers, wedding and portrait photographers, and fine art photographers.

THIS CHAPTER HAS THE BASIC CONTRACT FORMS you need to get started, whether you are a commercial photographer, wedding or portrait photographer, or fine art photographer. While the needs of the disciplines differ, the photographer must always balance what the client needs against what the photographer is willing to give. This may be an issue of reproduction rights or of ownership of physical objects, such as prints.

ASSIGNMENT ESTIMATE/CONFIRMATION/INVOICE

Designed for the commercial photographer, this form serves multiple purposes. If the box for estimate is checked, then the form is an estimate by which the photographer seeks to obtain an assignment. If the box for confirmation is checked, then the form is the contract under which the assignment will be done. And if the box for invoice is checked, the form is the billing for an assignment that has been completed. Reviewing the terms of the form gives you a checklist that you can also use to evaluate forms offered to you by clients.

To begin, the assignment must be described with clarity. Otherwise, it will be impossible to establish a fair fee and estimate expenses. The grant of rights should be large enough to let the client do what it wants, but no larger. If the client wants to exceed the initial grant of rights, then another negotiation can determine a reasonable fee for the reuse. Whether the photographer shall receive credit, and the placement of the credit, is important, especially in editorial work where such credit is expected. The timing of payment bears on the photographer's cash flow. Expenses, a markup for expenses if agreed to, and the photographer's fees all have to be detailed.

The Terms and Conditions on the reverse of the form are not only favorable to the photographer, but also list many of the terms the photographer should seek in this type of contract. The time for payment, advances (especially against expenses), reservation of any rights not granted, and the right to an additional fee if usage is to be made beyond the rights granted are all spelled out. If the form is used as an estimate, expenses can vary by as much as 10 percent. Reshoots and cancellations are also covered. Instead of putting the whole

burden for releases on the photographer, the client also takes a certain amount of responsibility. The right to samples of the client's finished piece is included. Also, the photographer is given the right to assign money owed to the photographer, but neither party can assign other duties under the contract. For speedier and less expensive dispute resolution, the contract specifies that the parties will arbitrate disputes in excess of the maximum claim that can be pursued in the local small claims court.

The Miscellany provision of the contract is boilerplate, common provisions that appear in most contracts. This doesn't mean such provisions are unimportant. For example, the Miscellany provides that the contract is binding on the parties' successors-in-interest; that it is the entire understanding between the parties and can only be modified in writing, except that the client may authorize additional fees or expenses orally; and that waiving a breach of one provision of the contract doesn't waive future breaches of that provision or other provisions. Which state's laws will govern the contract should be inserted in this provision, which can be significant if the laws vary between states.

WEDDING PHOTOGRAPHY CONTRACT

This contract can be easily adapted to serve as a portrait contract. Because the wedding or portrait photographer is selling to consumers who are novices with respect to buying photography, it is important that the contract be easy to understand. The contract has to resolve who is making the contract with the photographer. Is it the bride? The couple? One set or the other of the parents? What shots will be taken of what groupings in what locales? What style will the photographer use? Is there a checklist of must-have shots?

Setting the fee has to be done in such a way that no disputes arise later on. One approach is a package fee that covers the photographer's time and expenses as well as the cost of a certain number of photographs (perhaps in an album). The other approach is to charge a sitting or session fee, but not require the purchase of additional prints. In either approach the purchase of additional prints would be based on the photographer's standard price list. The contract should also deal with the possibility of additional time for work in Photoshop, the need for a reshoot, cancellation, and similar contingencies.

Dealing with consumers is not like dealing with businesses. You want to be certain that you will be paid. A deposit, perhaps half the total, is a good safeguard against nonpayment. The balance of the fee can be paid at the time of the wedding or when the order for photographs is filled.

The copyright in the photographs will belong to the photographer—a fact that will surprise many clients. The contract is a good place to determine what the photographer can do with the photographs in terms of advertising, portfolio, or promotional use.

The photographer needs protection against certain risks, such as camera malfunction or loss of the film by a lab. An arbitration clause is probably wise

to include, so both parties can resolve disputes in a speedy and relatively inexpensive manner.

Again, the provisions of the contract serve as a checklist to help you develop a form that will suit the special circumstances of your photographic specialty and clientele.

CONTRACT FOR THE SALE OF FINE ART PHOTOGRAPHY

The fine art photographer will exhibit in galleries and earn income through the sale of physical artworks, although some images may also be licensed and earn royalties. Because photographs can be reproduced over and over, the photographer has to create a system to ensure collectors that they are buying either unique or limited-edition works. The contract deals with this issue by having the photographer give a warranty—a statement on which the buyer can place reliance and recover damages if the statement is false—to the effect that the work is unique or part of a limited edition (in which case the nature of the edition is described). The artwork is described, including whether or not the photographer has signed the work (which adds to its value).

The contract details the sale, the price, the manner of delivery (including insurance), when the risk of loss shifts from the photographer to the collector, the reservation of copyright by the photographer, and the usual Miscellany provision.

However, there are other provisions that can be added to this contract of sale. In part, these provisions mimic the moral rights and droit de suite created under foreign laws, which give an artist the right to be acknowledged as the creator of his or her work, the right to maintain the integrity of the work as created, and the right to a small percentage of resale proceeds when the work is sold under certain conditions. Contractual attempts to achieve these outcomes might include a provision for nondestruction of the work, for integrity and attribution, a right to borrow for purposes of exhibition, a right to restore the work if damaged, and a right to a portion of resale proceeds. The artist might also want a security interest in the artwork until such time as payment is made in full. With proper filings of UCC Form 1, this would protect the artist against creditors of the collector seizing the artwork in the event of the collector's bankruptcy. While those who pursue the fine arts might hope to escape the mundane tussle of business, it is impossible once the artworks go into the world (and often before), so knowledge and preparation are likely to be the better part of valor.

DELIVERY MEMO

The photographer will often want to leave a print, transparency, or digital-storage medium with someone else. Particularly when the object left has great value or is unique, the photographer will have to make certain that the party holding it accepts liability and that a suitable amount of damages is specified in

the event of loss. This is the purpose of the Delivery Memo, which can be used to deliver images to a lab, a gallery, a client, or a stock agency.

The Delivery Memo creates a contract between the photographer and party receiving the images. The copyright and reproduction rights are stated to belong to the photographer, so that no confusion can arise and no illicit reproductions will be made. The recipient agrees to a high standard of care for the images, and the parties agree as to when the recipient responsibility will commence. In addition, the Delivery Memo specifies whether or not the recipient will insure the images. If the images are held longer than a certain time period, it is agreed that a holding fee will be paid. Arbitration and a Miscellany provision complete the Delivery Memo.

You should not give images to another party without having a Delivery Memo signed. Otherwise, in the event of loss or damage, you may find yourself in an unanticipated dispute without clear guidelines as to the level of the recipient's responsibility for the images.

LICENSE OF RIGHTS

The License of Rights covers a situation in which the photographer has already created a work in which he or she owns the copyright and now is approached to license a certain usage to another party. The key provision here is the grant of rights, which refines exactly which usage rights are granted and which are retained. This form does not grant any electronic rights, such as the right to use the image on a Web site or a CD-ROM.

Other important provisions include the fee, a prohibition against alteration, a time for payment, how loss or damage will be handled, samples, copyright notice, authorship credit, releases, arbitration, and miscellany. A form such as this one aids the photographer in maximizing income from residual uses of an image beyond the initial use for which the image was created.

Assignment Estimate/Confirmation/Invoice

Client _____ Date_____

Address _____ ❏ Estimate

_____ ❏ Confirmation

Client Purchase Order Number_____ ❏ Invoice

Client Contact _____ Job Number_____

Assignment Description _____

_____Due Date _____

Grant of Rights. Upon receipt of full payment, Photographer shall grant to the Client the following exclusive rights:

For use as _____

For the product, project, or publication named _____

In the following territory _____

For the following time period or number of uses_____

Other limitations_____

This grant of rights does not include electronic rights, unless specified to the contrary here_____

in which event the usage restrictions shown above shall be applicable. For purposes of this agreement, electronic rights are defined as rights in the digitized form of works that can be encoded, stored, and retrieved from such media as computer disks, CD-ROM, computer databases, and network servers.

Credit. The Photographer ❏ shall ❏ shall not

receive adjacent credit in the following form on reproduction _____

Fee/Expenses. The Client shall pay the Balance Due, including reimbursement of the expenses as shown below, within thirty days of receipt of an invoice. A reuse fee of $_____ shall be paid in the following circumstances:_____

Expenses		Fees	
Assistants	$_____	Photography fee	$_____
Casting	$_____	Other fees	
Crews/Special Technicians	$_____	Preproduction $_____/day;	$_____
Equipment Rentals	$_____	Travel $_____/day;	$_____
Film and Processing	$_____	Weather days $_____/day	$_____
Insurance	$_____	Space or Use Rate (if applicable)	$_____
Location	$_____	Cancellation fee	$_____
Messengers	$_____	Reshoot fee	$_____
Models	$_____	Fee subtotal $_____	
Props/Wardrobe	$_____	Plus total expenses $_____	
Sets	$_____	Subtotal $_____	
Shipping	$_____	Sales tax $_____	
Styling	$_____	**Total $_____**	
Travel/Transportation	$_____	Less advances $_____	
Telephone	$_____	**Balance due $_____**	
Other expenses	$_____		
subtotal $_____			
(Plus ____% markup) $_____			
Total expenses $_____			

Client_____
 Company Name

Photographer_____ By_____
 Authorized Signatory, Title

Subject to All Terms and Conditions Above and on Reverse Side

Assignment Estimate/Confirmation/Invoice (Continued)

Terms and Conditions

1. **Payment.** Client shall pay the Photographer within thirty days of the date of Photographer's billing, which shall be dated as of the date of delivery of the Assignment. The Client shall be responsible for and pay any sales tax due. Time is of the essence with respect to payment. Overdue payments shall be subject to interest charges of _____ percent monthly.
2. **Advances.** Prior to Photographer's commencing the Assignment, Client shall pay Photographer the advance shown on the front of this form, which advance shall be applied against the total due.
3. **Reservation of Rights.** Unless specified to the contrary on the front of this form any grant of rights shall be limited to the United States for a period of one year from the date of the invoice and, if the grant is for magazine usage, shall be first North American serial rights only. All rights not expressly granted shall be reserved to the Photographer, including but not limited to all copyrights and ownership rights in photographic materials, which shall include but not be limited to transparencies, negatives, and prints. Client shall not modify directly or indirectly any of the photographic materials, whether by digitized encodations or any other form or process now in existence or which may come into being in the future, without the express, written consent of the Photographer.
4. **Value and Return of Originals.** All photographic materials shall be returned to the Photographer by registered mail or bonded courier (which provides proof of receipt) within thirty days of the Client's completing its use thereof and, in any event, within _____ days of Client's receipt thereof. Time is of the essence with respect to the return of photographic materials. Unless a value is specified for a particular image either on the front of this form or on a Delivery Memo given to the Client by the Photographer, the parties agree that a reasonable value for an original transparency is $1,500. Client agrees to be solely responsible for and act as an insurer with respect to loss, theft, or damage of any image from the time of its shipment by Photographer to Client until the time of return receipt by Photographer.
5. **Additional Usage.** If Client wishes to make any additional uses, Client shall seek permission from the Photographer and pay an additional fee to be agreed upon.
6. **Authorship Credit.** Authorship credit in the name of the Photographer, including copyright notice if specified by the Photographer, shall accompany the photograph(s) when it is reproduced, unless specified to the contrary on the front of this form. If required authorship credit is omitted, the parties agree that liquidated damages for the omission shall be three times the invoiced amount.
7. **Expenses.** If this form is being used as an Estimate, all estimates of expenses may vary by as much as ten (10%) percent in accordance with normal trade practices. In addition, the Photographer may bill the Client in excess of the estimates for any overtime which must be paid by the Photographer to assistants and freelance staff for a shoot that runs more than eight (8) consecutive hours.
8. **Reshoots.** If Photographer is required by the Client to reshoot the Assignment, Photographer shall charge in full for additional fees and expenses, unless (a) the reshoot is due to Acts of God or is due to an error by a third party, in which case the Client shall only pay additional expenses but no fees; or (b) if the Photographer is paid in full by the Client, including payment for the expense of special contingency insurance, then Client shall not be charged for any expenses covered by such insurance in the event of a reshoot. The Photographer shall be given the first opportunity to perform any reshoot.
9. **Cancellation.** In the event of cancellation by the Client, the Client shall pay all expenses incurred by the Photographer and, in addition, shall pay the full fee unless notice of cancellation was given at least _____ hours prior to the shooting date, in which case fifty (50%) percent of the fee shall be paid. For weather delays involving shooting on location, Client shall pay the full fee if Photographer is on location and fifty (50%) percent of the fee if Photographer has not yet left for the location.
10. **Releases.** The Client shall indemnify and hold harmless the Photographer against any and all claims, costs, and expenses, including attorney's fees, due to uses for which no release was requested or uses which exceed the uses allowed pursuant to a release.
11. **Samples.** Client shall provide the Photographer with two copies of any authorized usage.
12. **Assignment.** Neither this Agreement nor any rights or obligations hereunder shall be assigned by either of the parties, except that the Photographer shall have the right to assign monies due hereunder. Both Client and any party on whose behalf Client has entered into this Agreement shall be bound by this Agreement and shall be jointly and severally liable for full performance hereunder, including but not limited to payments of monies due to the Photographer.
13. **Arbitration.** All disputes shall be submitted to binding arbitration before _____ in the following location _____ and settled in accordance with the rules of the American Arbitration Association. Judgment upon the arbitration award may be entered in any court having jurisdiction thereof. Disputes in which the amount at issue is less than $_____ shall not be subject to this arbitration provision.
14. **Miscellany.** The terms and conditions of this Agreement shall be binding upon the parties, their heirs, successors, assigns, and personal representatives; this Agreement constitutes the entire understanding between the parties; its terms can be modified only by an instrument in writing signed by both parties, except that the Client may authorize additional fees and expenses orally; a waiver of a breach of any of its provisions shall not be construed as a continuing waiver of other breaches of the same or other provisions hereof; and the relationship between the Client and Photographer shall be governed by the laws of the State of _____.

Wedding Photography Contract

Client_____ Date_____

Address_____ Telephone _____

_____ Order Number_____

Bride's Name_____ Groom's Name_____

Address_____ Address_____

_____ _____

Couple's future address _____

Description of Photographic Services to be Provided

❑ Black and White print for Newspapers ❑ Bride only ❑ Bride and Groom

Number of previews or proofs to be shown to Client ❑ Color _____ ❑ Black and White _____

Locations for Photography ❑ Studio Date_____ Time_____

❑ Home, address_____ Date_____ Time_____

❑ Rehearsal, address_____ Date_____ Time_____

❑ Ceremony, address_____ Date_____ Time_____

❑ Reception, address_____ Date_____ Time_____

Special Services, if required _____

Charges. The package fee is based on the Photographer's Standard Price List and includes the photographs described therein. If the fee is not based on a package but is a session fee, all photographs shall be billed in addition to the fee and in accordance with the Standard Price List. In addition to either the package fee or the session fee, the extra charges set forth below shall be billed if and when incurred.

❑ Package Fee (Package number _____) .. $_____

❑ Fee Without Package... $_____

Extra Charges

Additional prints ... $_____

Resitting... $_____

Special retouching .. $_____

Special finishes.. $_____

Rush service... $_____

Unreturned previews ... $_____

Overtime .. $_____

Travel... $_____

Other _____ $_____

Subtotal $_____

Sales tax $_____

Total Due $_____

Less deposit $_____

Balance Due $_____

The parties have read both the front and back of this Agreement, agree to all its terms, and acknowledge receipt of a complete copy of the Agreement signed by both parties. Each person signing as Client below shall be fully responsible for ensuring that full payment is made pursuant to the terms of this Agreement.

Client _____ Client _____ Client _____

Photographer _____ Date _____

This Agreement is subject to all the terms and conditions appearing on the reverse side.

Wedding Photography Contract (Continued)

Terms and Conditions

1. **Exclusive Photographer.** The Photographer shall be the exclusive photographer retained by the Client for the purpose of photographing the wedding. Family and friends of the Client shall be permitted to photograph the wedding as long as they shall not interfere with the Photographer's duties and do not photograph poses arranged by the Photographer.

2. **Deposit and Payment.** The Client shall make a deposit to retain the Photographer to perform the services specified herein. At such time as this order is completed, the deposit shall be applied to reduce the total cost and Client shall pay the balance due. If the Client refuses delivery of the order or refuses to pay within thirty (30) days of this order, Client shall be in default hereunder and shall pay _____ percent interest on the unpaid balance until payment is made in full.

3. **Cancellation.** If the Client shall cancel this Agreement thirty (30) or more calendar days before the wedding date, any deposit paid to the Photographer shall be refunded in full. If Client shall cancel within thirty days of the wedding date and if the Photographer does not obtain another assignment for that date, liquidated damages shall be charged in a reasonable amount not to exceed the deposit.

4. **Photographic Materials.** All photographic materials, including but not limited to negatives, transparencies, proofs, and previews, shall be the exclusive property of the Photographer. The Photographer shall make proofs and previews available to the Client for the purpose of selecting photographs, but such proofs and previews shall be on loan and, if they are not returned within fourteen (14) days of receipt by the Client, shall be charged to the Client at the same rate as finished prints of the same size. The Photographer may, with the Client's permission, make the proofs available on a Web site or CD-ROM.

5. **Copyright and Reproductions**. The Photographer shall own the copyright in all images created and shall have the exclusive right to make reproductions. The Photographer shall only make reproductions for the Client or for the Photographer's portfolio, samples, self-promotions, entry in photographic contests or art exhibitions, editorial use, or for display within or on the outside of the Photographer's studio. If the Photographer desires to make other uses, the Photographer shall not do so without first obtaining the written permission of the Client.

6. **Client's Usage.** The Client is obtaining prints for personal use only, and shall not sell said prints or authorize any reproductions thereof by parties other than the Photographer. If Client is obtaining a print for newspaper announcement of the wedding, Photographer authorizes Client to reproduce the print in this manner. In such event, Client shall request that the newspaper run a credit for the Photographer adjacent to the photograph, but shall have no liability if the newspaper refuses or omits to do so.

7. **Failure to Perform.** If the Photographer cannot perform this Agreement due to a fire or other casualty, strike, act of God, or other cause beyond the control of the parties, or due to Photographer's illness, then the Photographer shall return the deposit to the Client but shall have no further liability with respect to the Agreement. This limitation on liability shall also apply in the event that photographic materials are damaged in processing, lost through camera malfunction, lost in the mail, or otherwise lost or damaged without fault on the part of the Photographer. In the event the Photographer fails to perform for any other reason, the Photographer shall not be liable for any amount in excess of the retail value of the Client's order.

8. **Photographer.** The Photographer may substitute another photographer to take the photographs in the event of Photographer's illness or of scheduling conflicts. In the event of such substitution, Photographer warrants that the photographer taking the photographs shall be a competent professional.

9. **Inherent Qualities.** Client is aware that color dyes in photography may fade or discolor over time due to the inherent qualities of dyes, and Client releases Photographer from any liability for any claims whatsoever based upon fading or discoloration due to such inherent qualities.

10. **Photographer's Standard Price List.** The charges in this Agreement are based on the Photographer's Standard Price List. This price list is adjusted periodically and future orders shall be charged at the prices in effect at the time when the order is placed.

11. **Client's Originals**. If the Client is providing original prints, negatives, or transparencies owned by the Client to the Photographer for duplication, framing, reference, or any other purpose, in the event of loss or damage the Photographer shall not be liable for an amount in excess of $_____ per image.

12. **Arbitration.** All disputes arising under this Agreement shall be submitted to binding arbitration before _____ in the following location _____ and the arbitration award may be entered for judgment in any court having jurisdiction thereof. Notwithstanding the foregoing, either party may refuse to arbitrate when the dispute is for a sum less than $_____.

13. **Miscellany.** This Agreement incorporates the entire understanding of the parties. Any modifications of this Agreement must be in writing and signed by both parties. Any waiver of a breach or default hereunder shall not be deemed a waiver of a subsequent breach or default of either the same provision or any other provision of this Agreement. This Agreement shall be governed by the laws of the State of _____.

Contract for the Sale of Fine Art Photography

AGREEMENT, entered into as of the _____ day of _____, 20_____, between _____ (hereinafter referred to as the "Photographer"), located at_____

_____, and _____ (hereinafter referred to as the "Collector"),

located at _____, with respect to the sale of an artwork (hereinafter referred to as the "Work").

WHEREAS, the Photographer has created the Work and has full right, title, and interest therein; and

WHEREAS, the Photographer wishes to sell the Work; and

WHEREAS, the Collector has viewed the Work and wishes to purchase it;

NOW, THEREFORE, in consideration of the foregoing premises and the mutual obligations, covenants, and conditions hereinafter set forth, and other valuable considerations, the parties hereto agree as follows:

1. **Description of Work.** The Photographer describes the Work as follows:

 Title _____

 Medium _____

 Size _____

 Framing or Mounting _____

 Year of Creation _____

 Signed by Photographer: ❑ Yes ❑ No

 The Photographer warrants that this work is unique (one of a kind): ❑ Yes ❑ No

 If the Work is part of a limited edition, indicate the method of production _____; the size of the edition_____; how many multiples are signed_____; how many are unsigned_____; how many are numbered_____; how many are unnumbered_____; how many proofs exist_____; the quantity of any prior editions_____; and whether the master image has been cancelled or destroyed ❑ yes ❑ no.

2. **Sale.** The Photographer hereby agrees to sell the Work to the Collector. Title shall pass to the Collector at such time as full payment is received by the Photographer pursuant to Paragraph 4 hereof.

3. **Price.** The Collector agrees to purchase the Work for the agreed upon price of $_____, and shall also pay any applicable sales or transfer taxes.

4. **Payment.** Payment shall be made in full upon the signing of this Agreement.

5. **Delivery.** The ❑ Photographer ❑ Collector shall arrange for delivery to the following location: _____ _____ no later than _____, 20____. The expenses of delivery (including, but not limited to, insurance and transportation) shall be paid by _____.

6. **Risk of Loss and Insurance.** The risk of loss or damage to the Work and the provision of any insurance to cover such loss or damage shall be the responsibility of the Collector from the time of_____ _____.

7. **Copyright and Reproduction.** The Photographer reserves all reproduction rights, including the right to claim statutory copyright, in the Work. The Work may not be photographed, sketched, painted, or reproduced in any manner whatsoever without the express, written consent of the Photographer. All approved reproductions shall bear the following copyright notice: © by (Photographer's name) 20____.

8. **Miscellany.** This Agreement shall be binding upon the parties hereto, their heirs, successors, assigns, and personal representatives. This Agreement constitutes the entire understanding between the parties. Its terms can be modified only by an instrument in writing signed by both parties. A waiver of any breach of any of the provisions of this Agreement shall not be construed as a continuing waiver of other breaches of the same or other provisions hereof. This Agreement shall be governed by the laws of the State of _____.

IN WITNESS WHEREOF, the parties hereto have signed this Agreement as of the date first set forth above.

Photographer _____ Collector _____

Delivery Memo

Recipient _____ Date _____

Address_____ Delivery Memo No. _____

_____ Purchase Order No. _____

Per Request of _____ Telephone _____

Photo Return Due _____ Extension Granted _____

Purpose of Delivery _____

		Format/ Size	Original or Dupe		
___	___	___	___	_____	___
___	___	___	___	_____	___
___	___	___	___	_____	___
___	___	___	___	_____	___
___	___	___	___	_____	___
___	___	___	___	_____	___
___	___	___	___	_____	___
___	___	___	___	_____	___

* Value is in case of loss, theft, or damage.

Total Color_____ Total Black and White_____

Please count all photographs and confirm that the count is accurate by returning one signed copy of this form. If objection is not immediately made by return mail, the Recipient shall be considered to accept the count shown on this form as accurate and that the photographs are of a quality suitable for reproduction.

Acknowledged and Accepted _____ Date_____
<div align="center">Company Name</div>

By _____
<div align="center">Authorized Signatory, Title</div>

Subject to All Terms and Conditions Above and on Reverse Side

Delivery Memo (Continued)

Terms and Conditions

1. **Purpose.** Photographer hereby agrees to entrust the photographs listed on the front of this form to the Recipient for the purpose specified. "Photographs" are defined to include transparencies, prints, negatives, digitized encodings, and any other form in which the images can be stored, incorporated, represented, projected, or perceived, including forms and processes not presently in existence but which may come into being in the future.

2. **Acceptance.** Recipient accepts the listing and values as accurate if not objected to in writing by return mail immediately after receipt of the photographs. If Recipient has not signed this form, any terms on this form not objected to in writing within 10 days shall be deemed accepted.

3. **Ownership and Copyright.** Copyright and all reproduction rights in the photographs, as well as the ownership of the physical photographs themselves, are the property of and reserved to the Photographer. Recipient acknowledges that the photographs shall be held in confidence and agrees not to display, copy, or modify directly or indirectly any of the photographs submitted, nor will Recipient permit any third party to do any of the foregoing. Reproduction, display, sale, or rental shall be allowed only upon Photographer's written permission specifying usage and fees.

4. **Loss, Theft, or Damage.** Recipient agrees to assume full responsibility and be strictly liable for loss, theft, or damage to the photographs from the time of ❏ shipment by the Photographer ❏ receipt by the Recipient until the time of ❏ shipment by the Recipient ❏ receipt by the Photographer. Recipient further agrees to return all of the photographs at its own expense by the following method of transportation: _____. Reimbursement for loss, theft, or damage to a photograph shall be in the amount of the value entered for that photograph. Both Recipient and Photographer agree that the specified values represent the value of the photographs. If no value is entered for an original transparency, the parties agree that a fair and reasonable value is $1,500 (Fifteen Hundred Dollars).

5. **Insurance.** Recipient ❏ does ❏ does not agree to insure the photographs for all risks from the time of shipment from the Photographer until the time of delivery to the Photographer for the values shown on the front of this form.

6. **Holding Fees.** The photographs are to be returned to the Photographer within _____ days after delivery to the Recipient. Each photograph held beyond _____ days from delivery shall incur the following weekly holding fee: $_____ which shall be paid to the Photographer when billed.

7. **Arbitration.** Recipient and Photographer agree to submit all disputes hereunder in excess of $_____ to arbitration before _____ at the following location _____ under the rules of the American Arbitration Association. The arbitrator's award shall be final and judgment may be entered on it in any court having jurisdiction thereof.

8. **Miscellany.** This Agreement contains the full understanding between the parties hereto and may only be modified by a written instrument signed by both parties. It shall be governed by the laws of the State of_____.

License of Rights

AGREEMENT, entered into as of the _____ day of _____, 20 _____, between _____, located at _____ (hereinafter referred to as the "Client") and _____, located at _____ (hereinafter referred to as the "Photographer") with respect to the licensing of certain nonelectronic rights in the Photographer's photograph(s) (hereinafter referred to as the "Work").

1. **Description of Work.** The Client wishes to license certain nonelectronic rights in the Work which the Photographer has created and which is described as follows:

 Title_____Number of images_____

 Subject matter_____

 _____ .

 Form in which work shall be delivered ❏ computer file (specify format _____)

 ❏ original transparency (size _____) ❏ dupe (size _____)

2. **Delivery Date.** The Photographer agrees to deliver the Work within _____ days after the signing of this Agreement.

3. **Grant of Rights.** Upon receipt of full payment, Photographer grants to the Client the following nonelectronic rights in the Work:

 For use as_____in the_____language

 For the product or publication named_____

 In the following territory_____

 For the following time period_____

 With respect to the usage shown above, the Client shall have nonexclusive rights unless specified to the contrary here_____

 If the Work is for use as a contribution to a magazine, the grant of rights shall be for one time North American serial rights only unless specified to the contrary above.
 Other limitations_____

 If the Client does not complete its usage under this Paragraph 3 by the following date_____, all rights granted but not exercised shall without further notice revert to the Photographer without prejudice to the Photographer's right to retain sums previously paid and collect additional sums due.

4. **Reservation of Rights.** All rights not expressly granted hereunder are reserved to the Photographer, including but not limited to all rights in preliminary materials and all electronic rights. For purposes of this agreement, electronic rights are defined as rights in the digitized form of works that can be encoded, stored, and retrieved from such media as computer disks, CD-ROM, computer databases, and network servers.

5. **Fee.** Client agrees to pay the following: ❏ $_____ for the usage rights granted, or ❏ an advance of $_____ to be recouped against royalties computed as follows _____

6. **Additional Usage.** If Client wishes to make any additional uses of the Work, Client agrees to seek permission from the Photographer and make such payments as are agreed to between the parties at that time.

License of Rights (Continued)

7. Alteration. Client shall not make or permit any alterations, whether by adding or removing material from the Work, without the permission of the Photographer. Alterations shall be deemed to include the addition of any illustrations, photographs, sound, text, or computerized effects, unless specified to the contrary here_____

8. Payment. Client agrees to pay the Photographer within thirty days of the date of Photographer's billing, which shall be dated as of the date of delivery of the Work. Overdue payments shall be subject to interest charges of _____ percent monthly.

9. Loss, Theft, or Damage. The ownership of the Work shall remain with the Photographer. Client agrees to assume full responsibility and be strictly liable as an insurer for loss, theft, or damage to the Work and to insure the Work fully from the time of shipment from the Photographer to the Client until the time of return receipt by the Photographer. Client further agrees to return all of the Work at its own expense by registered mail or bonded courier which provides proof of receipt. Reimbursement for loss, theft, or damage to any Work shall be in the following amount:_____
Both Client and Photographer agree that these specified value(s) represent the fair and reasonable value of the Work. Unless the value for an original transparency is specified otherwise in this paragraph, both parties agree that each original transparency has a fair and reasonable value of $1,500 (Fifteen Hundred Dollars). Client agrees to reimburse Photographer for these fair and reasonable values in the event of loss, theft, or damage.

10. Samples. Client shall provide Photographer with _____ samples of the final use of the Work.

11. Copyright Notice. Copyright notice in the name of the Photographer ❏ shall ❏ shall not accompany the Work when it is reproduced.

12. Credit. Credit in the name of the Photographer ❏ shall ❏ shall not accompany the Work when it is reproduced. If the Work is used as a contribution to a magazine or for a book, credit shall be given unless specified to the contrary in the preceding sentence.

13. Releases. The Client agrees to indemnify and hold harmless the Photographer against any and all claims, costs, and expenses, including attorney's fees, due to uses for which no release was requested, uses which exceed the uses allowed pursuant to a release, or uses based on alterations not allowed pursuant to Paragraph 7.

14. Arbitration. All disputes arising under this Agreement shall be submitted to binding arbitration before _____ in the following location _____ and settled in accordance with the rules of the American Arbitration Association. Judgment upon the arbitration award may be entered in any court having jurisdiction thereof. Disputes in which the amount at issue is less than $_____ shall not be subject to this arbitration provision.

15. Miscellany. This Agreement shall be binding upon the parties hereto, their heirs, successors, assigns, and personal representatives. This Agreement constitutes the entire understanding between the parties. Its terms can be modified only by an instrument in writing signed by both parties, except that the Client may authorize expenses or revisions orally. A waiver of a breach of any of the provisions of this Agreement shall not be construed as a continuing waiver of other breaches of the same or other provisions hereof. This Agreement shall be governed by the laws of the State of _____.

In Witness Whereof, the parties hereto have signed this Agreement as of the date first set forth above.

Photographer_____ Client_____
 Company Name

 By:_____
 Authorized Signatory, Title

CHAPTER 17 / PRICING PHOTOGRAPHY

by Michal Heron
and David MacTavish

This chapter is adapted from *Pricing Photography* by Michal Heron and David MacTavish. Michal Heron, a New York–based photographer, works on assignment for editorial and corporate clients, is actively involved in stock photography, and is the author of *How to Shoot Stock Photos That Sell* and *Stock Photography Business Forms*. David MacTavish worked as a photographer for twenty-two years and is now an attorney specializing in intellectual property law—specifically, copyright, art, entertainment, trademark, computer, and Internet law.

IN PRICING PHOTOGRAPHY FOR PUBLICATION, you must always remember that you are rarely "selling" your images. This is true whether the images were made on assignment or are in your stock photography library. Photographers who do portrait and wedding photography make images that are sold to customers and are products. These images are not intended for publication.

If you are a publication photographer, get in the habit of thinking that you are only letting your clients temporarily use your images. You are, in essence, leasing the client temporary use of your work. This is called "licensing," and it is not to be confused with "leasing," "renting," or, especially, "selling." Each of these terms has distinct legal significance, and they do not describe your arrangement with your clients. Always think *licensing!*

WEDDING/PORTRAIT PRICING

If you are in the business of making images for sale to customers, you can nonetheless benefit from considering the factors that go into setting fees for photographers whose goal is publication. Especially the consideration given to overhead, salary, and profit in this chapter are important for all photographers to keep in mind. Studios will usually create price lists for wedding and portrait photography. The prices for wedding photographs will usually be based on a basic package, which includes a certain number of images in an album, and specified charges for additional images or albums. For portrait photography, in addition to charging for prints, there will usually be a basic creative fee for the sitting. As Ed Lilley points out in his book *The Business of Studio Photography*, "Most successful studios use a mixture of the fixed markup, what-the-competition-is-charging, and what-the-market-will-bear techniques." His book should be referred to for its excellent discussion of the special pricing issues facing wedding and portrait photographers.

WHAT ARE WE PRICING?

Publication prices, whether for stock or assignment, are based on general industry assumptions—namely, project budget size (and therefore the value to your client) and the usage rights demanded. These factors directly affect what a client should pay.

In other words, because advertising projects generally have the largest project budgets (and the most potential for realizing profit), larger fees are usually paid. And, if clients want to use a photograph on a billboard, on a package, and as a two-page spread advertisement, they should expect to pay more. But a price must be based on more.

Background

Over the years methods of pricing have developed differently in specific areas of photography. In editorial and corporate work, the day rate was a prominent feature of pricing. In advertising, a creative fee was the norm—with the day rate being incorporated as part of that fee. In recent years a day-rate-only mentality has gained precedence, and photographers have lost sight of the many other factors that affect pricing. It may not be coincidental that photographers have suffered a steady erosion in fees during this time.

Traditionally, photographers based assignment pricing on a "day rate plus expenses" for each billable day. A billable day was usually considered to be any day during which photography actually took place. If there were multiple days, the number was multiplied against the day rate for a total. This approach worked somewhat well for decades, although it didn't accurately reflect the real values of the assignment or the photographer's talents. And it brought about some friction with photo clients.

Too many clients, when confronted with the term "day rate," react negatively, comparing a day rate to the eight or so hours *they* toil daily. Because of the simplistic (and, therefore, deficient) "day rate" concept, clients expect to pay only for actual photography days. Worse, they probably don't realize that you may have fewer than one hundred billable days per year. Because they don't understand, clients may compare the amount that they make each day, possibly $100 to $300 per day, to the hundreds and perhaps thousands you may charge on a day rate basis. "Why," they may ask themselves, "should I pay this photographer so much for taking a few photographs?" Clients can't be expected to know that each billable day you work for them will take several additional days for preproduction and possibly another for editing, preparing the photographs for delivery, and so on. And they probably aren't aware that your fee goes to help pay for overhead items like insurance, health coverage, and the many benefits they take for granted as employees.

Conceived during the heyday of magazine photojournalism, the concept of "day rate," in today's marketplace, is philosophically and financially unwise. Do yourself and your client a big favor: quote a "creative fee" for the assignment and *not* a "day rate."

A creative fee encompasses much more than the simplistic day rate and consists of overhead (what it costs you to be in business each billable day), a profit (usually expressed as a percentage of overhead), and, based on the particular assignment, other relevant factors of value (like time, experience, hazards, value to the client, and so on). The grand total will be your creative fee. (Note: Expenses related to the assignment are not included within the creative fee but are usually listed as separate items.)

At first glance, it may seem easier to use the concept of day rate, since it is easily quantifiable and understandable, especially if you are inexperienced or if your authority over an assignment is limited. What if you incorrectly calculated, and additional time is required to complete the assignment? some may ask. If you estimate by using a creative fee, their reasoning goes, you might find yourself working extra days without pay. The simple solution is to note in your estimate or bid that "the creative fee assumes a specific time period . . . ," a range within which you feel you can do the photography, possibly one you've already agreed to based on discussions with your client. "Should extra time be required . . . ," your terms and conditions continue, not of your own causing, you "will have to revise the creative fee accordingly."

You will find clients commonly asking for your day rate. Don't be trapped. It's best to tell them that quoting a day rate is not the way you work because you price by the job, and quoting a rate is impossible without knowing all the factors of a job. Why not say, instead, "If you care to tell me about an assignment you recently did, or an upcoming one, I'll be glad to give you an idea of what I would charge." This approach has two benefits: Not only are you able to offer a more accurate idea of price; you also have the client involving you in discussions directly related to assignments.

Day Rate versus Shooting Time

In the seminars given around the country by the authors of this chapter, the most difficult concept in pricing seems to be relating the day rate vis-à-vis accounting for time spent shooting on an assignment. How can this be reconciled? If not through a day rate, how can we be sure our time is covered? Simple—photography shooting time is well accounted for under the umbrella of the creative fee. But, instead of being expressed in a flat fee, time expressed within a creative fee is calculated in a way that relates to your cost of being in business. The day rate, despite everyone's best intentions, becomes a flat fee when a client asks your day rate and forever categorizes you by that number. No longer can you account for the many factors that may affect a price—your day rate becomes permanently fixed, regardless of the type of assignment and the rights that are requested. Later, we will dissect the creative fee and show how to use your own costs to build a creative fee tailored to your business. For now, remember that time spent is *not* a day rate; time must be a factor in your calculations, and a value must be assigned to it. Time spent reflects the days

involved in the assignment, and these days are valued when you include a percentage of your overhead and profit, prorated over the number of potential billable days.

ELEMENTS OF PRICING

Although pricing assignments and stock licenses will be explained in greater detail in later chapters, let's take a brief look at the various elements that make up assignment and stock prices.

Assignments

An assignment price is the amount you will actually charge a client. It is important to remember that all costs associated with production (including your time and overhead) are borne by the client in exchange for the first use of the image(s). The elements that constitute the assignment's bottom line price are expressed as fees or expenses. This approach to assignment pricing works whether you are making images with a camera, computer, finger paints, or any other tools.

1. **Creative Fee:** This fee is made up of a number of separate elements, expressed as a single fee:

■ **Overhead.** The costs you have to account for even if you never take any photographs (e.g., the cost of photographic equipment, studio rental, using your vehicle in business, insurance, salaries, profit, and so on). Later, you'll see how to calculate overhead.

■ **Time.** The total amount of time you spend working on the assignment, and not necessarily just the time you spend photographing. Some photographers include in the creative fee a modest amount of time for pre- and postproduction, such as phone calls to arrange the assignment, casting, or meetings, unless the assignment calls for extensive logistical arrangements.

■ **Value factors** are components affecting your creative fee that include the market where the photos will appear, usage rights or how the client intends to use your image(s), and various photographic elements like special skill or creativity, special risks or hazards, and so on. (See the box, "Value Factors," below.) For example, you may charge less if your image is used in a nonprofit foundation newsletter but far more if a Fortune 500 company uses the same image in their annual report. When pricing usage, remember the old adage, "What the market will bear." Some types of use simply pay more than others. (Note: The pricing charts in this book are a visual explanation of what this means.)

The creative fee is the basic fee that must be charged (no matter what you call it), and for any assignment it can be formulated as: annual overhead total divided by the number of assignment days you expect in a year, multiplied by the number of days in the assignment you are pricing, added

to various usage or value factors. Don't panic—these terms will be fully explained later. The equation could be drawn as:

$$\text{Creative Fee} = \text{Annual Overhead} \div \text{Annual Photography Days} \times \text{Assignment Days} + \text{Value Factors}$$

2. Noncreative Fees: These are charges for your time working on an assignment that is not generally thought to be part of the creative act of photography. These fees can include

- Travel time
- Casting
- Postponement
- Cancellation
- Pre- and postproduction
- Reshoot fees
- Weather delays

These fees are charged as required to compensate you for your time or time lost and likely won't be charged very often, but they must be charged when necessary, or you will put yourself in the position of losing money.

3. Expenses: These are the costs you incur doing an assignment and are billed to the client. Assignment expenses do not include any of your overhead, because those costs are already incorporated into your creative fee. Some expense categories include: casting, crew, insurance, film/lab, location, messengers/shipping, props, rentals, sets, studio, talent, transportation (local), travel, and wardrobe. Reimbursable expenses are generally those items that are disposable or consumable, as opposed to items that are not consumed, like cameras, lighting equipment, and so on.

4. Assignment prices may include a number of other, miscellaneous charges:

- **Expense markups** are a small percentage added to the amount you have spent on expenses. The smart photographers add this charge to compensate themselves for the client's use of their money until they are paid. If you extend "credit" on expenses, you should expect to be paid for it.
- **Reuse fees.** Compensation for a client's later, additional use of your assignment photographs. This is a fee that is seldom charged along with your assignment invoicing. It usually comes later, when a client requests additional use of your images. If negotiated at the time of the original assignment, future reuse can be billed as part of the creative fee or as a separate fee amount. If reuse is requested at a later date, these fees may be negotiated and invoiced as reuse fees, similar to stock reproduction fees. The smart photographer will bring up the subject of reuse charges in the original negotiations, because it puts clients on notice that additional use is not free, that they don't own the images, and that you are thinking of their needs and willing to extend a lower rate for reuse.

Stock

Because stock photographs are existing images, and since you, not a client, may have shouldered the costs of production, the elements that make up the bottom line price for a stock photograph differ from those related to assignments. A word of advice: Bill all fees separately so that the reproduction fee doesn't appear to be excessive and so that it only reflects usage and the cost of image production.

 I. **Reproduction, License, or Use Fee:** Much like the creative fee in assignment photography pricing, the reproduction fee, also known as a use or licensing fee, compensates you for overhead and additional value factors that apply.
- **Overhead** may now have to reflect additional salaries for an assistant or secretary.
- **Pricing factors** are incorporated into the price because of the uniqueness of a particular photograph, the difficulty or danger in obtaining the image, special costs (e.g., equipment rental), the client's licensing use requests, and so on. See the "Pricing Factors" chart for more information.

Reproduction Fee = Overhead + Pricing Factors

 2. **Research Fees** may be charged to compensate for the cost of selecting and refiling submission requests and to help discourage casual requests by

buyers who are not really serious or are only shopping for ideas or inspiration. In the highly competitive world of stock photography, many stock agents have foolishly given up this charge to gain a competitive advantage. Of course, if everyone does the same thing, there goes the advantage. Research fees are often waived by crediting them against reproduction or license fee charges, but only if a client actually negotiates a license.

3. Holding Fee compensates you for the period of time photos are kept out of circulation by a client, thus preventing you from licensing them to others. If you provide digital files instead of original images, this fee is not necessary, unless you are withholding the image from use by others until the client decides whether to use the image.

4. Loss or Damage Fees are levied for any lost or damaged images to compensate you for lost potential income that you will be deprived of because the image cannot be used, or to compensate you for repairing damage (assuming it can be done digitally), or for having another duplicate image made.

You've seen that in pricing both stock and assignment photography, the main components are overhead, pricing factors, and time. Let's now explore each as they affect photographers, beginning with overhead.

OVERHEAD

Determining overhead is an important factor in pricing in every business except photography, it seems. Other pricing aids prefer simplicity. "Here are our prices, isn't that easy," is frequently their approach. Because photographers who depend upon such pricing aids remain ignorant of their overhead requirements, they too often engage in price-cutting. Again and again, however, these photographers struggle to get ahead, go out of business, and depress photography fees for everyone.

Overhead consists of many things that you have to make enough money to cover, from your salary to camera and other equipment purchases to utilities and many other things you take for granted—but you can't afford to take them for granted if you are in business.

If you only consult pricing charts, without knowing your overhead, you are on a short track to nowhere.

What Is Overhead?

Overhead, for photographers, is comprised of all of the costs that you incur that aren't directly attributable to specific assignments or stock licensing. The total of these costs is typically thought of as what it costs to be in business for one year, but it can also be figured on any other time basis: monthly, weekly, or daily. Overhead is a combination of two kinds of costs: fixed and variable.

Fixed costs are inevitable. Rent or studio/office ownership costs, for instance, are as inescapable as telephone bills and business insurance. Variable costs, on the other hand, will change in amount, depending upon the level of your activities.

Some variable costs are inevitable, even if you never have a billable day. For example, film will be used for testing, promotions, or stock production. These costs will vary week by week, month by month, but you will need to budget and account for them even though many variables can only be estimated.

Note: Fixed and variable costs are not the same as those expenses billed to a client that will be incurred in support of an assignment. Since assignment expenses are usually reimbursable, they are usually billed to your client and therefore do not become part of your overhead commitment.

After you have listed all of your overhead costs, fixed and variable, add them up to derive your overhead subtotal. Our two hypothetical photo businesses show:

The "Calculating Overhead" chart shows that photographer 1 has fixed costs of $60,102, variable costs of $9,962, and profit of $7,006, for an annual overhead total of $77,070.

Photographer 2 has fixed costs of $156,863, variable costs of $66,828, and profit of $22,369, for an annual overhead total of $246,060.

If you are doing digital imaging, you must add into your overhead analysis the much greater costs of fast computer(s), large monitors, film and flatbed scanners, removable media drives (e.g., CD-ROM), CD-writeable or "burner" drives, and so on. These are fixed costs that will likely be depreciated over only three years. Technological advances will require you to replace imaging equipment with ever faster tools. Digital imaging would be expected to add additional thousands of dollars each year, depending upon the extent of your involvement.

What Are Your Personal Needs?

Most people want to make money. But how much income do you really need on an annual basis? To start with, you have to figure a salary (i.e., your personal income) for yourself—otherwise, why go into business? Too often, especially when starting up, owners (and that is what you are) approach their small business without factoring in a salary for themselves, hoping instead to live off of any "extra profits." As a result, they never have a clear picture of the financial health of their operation, never get ahead, and slowly find they have to siphon more and more from their business, depleting its resources in order to ensure their own personal survival. Not properly accounting for your own salary (or for every other cost) in overhead is a sure prescription for failure. Another trap small business owners fall into is paying for personal items with company money, instead of investing it back into the company. By not setting up your business with hard and fast rules controlling finances, you will tap the business treasury until it's tapped out! The IRS does not look kindly on business owners who mix business funds and personal needs. Learn early one of the cardinal rules of running a profitable business: Thou shalt not pull the wool over thine own eyes!

Determining salary is somewhat simplified if you have recently been earning a regular salary; if your paycheck met all of your personal and family needs, you know how much you have to make. If it wasn't enough, you need to earn

CALCULATING OVERHEAD

FIXED COSTS	PHOTOGRAPHER #1	#2
Depreciation:		
cameras, lighting, etc.	2,200	9,891
computers	940	2,366
office equipment	650	1,861
office furnishings	985	2,129
van/car/truck	2,450	6,667
Insurance	1,800	4,276
Rent	6,000	24,000
(or mortgage or percent of home office)		
Salaries:		
yours	30,000	45,000
others	10,500	43,000
Taxes		
city	387	1,321
federal	1,783	2,489
property	1,007	4,541
Utilities	2,400	9,322
(telephone, electric, gas)		
Fixed costs subtotal	**$60,102**	**$156,863**

VARIABLE COSTS	PHOTOGRAPHER #1	#2
Production:		
film	799	4,349
processing	1,013	5,492
model fees		8,923
props		2,734
permits		500
assistants' fees (freelance)		1,800
Professional Fees:		
legal, accounting		1,240
bank charges		98
retirement		8,450
(pension plan, Keogh, IRA)		
Repairs:		
studio/office		1,400
photographic equipment	75	721
business equipment		373
Studio/Office:		
messengers		445
promotion/advertising	3,000	8,490
subscriptions/books		750
professional dues	275	275
education		
printing	2,000	3,215
postage	1,200	4,717
office supplies	1,000	2,786

(continued)

FIXED COSTS	PHOTOGRAPHER #1	#2
Transportation:		
car	477	1,740
taxicab	123	429
other		313
Travel:		
hotel		2,500
meals		876
airfare		3,267
car rental		945
Variable costs subtotal	**$9,962**	**$66,828**
Fixed costs subtotal	**$60,102**	**$156,863**
Variable costs subtotal	**$9,962**	**$66,828**
Overhead Subtotal	$70,064*	$223,691*
Profit: 10%	$7,006	$22,369
Annual Overhead Total	$77,070	$246,060

* The total of fixed and variable costs added together.

NOTE: If you are doing digital imaging, you will have to list in the depreciation section the greater annual overhead of computers, scanners, printers, and so on.

more. (And, if you were wallowing in excess money, why in the world are you reading this book?)

On the other hand, if you haven't received a regular paycheck, you must formulate a budget showing what you spend on housing, food, clothing, insurance, transportation, entertainment, and all other personal or family needs each year. The total is what you need for an annual salary. Remember, though, if you are starting up a new business, be prepared to sacrifice somewhat until you've become established. Also understand that your salary is not all of your overhead—it is just one item of overhead.

Profit as Part of Overhead

You need to determine an amount that can be considered profit—after all, isn't the reward for being in business for oneself a profit? Simply put, profit is money that allows your business to grow.

You can easily approach profit calculation from one of two ways: making it a fixed amount, or dealing with it as a percentage of overhead. A fixed amount for profit could be any reasonable sum you wish—say, $50 or $100 for every billable day—although it may have to be much more for a large operation. Better yet, multiply your overhead subtotal by some percentage to derive your profit amount. Since many businesses find 10 percent of overhead to be a more than adequate level, why not try that to start?

In our example for photographer 1, the overhead subtotal of $70,064 is multiplied by 10 percent, and the result ($7,006) is added to the overhead subtotal ($70,064), to make an annual overhead total of $76,767.

Caution—this is not a time to indulge in fantasy. The profit amount you use must maintain a reasonable relationship to your experience and value to your clients. The important point is to understand the concept and importance of profit, and always to include it in your calculations.

Finally, the easiest way to ensure that you cover your overhead costs is to determine what your overhead is on a daily basis.

Calculating Daily Overhead

Planning how to cover annual overhead total is difficult. Instead, think about "daily overhead"—that is, your annual overhead total evenly apportioned on a daily basis to the days when you will shoot an assignment.

Take the overhead total and divide it by the number of annual billable assignment days you can reasonably estimate or expect to have. The result is the minimum amount you must recover for every day you are actually photographing in order to cover (only) your overhead costs. Bill less than this, and you'll soon be getting midnight phone calls from debt collectors.

To help you better understand daily overhead, think about a business that is open fifty-two weeks per year, 5 days per week. The owner needs to know what overhead is each day the business is open, or 260 days per year. A business that is open 6 days per week, but that is closed two weeks for vacation, needs to know daily overhead for 300 days per year. Calculating daily overhead is easy: Divide annual overhead total by the number of days the business is open per year. Thus, a business open 300 days per year, with annual overhead of $300,000, has daily overhead of $1,000.

The problem for photographers is that, although many work five or six days per week, many of those days are devoted to non–income-producing activities like showing portfolios, mailing promotional materials, testing film, talking to insurance agents, photo labs, and so on. All photographers need to earn enough on the days they do billable work or licensing to make up for the days when no income is brought in.

Businesses engaged in stock licensing—and many photography studios and digital imagers—will tend to follow a more traditional Monday-through-Friday schedule for fifty-two weeks per year. They expect to do work every day that earns income. However, because there are several holidays each year, let's consider that the business will be open only fifty weeks each year. Multiplying fifty times five, one sees that the business will be open 250 days in a year.

Let's assume that photographer 2 operates a studio that is open 250 days per year. Annual overhead total for this firm is $246,060. By dividing annual overhead by 250, it is easy to see that daily overhead will be $984.24. If no sales are made on Monday, it must be made up on Tuesday, along with Tuesday's $984.24 daily overhead (now $1,968.48). Alternately, one could look at

recovering Monday's overhead by apportioning the $984.24 over the following days, so that on Tuesday, Wednesday, Thursday, and Friday $1,230.30 must be brought in.

Location photographers and some digital imagers generally aren't able to earn money on a day-of-the-week basis. For them, it may be easier to look at covering overhead on a different basis. Many will estimate how many days per year they will spend photographing for clients and will divide this number into their annual overhead total. Others will use actual photography days and add to that all days spent doing other things that support assignments. For example, if photographer 1 estimates she will have 75 actual days of photography for clients, her daily overhead will be $1,027.60 (i.e., $77,070 annual overhead divided by 75). On the other hand, if that same photographer estimates another 90 days working in support of her assignments, she will divide $77,060 by 165 days (i.e., 90 added to 75) for a daily overhead estimate of $467.09.

Use the following equation to calculate daily overhead. (Note: This is *not* a day rate, but the minimum amount you must recover every billable day. If you don't, you are losing money, running in the red, out of pocket, going in the hole . . . Got it?)

$$\text{Annual Overhead Total} \div \text{Days} = \text{Daily Overhead}$$

Here is the daily overhead calculation for our two hypothetical photographers:

Photographer 1
$77,070 ÷ 75 assignment days = $1,026.60 Daily Overhead

Photographer 2
$246,060 ÷ 143 days = $984.24 Daily Overhead

Notice the difference between the two? Even though the two photographers have considerably different annual overhead totals, photographer 1 has a greater daily overhead, $1,026.60, than photographer 2 at $984.24. These daily overhead numbers could be considerably different if photographer 2 knew she would have her studio open and did photography for a greater number of days.

Your daily overhead amount becomes part of your creative fee for assignment photography and digital imaging, or part of your license fee in stock photography.

A Mix of Stock and Assignments
Our examples tend to present photographers engaging in either a pure assignment or a stock photography business. However, in today's market most photographers find that they engage in both, finding a blend of the two to be more rewarding. It will be up to you to decide artistically if a blend will work, as it will be to determine how you will blend the two financially.

When you do a mix of work, you need to apportion annual overhead by the amount of assignment, stock, or digital imaging that is done. If you find, for example, that assignments are 75 percent of your business, then use 75 percent of your annual overhead total when calculating daily overhead for assignment pricing. The other way you could account for overhead, when you have a mix of work, is to base daily overhead on all of the days per year you work, whether it is doing assignments, stock, or digital imaging. Therefore, if you do a mix of photography and digital imaging assignments, add these together and use that total number of days to determine daily overhead.

CAUTION!

We stress the importance of calculating overhead as a basis for establishing your billable day overhead primarily because most photographers ignore this basic business premise. You should annually refigure it as a control on your business costs.

Warning—this can be a trap! Although you need an understanding of your overhead, and billable day overhead, never forget that this is only a foundation. Be very careful that you don't let these numbers dictate your pricing. Remember, client usage and budget remain important factors in determining price. One prominent photographer suggests keeping a sign by the phone, "it's the usage, dummy," to remind you to include all relevant factors when calculating your price.

The next step in pricing is possibly the most difficult. Value factors (see "Value Factors" chart) will be added to daily overhead, resulting in the fee you will actually charge a client.

PRICING FACTORS

This area of pricing is understandably the most difficult to quantify. Don't despair; understanding the process of pricing is akin to learning to drive a manual shift car. Once you know how, it's hard to remember what made it so tricky, yet it's difficult to explain the process so another driver will be equally skilled and smooth. Photographers skilled at pricing have picked up their knowledge through years of experience, absorbing it as they went, making mistakes but also a few coups.

The box "Pricing Factors" gives an overview of the relationship of the many factors that affect pricing. The better you understand them, the easier it will be to negotiate prices like those listed in the charts. Remember as you read the following material: Pricing factors are all about value.

What about My Photography?

Determining, "Do my photographs have value?" and, "What is the value of my photography?" is not a lot less difficult than the age-old question, "Which

comes first, the chicken or the egg?" It's a dilemma that puzzles many photographers as they wrestle with pricing as a balance of their time, creativity, and the client's need for and use of your work. Each question raises more questions:

- Is it the value of my time?
- Is it the value of my creativity?
- Is it the value of my technical skill?
- Is it the value of the effort or risk involved?
- Is it the value of my photography vis-à-vis the client's project?

They all are part of the equation, but is any one worth more?

PRICING FACTORS

Four general groups of factors can be said to affect pricing. They are all equally important in pricing your work. Two are client- and marketplace-related, and the other two are linked to you the photographer and business owner.

1. Market Type (Client/Market). Photo fees traditionally relate to the budgets (media-buy and total production costs) and profitability of the market area:

PURPOSE OF USE	DEFINITION	PRICE RANGE
Advertising	Selling a product or service	High
Corporate	Selling a corporate image	Medium–High
Editorial	Selling or decorating a product	Lowest
Other markets	Miscellany like mugs or calendars	Varies

2. Usage Needed (Client): These concern the visibility and length of time requested by a client.

VISIBILITY FACTORS	DETAILS
Size	One-quarter, half, full page, double-spread
Placement	Interior, display, part opener, front or back cover
Number of uses	Circulation of newspaper or magazine, press run of brochure or book, number of insertions for advertisement
Time	Length of time used (e.g., one-year billboard)
Distribution	Local, regional, national
Versions	Examples: One language and two translations; or point of purchase and product packaging

3. Overhead (Photographer): Fixed and variable costs incurred whether or not you license images, including rent, utilities, insurance, and office and photography equipment purchases.

4. Photographic Elements (Photographer): Everything that goes into a photograph:
- *Time:* photography, pre-/postproduction, editing
- *Skill:* expertise, special equipment
- *Creativity:* imagination in color, lighting style
- *Special:* hazards, risks, unique contributions
- *Expenses:* all job costs—materials, equipment, assistants

All of these factors come into play when pricing either assignments or stock licensing.

Pricing—The Salad Test

For the purpose of untangling the perplexities of placing a value on usage, let's say that photography is analogous to a restaurant meal and that the photographer is the restaurateur. The meal, or any one of its courses, from appetizer to dessert, will vary in the quality of the ingredients, skill in preparation, exquisiteness of flavor, and elegance of presentation, and the graciousness of service and atmosphere will vary from restaurant to restaurant. Prices for meals in individual restaurants will vary according to the level of quality inherent in all of these aspects, and the price to be charged will largely be based on perceived value to the customer. Some clients require only basic meat-and-potatoes photography, while others will be willing to pay more for the delicious flavor of your special lighting or elegantly decorated establishment.

That still leaves the problem of how to evaluate and price each element, whether food or photography.

Let's start with broad categories. The cost of a meal will depend on the category of restaurant a patron chooses: deluxe, middle-of-the-road, or neighborhood bistro, with costs running from high to low. Which one is selected will often be based largely on the patron's ability to pay. Restaurant classification based on cost can be roughly compared with the categories of photography—advertising, corporate, editorial—and the general difference in payment they offer, in their willingness to pay, from high to low.

Now we'll narrow the analogy. Say the photograph itself is a salad. Imagine that all salads contain the basic ingredients of lettuce (your time), tomatoes (your skill), and a dressing (your creative ability). Special and more expensive salads may include endive or radicchio or rare mushrooms; the list is practically endless.

Further, the waiter needs to know what size salad you need (analogous to client usage). Will it be an appetizer, a side dish, or the main course? How important is the salad to your meal (is it for major advertising or a small brochure)? And, finally, how many salads (the number of times they want to reproduce your photograph) will your party order?

It's that simple, and that complicated. However, if you don't make the effort to understand the relationship of pricing elements, you'll be charging prices for lettuce no matter how many exotic ingredients lavish your salad—a sure recipe for failure.

The value you place on the pricing factors will be based on your level of experience, creative ability, difficulty or danger involved in producing the images, and so on. This will affect your choice of the high-middle-low price range when you use the price charts. You will notice the "Pricing Factors" chart is absent any financial figures. Because it is impossible to place a specific value on them, experience will become your best guide. Until then, use the price charts in this book to help you seek a range.

Value to Client

As client need increases, so, usually, will their willingness to pay. A perusal of the pricing charts, for instance, will show that advertising assignments generally

bring higher fees than will editorial. In part, this has come about because of the demands of advertising—bigger productions, more prominent displays of the finished product, and, frankly, because you will be helping some company make more money. So, too, within any one category (e.g., corporate, advertising, editorial, etc.) you will also find varying rates. For example, corporate annual reports, because they help "sell" a company to investors, will usually support higher fees than photographs destined for an in-house magazine.

One of the most important indicators of importance to a client is found either in the publication's "space-rate/media-buy" (see *Standard Rate & Data*) in the case of advertising, or in the total production costs of corporate, editorial, and even advertising projects.

The advertising agency has to place the advertisement where the public can see it, usually in publications and, increasingly, on the Internet. The cost of space varies—the rate for one page in *Time* magazine will be much more than for a local publication; likewise, a billboard along a major city freeway will cost more than one in a small town. The easiest way to determine publication advertising space rates (the amount charged to place an advertisement in a publication) is to look in the publication *Standard Rate & Data* (commonly called the "Red Book") at your local library. You should have an understanding of the relationship between space rates and the value of your fees.

In corporate photography, an estimate of the value of a project to your client can be made by knowing the project production costs total; production costs can also be used as a guide for advertising and editorial assignments. More difficult to determine because there is no easy guidebook is the final size of the image as it is used in relationship to the advertisement, magazine or annual report page, brochure, computer screen, Web page, the press run size, and so on. Sometimes, your client will offer some or all of this information if you just inquire. Why not simply say, "This looks like a major effort, and I'd like to be part of it. You say the annual report is going to be sixty-four pages with a press run of one million! Who is going to be the lucky printer?" If you can't elicit this information, talk to printers, talk to graphic designers, or guess.

Editorial photographers will probably not discover the production costs incurred by a publisher, but instead will have to rely more on the press run and/or circulation of the publication as a guide to the importance and value of the work. Publishers tend to work with set rates for photography, so you may hear terms like "page rate," which simply means that they have budgeted a certain amount for photography per page. If it is by page rate, an indicator of project value would be any variance in the page rate from other projects this publisher has produced. Remember to check the Red Book for the space rate of a publication you are thinking of working for. Higher rates denote that a greater value is placed on each page by the publisher, and it may mean higher fees for you; but only if you ask.

Value to You

Never undervalue the time you have to spend producing photographs, whether it is film and equipment testing, dealing with the photo lab and other suppliers, traveling to a site, locating and scanning images for use on your computer, searching for and preparing stock images for shipment, and so on. Your time—all of it—has value, whether you are doing an assignment or creating stock or digital imagery.

Although it wouldn't be advisable to routinely factor this into your pricing and negotiating routine, some photographers give consideration to whether an assignment's photographs will be desirable as stock or for promotional use. If a job promises great photographic possibilities, some photographers may consider a slight downward pricing adjustment to ensure capturing the assignment. They are willing to risk the reduction in income, knowing that future stock sales will offset the lower assignment fees. Warning! This should be considered only by experienced photographers with established stock sales records, who can accurately assess the outcome.

Rid yourself of a misconception that many inexperienced or naïve business-people cling to: that clients who beat you down on price will someday make it up to you. Don't give your work away. No one will really appreciate it, and you can't operate a business for very long on hope.

PHOTOGRAPHY AND THE LAW

CHAPTER 18 **COPYRIGHT**

by Tad Crawford and Laura Stevens

Laura Stevens is an attorney in New York City with a special expertise in copyright and intellectual property.

THE RIGHTS THAT YOU SELL to your photographs come from your copyright in those photographs. *All rights* or *world rights* is the transfer of your entire copyright; *first North American serial rights* is the transfer of a limited piece of your copyright. Your authority to sell rights to your photographs stems from the United States federal copyright laws that protect you. These laws were first enacted in 1790 and are periodically revised, the most recent comprehensive revision taking effect on January 1, 1978.

If anyone wishes to use your copyrighted photographs, he or she must get your permission. You will then be able to set a suitable fee for the requested use. Anyone who reproduces, publicly displays or distributes, or alters your work (creating a derivative work) without your permission is infringing upon your copyright rights, and you can sue for damages and prevent him or her from continuing the infringement. Your copyright is, therefore, important in two ways: it guarantees that you will be paid when you let others make use of your photographs, and it gives you the power to deny use of your photographs if, for example, the fee is too low or you don't believe that particular person or company will use the photographs in a way you consider esthetically satisfactory.

In learning about copyright, you should keep in mind that the United States Copyright Office makes available many downloadable publications, circulars, and forms. Visit the Copyright Office Web site at *www.loc.gov/copyright* to see the full extent of the information available.

WHAT IS COPYRIGHTABLE?

Protection under copyright law extends to original works of authorship fixed in any tangible medium of expression, including, but not limited to, literary works; musical works; dramatic works; pantomimes and choreographic works; pictorial, graphic and sculptural works; motion pictures and other audiovisual works; sound recordings; and architectural works. There are, however, specific classes of works that are exempt from copyright protection. Among the works ineligible for copyright protection are works that have not been fixed in a tangible form of expression (e.g., an improvisational performance that is not written or recorded), works of the United States Government, titles, names, slogans, ideas, methods, procedures, systems, processes, concepts, principles, discoveries, or devices. However, it is important to keep in mind that these classes of

works may be otherwise protected under trademark, patent, or other theory of law.

RIGHTS TO COPYRIGHTED PHOTOGRAPHS

If "copyrighted photographs" sounds ominous, it shouldn't. You have your copyright in a photograph as soon as you take it. This copyright is separate from the physical transparency, negative, or print. For example, you can sell a transparency but reserve the copyright to yourself. The buyer would get a physical object—the transparency—but no right to reproduce your work. Or you could sell the copyright or parts of the copyright while retaining ownership of the transparency. It is common practice to require the return of the transparency when selling reproduction rights.

To you as copyright owner, the copyright law grants the following exclusive rights:

1. The right to authorize reproductions of your photographs;

2. The right to distribute copies of your photographs to the public (although a purchaser can resell a purchased copy);

3. The right to prepare derivative works based on your photographs. Derivative works are creations derived from another work of art. Thus, a photograph could be the basis for a lithographic plate used to make fine prints. In such a case, the fine prints would be derivative works based on the original photograph;

4. The right to perform your work if it is audiovisual or a motion picture; and

5. The right to display the photographs (except that the owner of a photograph can display it to people who are physically present at the place where the display occurs).

The exclusive rights are yours to keep or sell as you wish. Other users of these rights must first obtain your consent.

ELECTRONIC RIGHTS

Most of the copyright principles discussed in this chapter (i.e., protectability, exclusive rights, permitted uses, etc.) apply to works in the online and digital realms in the same manner in which they apply to works in the traditional offline world. A copyright owner may control the distribution of his or her photographs on the Internet in much the same way as would be done with respect to books or magazines. The Digital Millennium Copyright Act, enacted in 1998, extends copyright protections which already existed with respect to traditional media (e.g., books, photographs) to their online counterparts (e.g., e-books and photographs made available on the Internet). Although the DMCA contained some specific limitations on liability for particular classes of parties, it may be generally assumed that a use that requires permission offline (e.g., to include a

photograph in a magazine) would require permission online (e.g., to include a photograph in an e-zine).

TRANSFERRING LIMITED RIGHTS

As the copyright owner, you could always transfer *all rights* in your photographs, but that may not be the wisest choice. Whenever you sell rights, you naturally want to sell only what the user needs and is willing to pay for. The copyright law helps by requiring that transfers of exclusive rights of copyright be in writing. This requirement of a written transfer calls your attention to what rights are being given to the user. Such a transfer must be signed either by you or by your agent (if the agent has authorization from you to sign copyright transfers).

How can you tell whether the right that you are transferring is exclusive or not? Just ask the following question: If I transfer this right to two different users, will my transfer to the second user be a breach of my contract with the first user? If you transfer *first North American serial rights* to one magazine, you cannot transfer *first North American serial rights* to a second magazine. Obviously, both magazines could not be first to publish the work in North America. So *first North American serial rights* is an exclusive transfer and must be in writing and signed by you or your agent.

However, it is also possible to give a nonexclusive license to someone who wishes to use one of your photographs. Such a nonexclusive license does not have to be written and signed but can be given verbally or in the course of dealing between the two parties. If you have not given a signed, written authorization, you know that you have sold only nonexclusive rights. This means that you can give the same license to two users without being in breach of contract with either user.

A photographer had done a freelance advertising assignment for a cosmetics company and delivered a number of photographs. Nothing in writing was signed by the photographer. He asked: (1) Can I sell these photographs used by the advertiser to some other user? (2) What use can the advertiser make of the photographs? *Answer:* The photographer was free to resell the photographs to other users. Since no written transfer had been made, the advertiser had gotten only nonexclusive rights. As a practical matter, however, the photographer would almost certainly ask for the client's consent in order to keep on good terms and obtain future assignments. The question of what uses the advertiser can make of the photographs is harder to answer. If the advertiser's purchase order or the photographer's confirmation form or invoice specify what uses can be made, the problem may be solved. In the absence of a complete written contract, what the parties verbally agree to about usage would be considered. This can be quite difficult to prove and points to the value of having a clear written understanding before starting any assignment. Prior dealings between the parties or accepted practice in the field will also be considered by the courts if there is no written contract or the contract is ambiguous.

Since you want to sell limited rights, it's important to know how rights can be divided. Always think about the following bases on which distinctions can be made:

- Exclusive or nonexclusive transfer
- Duration of the use
- Geographical area in which the use is permitted
- Medium in which the use is permitted
- In a case involving words and photographs, the language in which use is permitted
- Electronic rights may be granted or specifically withheld

If a magazine or book publisher wants to publish your photograph, you should make it a practice, whenever possible, not to sell *all rights* or even exclusive publishing rights. It is preferable to sell the most limited rights that the publisher needs, since it is presumably paying for only those rights that it intends to use. Your transfer might be as follows: *exclusive first-time North American magazine rights.* The shorthand for this, of course, is *first North American serial rights.* Any of your exclusive rights as copyright owner can be subdivided and sold separately. The rest of the copyright still belongs to you for further exploitation.

COPYRIGHT ASSIGNMENT FORM

The Copyright Assignment Form can be used if you are getting a transfer of *all rights* back from a user. This was frequently necessary under the old law, although it should not occur very often after January 1, 1978. Also, you could use this

ASSIGNMENT OF COPYRIGHT

For valuable consideration, the receipt of which is hereby acknowledged, [*name of party assigning copyright*], whose offices are located at [*address*], does hereby transfer and assign to [*name of party receiving copyright*], whose offices are located at [*address*], his heirs, executors, administrators, and assigns, all its right, title, and interest in the copyrights in the photographs described as follows: [describe work, including registration number, if work has been registered]

_____ including any statutory copyright together with the right to secure renewals and extensions of such statutory copyright throughout the world, for the full term of said copyright or statutory copyright and any renewal or extension of same that is or may be granted throughout the world.

IN WITNESS WHEREOF, [*name of party assigning the copyright*] has executed this instrument by the signature of its duly authorized corporate officer on the _____ day of _____, 20___.

ABC Corporation

By: _____
 Authorized Signature

Name Printed or Typed

Title

form to transfer all rights to a user, but you would be better off working with the License of Rights form in Chapter 16 that provides for a limited rights transfer.

Once you receive an assignment of a copyright, you should record it with the Copyright Office. This is easy to do, since you need only send a fee, two copies of the Copyright Office Document Cover Sheet, and the original or a certified copy of the assignment to the Copyright Office. After processing and recording the assignment document the Copyright Office will send you a copy of the document along with a certificate of record. By recording the assignment within one month if it is made in the United States or within two months if made abroad, you establish your priority over others to whom the user may later, by mistake or otherwise, transfer the same copyright. In order to have priority, you will also have to register the copyright if it hasn't already been registered.

This system of recording is useful in another way. If you are trying to find out whether a work that you want to use is copyrighted and who the copyright owner is, the Copyright Office (for a fee) will search its records to help you obtain this information. Also, the Copyright Office has a free online searchable database for registrations and recordations that have been filed after January 1, 1978. This can be accessed on the Copyright Office Web site.

COPYRIGHT NOTICE

Although no longer required under copyright law, placing a copyright notice on each of your published photographs is advisable. Such notice identifies you as the copyright owner to potential licensees and warns off potential infringers. In addition, the notice prevents any infringer from asking for a lessening of damages because the infringement was innocent and based on the lack of copyright notice. Prior to March 1, 1989 (the enactment of the Berne Convention Implementation Act), publication of a work without copyright notice injected that work into the public domain (unless specific corrective measures were taken within a certain time period), meaning that the work was no longer protected by copyright in the United States. Publication basically means public distribution, including distribution over the Internet, whether by sale, lending, leasing, gifts, or offering copies to other people for further distribution. There are several benefits to providing copyright notices on your published works. The notice informs the public that the work is protected by copyright, that you are the author of the work, and the year in which the work was first published. By providing this information on each of your published photographs, individuals or companies seeking to license and/or reproduce your photograph are put "on notice" that the particular work is protected by copyright and they must obtain permission from you prior to using it. Offering your photographs to a number of art directors is probably not a public distribution, but there is no harm in putting the copyright notice on the work before sending it out for submission.

The copyright notice has three parts:

1. "Copyright" or "Copr." or ©
2. Your name or an abbreviation from which your name can be recognized, or a pseudonym by which you're known
3. The year date of first publication

An example of a proper notice would be: © Jane Photographer 2003. The year date may be omitted from toys, stationery, jewelry, postcards, greeting cards, and any useful articles. So, if a photograph were used on greeting cards, proper copyright notice could be: © Jane Photographer or even © JP.

As copyright notice is intended to provide the public with certain ownership information, it is important that the notice appears in an obvious and accessible location. For a photograph published in a book or magazine, the most obvious place for the notice would be adjacent to the photograph. However, there are a number of other placements that would be considered reasonable. If, for example, the magazine objected on esthetic grounds to an adjacent copyright notice, the notice could appear as follows:

1. For a photograph reproduced on a single page, notice can go under the title of the contribution on that page or anywhere on the same page if it's clear from the format or an explanation that the notice applies to the photograph.
2. For photographs appearing on a number of pages of a magazine, the notice can go under a title at or near the beginning of the contribution, on the first page of the main body of the contribution, immediately after the end of the contribution, or on any of the pages comprising the contribution if the contribution is no more than twenty pages, the notice is prominent and set apart from other materials on the page, and it is clear from the format or an explanation that the notice applies to the entire contribution.

Copyright Office Circular 3, *Copyright Notice,* gives further details as to the form and placement of copyright notice.

It's a good idea to have a stamp with your copyright notice: © Jane Photographer 20__. Before photographs or transparencies leave your studio, you simply stamp the copyright notice on them. Since the photographs won't have been published yet, the year date you put in the copyright notice should be the year you made the photographs. On publication, either in the United States or abroad, the year of first publication should appear in the notice. If the work is going to be distributed abroad, it is best to use ©, your full name, and the year date of first publication.

THE PUBLIC DOMAIN

Photographs and other artworks that are not protected by copyright are in the public domain. This means that they can be freely copied by anyone—they

belong to the public at large. This includes photographs whose copyrights have expired, were not timely renewed, or have been lost because they were published without proper notice prior to March 1, 1989, and such omission or error was not corrected in compliance with the copyright law's requirements.

DURATION OF COPYRIGHT

Copyright protection in works created on or after January 1, 1978, will normally last for the creator's lifetime plus seventy years. A photograph taken in 2000 by a photographer who dies in 2025 will have a copyright that expires in 2095.

Copyrights run through December 31 of the year in which they expire.

If you create a work jointly with another photographer, the copyright will last until 70 years after the death of the survivor.

If you create a work anonymously or using a pseudonym, the copyright will last 95 years from the date of publication or 120 years from the date of creation, whichever term is shorter. However, you can convert the term to your life plus 70 years by advising the Copyright Office of your identity prior to the expiration of the term.

If you work for hire, the copyright term will be 95 years from the date of publication or 120 years from the date of creation, whichever term is shorter. Remember, however, that when you do a work for hire you are no longer considered the creator of the work for copyright purposes. Instead, your employer or the person commissioning the work is considered the work's creator and completely owns the copyright.

For copyrights on photographs protected under the old federal copyright law (in other words, those works registered or published with copyright notice prior to January 1, 1978), the copyright term will be 95 years. However, the old copyright law required that copyrights be renewed at the end of 28 years. A law passed in 1992 made renewals automatic for works first copyrighted between 1964 and 1978. Although the filing of the renewal application with the Copyright Office is no longer required, it is advisable in part to make public record of your continuing ownership. Thus, pre-1978 copyrights that are in their first 28-year term should be renewed on Form RE.

Finally, you may have photographs that you created prior to January 1, 1978, but never registered or published. These photographs were protected by common law copyright. The new copyright law provides that such photographs shall now have protection for the photographer's life plus 70 years. In no event would the copyright on such photographs have expired before December 31, 2002, and, if the photographs were published on or before December 31, 2002, the copyright will run at least until December 31, 2047.

Since copyrights remain in force after the photographer's death, estate planning must take copyrights into account. You can leave your copyrights to whomever you choose in your will. If you don't do this, the copyrights will pass under state law to your heirs.

TERMINATION OF TRANSFERS

Because copyrights last for such a long time, the copyright law effective on January 1, 1978, adopted special termination provisions to protect photographers and other creators. It isn't possible to know how much a license or right of copyright will be worth in the distant future. So the law provides:

1. For licenses or rights of copyright given by the photographer on or after January 1, 1978, the transfer can be terminated during a 5-year period starting 35 years after the date of the transfer. If the right of publication is included in the transfer, the 5-year period for termination starts 35 years from the date of publication or 40 years from the date of the transfer, whichever is earlier.

2. For transfers made prior to January 1, 1978, by the photographer or the photographer's surviving heirs or successors in interest (as defined in the copyright law), the transfer can be terminated during a 5-year period starting 56 years from the date copyright was originally obtained, or starting on January 1, 1978, whichever is later. If, however, the termination window described in this paragraph had closed by October 27, 1998, the photographer or the photographer's surviving heirs' successors in interest (as defined in the copyright law) have a second opportunity to terminate a pre-1978 transfer at any time during the 5-year period beginning at the end of 75 years from the date copyright was originally secured in the photograph.

The termination provisions do not apply to transfers made by will or to works made for hire. Also, a derivative work made prior to termination may continue to be exploited even after termination of the transfer in the photograph on which the derivative work is based.

Termination requires that you give notice of your intention to terminate two to ten years in advance of the actual date of termination. If photographs of yours have maintained value for such a long period that the termination provisions could benefit you, it would be wise to have an attorney assist you in handling the termination procedures.

WORK FOR HIRE

You must be aware of one hazard under the copyright law. For an employee, work for hire means that the employer owns all rights of copyright as if the employer had in fact created the photographs. An employee can, of course, have a contract with an employer transferring rights of copyright back to the employee.

However, a freelance photographer may also be asked to do assignments on a work-for-hire basis. This treats the photographer like an employee for copyright purposes, but doesn't give the photographer any of the benefits employees normally receive. The American Society of Media Photographers and many other professional organizations representing creators have condemned the use of work-for-hire contracts with freelancers.

The copyright law safeguards freelancers by requiring that a number of conditions be met before an assignment will be considered work for hire:

1. The photographs must be specially ordered or commissioned;
2. The photographer and the user must both sign a written contract;
3. The written contract must expressly state that the assignment is done as work for hire (but also beware of any other phrases that sound as if you're being made an employee for copyright purposes); and
4. The assignment must fall into one of the following categories:
 - A contribution to a collective work, such as a magazine, anthology, or encyclopedia
 - A supplementary work, which includes photographs done to illustrate a work by another author (but only if the photographs are of secondary importance to the overall work)
 - Part of an audiovisual work or motion picture
 - An instructional text
 - A compilation (which is a work formed by the collection and assembly of many preexisting elements)
 - A test
 - Answer material for a test
 - An atlas

So, for a freelance photographer to do work for hire, four conditions must be satisfied: (1) there is a written contract; (2) the parties agree that the assignment is to be done as work for hire; (3) both parties sign the agreement; and (4) the assignment falls into one of the categories shown here in which the copyright law allows work for hire. Unless all four of these conditions are not satisfied, the resultant work will not be deemed a work made for hire.

In the 1980s there was some confusion as to whether a freelance photographer could do work for hire even if there was no written contract, as long as the commissioning party supervised the work. In 1989 the United States Supreme Court, in determining whether or not a work created by a freelance artist is a work made for hire, considered the following factors:

- The skill required
- The source of the instrumentalities and tools
- The location of the work
- The duration of the relationship between the parties
- Whether the hiring party has the right to assign additional projects to the hired party
- The extent of the hired party's discretion over when and how long to work
- The method of payment
- The hired party's role in hiring and paying assistants
- Whether the work is part of the regular business of the hiring party

- Whether the hiring party is in business
- The provision of employee benefits
- The tax treatment of the hired party.

These factors in essence require someone to be an employee in order for there to be work for hire in the absence of a written agreement.

When you create a work as a work made for hire, the hiring party will be considered the author and you will be unable to terminate the transfer, as you would otherwise be able to in the case of an assignment of rights. Of course, the broader the assignment, the greater the payment that you should demand.

CONTRIBUTIONS TO MAGAZINES

If you sell a photograph to a collective work, such as a magazine, without signing anything in writing specifying what rights you are transferring, the law presumes that you have transferred only the following nonexclusive rights:

1. The right to use your contribution in that particular collective work, such as that issue of the magazine.
2. The right to use your contribution in any revision of the collective work.
3. The right to use the contribution in any later collective work in the same series.

If you sold your photographs to a magazine, that same magazine could reprint the photographs in a later issue without paying you, but unless you agree or specify otherwise, the magazine would not be permitted to include your photograph in an electronic database. The right to electronically reproduce the photograph would have to be granted specifically. Nor could the magazine authorize a different magazine to reprint the photographs, even if the same company owned both magazines. If you sold your photographs to an anthology, they could be used again in a revision of that anthology (unless you agree or specify otherwise). However, they could not be used in a different anthology. Also, the owners of the collective work would have no right to change the photographs when reusing them.

A photographer has completed an assignment for a magazine. No agreement was ever reached about what rights were being transferred to the magazine. However, the photographer has now received a check with a legend on its back stating, "By signing this check, you hereby transfer all rights of copyright in your photograph titled to this magazine." The photographer asks: (1) Can this legend on a check be a valid transfer of copyright? (2) Should I cash the check or return it and demand a check without such a legend? *Answer:* There has been some disagreement among copyright authorities as to whether signing such a check creates the written instrument required for a copyright transfer, but some courts have held that specific assignment language on a check legend is sufficient to effect a transfer of copyright. If it is not your intention to assign

all rights in your photograph, you should return the check and request one that does not have the legend. The best practice is to have a clear understanding about rights before you start, so you can simply return any check that recites a greater rights transfer than what you have previously agreed to. The failure of the magazine to pay according to the terms agreed to would be a breach of contract for which the publication would be legally liable.

REGISTRATION OF PUBLISHED PHOTOGRAPHS

The forms for registering the copyrights in your photographs appear at the end of this chapter and can be downloaded from the Copyright Office Web site. To register, you send Form VA, two copies of the best edition of your published photographs, and a fee to the Library of Congress, Copyright Office, 101 Independence Avenue S.E., Washington, D.C. 20559-6000. According to the Copyright Office, the "best edition" is the edition published in the United States at any time before the date of deposit in the Copyright Office that the Library of Congress determines to be most suitable for its purposes. Generally, when more than one edition is available, the best edition is: larger rather than smaller; color rather than black and white; and printed on archival-quality rather than less-permanent paper. In addition, according to the Copyright Office, the digital deposit described below for group registration may be used even when registering a single published photograph in Form VA.

Under the copyright law, copyright protection subsists in copyrightable works from the moment they are "fixed" in a copy for the first time. If copyright protection exists from the moment you take your photographs, why should you bother to register? The reason is that registration gives you the following benefits:

1. You must register before you are able to file an action for copyright infringement.

2. Registration creates a presumption in your favor that your copyright is valid and the statements you made in the Certificate of Registration are true.

3. Registration in some cases limits the defense that can be asserted by infringers who were "innocent"—that is, who infringed in reliance on the absence of copyright notice in your name. You must register prior to an infringement's taking place (or within three months of publication) if you are to be eligible to receive attorney's fees and statutory damages.

If you have published contributions in magazines, the registration of the magazine will not register your contribution (unless you transferred all rights to the magazine, which you don't want to do). When registering your published contributions to magazines or newspapers, the Copyright Office requires one complete copy of the best edition of the entire collective work, complete section containing the contribution if published in a newspaper, entire page containing

contribution, contribution cut from the newspaper, or photocopy of the contribution as it was published.

It is also possible to have a group registration for published contributions to periodicals, such as magazines and newspapers. In making such a group registration, you would use the basic Form VA and also use Form GR/PPh/CON. In order to register your photographs in this cost-efficient manner, your contributions must satisfy the following conditions:

1. All of the photographs must be by the same photographer.
2. All of the photographs must have been published within the same calendar year.
3. All of the photographs must have the same copyright claimant (owner).

The group application provision allows you to register many contributions on a single form for a single registration fee. In addition, Form GR/PPh/CON indicates that the preferred method for deposit is as follows: "Digital form on one or more CD-ROMs, including CD-RWs and DVD-ROMs, in one of these formats: JPEG, GIF, TIFF, or PCD." However, other deposits are also acceptable as indicated on Form GR/PPh/CON.

REGISTRATION OF UNPUBLISHED PHOTOGRAPHS

So far, we have been discussing the registration of published photographs. However, you can also register unpublished photographs. In many cases, the registration of unpublished photographs will be easier and far less expensive than the registration of published photographs. Helpful publications from the Copyright Office include Circular 40, *Copyright Registration for Works of the Visual Arts*, and Circular 40a, *Deposit Requirements in Visual Arts Material*. The regulations provide that an unlimited number of unpublished photographs may be registered in a group on a single form and for a single fee if:

1. The deposit materials are in an orderly format.
2. The collection bears a single title, such as "Collected Photographs of Jane Photographer, 2003."
3. The same person claims copyright in all the photographs.
4. All of the photographs are by the same author, or, if they are by different authors, at least one of the authors has contributed copyrightable authorship to each of the elements.

As with the deposit for published groups of photographs, the deposit for unpublished groups may also be in "Digital form on one or more CD-ROMs, including CD-RWs and DVD-ROMs, in one of these formats: JPEG, GIF, TIFF, or PCD." If the digital deposit is not used, an advantage of an unpublished registration is that you have to deposit only one copy of each image. However, there are some requirements with respect to the format photographic

deposit materials must take. Your deposit materials all have to be the same size. Transparencies must be at least 35 mm and fixed in cardboard, plastic, or similar mounts to facilitate identification, handling, and storage. Prints, contact sheets, or photocopies should be no less than 3 x 3 inches and no more than 9 x 12 inches. The preferred size is 8 x 10 inches. For color transparencies you can deposit color photocopies in a contact-sheet type of layout. Color photographs or transparencies must be reproduced in color. It would be wise to place the deposit materials securely in a binder with the title and your name on the front.

Once you have registered a photograph as part of an unpublished group, you do not have to reregister it if it is later published. Keep in mind that the deposit materials must clearly show the entire copyrightable content of the work. For this reason, tacking a number of photographs up and shooting one photograph of all of them for deposit purposes is a poor technique and should be avoided.

Form VA is used for the group registration of unpublished photographs.

INFRINGEMENT

If someone uses one or more of your copyrighted photographs without your permission, that person is an infringer. Assuming the infringed photograph is property registered in the Copyright Office, you may bring a legal action against the infringer to stop the infringing activity and/or pay damages for the illegal use of your photograph(s).

You're entitled to your actual damages caused by the infringement, plus any extra profits the infringer may have made that aren't covered by your actual damages. If it would be difficult to prove your damages or the infringer's profits, you can elect to receive statutory damages, which are an award of between $200 and $150,000 (in the case of a willful infringement) for each work infringed, the exact amount being determined in the court's discretion.

Lawsuits for copyright infringement are brought in the federal courts and are expensive for both parties. For this reason, infringement suits are frequently settled before trial.

The test for infringement is two-part: first, whether an ordinary observer would find substantial similarity between the original photograph and the allegedly infringing one and, second, whether the creator of the allegedly infringing photograph had access to the original.

A photographer shows her lawyer the cover of a leading national magazine. On the cover is an illustration of a well-known doctor. The photographer produces her copyrighted photograph from which she believes the illustration on the cover has been copied. She asks: (1) Is this an infringement? (2) What should I do about it? *Answer:* The illustration will be an infringement if an ordinary observer would believe it to have been copied from the photograph. In this case, the attorney believes that it was, in fact, copied. Illustrators frequently work from files of photographs that they keep for reference. When working with a copyrighted photograph, they must change the image to such a degree that the

ordinary observer would no longer feel the illustration had been copied. As a practical matter, the photographer's attorney will contact the magazine, which will probably settle. Of course, the magazine may argue that no copying took place, in which case an infringement action will be necessary.

FAIR USE

Not every use of a copyrighted photograph will be an infringement. Fair use allows someone to use your copyrighted photographs in a way that is noncompetitive with the uses that you would normally be paid for. A fair use is not an infringement. The law gives four factors to consider in deciding whether a use is a fair use or an infringement. If you're considering using someone else's photograph, you would weigh these factors to decide whether you should obtain permission for the use:

1. The nature of the use, including whether it is a commercial or nonprofit and educational
2. The nature of the copyrighted work
3. How much of the copyrighted work is actually used
4. What effect the use will have on the potential market for or value of the copyrighted work [end numbered list]

Fair use is frequently invoked for purposes such as criticism, comment, news reporting, teaching (including multiple copies for classroom use), scholarship, or research. For example, if a critic wants to write about your photography, the critic could use one of your photographs to illustrate the article without obtaining your consent. Similarly, if a news reporter wants to feature you in a news story, the reporter can include one of your photographs in the news story as an example of your work. These are fair uses.

A photographer has been retained by a corporate client to do an annual report. One of the photographs is to be a montage composed of other photographs already in the possession of the client—a lake in Arizona that the company has developed, a young woman in a bathing suit, scenic views of the countryside, and so on. The photographer asks: (1) Is my use of this photograph a fair use, since the montage format creates a different image? (2) If I can't simply use these photographs, what should I do? *Answer:* The use is a commercial use. Changing the size of the photographs, or even cropping them, will not change the fact that they are being reproduced without permission. The photographer should contact the copyright owners of the photographs and ask for permission to use them. If a fee is required for the use, as is likely, it can be passed along to the client. At the same time, the photographer should obtain a model release from the woman in the bathing suit. Otherwise, she may bring an invasion-of-privacy lawsuit.

How do you obtain permission to use a photograph? The best way is to have a standard form, such as the following one:

I hereby grant to [*photographer's name*] permission to use the following photographs:

Title Description

_____ _____
_____ _____
_____ _____

in the following manner: [*name of publication and extent of usage, including whether the image can be used in traditional media, electronic media, or both*]. As an express condition of this authorization, a copyright notice and credit line shall appear in my name as follows: © [*owner's name*] 20____.

Copyright Owner

Date

You would send an explanatory cover letter along with an extra copy of the permission form that the copyright owner would sign and return to you. You can also use this permission form when requests are made to use photographs that you have taken. Of course, you would carefully outline the rights you are giving and specify fees that must be paid for the usage.

CLASSROOM EXEMPTION AND COMPULSORY LICENSING

The copyright law provides an exemption from infringement for nonprofit (and, in the case of online education, accredited) educational institutions when performing or displaying copyrighted works in a classroom setting. This limited exemption applies only to classroom (whether online or face-to-face) activities between teachers and students and is subject to several other restrictions set forth in the copyright law.

Compulsory licensing also deserves a brief mention. Copyright law allows nonprofit educational television stations, such as those in the Public Broadcasting Service, to use your published photographs without asking your permission. However, the Copyright Office, through its copyright arbitration panels, sets rates of payment that these stations are obligated to pay to you if they make use of your work and specifies what accountings must be made.

MORAL RIGHTS

Moral rights are widely recognized abroad and, as of 1992, have been adopted into the copyright law. Copyright law provides creators of works of visual arts with a right of attribution and integrity. Meaning that you have the right to receive credit when photographs of yours are published and the right to have the photographs published without distortion. However, the right of attribution and integrity does not apply to works made for hire. Although this law exists, it

has very limited application in the world of commercial photography, and it is therefore still important to contractually protect your right to a credit line and the publication of your work without distortions. With respect to moral rights and fine art photography, see *Legal Guide for the Visual Artist* by Tad Crawford.

WHAT ISN'T COPYRIGHTABLE

Your photographs will almost always be copyrightable. Even a home movie, such as the Zapruder film of the assassination of John F. Kennedy, was copyrighted. A photograph that is an infringement of a copyrighted work is not copyrightable. Ideas are not copyrightable, although the creative expression of an idea is. The idea to photograph a subject in a special way is not copyrightable, for example, but the photograph itself definitely would be copyrightable. Titles, names, and short phrases that may accompany your photographs are usually not copyrightable, because they lack enough creative expression. Also, the courts sometimes hold obscene photographs to be uncopyrightable, although the definition of obscenity presents a problem. The Copyright Office does not pass judgments on obscenity. It's up to the courts to make this determination. Works of a useful nature will not be copyrightable, unless they also have an artistic element. A lamp base would not be copyrightable, but a photograph on the lamp base certainly would be. Photographs that are purely mechanical in their creation, such as X rays or microfilmed text, are not copyrightable.

PATENTS AND TRADEMARKS

Patents and trademarks are often confused with copyrights. Protection for photographs comes from the copyright law.

A utility patent can be obtained for inventions of machines or processes that are useful, original, and not obvious to people with skill in that field. A utility patent is far more expensive to obtain than a copyright, since the services of a patent attorney are almost always a necessity. These can cost thousands of dollars, depending on the complexity of the patent. A new process for developing film could qualify for a utility patent, but simply taking a photograph would not. A design patent is somewhat less expensive to obtain, and it protects manufactured items that have ornamental, original, and unobvious designs.

Trademarks are distinctive names, emblems, or mottos that identify to the public the source of goods or services. Using someone else's trademark is forbidden because the public would then become confused as to whose product or service it was buying. It's wise to consult an attorney before selecting a trademark, since you wouldn't want your trademark to be an infringement of someone else's. Trademarks gain protection simply by being used, although they can also be registered for federal and state protection.

THE PRIOR COPYRIGHT LAW

The new copyright law—effective January 1, 1978—has taken long enough to explain without going back over what the law used to be before January 1, 1978.

However, photographs taken before that date were governed by the old copyright law. If, for example, you published a photograph without copyright notice under the old law, it immediately went into the public domain. The new law doesn't revive these lost copyrights. Sales to magazines and rights in commissioned works were also governed by different presumptions. If your photographs taken before January 1, 1978, had copyright protection, after January 1, 1978, they are governed by the new copyright law.

MORE COPYRIGHT INFORMATION

Some of the best sources for copyright information are the Copyright Office circulars, which are available free by writing to the Copyright Office, Library of Congress, 101 Independence Avenue S.E., Washington, D.C. 20559-6000, or on the Copyright Office's Web site, located at *http://www.loc.gov/copyright/*. The Copyright Office will not, however, give you legal advice about copyright. Extensive coverage of copyright in relation to photographers and other artists can be found in *Legal Guide for the Visual Artist* by Tad Crawford.

THE COPYRIGHT FORMS

No discussion of copyright would be complete without the copyright forms. Form VA is the basic form used for photography to register either published or unpublished photographs. Short Form VA is a simpler form to use when you are the author of a work that is new and not work for hire. Form GR/PPh/CON would be used in addition to Form VA if you wanted to register published photographs that qualify for group treatment. The forms have helpful instructions that are included here.

Looking at the Form VA, let's assume first that you want to register a single unpublished photograph. In Space 1 you would give the title of the work and indicate "photograph" as the nature of the work. In Space 2 you would give your name as author and indicate the work is not work made for hire. You would also give your birth date, state your nationality, and indicate that your contribution to the work was neither anonymous nor pseudonymous. Where it says "Author of," you would check the box for "photograph." In Space 3 you would give only the years of completion—the year in which the photograph was made. Space 4 would have your name and address as those of the copyright claimant. In Space 5 you would indicate that no earlier registration had been made for the work. Space 6 you would leave blank. In Space 7b you would give your name and address for correspondence. In Space 8 you would check the box for author, sign your name, print or type your name, and give the date. Finally, in Space 9 you would show your name and address so that the Certificate of Registration could be mailed to you. Of course, if your situation doesn't fit the facts in these answers, you would make the necessary changes as you go through the form.

Taking the next typical case, you want to make a group registration of unpublished works. You follow the directions just given for registering a single unpublished work with a few changes. In Space 1 the title of the work is the

collection's title, such as "Collected Photographs of Jane Photographer, 2003." It is helpful to state the number of photographs in the collection. And in Space 3, the year of completion is the year in which the most recently completed photograph in the collection was finished.

Now let's assume that you want to register a published photograph. Again, the steps are basically the same as for the registration of a single unpublished photograph, with the following changes. In Space 1 you would indicate if the photograph had been published as a contribution to a collective work, such as a magazine, an anthology, or an encyclopedia, and give the required information with respect to the collective work. In Space 3 you would give not only the year of creation, but also the date and nation in which the first publication took place. In Space 5 you would indicate whether the work had previously been registered and, if it had been, check the box indicating the reason for the new registration and give the year and number of the previous registration. Space 6 you would fill out only if the photograph had been derived in some way from another work, which is not a likely possibility. Everything else would be the same as for the registration of a single unpublished photograph.

Finally, you might seek to register a group of published contributions to periodicals, if you qualify as explained under the section on registration of published photographs. To do this, you would use not only Form VA, but also Form GR/PPh/CON. Form VA is filled out as for a published photograph, but with a few changes. Space 1 is left blank, except for the title, where you write, "See Form GR/PPh/CON, attached." In Space 3 you give the year of creation, but leave blank the information with respect to publication. Next, you go to Form GR/PPh/CON. Here in Space A, you indicate that you are the author and copyright claimant. In Space B you fill in the required information with respect to each image. In Space C you put your name and address for the certificate to be mailed to you. And that's all.

Once you send off your registration form, deposit materials, and fee, you'll have to wait while your application is processed by the Copyright Office. But your registration takes effect the moment that the proper forms, deposit materials, and fee are received by the Copyright Office, no matter how long it is before you actually receive the Certificate of Registration.

FORM VA
For a Work of the Visual Arts
UNITED STATES COPYRIGHT OFFICE

REGISTRATION NUMBER

VA _____ VAU
EFFECTIVE DATE OF REGISTRATION

Month Day Year

DO NOT WRITE ABOVE THIS LINE. IF YOU NEED MORE SPACE, USE A SEPARATE CONTINUATION SHEET.

1

Title of This Work ▼ NATURE OF THIS WORK ▼ See instructions

Previous or Alternative Titles ▼

Publication as a Contribution If this work was published as a contribution to a periodical, serial, or collection, give information about the collective work in which the contribution appeared. **Title of Collective Work ▼**

If published in a periodical or serial give: **Volume ▼** **Number ▼** **Issue Date ▼** **On Pages ▼**

2

a

NAME OF AUTHOR ▼ DATES OF BIRTH AND DEATH
Year Born ▼ Year Died ▼

Was this contribution to the work a "work made for hire"?
☐ Yes
☐ No

Author's Nationality or Domicile
Name of Country
OR { Citizen of _____
Domiciled in _____

Was This Author's Contribution to the Work
Anonymous? ☐ Yes ☐ No If the answer to either of these questions is "Yes," see detailed instructions.
Pseudonymous? ☐ Yes ☐ No

NOTE

Under the law, the "author" of a "work made for hire" is generally the employer, not the employee (see instructions). For any part of this work that was "made for hire" check "Yes" in the space provided, give the employer (or other person for whom the work was prepared) as "Author" of that part, and leave the space for dates of birth and death blank.

Nature of Authorship Check appropriate box(es). **See instructions**
☐ 3-Dimensional sculpture ☐ Map ☐ Technical drawing
☐ 2-Dimensional artwork ☐ Photograph ☐ Text
☐ Reproduction of work of art ☐ Jewelry design ☐ Architectural work

b

Name of Author ▼ Dates of Birth and Death
Year Born ▼ Year Died ▼

Was this contribution to the work a "work made for hire"?
☐ Yes
☐ No

Author's Nationality or Domicile
Name of Country
OR { Citizen of _____
Domiciled in _____

Was This Author's Contribution to the Work
Anonymous? ☐ Yes ☐ No If the answer to either of these questions is "Yes," see detailed instructions.
Pseudonymous? ☐ Yes ☐ No

Nature of Authorship Check appropriate box(es). **See instructions**
☐ 3-Dimensional sculpture ☐ Map ☐ Technical drawing
☐ 2-Dimensional artwork ☐ Photograph ☐ Text
☐ Reproduction of work of art ☐ Jewelry design ☐ Architectural work

3

a Year in Which Creation of This Work Was Completed _____ Year This information must be given in all cases.

b Date and Nation of First Publication of This Particular Work
Complete this information ONLY if this work has been published. Month _____ Day _____ Year _____
_____ Nation

4

COPYRIGHT CLAIMANT(S) Name and address must be given even if the claimant is the same as the author given in space 2. ▼

See instructions before completing this space.

Transfer If the claimant(s) named here in space 4 is (are) different from the author(s) named in space 2, give a brief statement of how the claimant(s) obtained ownership of the copyright. ▼

APPLICATION RECEIVED

ONE DEPOSIT RECEIVED

TWO DEPOSITS RECEIVED

FUNDS RECEIVED

DO NOT WRITE HERE OFFICE USE ONLY

MORE ON BACK ▶ • Complete all applicable spaces (numbers 5-9) on the reverse side of this page.
• See detailed instructions. • Sign the form at line 8.

DO NOT WRITE HERE
Page 1 of _____ pages

DO NOT WRITE ABOVE THIS LINE. IF YOU NEED MORE SPACE, USE A SEPARATE CONTINUATION SHEET.

PREVIOUS REGISTRATION Has registration for this work, or for an earlier version of this work, already been made in the Copyright Office?

☐ **Yes** ☐ **No** If your answer is "Yes," why is another registration being sought? (Check appropriate box.) ▼

a. ☐ This is the first published edition of a work previously registered in unpublished form.

b. ☐ This is the first application submitted by this author as copyright claimant.

c. ☐ This is a changed version of the work, as shown by space 6 on this application.

If your answer is "Yes," give: **Previous Registration Number** ▼ **Year of Registration** ▼

5

DERIVATIVE WORK OR COMPILATION Complete both space 6a and 6b for a derivative work; complete only 6b for a compilation.

a. Preexisting Material Identify any preexisting work or works that this work is based on or incorporates. ▼

6

a

See instructions
before completing
this space.

b. Material Added to This Work Give a brief, general statement of the material that has been added to this work and in which copyright is claimed. ▼

b

DEPOSIT ACCOUNT If the registration fee is to be charged to a Deposit Account established in the Copyright Office, give name and number of Account.

Name ▼ **Account Number** ▼

7

a

CORRESPONDENCE Give name and address to which correspondence about this application should be sent. Name/Address/Apt/City/State/ZIP ▼

b

Area code and daytime telephone number () Fax number ()

Email

CERTIFICATION* I, the undersigned, hereby certify that I am the

check only one ▶ {
☐ author
☐ other copyright claimant
☐ owner of exclusive right(s)
☐ authorized agent of _____
 Name of author or other copyright claimant, or owner of exclusive right(s) ▲

8

of the work identified in this application and that the statements made by me in this application are correct to the best of my knowledge.

Typed or printed name and date ▼ If this application gives a date of publication in space 3, do not sign and submit it before that date.

_____ Date _____

Handwritten signature (X) ▼

X _____

Certificate
will be
mailed in
window
envelope
to this
address:

Name ▼

Number/Street/Apt ▼

City/State/ZIP ▼

YOU MUST:
• Complete all necessary spaces
• Sign your application in space 8

**SEND ALL 3 ELEMENTS
IN THE SAME PACKAGE:**
1. Application form
2. Nonrefundable filing fee in check or money order payable to *Register of Copyrights*
3. Deposit material

MAIL TO:
Library of Congress
Copyright Office
101 Independence Avenue, S.E.
Washington, D.C. 20559-6000

Fees are subject to
change. For current
fees, check the
Copyright Office
website at
www.copyright.gov,
write the Copyright
Office, or call
(202) 707-3000.

9

*17 U.S.C. § 506(e): Any person who knowingly makes a false representation of a material fact in the application for copyright registration provided for by section 409, or in any written statement filed in connection with the application, shall be fined not more than $2,500.

Rev: June 2002—20,000 Web Rev: June 2002 ♻ Printed on recycled paper U.S. Government Printing Office: 2000-461-113/20,021

Short Form VA

For a Work of the Visual Arts
UNITED STATES COPYRIGHT OFFICE

Registration Number

VA VAU

Effective Date of Registration

Application Received

Examined By

Deposit Received
One Two

Correspondence
Fee Received

TYPE OR PRINT IN BLACK INK. DO NOT WRITE ABOVE THIS LINE.

Title of This Work:	**1**	
Alternative title or title of larger work in which this work was published:		
Name and Address of Author and Owner of the Copyright:	**2**	
Nationality or domicile: Phone, fax, and email:		Phone () Fax () Email
Year of Creation:	**3**	
If work has been published, Date and Nation of Publication:	**4**	a. Date _____ Month Day Year *(Month, day, and year all required)* b. Nation
Type of Authorship in This Work: Check all that this author created.	**5**	☐ 3-Dimensional sculpture ☐ Photograph ☐ Map ☐ 2-Dimensional artwork ☐ Jewelry design ☐ Text ☐ Technical drawing
Signature: Registration cannot be completed without a signature.	**6**	*I certify that the statements made by me in this application are correct to the best of my knowledge.** Check one: ☐ Author ☐ Authorized agent X _____
Name and Address of Person to Contact for Rights and Permissions: Phone, fax, and email:	**7**	☐ Check here if same as #2 above. Phone () Fax () Email

OPTIONAL

8
Certificate will be mailed in window envelope to this address:

Name ▼

Number/Street/Apt ▼

City/State/ZIP ▼

Complete this space only if you currently hold a Deposit Account in the Copyright Office.

9 Deposit Account #_____
Name _____

DO NOT WRITE HERE Page 1 of _____ pages

Copyright **175**

CONTINUATION SHEET FOR FORM VA

for Group Registration of Published Photographs

- This optional Continuation Sheet (Form GR/PPh/CON) is used only in conjunction with Form VA for group registration of published photographs.
- If at all possible, try to fit the information called for into the spaces provided on Form VA, which is available with detailed instructions.
- If you do not have enough space for all the information you need to give on Form VA or if you do not provide all necessary information on each photograph, use this Continuation Sheet and submit it with completed Form VA.
- If you submit this Continuation Sheet, clip (do not tape or staple) it to completed Form VA and fold the two together before submitting them.
- Space A of this sheet is intended to identify the author and claimant.
- Space B is intended to identify individual titles and dates of publication (and optional description) of individual photographs.
- Use the boxes to number each line in Part B consecutively. If you need more space, use additional Forms GR/PPh/CON.
- Copyright fees are subject to change. For current fees, check the Copyright Office website at www.copyright.gov, write the Copyright Office, or call (202) 707-3000.

FORM GR/PPh/CON
UNITED STATES COPYRIGHT OFFICE

REGISTRATION NUMBER

USE ONLY WITH FORM VA

EFFECTIVE DATE OF REGISTRATION

(Month) (Day) (Year)

CONTINUATION SHEET RECEIVED

Page _____ of _____ pages

DO NOT WRITE ABOVE THIS LINE. FOR COPYRIGHT OFFICE USE ONLY

A

Identification of Application

IDENTIFICATION OF AUTHOR AND CLAIMANT: Give the name of the author and the name of the copyright claimant in all the contributions listed in Part B of this form. The names should be the same as the names given in spaces 2 and 4 of the basic application.

Name of Author _____

Name of Copyright Claimant _____

B

Registration for Group of Published Photographs

COPYRIGHT REGISTRATION FOR A GROUP OF PUBLISHED PHOTOGRAPHS: To make a single registration for a group of works by the same individual author, all published within 1 calendar year (see instructions), give full information about each contribution. If more space is needed, use additional Forms GR/PPh/CON. Number the boxes.

Number

Title of Photograph _____

Date of First Publication _____ (Month) _____ (Day) _____ (Year) Nation of First Publication _____

Description of Photograph _____ (Optional)

Number

Title of Photograph _____

Date of First Publication _____ (Month) _____ (Day) _____ (Year) Nation of First Publication _____

Description of Photograph _____ (Optional)

Number

Title of Photograph _____

Date of First Publication _____ (Month) _____ (Day) _____ (Year) Nation of First Publication _____

Description of Photograph _____ (Optional)

Number

Title of Photograph _____

Date of First Publication _____ (Month) _____ (Day) _____ (Year) Nation of First Publication _____

Description of Photograph _____ (Optional)

Number

Title of Photograph _____

Date of First Publication _____ (Month) _____ (Day) _____ (Year) Nation of First Publication _____

Description of Photograph _____ (Optional)

Number		

Title of Photograph _____

Date of First Publication _____ (Month) _____ (Day) _____ (Year) Nation of First Publication _____

Description of Photograph _____ (Optional) _____

Number		

Title of Photograph _____

Date of First Publication _____ (Month) _____ (Day) _____ (Year) Nation of First Publication _____

Description of Photograph _____ (Optional) _____

Number		

Title of Photograph _____

Date of First Publication _____ (Month) _____ (Day) _____ (Year) Nation of First Publication _____

Description of Photograph _____ (Optional) _____

Number		

Title of Photograph _____

Date of First Publication _____ (Month) _____ (Day) _____ (Year) Nation of First Publication _____

Description of Photograph _____ (Optional) _____

Number		

Title of Photograph _____

Date of First Publication _____ (Month) _____ (Day) _____ (Year) Nation of First Publication _____

Description of Photograph _____ (Optional) _____

Number		

Title of Photograph _____

Date of First Publication _____ (Month) _____ (Day) _____ (Year) Nation of First Publication _____

Description of Photograph _____ (Optional) _____

Number		

Title of Photograph _____

Date of First Publication _____ (Month) _____ (Day) _____ (Year) Nation of First Publication _____

Description of Photograph _____ (Optional) _____

Number		

Title of Photograph _____

Date of First Publication _____ (Month) _____ (Day) _____ (Year) Nation of First Publication _____

Description of Photograph _____ (Optional) _____

Number		

Title of Photograph _____

Date of First Publication _____ (Month) _____ (Day) _____ (Year) Nation of First Publication _____

Description of Photograph _____ (Optional) _____

Number		

Title of Photograph _____

Date of First Publication _____ (Month) _____ (Day) _____ (Year) Nation of First Publication _____

Description of Photograph _____ (Optional) _____

Copyright **177**

"To produce an income tax return that has any depth to it, any feeling, one must have Lived—and Suffered." The truth of this quip by author Frank Sullivan might be felt most vividly in April, when many photographers scramble to gather the information, and sometimes the funds, to file their income tax returns. This chapter is written with the intent of enabling you to plan, keep proper records on a regular basis, and pay estimated taxes on time. Sometimes, you can take steps near the end of the year to relieve your tax burden, but, more often, the end of the year is too late. You need to keep your tax information up to date on a regular basis throughout the entire year. If you follow the simple recommendations here, tax preparation should be considerably easier, your tax bill might be smaller, and you will be better prepared to handle an IRS audit. Nonetheless, this chapter is not intended to substitute for the advice or services of a qualified tax advisor. Tax regulations change continuously, and few books can aspire to be completely accurate and current when it comes to income tax rules. This chapter is an overview based on current tax law, intended to explain the basic concepts most important to photographers, so you can prepare and carry out a tax strategy that will make your accountant's job easier in April. The IRS publications mentioned in this chapter can be obtained free by request from the IRS or by visiting the IRS Web site at *www.irs.gov*.

TAX YEARS AND ACCOUNTING METHODS

Your tax year is probably the calendar year, running from January 1 through December 31. This means that your income and expenses between those dates are used to fill out Schedule C, "Profit or Loss from Business." Schedule C is attached to your Form 1040 when you file your tax return.

What's the alternative to using the calendar year as your tax year? You could have what's called a fiscal year. This means a tax year starting from a date other than January 1, such as from July 1 through June 30. Most photographers use the calendar year and, if you do use a fiscal year, you will almost certainly have an accountant. For these reasons, we are going to assume that you are using a calendar year.

But how do you know whether income you receive or expenses you pay fall into your tax year? This depends on the accounting method that you use. Under the cash method, which most photographers use, you receive income for tax purposes when you in fact receive the income. That's just what you would

expect. And you incur an expense for tax purposes when you actually pay the money for the expense. So it's easy to know which tax year your items of income and expense should be recorded in.

What is the alternative to cash-method accounting? It's called accrual accounting. Essentially, it provides that you record an item of income when you have a right to receive it and record an item of expense when you are obligated to pay it. Once again, it's unlikely you will use the accrual method, so we will focus on the more typical case of the photographer who uses the cash method.

One final assumption is that you are a sole proprietor and not a partnership or corporation. The benefits and drawbacks of proprietorships, partnerships, corporations, and limited liability companies were discussed in chapter 8. In any event, the general principles discussed in this chapter apply to all forms of doing business.

RECORD KEEPING

Tax Records
If you want to avoid trouble with the Internal Revenue Service, you must keep your books in order. One of the most common reasons for the disallowance of deductions is simply the lack of records to corroborate the expenses. Your records can, however, be simple. And you don't have to know a lot of technical terms. You only have to record your income and expenses accurately so that you can determine how much you owe in taxes for the year.

You may use software like Quicken or QuickBooks to help you keep your tax records. These programs are helpful in many ways, because they not only keep track of income and expenses, but also place items of income or expense into proper categories and generate reports that are useful for you and your accountant. If you don't use such software, at the least you will want to keep a simple ledger or diary in which you enter your items of income and expense as they arise. This would mean that you enter the items regularly as they occur—at least on a weekly basis—and don't wait until the end of the year to make the entries. If you're consistent this way, you will be able to take some expenses even if they're not documented by receipts or canceled checks. Such substantiation is generally not required for expenses that are less than $75. The ledger or diary should include a log of business travel, local automobile mileage, and the details of any entertainment or gift expenses. You should open a business checking account so that the distinction between personal and business expenditures is clear. If an item raises a question, you will want to make a note in your records as to why it is for business and not personal.

You should also keep a permanent record of expenditures for capital assets—those assets that have a useful life of more than one year—such as a camera. This is necessary for you to justify the depreciation expense you will compute for the assets. In addition, grant letters, contracts, and especially tax returns should be retained as part of your permanent files.

If you are keeping your records by hand, you might want to set up an Expense Ledger and an Income Ledger. The Expense Ledger could be set up in the form shown on this page. Each time you incur an expense, you make two entries. First you put the amount under Total Cash if you paid with cash, or Total Check if you paid by check. Then you enter the amount under the appropriate expense heading. In this way, you can be certain of your addition, because the total of the entries under Total Cash and Total Check should equal the total of the entries under all the columns for specific expenses. If you paid cash for ten rolls of film on January 2, 2004, the entry of $78 would appear once under Total Cash and once under Film and Processing. If, on January 4, you then hired for $750 each three models and paid them by check, the entry of $750 would appear under Total Check and under Model Fees. Ledger books with many-columned sheets can be purchased at any good stationery store.

EXPENSE LEDGER

Date	Item	Total cash	Total check	Legal and accounting fees	Film and processing	Office supplies	Salaries	Model fees	Advertising	Props and wardrobe	Entertainment	Rent	Utilities	Commissions	Freelance assistants and stylists	Meals and lodging	Transportation	Telephone	Equipment	Insurance	Miscellaneous

If you coordinate the expense categories in your Expense Ledger with those on Schedule C of your income tax form, you can save a lot of time when you have to fill out your tax forms.

How should you file receipts you get for paying your expenses? A simple method is to have a Bills Paid file in which you put these receipts in alphabetical order. An accordion-type file works fine and you'll be able to locate the various receipts easily.

After you have set up your Expense Ledger, you have to set up your Income Ledger. This can be done with the following format:

INCOME LEDGER

Date	Client or Customer	Job No.	Fee	Billable Expenses	Sales Tax	Other
1/3	Acme Advertising	35	$700	$375	$80	
1/6	Johnson Publishing	43	$315	$145		

We've assumed that you are using the simplest form of bookkeeping. However, if you accurately keep the records we've just described, you'll be able to support your deductions in the event of an audit. For further information about the "permanent, accurate and complete" records the IRS requires, you can consult IRS Publications 552, *Recordkeeping for Individuals,* and 583, *Starting a Business and Keeping Records.*

INCOME

Income for tax purposes includes all the money generated by your business—fees, royalties, sales of art, and so on. Prizes and awards will usually be included in income, unless they're the kind of prizes or awards that you receive without having to make any application. Grants will usually be included in income, except for amounts paid for tuition, books, supplies, and fees for students who are degree candidates (which is explained more fully in IRS Publication 520, *Scholarships and Fellowships*). You can find more information about what constitutes income in IRS Publication 17, *Your Federal Income Tax,* chapter 7, "What Income is Taxable." All IRS publications are available free of charge from your local IRS office.

It's worth mentioning that insurance proceeds received for the loss of photographs, negatives, or transparencies are income. And if you barter, the value of what you receive is also income. So trading a photograph for the services of an accountant gives you income in the amount of the fair market value of the accountant's services.

In general, the photographer's income will be *earned ordinary income,* such as that from salary, fees, royalties, sales of art, and so on. *Unearned ordinary income*

would be such items as interest on a savings account, dividends from stock, or short-term capital gains (which is profit from the sale of capital assets, such as stocks, bonds, and gold, that you have owned one year or less). The lowest tax rates apply to long-term capital gains, which is profit from the sale of capital assets that you have owned for more than one year. Unfortunately, photographers will almost always have earned ordinary income from their business activities and not long-term capital gains.

The income tax rate, by the way, is progressive. The more money you earn, the higher is the percentage you have to pay in taxes. But the higher percentages apply only to each additional amount of taxable income, not to all your taxable income. So if the tax on your first $3,000 of taxable income is $303 (about 10 percent), the tax on that first $3,000 will always be 10 percent—even if your highest increment is at $100,000 of taxable income and is taxed at roughly 30 percent. In fact, the tax on a single filer with an income of $100,000 is $24,308, so the average rate of tax is 24.3 percent, even though the lowest amounts of income have a lower rate of tax and the highest amounts of income have a higher rate of tax.

EXPENSES

Expenses reduce your income. Any ordinary and necessary business expense may be deducted from your income for tax purposes. This includes photographic supplies, office supplies and expenses such as paper and postage, messenger fees, prop rentals, transportation costs, business entertainment, secretarial help, legal and accounting fees, commissions paid to an agent, books or subscriptions directly related to your business, professional dues, telephone expenses, rent, and so on. On Schedule C these expenses are entered on the appropriate lines or, if not listed, under "Miscellaneous."

Because your right to deduct certain expenses can be tricky, we're going to discuss some of the potential items of expense in detail.

HOME STUDIO

If you have your studio at a location away from your home, you can definitely deduct rent, utilities, maintenance, telephone, and other related expenses. Under today's tax laws, you would be wise to locate your studio away from home if possible, because if your studio is at home, you will have to meet a number of requirements before you can take deductions for your studio. To put it another way, if you're going to have your studio at home, be certain you meet the tests and qualify to take a business deduction for rent and related expenses.

The law states that a deduction for a studio at home can be taken if "a portion of the dwelling unit is exclusively used on a regular basis (A) as the taxpayer's principal place of business, (B) as a place of business which is used by patients, clients, or customers in meeting or dealing with the taxpayer in the normal course of his trade or business, or (C) in the case of a separate structure which is not attached to the dwelling unit, in connection with the taxpayer's trade or

business." Exclusivity means that the space is used only for the business activity of being a photographer. If the space is used for both business and personal use, the deduction will not be allowed. For example, a studio that doubles as a television room will not qualify under the exclusivity rule. (However, the Tax Court recently allowed a home office deduction when the taxpayer, a musician, "exclusively used a clearly defined portion" of a room for business purposes. This case cannot be relied on because it was decided under a provision of the tax laws aimed at settling disputes under $50,000—and these determinations are not precedents. But it might be worth discussing this with your accountant.) The requirement of regularity means that the photographer must use the space on a more or less daily basis for a minimum of several hours per day. Occasional or infrequent use certainly will not qualify.

If the work space is used exclusively and on a regular basis, the studio expenses can qualify as deductible under one of three different tests. First, they will be deductible if the studio is your principal place of business. But what happens if you must work at other employment or run another business in order to earn the larger part of your income? In this case, it would appear that the principal-place requirement refers to each business separately. Is the studio at home the principal place of the business of being a photographer? If it is, the fact that you also work elsewhere shouldn't matter. However, you could not deduct a studio at home under this provision if you did most of your work in another studio, maintained at a different location. The second instance in which the expenses can be deductible occurs when the studio is used as a place of business for meeting with clients or customers in the normal course of a trade or business. Many photographers do open their studio at home to clients in the normal course of their business activities, so this provision might well be applicable. Finally, the expenses for a separate structure, such as a storage shed, would qualify for deduction if the structure were used in connection with the business of being a photographer. If you are seeking to deduct home studio expenses as an employee rather than a freelancer, you must not only use the space exclusively on a regular basis for business and meet one of the three additional tests just described, but you must also maintain the space for the convenience of your employer. A photography teacher, for example, might argue that a studio at home was required by the school, especially if no studio space were available at the school and professional achievements in photography were expected of faculty members.

The photographer who does use the work space exclusively on a regular basis for one of the three permitted uses just discussed must pass yet one more test before being able to deduct the expenses. This is a limitation on the amount of expenses that can be deducted in connection with a studio at home. Basically, such expenses cannot exceed your gross income from your business as a photographer. The computation is done on Form 8829, *Expenses for Business Use of Your Home.* For additional information, refer to IRS Publication 587, *Business Use of Your Home.*

EDUCATIONAL EXPENSES

You may want to improve your skills as a photographer by taking a variety of educational courses. The rule is that you can deduct these educational expenses if they are for the purpose of maintaining or improving your skills in a field that you are already actively pursuing. You cannot deduct such expenses if they are to enable you to enter a new field or meet the minimal educational requirements for an occupation. For example, photography students in college cannot deduct their tuition when they are learning the skills necessary to enter a new field. A photographer who has been in business several years could deduct expenses incurred in learning better photographic techniques or even better business techniques. Both would qualify as maintaining or improving skills in the photographer's field.

PROFESSIONAL EQUIPMENT

You can spend a tremendous amount of money on cameras, lights, darkroom equipment, and the like. This equipment will last more than one year. For this reason, you cannot deduct the full price of the equipment in the year that you buy it. Instead, you must depreciate it over the years of its useful life. Depreciation is the process by which a part of the cost of equipment is deducted as an expense in each year of the equipment's useful life.

To take a simplified example, you might purchase a camera for $1,000. Based on your experience, you believe that a reasonable estimate of the useful life of the camera is five years. Using the simplest method of depreciation—straight-line depreciation—you would divide five years into $1,000. Each year for five years, you would take a $200 depreciation deduction for the camera.

In fact, the calculation of depreciation is more complicated than this because there are methods of depreciation other than straight-line, which result in quicker write-offs. The complexities of these various options are discussed in IRS Publication 946, *How to Depreciate Property.* That publication also deals with Section 179 property. This allows you to write off the full cost in the year purchased of certain property that would normally have to be depreciated. For 2002, the maximum amount of property that could be written off pursuant to Section 179 was $24,000. This is scheduled to increase to $25,000 for 2003 and subsequent years. Also, the total amount of property expensed under this provision in any one year cannot exceed the taxable income derived from the conduct of the business during that year. Any excess would be carried forward to be deducted in future years.

If you have a substantial investment in equipment, it would be worthwhile to have an accountant aid you in the depreciation and Section 179 computations.

TRAVEL

Many photographers are required to travel in the course of their work. Some examples of business travel include travel to do an assignment, to negotiate a deal, to seek new clients, or to attend a business or educational seminar related

to your professional activities. Travel expenses (as opposed to transportation expenses, which are explained later) are incurred when you go away from your home and stay away overnight or at least have to sleep or rest while away. If you qualify, you can deduct expenses for travel, meals and lodging, laundry, transportation, baggage, reasonable tips, and similar business-related expenses. This includes expenses on your day of departure and return, as well as on holidays and unavoidable layovers that come between business days.

The IRS has strict record-keeping requirements for travel expenses. These requirements also apply to business entertainment and gifts, since these are all categories that the IRS closely scrutinizes for abuses. The requirements are for records or corroboration showing: (1) the amount of the expense; (2) the time and place of the travel or entertainment, or the date and description of any gift; (3) the business purpose of the expense; and (4) the business relationship to the person being entertained or receiving a gift.

If you travel solely for business purposes, all your travel expenses are deductible. If you take part in some nonbusiness activities, your travel expenses to and from the destination will be fully deductible as long as your purpose in traveling is primarily for business and you are traveling in the United States. However, you can deduct only business-related expenses, not personal expenses. If you go primarily for personal reasons, you will not be able to take the travel expenses incurred in going to and from your destination (but you can deduct legitimate business expenses at your destination).

If you are traveling outside the United States and devoting your time solely to business, you may deduct all your travel expenses just as you would for travel in the United States. If the travel outside the United States was primarily for business but included some personal activities, you may deduct the expenses as you would for travel primarily for business in the United States if you meet any of the following four tests: (1) You had no substantial control over arranging the trip; (2) You were outside the United States for a week or less; (3) You spent less than one-quarter of your time outside the United States on nonbusiness activities; (4) You can show that personal vacation was not a major factor in your trip. If you don't meet any of these tests, you must allocate your travel expenses. Expenses that are less than $75 do not require documentation.

By the way, if your spouse goes with you on a trip, his or her expenses are not deductible unless you can prove a bona fide business purpose and need for your spouse's presence. Incidental services, such as typing or entertaining, aren't enough.

The IRS is very likely to challenge travel expenses, especially if the auditor believes a vacation was the real purpose of the trip. To successfully meet such a challenge, you must have good records that substantiate the business purpose of the trip and the details of your expenses. For more information with respect to travel expenses, you should consult IRS Publication 463, *Travel, Entertainment, Gift, and Car Expenses.*

TRANSPORTATION

Transportation expenses must be distinguished from travel expenses. First of all, commuting expenses are not deductible. Traveling from your home to your studio is considered a personal expense. If you have to go to your studio and then go on to a business appointment, or if you have a temporary job that takes you to a location remote from your home and you return home each night, you can deduct these expenses as transportation expenses. But only the transportation itself is deductible, not meals, lodging, and the other expenses that could be deducted when travel was involved. If you have a home office, your expenses to go to another work location in the same business would be deductible (although the IRS will only follow this court decision if the residence is also the principal place of business).

The IRS sets out guidelines for how much you can deduct when you use your automobile for business transportation. The standard mileage rate was 36.5 cents for 2002 and decreased to 36 cents for 2003. In addition, you can deduct interest on a car loan, parking fees, and tolls if spent for a business purpose.

However, you don't have to use the standard mileage rate. You may prefer to depreciate your automobile and keep track of gasoline, oil, repairs, licenses, insurance, and the like. By calculating both possible ways, you may find that actually keeping track of your expenses gives you a far larger deduction than the standard mileage amount.

Of course, if you use your automobile for both business and personal purposes, you must allocate the expenses to the business use for determining what amount is deductible. IRS Publication 463, *Travel, Entertainment, Gift, and Car Expenses,* details the deductibility of car expenses.

ENTERTAINMENT AND GIFTS

The IRS guidelines for documenting entertainment and gift expenses were already set out when we discussed travel.

Entertainment expenses must be either directly related to your business activities or associated with such business if the expense occurs directly before or after a business discussion.

Business luncheons, parties for business associates or clients, entertainment, and similar activities are all permitted if a direct business purpose can be shown. However, the expenses for entertainment must not be lavish or extravagant. Also, in general, only 50 percent of the expenses for meals and other entertainment expenses will be allowable as deductions. This 50 percent limitation applies to entertainment expenses for meals and beverages incurred while traveling (but meals eaten alone on a trip would be deductible in full).

Business gifts are deductible, and you can give gifts to as many people as you want. However, the gifts are deductible only up to the amount of $25 per person each year.

For both entertainment and gift expenses, you should again consult IRS Publication 463, *Travel, Entertainment, Gift, and Car Expenses.*

SCHEDULE C (Form 1040)	**Profit or Loss From Business** (Sole Proprietorship)	OMB No. 1545-0074
Department of the Treasury Internal Revenue Service (99)	▶ Partnerships, joint ventures, etc., must file Form 1065 or 1065-B. ▶ Attach to Form 1040 or 1041. ▶ See Instructions for Schedule C (Form 1040).	**2002** Attachment Sequence No. 09

Name of proprietor | Social security number (SSN)

A Principal business or profession, including product or service (see page C-1 of the instructions) | B Enter code from pages C-7, 8, & 9 ▶

C Business name. If no separate business name, leave blank. | D Employer ID number (EIN), if any

E Business address (including suite or room no.) ▶ ...
City, town or post office, state, and ZIP code

F Accounting method: (1) ☐ Cash (2) ☐ Accrual (3) ☐ Other (specify) ▶
G Did you "materially participate" in the operation of this business during 2002? If "No," see page C-3 for limit on losses ☐ Yes ☐ No
H If you started or acquired this business during 2002, check here ▶ ☐

Part I Income

1	Gross receipts or sales. Caution. If this income was reported to you on Form W-2 and the "Statutory employee" box on that form was checked, see page C-3 and check here ▶ ☐	1	
2	Returns and allowances 	2	
3	Subtract line 2 from line 1 	3	
4	Cost of goods sold (from line 42 on page 2) 	4	
5	Gross profit. Subtract line 4 from line 3 	5	
6	Other income, including Federal and state gasoline or fuel tax credit or refund (see page C-3) . . .	6	
7	Gross income. Add lines 5 and 6 ▶	7	

Part II Expenses. Enter expenses for business use of your home only on line 30.

8	Advertising 	8		19	Pension and profit-sharing plans	19
9	Bad debts from sales or services (see page C-3) . .	9		20	Rent or lease (see page C-5):	
				a	Vehicles, machinery, and equipment .	20a
10	Car and truck expenses (see page C-3) 	10		b	Other business property . .	20b
11	Commissions and fees . .	11		21	Repairs and maintenance .	21
12	Depletion 	12		22	Supplies (not included in Part III) .	22
13	Depreciation and section 179 expense deduction (not included in Part III) (see page C-4) . .	13		23	Taxes and licenses 	23
				24	Travel, meals, and entertainment:	
				a	Travel 	24a
14	Employee benefit programs (other than on line 19) . . .	14		b	Meals and entertainment	
15	Insurance (other than health) .	15		c	Enter nondeductible amount included on line 24b (see page C-5) .	
16	Interest:			d	Subtract line 24c from line 24b	24d
a	Mortgage (paid to banks, etc.) .	16a		25	Utilities 	25
b	Other 	16b		26	Wages (less employment credits) .	26
17	Legal and professional services 	17		27	Other expenses (from line 48 on page 2) 	27
18	Office expense 	18				

28	Total expenses before expenses for business use of home. Add lines 8 through 27 in columns . ▶	28	
29	Tentative profit (loss). Subtract line 28 from line 7 	29	
30	Expenses for business use of your home. Attach Form 8829 	30	
31	Net profit or (loss). Subtract line 30 from line 29. • If a profit, enter on Form 1040, line 12, and also on Schedule SE, line 2 (statutory employees, see page C-6). Estates and trusts, enter on Form 1041, line 3. • If a loss, you must go to line 32.	31	

32 If you have a loss, check the box that describes your investment in this activity (see page C-6).
• If you checked 32a, enter the loss on Form 1040, line 12, and also on Schedule SE, line 2 (statutory employees, see page C-6). Estates and trusts, enter on Form 1041, line 3.
• If you checked 32b, you must attach Form 6198.

32a ☐ All investment is at risk.
32b ☐ Some investment is not at risk.

For Paperwork Reduction Act Notice, see Form 1040 instructions. Cat. No. 11334P Schedule C (Form 1040) 2002

Part III	Cost of Goods Sold (see page C-6)

33 Method(s) used to value closing inventory: a ☐ Cost b ☐ Lower of cost or market c ☐ Other (attach explanation)

34 Was there any change in determining quantities, costs, or valuations between opening and closing inventory? If "Yes," attach explanation . ☐ Yes ☐ No

35	Inventory at beginning of year. If different from last year's closing inventory, attach explanation . .	35
36	Purchases less cost of items withdrawn for personal use	36
37	Cost of labor. Do not include any amounts paid to yourself	37
38	Materials and supplies	38
39	Other costs	39
40	Add lines 35 through 39	40
41	Inventory at end of year	41
42	Cost of goods sold. Subtract line 41 from line 40. Enter the result here and on page 1, line 4 . .	42

Part IV	Information on Your Vehicle. Complete this part only if you are claiming car or truck expenses on line 10 and are not required to file Form 4562 for this business. See the instructions for line 13 on page C-4 to find out if you must file.

43 When did you place your vehicle in service for business purposes? (month, day, year) ▶/......../........ .

44 Of the total number of miles you drove your vehicle during 2002, enter the number of miles you used your vehicle for:

a Business b Commuting c Other

45 Do you (or your spouse) have another vehicle available for personal use? ☐ Yes ☐ No

46 Was your vehicle available for personal use during off-duty hours? ☐ Yes ☐ No

47a Do you have evidence to support your deduction? ☐ Yes ☐ No

b If "Yes," is the evidence written? . ☐ Yes ☐ No

Part V	Other Expenses. List below business expenses not included on lines 8 –26 or line 30.

..		
..		
..		
..		
..		
..		
..		
..		
48 Total other expenses. Enter here and on page 1, line 27	48	

⊕

Schedule C (Form 1040) 2002

SCHEDULE C-EZ
(Form 1040)

Department of the Treasury
Internal Revenue Service (99)

Net Profit From Business

(Sole Proprietorship)

▶ Partnerships, joint ventures, etc., must file Form 1065 or 1065-B.

▶ Attach to Form 1040 or 1041. ▶ See instructions on back.

OMB No. 1545-0074

2002

Attachment
Sequence No. **09A**

Name of proprietor

Social security number (SSN)

Part I General Information

**You May Use
Schedule C-EZ
Instead of
Schedule C
Only If You:**

- Had business expenses of $2,500 or less.
- Use the cash method of accounting.
- Did not have an inventory at any time during the year.
- Did not have a net loss from your business.
- Had only one business as a sole proprietor.

And You:

- Had no employees during the year.
- Are not required to file **Form 4562**, Depreciation and Amortization, for this business. See the instructions for Schedule C, line 13, on page C-4 to find out if you must file.
- Do not deduct expenses for business use of your home.
- Do not have prior year unallowed passive activity losses from this business.

A Principal business or profession, including product or service

B Enter code from pages C-7, 8, & 9
▶

C Business name. If no separate business name, leave blank.

D Employer ID number (EIN), if any

E Business address (including suite or room no.). Address not required if same as on Form 1040, page 1.

City, town or post office, state, and ZIP code

Part II Figure Your Net Profit

1 Gross receipts. **Caution.** If this income was reported to you on Form W-2 and the "Statutory employee" box on that form was checked, see **Statutory Employees** in the instructions for Schedule C, line 1, on page C-3 and check here ▶ ☐ **1**

2 Total expenses (see instructions). If more than $2,500, you **must** use Schedule C **2**

3 Net profit. Subtract line 2 from line 1. If less than zero, you **must** use Schedule C. Enter on **Form 1040, line 12,** and **also** on **Schedule SE, line 2.** (Statutory employees **do not** report this amount on Schedule SE, line 2. Estates and trusts, enter on Form 1041, line 3.) **3**

Part III Information on Your Vehicle. Complete this part **only** if you are claiming car or truck expenses on line 2.

4 When did you place your vehicle in service for business purposes? (month, day, year) ▶/...../...... .

5 Of the total number of miles you drove your vehicle during 2002, enter the number of miles you used your vehicle for:

a Business **b** Commuting **c** Other

6 Do you (or your spouse) have another vehicle available for personal use? ☐ **Yes** ☐ **No**

7 Was your vehicle available for personal use during off-duty hours? ☐ **Yes** ☐ **No**

8a Do you have evidence to support your deduction? ☐ **Yes** ☐ **No**

b If "Yes," is the evidence written? . ☐ **Yes** ☐ **No**

For Paperwork Reduction Act Notice, see Form 1040 instructions. Cat. No. 14374D Schedule C-EZ (Form 1040) 2002

Form **8829**	**Expenses for Business Use of Your Home**	OMB No. 1545-1266
Department of the Treasury Internal Revenue Service (99)	► File only with Schedule C (Form 1040). Use a separate Form 8829 for each home you used for business during the year. ► See separate instructions.	**2002** Attachment Sequence No. **66**

Name(s) of proprietor(s) Your social security number

Part I — Part of Your Home Used for Business

1	Area used regularly and exclusively for business, regularly for day care, or for storage of inventory or product samples (see instructions)	1	
2	Total area of home	2	
3	Divide line 1 by line 2. Enter the result as a percentage	3	%

• For day-care facilities not used exclusively for business, also complete lines 4–6.
• All others, skip lines 4–6 and enter the amount from line 3 on line 7.

4	Multiply days used for day care during year by hours used per day	4	hr.
5	Total hours available for use during the year (365 days × 24 hours) (see instructions)	5	8,760 hr.
6	Divide line 4 by line 5. Enter the result as a decimal amount	6	.
7	Business percentage. For day-care facilities not used exclusively for business, multiply line 6 by line 3 (enter the result as a percentage). All others, enter the amount from line 3 ►	7	%

Part II — Figure Your Allowable Deduction

8	Enter the amount from Schedule C, line 29, **plus** any net gain or (loss) derived from the business use of your home and shown on Schedule D or Form 4797. If more than one place of business, see instructions	8		

See instructions for columns (a) and (b) before completing lines 9–20.

			(a) Direct expenses	(b) Indirect expenses		
9	Casualty losses (see instructions)	9				
10	Deductible mortgage interest (see instructions)	10				
11	Real estate taxes (see instructions)	11				
12	Add lines 9, 10, and 11	12				
13	Multiply line 12, column (b) by line 7			13		
14	Add line 12, column (a) and line 13				14	
15	Subtract line 14 from line 8. If zero or less, enter -0-				15	
16	Excess mortgage interest (see instructions)	16				
17	Insurance	17				
18	Repairs and maintenance	18				
19	Utilities	19				
20	Other expenses (see instructions)	20				
21	Add lines 16 through 20	21				
22	Multiply line 21, column (b) by line 7			22		
23	Carryover of operating expenses from 2001 Form 8829, line 41			23		
24	Add line 21 in column (a), line 22, and line 23				24	
25	Allowable operating expenses. Enter the **smaller** of line 15 or line 24				25	
26	Limit on excess casualty losses and depreciation. Subtract line 25 from line 15				26	
27	Excess casualty losses (see instructions)			27		
28	Depreciation of your home from Part III below			28		
29	Carryover of excess casualty losses and depreciation from 2001 Form 8829, line 42			29		
30	Add lines 27 through 29				30	
31	Allowable excess casualty losses and depreciation. Enter the **smaller** of line 26 or line 30				31	
32	Add lines 14, 25, and 31				32	
33	Casualty loss portion, if any, from lines 14 and 31. Carry amount to **Form 4684**, Section B				33	
34	Allowable expenses for business use of your home. Subtract line 33 from line 32. Enter here and on Schedule C, line 30. If your home was used for more than one business, see instructions ►				34	

Part III — Depreciation of Your Home

35	Enter the **smaller** of your home's adjusted basis or its fair market value (see instructions)	35	
36	Value of land included on line 35	36	
37	Basis of building. Subtract line 36 from line 35	37	
38	Business basis of building. Multiply line 37 by line 7	38	
39	Depreciation percentage (see instructions)	39	%
40	Depreciation allowable (see instructions). Multiply line 38 by line 39. Enter here and on line 28 above	40	

Part IV — Carryover of Unallowed Expenses to 2003

41	Operating expenses. Subtract line 25 from line 24. If less than zero, enter -0-	41	
42	Excess casualty losses and depreciation. Subtract line 31 from line 30. If less than zero, enter -0-	42	

For Paperwork Reduction Act Notice, see page 4 of separate instructions. Cat. No. 13232M Form **8829** (2002)

BEYOND SCHEDULE C

So far, we've mainly been discussing income and expenses that would appear on Schedule C. Copies of Schedule C, Schedule C-EZ, and Form 8829 are included here for your reference. It's worth mentioning that some accountants for photographers believe that high gross receipts themselves or a high ratio of gross receipts on line I to net profits on line 31 may invite an audit. If you incur many expenses that are reimbursed by your clients, these accountants simply treat both expenses and reimbursement as if they cancelled each other out; this results in the same net profit, but your gross receipts are less. The expenses and reimbursements are shown on a page attached to Schedule C or in a footnote indicating the total amounts at the bottom of the front page of Schedule C. Or you could include the reimbursement as part of gross receipts and then subtract the expenses as deductions.

Schedule C is not the only schedule of importance to the photographer. There are potential income tax savings—and obligations—that require using other forms.

RETIREMENT ACCOUNTS

You, as a self-employed person, can contribute to a retirement plan called a Keogh plan (after the sponsor of the legislation that allowed such contributions). The amount that you contribute to the plan is deducted from your income on Form 1040. While you must set up the Keogh plan during the tax year for which you want to deduct your payments to the plan from your income, once you have set up the plan, you are permitted to wait to make the actual payment of money until your tax return must be filed (including extensions). The payments into a Keogh plan must be kept in certain special types of accounts, such as a custodial account with a bank, a trust fund, or special United States Government retirement bonds. You don't have to pay taxes on any income earned by money in your Keogh account, but you are penalized if you withdraw any money from the account prior to age 59 1/2 (unless you are disabled or die—in which case your family could withdraw the money). The money will be taxed when you withdraw it for your retirement, but you may be in a lower tax bracket then. In any case, you will have had the benefit of all the interest earned by the money that would have been spent as taxes if you hadn't created a Keogh retirement plan.

You can create a Keogh plan as long as you have net self-employment income. This is true even if you have another job and your employer also has a retirement plan for you. If you have only a small amount of self-employment income, you'll still be able to make a minimum payment to a Keogh plan. IRS Publication 560, *Retirement Plans for Small Business,* discusses the Keogh and other retirement plans that can be used by a small business.

If you have no Keogh plan and your employer does not provide any retirement plan, either, you are eligible to create an Individual Retirement Account (IRA). You can create such a plan any time before your tax return for the year

must be filed (without regard to extensions, so this will usually be April 15) and pay in your money at the same time. The money you pay in—for 2002–2004, the limits are $3,000 for an individual or $6,000 for married couples filing jointly—is deducted from your income for the year covered by the tax return. If you are over 50, the limits increase to $3,500 for an individual and $7,000 for joint filers. If you make too large an income, you will be restricted from contributing to an IRA.

A more recent variant of the IRA is the Roth IRA. The initial contribution to a Roth IRA is not deductible, so after-tax dollars go into the plan. The advantage of the Roth IRA is that distributions coming out of the plan are not taxed (provided that such distributions are made after the five-year period commencing with the first year in which a contribution was made and that you are 59 1/2 or older). This means that any appreciation in value of the plan assets will escape taxation. The Roth IRA has the same contribution limits as the traditional IRA. If contributions are made to both types of IRAs, the contribution limits in total are still the amounts shown in the preceding paragraph. So if you are under 50, file jointly, and contribute $4,000 to a traditional IRA, you can only contribute $2,000 to a Roth IRA. If you can afford to contribute to a Roth IRA, it seems a better investment than the traditional IRA.

You can obtain more information about retirement plans from the institutions that administer them. In addition to IRS Publication 560, *Retirement Plans for Small Business,* other helpful publications are IRS Publication 17, *Your Federal Income Tax,* and IRS Publication 590, *Individual Retirement Accounts.*

CHILD AND DISABLED DEPENDENT CARE

If you have a child or disabled dependent for whom you must hire help in order to be able to work, you should be able to take a tax credit for part of the money you spend. This is more fully explained in IRS Publication 503, *Child Care and Dependent Care Expenses.*

CHARITABLE CONTRIBUTIONS

Photographers cannot, unfortunately, take much advantage of giving charitable contributions of their photographs or copyrights. Your tax deduction is limited to the costs that you incurred in producing what you are giving away. You are penalized for being the creator of the photograph or copyright, since someone who purchased either a photograph or copyright from you could donate it and receive a tax deduction based on the fair market value of the contributed item. Groups representing creators have been working since 1969 to amend this unfair aspect of the tax laws.

BAD DEBTS

What happens if someone promises to pay you $1,000 for a photograph that you deliver but then never pays you? You may be able to sue him or her for the money, but you cannot take a deduction for the $1,000, because you never

recorded the money as income since you're a cash-method taxpayer. The whole idea of a bad-debt deduction is to put you back where you started, so it applies mainly to accrual basis taxpayers. If you lend a friend some money and don't get it back, you may be able to take a nonbusiness bad-debt deduction. This would be taken on Schedule D as a short-term capital loss, but only after you had exhausted all efforts to get back the loan.

SELF-EMPLOYMENT TAX
In order to be eligible for the benefits of the social security system, self-employed people must pay the self-employment tax. This tax is computed on Schedule SE, *Self-Employment Tax*. Additional information about the self-employment tax can be found in IRS Publication 533, *Self-Employment Tax*. To answer specific questions about social security, you can visit the Web site of the Social Security Administration at *www.ssa.gov/SSA_Home.html*.

ESTIMATED TAX PAYMENTS
Self-employed people should make estimated tax payments on a quarterly basis. In this way you can ensure that you won't find yourself without sufficient funds to pay your taxes in April. Also, you are legally bound to pay estimated taxes if your total income and self-employment taxes for the year will exceed taxes that are withheld by $1,000 or more (subject to certain safe harbor provisions). The estimated tax payments are made on Form 1040-ES, *Estimated Tax for Individuals,* and sent in on or before April 15, June 15, September 15, and January 15. The details of estimated tax payments are explained in IRS Publication 505, *Tax Withholding and Estimated Tax.*

PROVING PROFESSIONALISM
The IRS may challenge you on audit if they find that you've lost money for a number of years in your activities as a photographer. It's demoralizing when this happens, since the auditors will call you a hobbyist and challenge your professionalism. However, you have resources and should stand up for yourself. In fact, you should probably be represented by an accountant or attorney to aid you in making the arguments to prove you're a professional.

First, if you have a profit in three years of the five years ending with the year they're challenging you about, there's an automatic presumption in your favor that you intend to make a profit. That's the crucial test for professionalism—that you *intend to make a profit*. But, if you can't show a profit in three years of those five, there is no presumption saying you are a hobbyist. Instead, the auditor is supposed to look at all the ways in which you pursue your photographic business and see whether you have a profit motive. In particular, the regulations set out nine factors for the auditor to consider. You should try to prove how each of those factors shows your profit motive. But don't be discouraged if some of the factors go against you, since no one factor is dispositive. Here, we'll list the nine factors and briefly suggest how you might argue your professionalism:

1. *The manner in which the taxpayer carries on the activity.* Your record keeping is very important. Do you have good tax records? Good records for other business purposes? Use of professional efforts shows professionalism. Seeking a representative, stock agency, or gallery all show intent to sell your work. Membership in professional associations suggests you are not a hobbyist. Similarly, grant and contest applications show your serious intent to make a profit. The creation of a professional studio and use of professional equipment also suggest you are not a hobbyist. Maintaining your prices at a level consistent with being a professional is important, but on the other hand the price level must not be so high as to prevent your obtaining assignments and selling your work.

2. *The expertise of the taxpayer or his or her advisers.* You would normally attach your resume to show your expertise. You would make certain to detail your study to become a photographer—whether you studied formally or as someone's assistant. Any successes are significant. Have you sold your work, done assignments for clients, given shows in galleries? Reviews or other proofs of critical success are important. Teaching can be a sign of your expertise. Obtaining statements from leading photographers or one of the professional organizations as to your professionalism aids your cause. Even the place where you work can be important, if it is known as the location of many successful photographic studios. You should use your imagination in seeking out all the possible factors that show your expertise.

3. *The time and effort* expended by the taxpayer in carrying on the activity. You must work at your photography on a regular basis. Of course, this includes time and effort related to marketing your work and performing all the other functions that accompany the actual shooting of the photographs.

4. *The expectation that assets used in activity may increase in value.* This factor is not especially relevant to photographers. You might argue, however, that the photographs and copyrights you are creating are likely to increase in value. This is most believable if you place your photographs with stock agencies for resale or sell prints as original works.

5. *The success of the taxpayer in carrying on other similar or dissimilar activities.* If you have had success in another business venture, you should explain the background and show why that leads you to believe your photography business will also prove successful. If the success was in a closely related field, it becomes even more important. You might expand this to include your successes as an employee, which encouraged you to believe you could be successful on your own.

6. *The taxpayer's history of income or losses with respect to the activity.* Losses during the initial or startup stage of an activity may not necessarily be an indication that the activity is not engaged in for profit. Everyone knows that businesses are likely to lose money when they start. The point is to show a succession of smaller and smaller losses that, in the best case, end up with a small profit. You might want to draw up a chart ranging from the beginning of

your photographic career to the year at issue, showing profit or loss on Schedule C, Schedule C gross receipts, the amount of business activity each year, and taxable income from Form 1040. The chart should show shrinking losses and rising gross receipts. This suggests that you may start to be profitable in the future. By the way, you can include items on the chart years after the year at issue. The additional years aren't strictly relevant to your profit motive in the year at issue, but the auditor will consider them to some degree.

7. *The amount of occasional profits, if any, that are earned.* It helps to have profits. But the reason you're being challenged as a hobbyist is that you didn't have profits for a number of years. So don't be concerned if you can't show any profitable years at all. It's only one factor. Also, keep in mind that your expectation of making a profit does not have to be reasonable; it merely has to be a good-faith expectation. A wildcat oil outfit may be drilling against unreasonable odds in the hopes of finding oil, but all that matters is that the expectation of making a profit is held in good faith. Of course, you would probably want to argue that your expectation is not only in good faith but reasonable as well, in view of the circumstances of your case.

8. *The financial status of the taxpayer.* If you're not wealthy and you're not earning a lot each year, it suggests you can't afford a hobby and must be a professional. That's why showing your Form 1040 taxable income can be persuasive as to your profit motive. If you are in a low tax bracket, you're really not saving much in taxes by taking a loss on Schedule C. And, if you don't have a tax motive in pursuing your photography, it follows that you must have a profit motive.

9. *Elements of personal pleasure or recreation.* Since so many people have fun with cameras, it may be hard for the auditor to understand that you are working when you use one. Explain that photography is a job for you as the auditor's job is one for him or her. The pleasure you get out of your work is the same pleasure that auditors get out of theirs, and so on. If you travel, you're especially likely to be challenged, so have all your records in impeccable shape to show the travel is an ordinary and necessary business expense.

The objective factors in the regulations don't exclude you from adding anything else you can think of that shows your professionalism and profit motive. The factors are objective, however, so statements by you as to your subjective feelings of professionalism won't be given too much weight. An important case is *Churchman v. Commissioner,* 68 Tax Court No.59, in which an artist who hadn't made a profit in twenty years was found to have a profit motive.

GIFT AND ESTATE TAXES

The subject of gift and estate taxes is really beyond the scope of this book. It's important to plan your estate early in life, however, and the giving of gifts can be an important aspect of this planning. In addition to considering the saving

of estate taxes and ensuring that your will (or trust) indicates those whom you wish to benefit, you must also plan for the way in which your work will be treated after your death. These issues, including the giving of gifts and the choosing of executors, are discussed in *Legal Guide for the Visual Artist* by Tad Crawford. Good general estate planning guides include *Your Living Trust and Estate Plan* and *Your Will and Estate Plan,* both by Harvey Platt.

HELPFUL AIDS

All IRS publications are available free of charge by request or by visiting the IRS Web site at *www.irs.gov.* Two publications of special interest are IRS Publication 17, *Your Federal Income Tax,* and IRS Publication 334, *Tax Guide for Small Business.* Keep in mind, however, that these books are written from the point of view of the IRS. If you're having a dispute on a specific issue, you should obtain independent advice as to whether you have a tax liability.

A good basic guide for income taxation, estate taxation, and estate planning is contained in *Legal Guide for the Visual Artist* by Tad Crawford. For preparing a current return, a good and comprehensive guide for the general public is *The Ernst & Young Tax Guide 2003.*

20 **INVASION OF PRIVACY AND RELEASES**

THE LAWS GUARANTEEING PRIVACY are a key area for you to understand. Photographers shoot people in every conceivable human situation for an immense variety of uses. Frequently, you will need to obtain a release from the person you are photographing. This is because of that person's right of privacy, a right that can be invaded in the following ways:

1. By using a person's photograph, likeness, or name for purposes of advertising or trade
2. By disclosing embarrassing private facts to the public
3. By using a photograph in a way that suggests something fictional or untrue
4. By physically intruding into a person's privacy—for example, by trespassing to take a photograph

The law of privacy abounds with subtle interpretations. The best advice is to obtain a release if you have any doubt about whether the way you're taking the photograph or the use you intend to make of it could be an invasion of privacy. A number of standard release forms are gathered for your use at the end of this chapter. However, there are many situations when you clearly will not need a release. This chapter will give examples of many common situations the photographer faces, so you'll understand whether or not a release is needed.

PRIVACY

The creation of privacy as a legal right came about in 1903 by a statute enacted in New York State. Since that time, almost every state—with a few exceptions as of this writing—has either enacted a similar statute or recognized the right of privacy in court decisions.

The law with respect to privacy can differ from state to state, but New York has been the leader in the privacy area, and most law with respect to privacy is the same in all jurisdictions. If you're wondering about a situation in which the law appears unclear, you should use a release or consult a local attorney.

Privacy is the right to peace of mind and protection from intrusions or publicity that would offend the sensibilities of a normal person living in a community. It is an individual right granted to living people. If a person's privacy is invaded by a photographer, that person must bring suit—not the spouse, children, or anyone else. The right to sue for an invasion of privacy ends upon the death of the individual whose privacy was invaded. If the lawsuit for the invasion

was started prior to death, some states allow the legal representative to continue the lawsuit, while other states dismiss the suit. Very few states, however, permit a lawsuit to be started after a person's death for an invasion of the deceased person's privacy. Also, because the right belongs to individuals, the names of partnerships or corporations are not protected by the privacy laws.

ADVERTISING OR TRADE PURPOSES

The New York statute provides, "Any person whose name, portrait or picture is used within this state for advertising purposes or for the purposes of trade without . . . written consent . . . may maintain an equitable action in the supreme court of this state . . . to prevent and restrain the use thereof; and may also sue and recover damages for any injuries sustained by reason of such use . . ."

What are advertising or trade purposes? For advertising, we naturally think of advertisements for products or services. For trade, the immediate association is with a photograph on a product that is being sold to the public. For example, when photographer Ronald Galella sent out a Christmas card with a photograph he had taken of Jacqueline Onassis on the card, a court found this to be an advertising use and an invasion of her privacy. Even an instructional use can, in certain cases, be for advertising purposes. A woman was photographed for a railroad company and appeared in a poster instructing passengers how to enter and leave the railcars safely. The court, in a 3-2 divided vote, decided that the unselfish purpose of the poster could not change its nature as advertising. The woman's privacy had been invaded.

If a photographer hangs a photographic portrait in the studio window with a sign advertising portrait services, the photograph is being used for advertising purposes. The New York statute has a special provision, however, permitting a photographer to exhibit specimen photographs at the studio unless a written objection is made by the person in the photograph.

An example of a trade use would be placing a person's photograph on postcards for public sale. Such use is intended to create a desirable product that the public will purchase.

The problem is that advertising and, especially, trade purposes become more difficult to identify when the photographs are used in media protected by the First Amendment. Freedom of speech and press narrow the right of privacy.

THE PUBLIC INTEREST

Public interest is the other side of the coin. The public interest is served by the dissemination of newsworthy and educational information. It is not limited to matters of current news but extends to whatever the public is legitimately interested in. Using a photograph to illustrate a news story about a person who has won a prize for public service in no way requires a release. A photograph of a scientist could be used with an article in a book commenting on the scientist's discoveries, even if these discoveries are not current news.

Unfortunately, it isn't always so easy to know whether a purpose is for advertising or trade as opposed to being for the public interest. The best way to get a feeling of what is permitted and what isn't is by examining situations that are likely to come up.

PHOTOGRAPHING IN PUBLIC PLACES

You can usually photograph in public places without any restrictions on your right to shoot. Of course, if you're making a movie or photographing in such a way as to disrupt the community's normal flow of activity, you may need to get a permit from the local authorities. The main problem is not taking the pictures, but using them. Even though you took someone's photograph in a public place, you cannot use it for advertising or trade purposes without the person's consent. On the other hand, you are free to use such a photo in the public interest, such as for newsworthy purposes, without worrying about releases.

BYSTANDERS AT PUBLIC EVENTS—REQUIREMENT OF RELATEDNESS

Let's say you're taking some photographs of a parade. Along the route of the parade are bystanders who are watching the floats and listening to the bands. Your photographs of the parade itself, naturally, include a lot of shots of bystanders. Can you include bystanders in the photographs of the parade when the article is published? Yes, you can, and you don't need a release. This is because the parade is newsworthy. When someone joins in a public event, he or she gives up some of the right to privacy.

But what if the magazine wants to use a photograph of the bystander on its cover—not just as one face among others, but singled out? Is this focusing on that bystander to such a degree that you'll need a release? This happened at *New York* magazine when the editors used the photograph of a bystander on their cover beneath the caption "The Last of the Irish Immigrants." The bystander had, in fact, been photographed at the St. Patrick's Day Parade in New York City, but he was not Irish. And, while his name did not appear on the cover or in the article, he sued for the use of the photograph. Essentially, he argued that the use would have been in the public interest if it had just been to illustrate an article, but falsely implying that he was Irish and placing the photograph on the cover made the primary purpose to sell the magazine—a trade use.

New York's highest court didn't agree. Even though the photograph was on the cover, it was illustrating an article about an event of genuine public interest. And the photograph was related to the contents of the article. This is a crucial requirement: that the photograph in fact be appropriate to illustrate the article. Since the bystander participated in the parade by being there, the use of the photograph on the cover was not an invasion of his privacy.

This same challenge comes up frequently with book jackets. The well-known football quarterback Johnny Unitas sued for invasion of privacy when his photograph appeared on the jacket of a book about football. The court held

for the publisher, saying that the photograph was related to the contents of the book and therefore was not for purposes of trade.

Going a step further, what about the cover of a company's annual report with the photograph of a customer purchasing an item in one of the company's retail stores? The customer turned out to be a lawyer who sued for the invasion of his privacy. The court stated that no case had ever held the annual report—required by the Securities Exchange Commission—to be for purposes of advertising or trade. The court indicated that, if pressed, it would have decided that this use of a photograph of a customer in a retail store was related to the presentation of a matter in the public interest.

USES THAT ARE NOT RELATED

An Illinois case provides a good example of the possibility of an invasion of privacy by an unrelated use. An imprisoned criminal was slipped a pistol by his girlfriend, escaped from jail, and fatally shot a detective trying to recapture him. A magazine retold the story three months later in an article titled, "If You Love Me, Slip Me a Gun." A photograph of the deceased detective's wife was used to illustrate this story, showing her grief-stricken over her husband's death. An appeals court concluded that this use could be found to be unrelated to the thrust of the story and shocking to basic notions of decency. The issue was whether use of the photograph served the public interest by providing newsworthy or educational information or merely served the publisher's private interest in selling more copies of the magazine. There is no doubt, by the way, that the photograph of the widow would have been in the public interest to illustrate a factual article about the death of her husband in the line of duty. But use in a sensationalized way that was not related to the article could make it for purposes of trade—to sell copies of the magazine by capitalizing on the widow's grief.

A classic case of unrelated use involved an article about street gangs in The Bronx in New York City. The photograph illustrating the article showed a number of people in a street scene in that area. The people who sued, and won, were in no way connected with street gangs, so the use of the photograph was for trade purposes.

FICTIONAL USE

If a photograph is used in a false way, it can't be legitimately related to an article in the public interest. The photograph can be perfectly innocent—for example, a young lady looking across a bay on a moonlit night. Now suppose a writer exercises all his or her ingenuity and comes up with a wild, entirely fictional story. Using the photograph to accompany the story raises the risk of an invasion-of-privacy lawsuit. The use of the photograph is not to illustrate a story or article in the public interest. Legally speaking, it is merely to entertain by highlighting an imaginative yarn. In fact, the general rule is that media used solely for entertainment are far more likely to invade someone's privacy than media

used in the public interest. A novel, a fictional film, or a television serial are held to be solely for entertainment value. The risk of invasion of privacy is greater in those cases than in a biography, a documentary, or a television news program. A fictional use of a photograph is for trade purposes, since its only goal is considered to be the enhancement of sales.

It would definitely be an invasion of privacy to use the photograph of a businessman carrying a briefcase to illustrate the escape of a desperate and violent bank robber with the loot. But what if that same photograph—of an ordinary businessman on his way home from the office—is used to accompany an article praising him for accomplishments he has not attained? It might say that he has just come from an international convention of scientists and is carrying in his briefcase the remarkable invention for which his peers have so justly applauded him. But the man isn't a scientist and has no invention. This fiction could be extremely embarrassing. It all adds up to an invasion of privacy. Famous baseball pitcher Warren Spahn successfully prevented publication of a biography of him because it contained so many mistakes. Not surprising, except for the fact that the mistakes were all laudatory—all designed to make him even more of a hero than he already was. Praise will not avoid an invasion of privacy, unless the praise has a basis in fact.

INCIDENTAL ADVERTISING USES

You've shot a famous baseball player for the pages of a sports magazine. The photographs properly accompany an article about the performance of the player's team. But then the magazine surprises you. They take those same photographs and use them to advertise the magazine. You feel shaky when you see the advertisement, because you never got a release. You knew it was for editorial use and you didn't see why you needed one.

This type of case has come before the courts a number of times—with an athlete, an actress, a well-known author, and others. The courts have uniformly held that no invasion of privacy takes place in these situations if the purpose of the advertisement is to show that the magazine carries newsworthy articles. The photographs for the original article were not an invasion of privacy, because they were in the public interest. If the advertisement is to inform the public about the types of newsworthy and educational articles that the magazine runs, the advertisement is protected in the same way as the original article. This is true even if the advertisement is not advertising the specific issue in which the article appeared, but rather advertising the magazine generally.

But you have to be very careful here. If the photographs are not used in the same way they were when they accompanied the original article, you may end up with an invasion of privacy. Obviously, it would be an invasion of privacy to take the same photographs and say that the person endorsed the value of the magazine. Or to use the photographs on posters that are sold to the public. Advertising incidental to a protected editorial use—to show that the publication serves the public interest because of the nature of its contents—is a narrow

exception to the general rule banning the use of photographs for advertising or trade purposes without the consent of the person portrayed.

A related case occurred when a newspaper photographed a paid model to illustrate a new bathing suit for a fashion item. The photograph included in the background several ten-year-old boys who happened to be at the swimming pool. The text accompanying the photograph ended by describing the bathing suit as "a bikini, very brief pants plus sawed-off tank top. Colored poor-looking brown, the suit is by Elon, $20, Lord & Taylor." Lord & Taylor did not pay to have the item appear. Rather, the newspaper published it as a newsworthy piece of information. The court agreed that the item was in the public interest and that the use of the boys in the photograph was not for advertising or trade purposes. So the boys lost their invasion-of-privacy suit. If Lord & Taylor had paid for the fashion "news" item to be run, the result would presumably have been different. Even though the item would seem to have been published for its current interest, it in fact would be an advertisement in disguise if paid for. This would have violated the boys' rights.

In a recent case, actor Dustin Hoffman sued *Los Angeles* magazine for invasion of privacy when the magazine used a computer-altered image of the actor in an evening gown and high heels without his permission. The image was accompanied by the caption, "Dustin Hoffman isn't a drag in a butter-colored silk gown by Richard Tyler and Ralph Lauren heels." The defendant argued that the material was protected by the First Amendment and based not on Dustin Hoffman but on the character that he had played in the film *Tootsie*. Although the magazine gave the cost of the clothing and where to purchase it, the court concluded that it was not an advertisement but an "editorial comment on classic films and famous actors." The decision was rendered in favor of the defendant.

PUBLIC DISCLOSURE OF EMBARRASSING PRIVATE FACTS

The public disclosure of embarrassing private facts can be an invasion of privacy. Peculiar habits, physical abnormalities, and so on can easily be captured by the photographer. There is no benefit to the public interest, however, in making public such information about a private citizen. On the other hand, if the information is newsworthy, no invasion of privacy will occur. The examples discussed here show how disclosures that normally would invade privacy are protected when newsworthy.

One case involved a husband and wife photographed in the ice cream concession they owned. The man had his arm around his wife, and their cheeks were pressed together—a romantic pose. This photograph was then used to illustrate a magazine article about love. The court decided that the photograph was not embarrassing or offensive. In fact, the couple had voluntarily assumed the pose in a public place. And, in any case, it did relate to an article serving the public interest. So the couple lost their invasion-of-privacy suit.

In another case a body surfer well known for his daring style gave an interview in which he told of his peculiar behavior—eating insects, putting out cigarettes in

his mouth, pretending to fall down flights of stairs, and fighting in gangs as a youngster. When he found out that these odd traits would be included in the magazine article, he sued on invasion-of-privacy grounds. The court decided that these facts could be included in the article because they were relevant in explaining his character. And his character was of public interest since it related directly to his exploits as a body surfer. But if his body surfing had not been legitimately newsworthy, the disclosure of facts of that kind could certainly have been an invasion of privacy.

CRIMINALS AND VICTIMS

The commission of a crime and the prosecution of criminals are certainly newsworthy, since they are of legitimate concern to the public. Photographs of alleged or convicted adult criminals can thus be used in the course of reporting news to the public. However, many states protect the identity of juvenile defendants and victims of certain crimes, such as rape. You have to check your own state's laws to determine what restrictions you may face. It's worth noting that the United States Supreme Court has decided that the disclosure of the identity of a deceased rape victim did not give grounds for an invasion-of-privacy action. The court pointed out that the victim's identity was a matter of public record. The embarrassment caused to the victim's father, who initiated the lawsuit, could not outweigh the value of communicating newsworthy information to the public. And a state court decision denied a fourteen-year-old rape victim recovery in an invasion-of-privacy suit based on the disclosure of her identity as a victim of a rape. The reasoning is again that the identity is newsworthy and, therefore, cannot be an invasion of privacy.

PUBLIC FIGURES

Public figures must sacrifice a great deal of their right of privacy. This follows from the fact that public figures are, by definition, newsworthy. The public wants to know all about them. The media are merely serving this public interest by making the fullest disclosure of the activities of public figures. So the disclosure of a private fact—which would be an invasion of privacy if a private citizen were involved—may very well be newsworthy and permissible if a public figure is being discussed. For example, a braless tennis professional competing in a national tournament momentarily became bare-chested while serving. A photographer captured this embarrassing moment, and the photograph appeared nationwide. The event was newsworthy. But in a similar case—a private citizen's skirts being blown up in the funhouse at a county fair—the event was not newsworthy, and publication of the photograph was an invasion of privacy.

Who is a public figure? Anyone who has a major role in society or voluntarily joins in a public controversy with the hope of influencing the outcome is a public figure. This includes politicians, famous entertainers, well-known athletes, and others who capture the public imagination because of who they are or what they've done—whether good or bad. Beyond this, however, it also

encompasses private citizens who take a stand on a controversy of public interest, such as a housewife publicly campaigning to defeat the budget of a local school board. However, the United States Supreme Court has decided in one case that "public figure" does not include a woman who is in the process of getting divorced from a well-known businessman. When the grounds for her divorce decree were incorrectly reported in a national magazine, the court found she was a private citizen who had not voluntarily become involved in activities of public interest—despite her social status and the fact she had voluntarily given several press conferences to provide information about her divorce to the press.

The more famous the public figure, the greater the right of privacy that the public figure sacrifices. The president of the United States has almost no right of privacy, since practically everything about the life of the president is of interest. A housewife speaking out about a matter of public interest, however, would sacrifice far less of her right of privacy than the president.

One of the leading invasion-of-privacy cases arose from photographer Ron Galella's pursuit of former first lady Jacqueline Onassis. Faithful to the creed of the paparazzi, he jumped and postured about her while taking his photographs, bribed doormen to keep track of her, once rode dangerously close to her in a motorboat while she was swimming, invaded her children's private schools, leaped in front of her son's bicycle to photograph him, interrupted her daughter on the tennis courts, and romanced a family servant to keep himself current on the location of the members of her family. Could she prevent Galella from harassing her in this way? Or did her status as a public figure make her fair game for whatever tactics a paparazzo might choose to employ?

The court's decision struck a compromise between Mrs. Onassis's right to privacy and the legitimate public interest in knowing of her life. It prohibited Galella from blocking her movements in public places or from doing anything that might reasonably be foreseen to endanger, harass, or frighten her. But it did not stop him from taking and publishing his photographs, because that served the public interest.

However, in 1982, a new action was brought by Mrs. Onassis against Galella on the grounds that he had violated the 1975 court order on at least twelve occasions. Although the First Amendment protected the photographer's right to take photographs of a public figure, the contempt citations might still have resulted in Galella being imprisoned and paying heavy fines. To avoid this, Galella agreed never to photograph Mrs. Onassis or her children again.

The right of the public to know the appearance of public figures is simply an extension of the rules relating to what is newsworthy and informational. It's important to realize, however, that public figures keep their right of privacy with respect to commercial uses. If you use a public figure's photograph to advertise a new aftershave lotion, you have definitely committed an invasion of privacy. In fact, celebrity rights and the right of publicity discussed in the next chapter show that public figures can actually have a property right in their names, portraits, or pictures.

If an invasion of privacy is found to have occurred, the intention behind the invasion won't matter in the ordinary case involving a private person who is not involved in a matter of public interest. But the courts have determined that a higher standard should apply to false reports of matters in the public interest, including reports involving public figures. To recover for invasion of privacy in cases involving public figures, the public figure must show that the false report was published with knowledge of its falsity or a reckless disregard as to whether or not it was true. This can be a difficult standard to meet, but it reflects the concern of the United States Supreme Court to protect the First Amendment rights of the news media.

STALE NEWS

At some point news becomes stale and the use of someone's photograph is no longer newsworthy. For example, motion pictures of a championship boxing match were no longer newsworthy when, fifteen or twenty years after the bout, they were used as part of a television program titled "Greatest Fights of the Century." The boxer's claim, based on invasion of privacy, could not be defeated on the ground that the program disseminated news. Similarly, the story of a sailor who saved his ship by sending a wireless message was newsworthy when it happened. But to use the sailor's name and have him portrayed by an actor in a commercial film released one month later was a trade use and an invasion of the sailor's right of privacy. Its dissemination was no longer protected as newsworthy.

On the other hand, a child prodigy remained newsworthy twenty-five years later, despite having vanished completely from public sight. In fact, the prodigy hated his early fame and had sought obscurity, but the court concluded that the public interest would be served by knowing whether his early promise was ever realized. A magazine article about him, although it embarrassed him and brought him into the public view in a way he dreaded, was not an invasion of his privacy.

RECOGNIZABLE PERSON

One way photographers avoid invasion-of-privacy problems is by retouching photographs so the people aren't identifiable. If you can't identify someone, no invasion of privacy can occur.

A novel case involved a photograph of the well-known actress Pola Negri, used to advertise a pharmaceutical product. The advertiser argued that the photograph of the actress had been made forty years before the lawsuit. Since she had aged and her appearance was quite different, no invasion of privacy could take place. Needless to say, the court rejected this argument. Whether the photograph was made last year or forty years ago doesn't matter if it is put to an advertising use and the person pictured is still alive.

A recognizable likeness, even if not an exact photograph as originally made, can also constitute an invasion of privacy. For example, *Playgirl* magazine ran a

picture showing a nude black man sitting in the corner of a boxing ring with his hands taped. Although the picture was captioned "Mystery Man," it clearly was a likeness of boxer Muhammad Ali. In fact, an accompanying verse referred to the figure as "the Greatest." The picture was fictional and offensive. It certainly was not newsworthy or instructive, since it didn't even accompany an article. The court decided that an invasion of Ali's privacy had occurred. The nude picture was for purposes of trade—to attract the public's attention and sell the magazine.

PARTS OF THE BODY

If a person must be recognizable for an invasion of privacy to occur, it follows that you can photograph unidentifiable parts of the body for advertising and trade use without fear of causing an invasion of privacy. Arms, legs, the backs of heads, and so on are all right as long as the person is neither identified nor identifiable.

But why do most agencies still insist on a release from models in these cases? Simply because the release serves as the contract between the photographer and the model. It gives written proof that the model agreed to render services for a specified fee that you (or the agency) agreed to pay. While you may not have to be concerned about an invasion of privacy suit, it also saves you from having to worry about a breach of contract suit.

DOGS, HORSES, CARS, AND HOUSES

What about photographing property belonging to someone else, such as a German Shepherd or the interior of a house? This shouldn't be an invasion of privacy, especially if the owner isn't identified in any way by the photograph. For example, you could photograph a horse running in a field and use the photograph in an advertisement. The owner would have no right to object, since the right of privacy protects people, not animals. By the same token, there's no reason why you shouldn't be able to use a car, the interior of a house, or other private property in an advertisement as long as the owner cannot be identified. But, if you promised to pay for the right to photograph the person's property, or if you took or used the photographs in violation of an understanding that you reached with the owner, you may very well face a breach-of-contract lawsuit. As a practical matter, you should seriously consider obtaining a release if you plan to use the photograph for advertising or trade uses, since it could also serve as your contract with the owner and would eliminate any risk of a lawsuit—however frivolous.

TRESPASSING

You can't trespass to get photographs, even if the photographs are newsworthy. A trespass—an unlawful entry on a person's property—can serve as the basis for an invasion-of-privacy lawsuit. And it doesn't matter whether you publish the photographs, since the invasion is based on the trespass, not the publication.

A Florida case involving a police raid on a controversial private school stated this prohibition colorfully. The police had television news cameramen accompany the raiding party that rousted students and faculty from bed. The cameramen took embarrassing footage that was televised. The court said that to permit such conduct

> could well bring to the citizenry of this state the hobnail boots of a Nazi storm trooper equipped with glaring lights invading a couple's bedroom at midnight with the wife hovering in her nightgown in an attempt to shield herself from the scanning TV camera. In this jurisdiction, a law enforcement officer is not as a matter of law endowed with the right or authority to invite people of his choosing to invade private property and participate in a midnight raid of the premises.

But in a similar case a newspaper photographer, at the request of police, took photographs of the silhouette of the body of a girl who had died tragically in a fire. Her mother learned of the death by seeing the published photographs taken inside the burned-out home. She sued for an invasion of her own privacy. The court concluded that the photographs were newsworthy and, under the circumstances, the photographer had not committed a trespass in coming on the mother's premises without her permission.

Trespass cannot be justified simply because a public figure is involved. Breaking into a senator's office to obtain newsworthy information is an invasion of privacy. The First Amendment does not protect you against illegal acts committed in the course of getting newsworthy or informative photographs.

INTRUSION INTO PRIVATE PLACES

Photographing a private citizen without consent in the seclusion of his or her home may of itself be an invasion of privacy. Certainly, there are public places that can become as private as the home. A person using a public restroom or going into a hospital does so with the understanding that he or she will have the same privacy as at home. Because of this, photographs taken in these places can be an invasion of privacy.

One case involved employees of *Life* magazine seeking to expose a quack doctor. Pretending to be patients, they gained access to the doctor's home and took photographs with hidden cameras. Subsequently, *Life* used the photographs in an exposé about the doctor. While the story was newsworthy, the intrusion was an invasion of privacy. And the court said that the later publication of the photographs could be used as a factor in increasing the damages flowing from the invasion.

Photographs taken of patients also present problems. For example, the publication of a patient's photograph to accompany an article written by the doctor could be regarded as for the purposes of advertising the doctor's skills. Or the exhibition of a film showing a birth by Caesarian section could be a

trade use if admission is charged. However, if the use is in the public interest, such as an article about a new medical development or an instructive film (especially if no admission fee is charged), you are on safer ground. To avoid uncertainty, you will usually want a release from the patient.

SURVEILLANCE

Surveillance of people who have a personal injury claim against an insurance company is not uncommon. The purpose is to show that the injuries sustained by the person in an automobile or other accident are not as severe as claimed. The insurance company will often retain a private investigator and a photographer who will use a motion picture or video camera to record the claimant's physical condition.

In such cases, the surveillance is not an invasion of privacy as long as it is conducted in a reasonable manner. For example, following at a reasonable distance behind a claimant's car and photographing her while driving and in other public places would not invade her privacy. In fact, the court felt that there is a social value in the investigation of claims that may be fraudulent. However, harassment or outrageous conduct could violate a claimant's privacy.

BUSINESS PREMISES

The right of privacy does not protect corporate or other business names. The taking and use of photographs of business premises cannot, therefore, be an invasion of the privacy of the corporation or other business. It could be a trespass, unfair competition, or breach of contract, however, as discussed in the next chapter.

Two cases illustrate this. In one case, a satirical magazine used a photograph of a real bar to illustrate a fictitious story titled "The Case of the Loquacious Rapist." The actual name of the bar—"Busy Bee"—appeared in the photograph, although the fictional bar in the accompanying satire was called "The Stop and Frisk." There simply was no invasion of privacy here. Nor did an invasion of privacy occur when a photograph of the business name "Jollie Donuts" and the premises of the doughnut shop appeared in a nationally televised broadcast. This was not the name, portrait, or picture of a person. What about a patron who is photographed on the business premises? Can he sue? After a bomb threat, a government building was evacuated and a number of the employees went to a nearby hotel bar. A television camera crew photographed a government employee in the bar and broadcast the film on the evening news. The employee lost his invasion-of-privacy suit, since he had become, however involuntarily, an actor in an event of public interest.

EXHIBITION OF PHOTOGRAPHS

Photographers often exhibit in galleries, raising the question of whether an exhibition can be an invasion of privacy. The very fact that the New York statute made a special exemption to allow exhibition of specimen photographs under

certain conditions suggests that this type of exhibition is an advertising use when the conditions aren't met. It is publicizing the photographer's services.

The courts have also found that the *sale* of postcards, portraits, or posters based on someone's photographic portrait is a trade use. A single photograph or limited edition exhibited for sale in a gallery might also be a trade use. It could be argued, however, that the exhibition and sale of a photographic work of art is in the public interest, much like the sale of a photograph in a book collecting examples of a photographer's work. Looking at it from this point of view, the courts might consider the media used, the nature of the subject matter, and the extent of the invasion. Presumably, a person striking a voluntary pose in a public place would have a much harder time recovering than someone who was photographed in an embarrassing pose in a private place. That doubt exists in this area, however, suggests the wisdom of obtaining a release.

If the photograph were exhibited in a museum for educational purposes and not for sale, it would not appear to be a trade use. Several cases state that the exhibition of a film without an admission charge is not a trade use. So it is less likely that an invasion of privacy would occur if an exhibition were for educational purposes and the photograph not offered for sale. However, an embarrassing photograph taken in a private place might still cause an invasion of privacy.

What about a poster—or photograph exhibited in a gallery—of a political figure campaigning? While the poster was offered for sale, the court decided that it served the public interest by disseminating knowledge about political candidates. The candidate, by the way, was comedian Pat Paulsen, who had licensed the right to make posters to a competitive company. If Paulsen had not been running for public office in 1968 when the distribution occurred, he might have found protection under the right of publicity discussed in the next chapter.

Not only is the area of exhibition likely to see more lawsuits in the future, but also the laws may differ from state to state. Again, the safest course is to obtain a release.

DAMAGES

It can be difficult to measure what damages should be payable to someone who wins an invasion-of-privacy suit. After all, the injury is to peace of mind and the right to seclusion. Yet a person suing for invasion of privacy has a right to recover substantial damages, even if the only damage suffered is his or her mental anguish. The fact that the damages are difficult to ascertain or can't be precisely determined in terms of money is not a reason to deny recovery for the invasion. Nor are the damages limited to compensation for the mental anguish that a person of ordinary sensibilities would suffer in the situation. The damages can extend beyond this to cover any actual financial losses. The exact amount of damages is decided on a case-by-case basis, depending on the facts involved.

If someone commits an invasion of privacy, it really doesn't matter what the motives were. It's the acts constituting the invasion that create a right to sue. The New York statute does state that anyone who "knowingly" invades another's privacy may be subject to punitive damages. These are extra damages awarded not to compensate the person who has been injured, but rather to punish the offender and prevent similar acts in the future.

RELEASES

New York's statute requires that a release be in writing, but in most other states an oral release will be valid. The release gives you the right to use someone's photograph without invading his or her right of privacy. You would be wise always to have written releases, such as those that appear at the end of this chapter. This is because the releases must be appropriate for the use you intend to make of the photograph. Also, the details of oral understandings tend to fade from memory and can be difficult to prove in court.

The release must be signed by the proper person—normally, the subject of the photograph. But if that person is a minor, the parent or guardian must sign. Most states have adopted eighteen, rather than twenty-one, as the age of reaching majority, but you should check the law in your own state. In a significant case, Brooke Shields sought to disavow releases signed by her mother for a nude photo session in a bathtub when Shields had been ten. The court concluded that the release signed by the parent was binding and could not be disavowed. When using minors as models, you should also be very careful to comply with state legal requirements regarding special permits, chaperones, requirements with respect to not shooting during school hours, hours of employment, and the like.

The release should specify what use will be made of the photograph. For example, the model might consent to the use of the photograph "for advertising dress designs in trade magazines." Use of the photograph in other situations, such as advertising cigarettes on a billboard, would at the least be a breach of contract. So you might want to broaden the release by use of a phrase such as "any and all purposes, including advertising in all forms."

The release should give permission to the party that will actually use the photograph—not just you, but also the advertising agency or other businesses to which you might assign the right of usage. So you will want to recite that the release gives consent not only to you, but also to agents, assigns, and legal representatives.

You should always get your own release form signed, even if an advertising agency or a new client gives you its form that you also have the model sign. If, for some reason, you are relying on the client's form and not getting your own form signed, you should check very closely to see that the client's form protects you. If you feel it doesn't, you should request that the client indemnify you— that is, agree to pay your losses and expenses that may result if the release is, in fact, inadequate to protect you.

The payment of money to the model isn't necessary for a valid release, but it may be a wise step to take. In this way, a release differs from a contract, since you must give something of value if you want to make a contract binding. Normally, for a release, you would give a fee and, if you do, you naturally should state that in the release. One revealing case involved a woman who received no fee for consenting to use of her photograph in advertising for a perfume. Twenty years later, she was able to revoke her consent, despite the money spent by the manufacturer to obtain a trademark and develop the market for the product. In fact, you might want not only to pay to prevent the revocation, but also to specify in the release how long the subject's consent is to be effective. When a man agreed at the age of twenty-four to the advertising use by a health spa of before-and-after photographs of himself, the advertising use of such photographs ten years later was an invasion of privacy. Nor did the man even revoke his consent in this case. But he hadn't received a fee and the court felt his consent lasted only for a reasonable time after the making of the photographs.

Tough cases develop when photographs are altered. Does the release permit such changes? Or are they perhaps allowed by trade custom?

A model agreed to do an advertisement for a bookstore. The release gave an irrevocable consent to the bookstore and its assigns to use her photograph "for advertising purposes or purpose of trade, and I waive the right to inspect or approve such . . . pictures, or advertising matter used in connection therewith." The bookstore's advertisement showed the model reading in bed and was captioned, "For People Who Take Their Reading Seriously." The bookstore then violated its contract with the photographer by assigning rights of use to a bedsheet manufacturer known for its offensive advertisements. The manufacturer altered the advertisement so the model in bed was in the company of an elderly man reading a book titled *Clothes Make the Man* (described by the court as a "vulgar" book). The implication was that the model had agreed to portray a call girl for the bedsheet advertisement. These changes in the content made a different photograph in the view of the court and gave the model a right to sue for invasion of privacy. So, while the photograph could be assigned for other advertising uses, it could not be altered in such an objectionable manner. To protect yourself from liability, it's wise to limit in your confirmation or invoice forms the uses that can be made of the photograph to those permitted in the release you've obtained. It is important to note that the photographer had no liability in this case, since he had not participated in the acts that violated the model's privacy.

On the other hand, a basketball player signing a release allowing the advertising use of photographs of himself in "composite or distorted" form could not complain when a glass of beer was added to make an advertisement for beer. Nor could an actress complain when the photographs used for a movie poster were altered to emphasize the sexuality of the woman portrayed. Since the actress had consented to the use of her "likeness" in advertising for the movie, the court felt trade usage permitted the sexual emphasis. But, in a very similar

case involving a movie actor shown in a composite photograph notifying his admirers by telegraph where to see his new film, the court said the actor's release for publicity only extended to a true photograph—not a composite portraying something that never occurred. This points up how dangerous it can be to rely on trade custom. If trade custom conflicts with a clear written contract, it won't even be admissible in court. So a carefully drafted release is a far safer approach.

When using a release, always fill in the blanks—the date, the model's name, your name, any addresses, any fees, and so on. It's important that you keep records enabling you to relate the release to the photographs for which it was given. This can be done by use of a numbering system matching the releases to the negatives or transparencies. Or you might date the film, so the date will be the same as that of the signed release you obtained at the shooting session.

You should make a practice of getting the release signed at the session. Don't put it off, even if you're not exactly certain what the final use of the photograph will be. Also, while you don't have to have a witness for the release, it can help in proving proper execution of the release. You may also want to include an image of the model with the release, which will identify the model and, if a driver's license is used, the proof of the model's age.

The releases shown here follow the principles that we've discussed. The forms can, of course, be modified to meet special needs that you may have.

MODEL RELEASE—SHORT FORM

In consideration of $ _____, receipt of which is acknowledged, I, _____ (print Model's name) do hereby give _____ (the Photographer), his (her) assigns, licensees, and legal representatives the irrevocable right to use my name (or any fictional name), picture, portrait, or photograph in all forms and media and in all manners, including composite or distorted representations, for advertising, trade, or any other lawful purposes, and I waive any right to inspect or approve the finished product, including: written copy, that may be created in connection therewith. I am of full age.* I have read this release and am fully familiar with its contents.

Witness: _____

Signed: _____

Address: _____

Address: _____

Date: _____, 20_____

Consent (if applicable)
I am the parent or guardian of the minor named above and have the legal authority to execute the above release. I approve the foregoing and waive any rights in the premises.

Witness: _____

Signed: _____

Address: _____

Address: _____

Date: _____, 20_____

> **Attach visual reference for model here, such as a photocopy of a driver's license or other identifying image.**

MODEL RELEASE—LONG FORM

In consideration of _____ Dollars ($ _____), and other valuable consideration, receipt of which is acknowledged, I, _____ (print Model's name) do hereby give _____ (the Photographer), his or her assigns, licensees, successors in interest, legal representatives, and heirs the absolute and irrevocable right to use my name (or any fictional name), picture, portrait, or photograph in all forms, including, in whole or in part, in all manners, and in all media, whether now known or hereinafter discovered, without any restriction as to changes or alterations (including but not limited to composite or distorted representations or derivative works made in any medium) for advertising, trade, commercial, promotion, exhibition, editorial, or any other lawful purposes. I acknowledge that I have no rights with respect to the photograph(s) and I waive any right to inspect or approve the photograph(s) or finished version(s) incorporating the photograph(s), including written copy, if any, that may be created and appear in connection therewith. I hereby release and agree to hold harmless the Photographer, his or her assigns, licensees, successors in interest, legal representatives, and heirs from any liability by virtue of any blurring, distortion, alteration, optical illusion, or use in composite form whether intentional or otherwise, that may occur or be produced in the taking of the photographs, or in any processing tending toward the completion of the finished product, unless it can be shown that they and the publication thereof were maliciously caused, produced, and published solely for the purpose of subjecting me to conspicuous ridicule, scandal, reproach, scorn, and indignity. I agree that the Photographer owns the copyright in these photographs and I hereby waive any claims I may have based on any usage of the photographs or works derived therefrom, including but not limited to claims for either invasion of privacy or libel. I am of full age* and competent to sign this release. I agree that this release shall be binding on me, my legal representatives, heirs, and assigns. I have read this release and am fully familiar with its contents.

Witness: _____ Signed: _____
 Model

Address: _____ Address: _____

Date: _____, 20 _____

Consent (if applicable)
I am the parent or guardian of the minor named above and have the legal authority to execute the above release. I approve the foregoing and waive any rights in the premises.

Witness: _____

Signed: _____
 Parent or Guardian

Address: _____

Address: _____

Date: _____, 20 _____

*Delete this sentence if the subject is a minor.
The parent or guardian must then sign the consent.

> **Attach visual reference for model here, such as a photocopy of a driver's license or other identifying image.**

RELEASE—BY OWNER OF PROPERTY

In consideration of the sum _____ of Dollars ($_____), receipt of which is acknowl-
edged, I do hereby irrevocably authorize _____, of _____ (address), City
of _____, County of _____, State of _____, his (her) legal repre-
sentatives, assigns, and those acting under his (her) permission and on his (her) authority, to copy-
right, publish, and use in all forms and media and in all manners for advertising, trade, promotion,
exhibition, or any other lawful purpose whatsoever still, single, multiple, or moving photographic
portraits or pictures of the following property that I own and have sole authority over to license for
the taking of photographic portraits or pictures:

regardless of whether said use is composite or distorted in character or form, in conjunction with
my own or a fictitious name, or reproduction thereof is made in color or otherwise or other deriv-
ative works are made through any medium.

I do hereby waive any right that I may have to inspect or approve the finished product or the
advertising or other copy that may be used in connection therewith or the use to which it may be
applied.

I hereby release, discharge, and agree to hold harmless _____, his (her) legal
representatives, assigns, and all persons acting under his (her) permission or authority, from any
liability by virtue of any blurring, distortion, alteration, optical illusion, or use in composite form
whether intentional or otherwise, that may occur or be produced in the taking of the pictures, or
in any processing tending toward the completion of the finished product, unless it can be shown
that they and the publication thereof were maliciously caused, produced, and published solely for
the purpose of subjecting me to conspicuous ridicule, scandal, reproach, scorn, and indignity.

I do hereby warrant that I am of full age and have every right to contract in my own name in
the above regard. Further, I have read the above authorization and release, prior to its execution,
and I am fully familiar with the contents thereof.

Witness: _____

Signed: _____

Address: _____

Address: _____

Date: _____, 20 _____

CHAPTER 21 BEYOND PRIVACY

INVASION OF PRIVACY is not the only risk you face when taking and publishing your photographs. Both private individuals and the public are protected by other laws drawn from a variety of sources. This chapter will elaborate on what you must know about in addition to privacy so you can pursue your professional activities without violating any laws or legal rights.

RIGHT OF PUBLICITY

The right of publicity is possessed by athletes, entertainers, and other people who seek to create a value in their name or likeness by achieving celebrity status. It is different from the right of privacy, which protects peace of mind and the right to live free of unwanted intrusions. The right of publicity is a property right based on the value inherent in a celebrity's name or likeness. The right of privacy protects everyone. The right of publicity protects only those who have succeeded in becoming celebrities. The right of privacy cannot be assigned. The right of publicity, like other property rights, can be assigned. The right of privacy ends when the person whose privacy was invaded dies. The right of publicity can survive the celebrity's death and benefit his or her heirs or assignees.

If you photograph a baseball player for a company that manufactures baseball cards, the company is going to need a license from the player in order to use the photograph on its baseball cards. Or, if you photograph a football player for a company that wants to use the photograph in a game for children, a license from the player will be needed to avoid having the game violate his right of publicity. In one interesting case, a baseball player gave a license to a sporting goods company and its assignees to use his name, facsimile signature, initials, portrait, or nickname in the sale of its gloves, baseballs, and so on. The sporting goods company sold baseballs to a meat company for use in a promotion with meats. They also gave the meat company the right to use the player's name and likeness in connection with the promotion. The player sued to prevent the meat company from using his name and likeness in this way, but he lost because he had assigned his right of publicity without limiting what types of companies it could be assigned to.

The right of publicity protects against commercial exploitation. It cannot prevent the reporting of events that are newsworthy or in the public interest. For a guide to what is newsworthy or in the public interest, you can refer back to the many examples given in the chapter on privacy.

The courts have said that the right of publicity will survive a celebrity only if that person exploits the right while alive. This means that celebrities must take steps to exercise these rights—for example, by means of contracts to use their name or likeness for endorsements or on products—if assignees or heirs are to be able to assert the right after the celebrity's death. If a celebrity's right of publicity would be violated by the commercial use of a photograph, a license should be obtained from the celebrity.

CELEBRITY RIGHTS LAWS

In 1984, California used the right of publicity as the basis to enact a celebrity rights law. A number of other states have followed California's lead. The basic approach of these laws is to protect the publicity rights of deceased people for up to fifty years after their death. This applies to people whose name, voice, signature, or likeness had commercial value at the time of death, whether or not that commercial value had been exploited during life. Prohibited uses cover commercial exploitation to sell merchandise or services, including advertising. Typical exemptions from the coverage of the law would include works in the public interest, material of political or newsworthy value, and single and original works of fine art.

These celebrity rights laws impinge on the freedom of expression guaranteed to artists by the First Amendment. Since creative works are likely to be disseminated nationally, it may be that the most restrictive celebrity rights law will govern whether the artist must seek permission from the people to whom the decedent has transferred the celebrity rights or, if no transfer has been made, the heirs of the decedent.

LIBEL

Libel is communicating to the public a false statement about someone, which damages the person's reputation. Computer-manipulated photographs can create a false image and damage someone's reputation. So can errors in the lab.

But the most common area of libel in photography is the association of an innocent photograph with a text that is libelous. There is, by the way, no reason why the photographer would be responsible in such a case if he or she had nothing to do with the offending text. For example, a photograph might show a man and a woman riding in a carriage. It can't possibly say anything false. But suppose the picture is printed in a newspaper, and the caption says the man and woman are husband and wife, and this isn't true. In fact, the woman is married to someone else. A woman in such a case sued the newspaper, claiming that the public impression would be that she was not married to her real husband. If that were the case, she would have been living with him in sin. This was not true and injured her reputation. The case arose in 1929 in England, where the court agreed with the woman and gave judgment for her. What is damaging to the reputation can change from one time and place to another.

The First Amendment cuts into the individual's protection against libel. In a libel suit brought by a public official or public figure over a report that is

newsworthy, the person suing must show that the false statement was made with reckless disregard for whether it was true or false or with actual knowledge that it was false. This is a very difficult standard to meet. The question of who is a public figure, already discussed under invasion of privacy, becomes important in libel, because of the higher standard of proof required. For private individuals who become involved in matters of public interest, the states may set a lower standard. For example, in order to recover, the private individual might have to show only negligence in the publication of the false material. For private individuals suing for libel over a matter not in the public interest, proof that the defendant knew the statement was false would be necessary only to get the extra damages, called punitive damages.

Libel is in general of less concern to photographers than to writers. However, if you fear that use of a photograph may libel someone, you should consult an attorney and consider obtaining a release from the person who might bring the libel suit.

PRIVATE PROPERTY/BUILDINGS

In the last chapter we discussed whether photographs of dogs, horses, automobiles, interiors of houses, and other private property could cause an invasion of privacy. As long as the owner was not identified, it did not appear that his or her privacy could be invaded. Several cases, however, illustrate some risks other than invasion of privacy that you should keep in mind.

A photographer was commissioned to photograph a woman's dog. The woman purchased several prints, and, as far as she was concerned, the transaction was finished. The photographer, however, sold the dog's photographs to an advertising agency that used them for dog biscuit advertisements in local and national newspapers. The woman sued the photographer, his agent, the advertising agency, the dog biscuit company, and the newspapers based on the use of the photographs of the dog. The court decided that the photographer and his agent had breached the original contract with the woman, since the customer is the owner of all proprietary rights in works done on commission. Because of this, the photographer and his agent would have to pay damages for their breach of contract, while the other defendants would merely be barred from running the advertisement again.

If the dog had been wandering the streets and the photographer had taken the picture on his own initiative, the owner would presumably not have had any right to object to a subsequent advertising use, since the photographer would have owned all the proprietary rights. An intriguing point here, however, is that the copyright law has changed since this case was decided. After January 1, 1978, the photographer owns the copyright in the photographs of the dog, whether the owner commissions the photographs or the dog is running free in the streets. Could this change the result of the case if it were to come up again? Probably not, because the courts would be likely to conclude that an implied provision of the contract to photograph the dog is that the photographs will be

only for the owner's use. Despite the photographer's owning the copyright, the contract would implicitly forbid reuse for purposes other than those intended by the owner.

The other case may be unique, but it's certainly worth taking into account. It arose out of the New York World's Fair of 1964. A postcard company took photographs of the buildings, exhibits, and other activities going on inside the fairgrounds. These were then sold on postcards, albums, and related items. Admission was charged for entrance to the World's Fair, and, in fact, the World's Fair Corporation had entered into a contract with another company to exploit similar photographs of the buildings, exhibits, and so on. In addition to this, the postcard company had bid for the right to make the photographs and sell the commercial items both inside and outside the fairgrounds. On considering these special facts, the court decided that an injunction should be granted to prevent the postcard company from continuing its commercial exploitation. The court likened the buildings and exhibits to a show in which the World's Fair Corporation had a property interest. Two of the five judges dissented, however, and said they didn't think anything could prevent selling items incorporating photographs of the exteriors of the buildings. This case is probably limited to its unique facts—an unsuccessful bidder commercially using photographs of unusually attractive buildings on private grounds to which admission is charged. It could hardly prevent you from making postcards from photographs of the Empire State Building or the New York City skyline. But the cautious photographer will take the case into account before launching a similar enterprise.

In another case, the Rock and Roll Hall of Fame argued that it had a trademark in the unique shape of its building and, therefore, photographer Charles Gentile should be prevented from selling his posters of the Rock and Roll Hall of Fame. The court agreed that the building, designed by I. M. Pei, was unique and distinctive with "a large, reclining triangular facade of steel and glass, while the rear of the building, which extends out over Lake Erie, is a striking combination of interconnected and unusually shaped, white buildings." Gentile's posters sold for $40 and $50, while the Hall of Fame's own poster sold for $20, but the photographs in the posters were very different treatments of the building. The court concluded that the building, while fanciful, was not fanciful in the way that a trademark identifies a company as the source of goods or services to the public and that, indeed, there had been no showing that the public might have come to associate the building's design as a trademark connected to products or services offered by the Hall of Fame. In what the court admitted to be an unusual case, Gentile was allowed to sell his posters.

TRESPASS

The preceding chapter reviewed when trespasses might give individuals a right to recover for invasion of privacy. That discussion noted that businesses were not protected by a right of privacy. However, businesses are protected against trespasses, even when the news media are involved.

In one case a television news team was doing a report on a New York City restaurant charged with health code violations. The camera crew and its reporter burst noisily into the restaurant. The reporter gave loud commands to the crew, who turned their lights and camera on in the dining room. In the resulting tumult, the patrons waiting to be seated left the restaurant, many of those seated covered their faces with their napkins, and others waiting for their checks simply left without paying. For this trespass, the court decided the television station would have to pay damages to the restaurant. Beyond this, however, the jury had originally awarded $25,000 as punitive damages, but this was reversed because an important witness for the defense hadn't been heard. A new trial was ordered, at which punitive damages would be awarded if the jury concluded that the television crew had acted with reckless indifference or an evil motive in trespassing. The First Amendment, the court noted, does not give the news media a right to trespass.

UNFAIR COMPETITION

Unfair competition seeks to prevent confusion among members of the public as to the source of goods or services. It is a right that is highly flexible. For example, titles are not copyrightable. Yet unfair competition could be used to prevent one title from too closely imitating another. If the public came to identify a work by one title—such as *The Fifth Column,* by Ernest Hemingway—no one could use a similar title for a competing work. An obvious application would be to prevent one photographer from using the name of another in order to pass off his or her own work. So, if Jane Photographer is well known, another photographer adopting her name would be unfairly competing. Nor could one photographer imitate the style of another and try to pass off the work. In a case involving cartoon strips, the court stated that using the title of a cartoon strip and imitating the cartoonist's style was unfair competition.

There is another aspect to the doctrine of unfair competition. In some cases photographers have tried to use unfair competition to prevent distorted versions of their work from being presented to the public by licensees. The reasoning is that the distorted version is not truly created by the photographer. Presenting it to the public injures the photographer's reputation and unfairly competes with his or her work. Such an attempt to create moral rights from American legal doctrines is difficult at best.

OBSCENITY

Censorship has a long history. Few people realize today that the censors' fascination with pornography is relatively recent, dating from the era of Queen Victoria. Prior to that, censors focused on suppressing sedition against the Crown and heresy against the Church.

In the United States, censorship conflicts with the First Amendment's guarantees for free speech and free press. The result is an uncomfortable and rather arbitrary compromise as to what sexually oriented materials can be banned. Works

of serious artistic intention are protected from censorship under guidelines set forth by the United States Supreme Court. Specifically, the factors in determining obscenity are:

> (a) whether 'the average person, applying contemporary community standards' would find that the work, taken as a whole, appeals to the prurient interest . . .; (b) whether the work depicts or describes, in a patently offensive way, sexual conduct specifically defined by the applicable state law; and (c) whether the work, taken as a whole, lacks serious literary, artistic, political, or scientific value.

The laws affecting obscene materials prohibit such uses as possession for sale or exhibition, sale, distribution, exhibition, importation through customs, and mailing. Distributors are usually the defendants. Especially on the contemporary community standard as applied by the average person, it is difficult to know what the result of an obscenity prosecution may be from one locality to the next.

A number of statutes outlaw the use of children in the photographing of sexually explicit acts, whether or not the acts are obscene. Whether these laws would apply to photographs of minors used in an educational context would appear to raise substantial First Amendment questions. Beyond this, however, the courts have ruled that pornographic materials intended for an audience of minors can be subjected to higher standards than those of the average citizen.

The First Amendment does provide procedural safeguards in cases raising issues of obscenity. Essentially, before materials may be seized as obscene, an adversary hearing must be held at which both sides are able to present their views with respect to whether or not the items are obscene. Only after this review can law enforcement officials confiscate materials that have been determined to be obscene.

FLAGS AND PROTECTED SYMBOLS

State and federal flags are protected from desecration by both state and federal statutes. Desecration includes mutilation, defacement, burning, or trampling on such a flag. It also covers the use of any representation of a flag for advertising or commercial uses, such as product packaging or business stationery. Each statute has special exceptions, so that laws have to be checked state by state.

The police power to prevent desecration of the flag is not absolute but must be weighed against the right of the individual to have freedom of expression. When the use of a flag is a form of speech, the First Amendment may protect conduct that would otherwise be criminally punishable as a desecration. If you are considering the use of flags, especially for advertising or commercial purposes, you should definitely seek advice from an attorney to be certain that you aren't committing a criminal offense.

In addition, both state and federal statutes protect a variety of official or well-known names and insignias from unauthorized use, especially if the use is commercial. Federal law places restrictions on symbols such as the great seal of the United States, military medals or decorations, the Swiss Confederation coat of arms, the Smokey Bear character or name, and the Woodsy Owl character or name or slogan. While the prohibited uses vary, they often include advertising, product packaging, or uses that might mislead the public. For an artist to use such an emblem, insignia, or name may require legal advice or obtaining an opinion from the appropriate government agency as to whether the use is allowed.

As with flags, these restrictions may be found unconstitutional if their enforcement would limit the First Amendment rights of citizens, and the government cannot show a compelling reason for such limitations. The safest course is to consult with the secretary of the appropriate agency if you are planning to use its emblem, insignia, or name. If this doesn't seem practical or problems arise, you should get help from your own attorney.

State statutes also protect many badges, names, or insignia of governmental agencies and various orders and societies. As a general rule, if you are going to make use of any insignia belonging to a private group or governmental body, you should check in advance to be certain you are not violating the law. Contacting the group is a good way to start, but ultimately you may again want advice from an attorney.

COINS, BILLS, AND STAMPS

Counterfeiting statutes limit the freedom with which you can reproduce currency and stamps. The purpose of the counterfeiting statutes, of course, is to prevent people from passing off fake currency or stamps. Because of this, you can probably make copies as long as you are certain there is no chance of the copies being mistaken for real currency or stamps. However, to be completely safe, you would be wise to follow the restrictive guidelines that have been set out in the law. According to the Treasury Department:

> The Department will henceforth permit the use of photographic or other likenesses of United States and foreign currencies for any purposes, provided the items are reproduced in black and white and are less than three-quarters or greater than one-and-one-half times the size, in linear dimension, of each part of the original item. Furthermore, negatives and plates used in making the likenesses must be destroyed after their use.

You may notice that coins aren't mentioned at all. This is because photographs, films, or slides of United States or foreign coins may be used for any purposes, including advertising. Such photographs of coins don't present the type of risk that the counterfeiting statutes are designed to guard against.

Restrictions similar to those for money also apply to reproductions of stamps.

The United States Secret Service has responsibility for enforcing the laws relating to counterfeiting. Its representatives will give you an opinion as to whether the particular use you intend to make is legal, but their opinion would not prevent a later prosecution by either the Department of Justice or any United States Attorney.

DECEPTIVE ADVERTISING

The Federal Trade Commission Act, passed in 1914, provides that "unfair methods of competition are hereby declared unlawful." One of the important areas in which the Federal Trade Commission has acted is misleading, or false, advertising. If you work for advertising agencies, the total impression of the advertisement must not be false or misleading. While some puffery of or bragging about products is permitted, the advertisement must not confuse even an unsophisticated person as to the true nature of the product. It isn't difficult to imagine how photography can be used to mislead. One example would be the use of props that don't fairly represent the product, such as a bowl of vegetable soup with marbles in the bottom of the bowl to make the vegetables appear thicker. This isn't permissible. On the other hand, the advertising agency doesn't want to create trouble for its client. So in most cases the agency's legal staff will take the necessary steps to ensure the advertising is not misleading or deceptive.

Aside from the activities of the Federal Trade Commission, there are a number of ways that advertising is controlled. Other federal laws govern the advertising and labeling of a number of specific products. State laws form a patchwork of regulations over different products. The Council of Better Business Bureaus has adopted its own *Code of Advertising* to ensure that fair standards are followed. Many individual industries have set standards to govern the advertising of their products, although the application of these standards to local distributors or dealers can be difficult. Often, the media that sell advertising will refuse to accept advertisements that are not considered in good taste. The National Advertising Review Council seeks to maintain high standards by providing guidance with respect to the truth and accuracy necessary in national advertising.

While the National Advertising Review Board cannot force an advertiser to change an advertisement, it can bring peer pressure to bear. A typical case involving the board was an advertisement for dog food, which photographically depicted "tender juicy chunks" that appeared to be meat but in actuality were made from soybeans. The board's investigative division demanded that the deceptive advertising be corrected. After sufficient time for a response had passed without the division's hearing from the dog food company, officials referred the matter to the appeals division. After the referral, however, the dog

food company did respond and stated that the advertising in question had been changed to eliminate the elements found to be deceptive. Because of this, the appeals division dismissed the complaint. This is a good illustration of the disposition of a typical complaint.

Most advertising agencies want to avoid problems as much as you do. You should be able to rely on their expert attorneys for guidance in any area that raises questions. And, if you truthfully present the product, you certainly shouldn't have anything to worry about.

PHOTOGRAPHING IN COURTROOMS

Photography is sometimes permitted in courtrooms. Concern about the effect of such filming, photography, and broadcasting is still expressed by many attorneys, and some jurisdictions even forbid photographing anywhere in court buildings. However, a number of states have now enacted rules permitting the coverage of court proceedings. These rules vary with each court. The best way to find out whether cameras are allowed is to contact the clerk of the court in which you wish to photograph. If he or she advises you that cameras are permitted, you'll also be able to find out the applicable conditions and rules.

SETTLING DISPUTES AND FINDING ATTORNEYS

DISPUTES CAN BE DEMORALIZING and harmful to your business, whether because of money lost, opportunities missed, or time wasted. Yet there are sound approaches to avoiding or settling disputes. One of the best ways to avoid disputes is to have a carefully drafted, written contract before you begin working for a client. When the terms guiding the relationship have been clearly spelled out, there is less possibility of a dispute arising and a greater likelihood any disagreement can be quickly settled. If you do need an attorney, there are effective ways in which you can find the right attorney for your particular needs.

PAYMENT DISPUTES

Payment disputes with clients are among the most common problems to plague photographers. In fact, poor cash flow is at the core of so many photographers' business problems. If you do assignment photography, it may seem that you're locked into industry practice with respect to billing and being paid after completion of an assignment. But many professionals do request advances, especially against expenses, so that they don't have to finance clients for months at a time. Photographers who take portraits for sale to clients should insist on payment when the sitting is completed—whether by cash, check, or credit card—or at least demand a deposit against final payment upon delivery of finished prints. Credits cards will cost you several percentage points (varying from card to card), but this may be more than offset by increased sales and the certainty of collection.

But if you're forced to extend credit (as in the case of ad agencies) or do so as a convenience for your customers, what will this mean for your business? The longer an amount owed to you is overdue, the less likely you are to collect it. A debt that is overdue sixty to ninety days will probably be paid to you, but, if the debt is overdue a year, you probably only have about a 50 percent chance of collecting the money, and this percentage falls as more time passes.

So you must have a firm policy about extending credit and pursuing collections. You should grant credit only to clients who have a good reputation (based on occupation, address and length of residence, bank references, professional credit rating agencies, and personal references), a sound financial position, and measurable success in their own business (especially if the client is an agency or a corporate client that will expect to be billed as a matter of course), and who are willing to accept conditions that you may place on the

extension of credit (such as maximum amounts of credit you extend, maximum amounts of time for payment, and similar provisions). By the way, if you feel you don't want to extend credit to a client who absolutely expects it, you should not do business with that client. You must constantly check your credit system to make sure it's functioning properly (more than half your accounts should pay in full on receipt of your statement).

COLLECTION PROCEDURES

If you have a client who won't pay, you have to initiate collection procedures. You start with a reminder that the account has not been paid. This can simply be the sending of your invoice stamped "Past Due." Or you might use a pleasant form letter to bring the debt to the attention of the client. If this fails, you should make a request to your client for an explanation. Obviously, it isn't an oversight that the client has failed to pay. There may be a valid explanation for not paying. In any case, you must find out—usually by sending a letter requesting the necessary information. If the client still does not pay, you can assume that you're not going to collect without applying pressure. What kind of pressure? Whatever kind—within the bounds of the law—that you judge will get your money without your having to use an attorney or collection agency. You can escalate through all the following options:

- Letters
- E-mails
- Faxes
- Telephone calls
- Registered letters
- Cutting off credit
- Threatening to report to a credit bureau
- Threatening to use an attorney or collection agency
- Using an attorney or collection agency

Of course, you should never threaten people unless you intend to back up your words. You must act decisively if, after threatening to take a certain action, you still are not paid. You will bear an expense in using an attorney or collection agency to collect, but you may still be able to get part of the money owed you. And you will have a reputation as someone who won't stand for clients who don't pay what they owe.

FINDING THE RIGHT ATTORNEY

What do you do when you need a lawyer? Maybe a client refuses to make payment in full. Or you've been handed a contract and don't want to try to navigate through the legalese without some expert advice. Or you opened your favorite magazine and saw one of your photographs, which was very nice except

that you never got paid by the magazine or by anybody else. Or somebody smacked into your car and the insurance company doesn't want to settle. Or you've just had your first child and are wondering whether you need a will.

Many photographers already have a lawyer and are pleased with his or her performance. But what if you don't have a lawyer; where do you turn? That depends on the nature of your legal problem. This is a time of greater and greater specialization in the field of law. You have to evaluate whether your problem needs a specialist or can be handled by a lawyer with a general practice. For example, suppose you haven't been paid for an assignment you successfully completed. Any lawyer with a general practice should be able to handle this for you. What if you've been offered a book contract for a collection of your photographs? Here you'd be wise to find a lawyer with a special understanding of copyright law and the publishing field. Or you think that you should draft your will. Do you have a lot of assets, including special property in the form of negatives and transparencies, or do you have a very modest estate? If your estate is complex, you'll want to use an estate-planning specialist, particularly if you're concerned about who will own your photographs and how they will be treated after your death. But, if your estate is modest and you're not especially concerned about what happens to your photographs, a general practitioner should be able to meet your needs.

One implication of legal specialization, by the way, is that you may not use the same lawyer for each legal matter you have to solve. On the other hand, if you have a good relationship with your regular lawyer, he or she should direct you to specialists when you need them. This is probably the best way of making sure you have access to the expertise that is called for.

LAWYER'S FEES

Before discussing ways of contacting the lawyer you need, it's worthwhile to stop a moment and discuss the cost of legal services. You *can* afford these services, but you have to be careful. In the long run, using lawyers at appropriate times will save you money and, quite possibly, a lot of anguish.

How do you find out what a lawyer charges? Ask! If you're worried about paying for that first conference, ask on the phone when you call. If you're worried about what the whole legal bill will run, get an estimate the first time you sit down with the lawyer. Keep in mind that some lawyers will work on a contingency arrangement if you can't afford to pay them. This means that they will take a percentage of the recovery if they win but not charge you for their services if they lose. Or they may combine a flat fee with a contingency or require you to pay the expenses but not pay for their time. Some will even barter legal services for photographs. In other words, it isn't all cut and dried.

And you don't necessarily need a law firm with five names in the title—maybe a legal clinic can do the trick, or one of the volunteer lawyers for the arts groups. So let's move ahead to the problem of contacting the right lawyer for you.

INFORMAL REFERRALS

If you have a family attorney, that person should either handle whatever legal issue you face or refer you to a specialist. If you don't have an attorney to ask, ask a friend, another photographer, or your uncle who won that lawsuit the summer before last. A person usually knows when he or she has received good legal service. If your problem is similar, that person's lawyer may be right for you. You certainly know other professionals in the photography business. If you start asking them, you'll probably come up with a good lead.

This may not sound scientific, but it's the way most people do find lawyers, and it's not a bad way. It gives you a chance to find out about the lawyer's skills, personality, and fees. It gives you confidence because the recommendation comes from someone you know and trust. Of course, when you talk to the lawyer, make sure that he or she is the right person for your special problem. If he or she hasn't handled a case like yours before, you may want to keep looking. Or, if a particular lawyer doesn't feel your problem is what he or she handles best, you should request a referral to another lawyer.

VOLUNTEER LAWYERS FOR THE ARTS

All across the country, lawyers are volunteering to aid needy photographers, writers, composers, and other artists. There's no charge for these legal services, but you have to meet certain income guidelines and, perhaps, pay the court costs and any other expenses. If you qualify, that's great, but, even if you don't qualify for free help, you may get a good referral to someone who can help you.

Rather than listing all the volunteer lawyers groups, we're giving you the names of three of the most active. You can call the group nearest you to find out whether there are any volunteer lawyers for the arts in your own area.

- *California Lawyers for the Arts.* Fort Mason Center, C-255, San Francisco, CA 94123, (415) 775-7200, *www.calawyersforthearts.org.* There are also offices in Santa Monica, Sacramento, and Oakland.
- *Volunteer Lawyers for the Arts.* One East 53rd Street, Sixth Floor, New York, NY 10022, (212) 319-2787, *www.vlany.org.*
- *Lawyers for the Creative Arts.* 213 West Institute Place, Suite 401, Chicago, IL 60610, (312) 649-4111, *www.law-arts.org.*

PROFESSIONAL ASSOCIATIONS

There is great value in belonging to an appropriate professional organization of photographers. But whether or not you belong, you might still try contacting such an organization in your area to ask for a lawyer who understands photographers' legal problems. The society's members have probably had a problem similar to yours at one time or another. The executive director or office manager should know which lawyer helped that member and how the matter turned out. If they can't give you a name immediately, they can usually come up with one after asking around among the members. Needless to say,

you're going to feel more comfortable asking if you belong to the organization. Professional organizations are listed in appendix B.

LEGAL CLINICS

Legal clinics are easy to find, since they advertise their services and fee schedules in media such as newspapers and the Yellow Pages, where they are listed under "Attorneys" or "Lawyers." Another good way to find a clinic is through your network of friends and acquaintances, some of whom have probably either used a clinic or know of one to recommend. In many ways, a clinic is just like any other law firm. The good clinic, however, will have refined its operation so it can handle routine matters efficiently and in large volume. This allows the institution of many economies, such as using younger lawyers and paralegals (who are assistants with the training necessary to carry out routine tasks in a law office), having forms and word processing equipment, and giving out pamphlets to explain the basic legal procedures relevant to your case. Not all clinics, by the way, call themselves "clinics." They may simply use a traditional law firm name but advertise low-cost services based on efficient management.

What types of matters can the legal clinic handle for you? Divorce, bankruptcy, buying or selling real estate, wills, and other simple, everyday legal problems. What types of problems should you not take to a clinic? The complicated or unusual ones, such as book contracts, invasion-of-privacy suits, questions about copyright, and so on. The clinic can be efficient only when it handles many cases like yours. The special problems faced by the photographer will not be the problems a clinic can handle best. And, if you're wondering whether there are legal clinics specially designed for photographers and other creators of artistic works, the answer is "Not yet." But it's not a bad idea, especially for an urban area where many photographers earn their livelihood.

LAWYER REFERRAL SERVICES

A lawyer referral service is usually set up by the local bar association. It can be found in the Yellow Pages under "Lawyer Referral Service." If it's not listed there, check the headings for "Attorneys" and "Lawyers." If you still can't find a listing, call your local or state bar association to find out whether such a lawyer referral service is being run for your area.

Unfortunately, the local referral services are not of uniform quality. Two criticisms are usually levied against them: first, their not listing lawyers by area of specialty and, second, their listing lawyers who need business rather than the best legal talent available. Even referral services that do list lawyers by specialty may not have a category that covers photographers' unique needs. But the advantages of a good referral service shouldn't be overlooked. A good service puts you in touch with a lawyer with whom you can have a conference for a small fee. If you don't like that lawyer, you can always go back to the service again. Some services do assign lawyers on the basis of specialty and, in fact, send out follow-up questionnaires to check on how the lawyers perform. This tends to

improve the quality of the legal services. And a number of services require the lawyer to have malpractice insurance, so you can recover if the lawyer is negligent in representing you. Such services are certainly another possible avenue for you to take in searching for a good lawyer.

COLLECTION AGENCIES

While we're on the subject of lawyers, it's certainly worth briefly mentioning a few alternatives. As mentioned earlier, if you are having trouble collecting some of your accounts receivable, you might consider using a collection agency. Such agencies are easy to find, since they're listed in the Yellow Pages. They will go after your uncollected accounts and dun them with letters, phone calls, and so on, until payment is made. Payment for the agency is either a flat fee per collection or a percentage of the amount recovered. These percentages vary from as little as 20 percent to as much as 45 percent. If the agency can't collect for you, you're right back where you started and need a lawyer.

What are the pros and cons of using collection agencies? On the plus side is the fact that you have a chance at recovering part of the money owed to you without the expense of hiring a lawyer. The negative side is the agency's fee and the fact that some agencies resort to unsavory practices. Needless to say, this may lose you clients in the long run. But a reputable collection agency may be able to aid you by recovering without the need to go to court.

MEDIATION AND ARBITRATION

If a photographer has a dispute with a client, there are several steps short of a lawsuit that can be taken, including mediation or arbitration.

In mediation, parties seek the help of a neutral party to resolve disputes. They are not bound, however, by what the mediator proposes. Arbitration requires that the parties agree to be bound legally by the decision of the arbitration panel. If someone who has lost an arbitration refuses to pay, the arbitration award can be entered in a court for purposes of enforcement.

Mediation is especially useful when the participants have an emotional investment in a project, or an interest in maintaining their relationship in the future. The mediators work to help both sides hear each other's concerns and develop a sense of overall fairness. By improving their communication through the mediation process, the participants are often able to continue to work together for their mutual benefit.

Photographers who are negotiating contracts should consider adding a clause calling for alternative dispute resolution methods in the event of a dispute. A contract might include the following provision: "All disputes arising out of this agreement shall be submitted to mediation before _____ (or before a mutually selected mediation service) in the following city _____ pursuant to the laws of the State of _____."

Arbitration leads to a binding resolution. An arbitration award may be enforced by a state court and is difficult to appeal. If a photographer

chooses to include arbitration in a contract, the provision could specify the following:

> All disputes arising out of this agreement shall be submitted to final and binding arbitration. The arbitrator shall be _____ (or a mutually selected arbitrator) and the arbitration shall take place in the following city _____ pursuant to the laws of the State of _____. The arbitrator's award shall be final, and judgment may be entered upon it by any court having jurisdiction thereof.

The photographer may choose to use the American Arbitration Association, or another mediation or arbitration provider. For example, the California Lawyers for the Arts have offered both mediation and arbitration services. If the photographer has a specific organization in mind to serve as mediator or arbitrator, it would be wise to review the contractual phrasing to see if the arbitration provider would prefer to use other rules or state laws. For example, if the American Arbitration Association is selected, the language would be changed as follows: "All disputes arising under this Agreement shall be submitted to binding arbitration before the American Arbitration Association in the following location _____ and settled in accordance with the rules of the American Arbitration Association." The American Arbitration Association will provide additional information about its services and procedures. It has offices at 335 Madison Avenue, New York, NY 10017-4605; *www.adr.org;* (212) 716-5800.

Since it might be easier to go to small claims court for amounts within the small claims jurisdictional limit, the following clause might be added at the end of the arbitration provision: "Notwithstanding the foregoing, either party may refuse to arbitrate when the dispute is for a sum of less than $____." The amount of the small claims limit would be inserted as the dollar amount. This should be decided on a case-by-case basis. If the small claims court in the photographer's area is quick and inexpensive, it may be preferable to sue there for amounts less than the maximum amount for which suit can be brought in small claims court.

It would be ideal, by the way, if the mediation or arbitration panel had a knowledge of business practices in photography. Choosing the right people to serve, or the right organization, may make it possible to accomplish this goal.

SMALL CLAIMS COURTS

When small sums of money are involved, and your claim is a simple one, using a lawyer may be too expensive to justify. Most localities have courts that take jurisdiction over small claims, those ranging from a few hundred dollars in some areas to a few thousand dollars in other areas, and you can represent yourself in these small claims courts. To find the appropriate small claims court in your area, look in the phone book under local, county, or state governments. If a

small claims court is not listed there, a call to the clerk of one of the other courts is a quick way of finding out whether there is such a court and where it's located.

The procedure to use a small claims court is simple and inexpensive. There will be a small filing fee. You fill out short forms for a summons and complaint. These include the defendant's accurate name and address, the nature of your claim stated in everyday language, and the amount of your claim. If you aren't sure of the defendant's exact business name and it isn't posted on the premises, the clerk of the county in which the defendant does business should be able to help you. The clerk will set a date for the hearing and send the summons to the defendant requiring an appearance on that date. If you have witnesses, you bring them along to testify. If the witnesses don't want to testify, or if you need papers that are in the possession of the party you're suing, ask the court to issue a subpoena to force the witnesses to come or the papers to be produced. Of course, you bring along all the relevant papers that you have, such as confirmation forms, invoices, and so on.

The date for your hearing will probably be no more than a month or two away. Many small claims courts hold sessions in the evening, so don't worry if you can't come during the day. The judge or referee will ask you for your side of the story. After both sides have had their say, the judge will often encourage a settlement. If that's not possible, a decision will either be given immediately or be sent to you within a few weeks. The decision can be in favor of you or the other party, or it can be a compromise. After winning, you may need the help of a marshal or sheriff to collect from a reluctant defendant, although most losers will simply put their check in the mail. Of course, the laws governing small claims courts vary from jurisdiction to jurisdiction, so it's helpful if you can find a guide specially written for your own court. Asking the clerk of the court is one way to find out whether such a guide exists. Or you might give a call to your Better Business Bureau or Chamber of Commerce.

APPENDICES

APPENDIX A: AMERICAN SOCIETY OF MEDIA PHOTOGRAPHERS CODE OF ETHICS

IN 1992, THE ASMP BOARD OF DIRECTORS crafted and approved the ASMP Code of Ethics, a guide for ethical business dealings, protecting the profession, the photographer, vendors, employees, subjects, clients, and colleagues. By abiding by this code and encouraging other photographers to follow its guidelines, ASMP members contribute to the health of their industry—clients, subjects, and colleagues.

Responsibility to colleagues and the profession:
 1. Maintain a high quality of service and a reputation for honesty and fairness.
 2. Oppose censorship and protect the copyrights and moral rights of other creators.
 3. Never advance one's own interests at the expense of the profession.
 4. Foster fair competition based on professional qualification and merit.
 5. Never deliberately exaggerate one's qualifications, nor misrepresent the authorship of work presented in self-promotion.
 6. Never engage in malicious or deliberately inaccurate criticism of the reputation or work of another photographer.
 7. Negotiate licensing agreements that protect the historical balance between usage fees and rights granted.
 8. Never offer nor accept bribes, kickbacks, or other unethical inducements.
 9. Never conspire with others to fix prices, organize illegal boycotts, nor engage in other unfair competitive practices.
 10. Refuse agreements that are unfair to the photographer.
 11. Never undertake assignments in competition with others for which payment will be received only if the work is accepted.
 12. Never enter commercial competitions in which usage rights are transferred without reasonable fees.
 13. Donate time for the betterment of the profession and to advise entry-level photographers.

Responsibility to subjects:
 14. Respect the privacy and property rights of one's subjects.
 15. Never use deceit in obtaining model or property releases.

Responsibility to clients:
 16. Conduct oneself in a professional manner, and represent a client's best interests within the limits of one's professional responsibility.
 17. Protect a client's confidential information; Assistants should likewise maintain confidentiality of the photographer's proprietary information.

18. Accurately represent to clients the existence of model and property releases for photographs.

19. Stipulate a fair and reasonable value for lost or damaged photographs.

20. Use written contracts and delivery memos with a client, stock agency, or assignment representative.

21. Consider an original assignment client's interests with regard to allowing subsequent stock use of that work by the client's direct competition, absent an agreement allowing such use.

Responsibility to employees and suppliers:

22. Honor one's legal, financial and ethical obligations toward employees and suppliers.

23. Never take unfair advantage of one's position as employer of models, assistants, employees or contract labor.

Responsibility of the photojournalist:

24. Photograph as honestly as possible, provide accurate captions, and never intentionally distort the truth in news photographs.

25. Never alter the content or meaning of a news photograph and prohibit subsequent alteration.

26. Disclose any alteration or manipulation of content or meaning in editorial feature or illustrative photographs and require the publisher to disclose that distortion or any further alteration.

APPENDIX B: ORGANIZATIONS FOR PHOTOGRAPHERS

THIS APPENDIX GATHERS INFORMATION about a number of the leading membership organizations for photographers as well as some other organizations of interest to photographers.

Advertising Photographers of America (APA). 145 South Orange Street, Orange, CA 92866; (800) 272-6264; *www.apanational.org*. The purpose of APA national is to promote high professional standards and ethics and to communicate and exchange information among APA chapters, APA chapter members, and APA members-at-large. APA national works toward the advancement of advertising and commercial photographers by exchanging information and ideas, resolving common problems, and strengthening the relationships between photographers, advertising agencies, clients, and suppliers. All APA chapters and APA national are independently managed and funded.

Advertising Photographers of New York, Inc. (APNY). 27 West 20th Street, New York, NY 10010; (212) 807-0399; *www.apany.com*. APNY began as Advertising Photographers of America, Inc. (APA) in 1981 and became APNY in 1990. A professional trade association, APNY promotes the highest standards of business practice within the industry. Benefits include the APNY/SPAR Estimate/Invoice Form and Stock Delivery Memo, APNY Newsletter, APNY Hotline, free legal consultation, group medical insurance, group disability income, rental car discount, seminars, and the assistants' directory.

American Society of Media Photographers (ASMP). 150 North Second Street, Philadelphia, PA 19106; (215) 451-2767; *www.asmp.org*. This organization, with chapters throughout the country, promotes the photographic profession through advocacy, education, and information exchange on rights, ethics, standards, and business practices. Its services include publications, insurance, surveys, member support with clients, business counseling, and marketing assistance. It is the copublisher, with Allworth Press, of *ASMP Professional Business Practices in Photography,* now in its sixth edition.

American Society of Picture Professionals (ASPP). 409 South Washington Street, Alexandria, VA 22134; (703) 299-0219; *www.aspp.com*. The ASPP has a wide membership base and a number of chapters, which include photographers, stock agencies, researchers, and buyers. The organization publishes a quarterly magazine, the *Picture Professional,* a newsletter, and an annual directory and provides a job posting service for members on its Web site.

Art Directors Club, Inc. (ADC). 106 West 29th Street, New York, NY 10001; (212) 643-1440; *www.adcny.org*. Established in 1920, the Art Directors Club is an international nonprofit

membership organization for creative professionals, encompassing advertising, graphic design, new media, photography, illustration, typography, broadcast design, publication design, and packaging. Programs include publication of the Art Director's Annual, a hardcover compendium of the year's best work compiled from winning entries in the Art Directors Annual Awards. The ADC also maintains a Hall of Fame, ongoing gallery exhibitions, speaker events, portfolio reviews, scholarships, and high school career workshops.

Association for Independent Video and Filmmakers, Inc. (AIVF) and Foundation for Independent Video and Film (FIVF). 304 Hudson Street, New York, NY 10013. Founded in 1974 to create public awareness of independent media, AIVF is the national service organization for independent media producers, with over five thousand members to date. The AIVF has been the leading advocate for independents' access to public television and cable systems, as well as to theaters, museums, galleries, and community centers across the country. The FIVF is a nonprofit organization that supports the educational activities of AIVF. These include the magazine titled the *Independent,* a Festival/Distribution Bureau, book publication and distribution, and seminars. Student memberships are available.

Editorial Photographers (EP). P.O. Box 591811, San Francisco, CA 94159-1811; *www. editorialphoto.com.* EP's mission is to educate photographers about business issues and in the process raise the level of business practices in the profession. EP advocates fair contracts from publishers and promotes the position that both photographers and publishers must seek win/win working relationships for either side to prosper.

The Foundation Center. 79 Fifth Avenue, New York, NY 10003; (212) 620-4230; *www. fdncenter.org.* The Foundation Center Network is an independent national service organization that provides authoritative sources of information on private philanthropic giving. There are Foundation Centers in New York City, Washington, D.C., Cleveland, and San Francisco, with over one hundred cooperating library collections.

National Press Photographers Association (NPPA). 3200 Croasdaile Drive, Suite 306, Durham, NC 27705; (919) 383-7246; *www.nppa.org.* The NPPA membership services include major medical and equipment insurance as well as a variety of publications. The NPPA offers student, professional, and international memberships.

North American Nature Photographers Association. 10200 West 44th Avenue, Suite 304, Wheat Ridge, CO 80033-2840; (303) 422-8527; *www.nanpa.org.* NANPA's mission is to provide education, foster professional and ethical conduct, gather and disseminate information, and develop standards for all persons interested in the field of nature photography. NANPA further seeks to promote nature photography as an art form and a medium of communication for the sciences, nature appreciation, and environmental protection.

Picture Archive Council of America, Inc. (PACA). c/o Cathy Aron, President, Photo Network Stock, 1520 Brookhollow Drive, Suite 30, Santa Ana, CA 92705; (518) 392-3967; *www.stockindustry.org.* PACA's goal is to develop uniform business practices within the stock picture industry, based upon ethical standards established by the council. PACA serves

member agencies, their clients, and their contributing photographers and illustrators by promoting communication among picture agencies and other professional groups. Through these improved channels of communication, the council hopes to make available information necessary to improve and protect the business of its members. An annual directory of the membership is available.

Professional Photographers of America (PPA). 229 Peachtree Street N.E., Suite 2200, International Tower, Atlanta, GA 30303; (800) 786-6277; *www.ppa.com*. PPA publishes *Professional Photographer Storytellers* and *Photo Electronic Imaging Magazine*. PPA offers a variety of memberships for photographers of various specialties, including portrait, wedding, industrial, and specialist categories, and has over fourteen thousand members in sixty-four countries.

Society of Photographer and Artist Representatives, Inc. (SPAR). 60 East 42nd Street, Suite 1166, New York, NY 10165; (212) 779-7464; *www.spar.org*. SPAR was formed in 1965 for the purposes of establishing and maintaining high ethical standards in the business conduct of representatives and the creative talent they represent, as well as fostering productive cooperation between talent and client. This organization runs speakers' panels and seminars with buyers of talent from all fields, works with new reps to orient them on business issues, offers model contracts, and gives free legal advice. Categories for members are regular (agents), associates, and out-of-town. Publishes a newsletter.

Society for Photographic Education (SPE). 110 Art Building, Miami University, Oxford, OH 45056-2486; (513) 529-8328; *www.spenational.org*. SPE is a nonprofit membership that provides a forum for the discussion of photography related media as a means of creative expression and cultural insight. Through its interdisciplinary programs, services, and publications, the society seeks to promote a broader understanding of the medium in all its forms, and to foster the development of its practice, teaching, scholarship, and criticism.

Volunteer Lawyers for the Arts (VLA). One East 53rd Street, Sixth Floor, New York, NY 10022; (212) 319-2787; *www.vlany.org*. VLA is dedicated to providing free arts-related legal assistance to low-income artists and not-for-profit arts organizations in all creative fields. Five hundred plus attorneys in the New York area annually donate their time through VLA to artists and arts organizations unable to afford legal counsel. VLA also provides clinics, seminars, and publications designed to educate artists on legal issues that affect their careers. California, Florida, Illinois, Massachusetts, and Texas, to name a few, have similar organizations. Check "Lawyer" and "Arts" phone directory listings in other states or search on the Web.

Wedding and Portrait Photographers International (WPPI). 1312 Lincoln Boulevard, Santa Monica, CA 90406; (310) 451-0090; *www.wppinow.com*. WPPI publishes a monthly newsletter, has print competitions, and sponsors an annual convention.

Selected Bibliography

The American Society of Media Photographers (ASMP). *ASMP Professional Business Practices in Photography.* 6th ed. New York: Allworth Press, 2001.

Brinson, J. Dianne, and Mark F. Radcliffe. *Internet Legal Forms for Business.* Menlo Park, CA: Ladera Press, 1997.

Crawford, Tad. *Business and Legal Forms for Fine Artists.* Rev. ed. New York: Allworth Press, 1999.

Crawford, Tad. *Business and Legal Forms for Photographers.* Rev. ed. New York: Allworth Press, 2002.

Crawford, Tad. *Legal Guide for the Visual Artist.* 4th ed. New York: Allworth Press, 1999.

Crawford, Tad, and Kay Murray. *The Writer's Legal Guide.* 3rd ed. New York: Allworth Press, 2002.

Crawford, Tad, and Susan Mellon. *The Artist Gallery Partnership.* Rev. ed. New York: Allworth Press, 1998.

DeLaney, Chuck. *Photography Your Way.* New York: Allworth Press, 2000.

DuBoff, Leonard D. *The Law (in Plain English) for Photographers.* New York: Allworth Press, 2002.

Engh, Rohn. *SellPhotos.com.* Cincinnati: Writers Digest Books, 2000.

Engh, Rohn. *Sell and Re–Sell Your Photos.* Cincinnati: Writers Digest Books, 1991.

Farace, Joe. *The Photographer's Internet Handbook.* Rev. ed. New York: Allworth Press, 2001.

Frost, Lee. *Photos That Sell.* New York: Watson-Guptill Publications, 2001.

Grant, Daniel. *The Business of Being an Artist.* Rev. ed. New York: Allworth Press, 2000.

Heron, Michal, and David MacTavish. *Pricing Photography: The Complete Guide to Assignment and Stock Prices.* Rev. ed. New York: Allworth Press, 2002.

Jacobs, Lou. *The Big Picture.* Cincinnati: Writer's Digest Books, 2000.

Kieffer, John. *The Photographer's Assistant.* Rev. ed. New York: Allworth Press, 2000.

Krages, Bert. *Legal Handbook for Photographers.* Amherst, NY: Amherst Media, 2001.

Leland, Caryn R. *Licensing Art and Design.* Rev. ed. New York: Allworth Press, 1995.

McDonald, Tom. *The Business of Portrait Photography.* Rev. ed. New York: Amphoto, 2002.

Photographers Market. 2003 ed. Cincinnati: Writers Digest Books, 2002.

Piscopo, Maria. *The Photographer's Guide to Marketing and Self-Promotion.* 3rd ed. New York: Allworth Press, 2001.

Oberrecht, Kenn. *How to Start a Home-Based Photography Business.* 3rd ed. Guilford, CT: Globe Pequot Press, 2000.

Rossol, Monona. *Overexposure: Health Hazards in Photography.* Rev. ed. New York: Allworth Press, 1991.

Sedge, Michael. *The Photojournalist's Guide to Making Money.* New York: Allworth Press, 2000.

Wexler, Ira. *The Business of Commercial Photography.* New York: Amphoto, 1997.

Zimberoff, Tom. *Photography: Focus on Profit.* New York: Allworth Press, 2002.

Index

through-the-lens flash. *See* TTL (through-the-lens) flash metering

Time, 30

toxicity characteristic leach procedure (TCLP), 85. *See also* photochemicals; waste

trade credit, 57–58

trade shows, marketing resources from, 98

trade use, privacy invasion by, 198, 209

trademarks, 170

trade-school education, 12

traditional education, 9–16
 advantages of, 13–16
 checklist for, 12–13
 evaluating, 11–13
 learning process in, 13–14
 networking in, 13–14

training. *See* education

transportation expenses, tax deductions for, 186

travel
 photography, 31–32
 portfolio, 102
 tax deductions for, 184–186

Travel Photography (McCartney), 32

trespassing, 206–207, 218–219

tripods, 49

Trump, Donald, 8

TTL (through-the-lens) flash metering, 34

umbrella insurance, 82

undercapitalization, 56, 58

Unitas, Johnny, 199–200

United States Copyright Office, 155, 161, 165, 171

United States Secret Service, 222

United States Supreme Court, 204–206, 220

USA Warranty, 42–43

use
 advertising, 198, 200–201
 fair, 168–169
 fictional, 200–201
 trade, 198, 209
 unrelated, privacy invasion by, 200

used equipment
 inspecting, 45
 stores, 44–45
 warranty policy for, 45–46

value factors for pricing, 139, 141, 148–152

ventilation systems
 for black-and-white processes, 87–88, 87*f*
 local exhaust, 88–89
 performance of, 88, 89
 placement, 87*f*

victims, privacy invasion of, 203

Volunteer Lawyers for the Arts (VLA), 227, 239

warranty policies
 for new equipment, 42–43

for used equipment, 45–46

waste
 down-the-drain, 84
 facilities, 86
 generators, 84, 85
 metal, 85
 silver, 84
 storing, 84–85
 in trash, 85

water waste regulations, 84

web site(s)
 about page of, 112
 audience, 106
 contact page of, 111
 criteria, 107–108
 e-mail attachments from, 111–112
 home page of, 108
 HTML, 109
 images, 107
 layout, 108
 marketing, 113–114
 message, 109
 navigation, 108, 109, 110
 office access to, 112
 portfolio, 109–110
 reproduction rights for, 110–111, 156–157
 search engine optimization for, 108, 113
 shopping by, 41–42, 44–45
 software, 107
 traffic, 112–113

Wedding and Portrait Photographers International (WPPI), 32, 239

wedding photography, 32
 apprenticeships, 21–22
 contract, 124–125, 129–130
 portfolios, 103
 pricing, 135

Weisgrau, Richard, 117

wildlife photography, 29–30

Windows PC, 74, 75–76

Wolfe, Art, 30

word processing software, 70–71

work for hire, copyright protection of, 162–164

Workbook, 29, 113

workmen's compensation insurance, 79

workshops, 10

World's Fair Corporation, 218

WPPI. *See* Wedding and Portrait Photographers International (WPPI)

Yellow Pages, marketing by, 114

Your Living Trust and Estate Plan (Platt), 196

Your Will and Estate Plan (Platt), 196

Zimberoff, Tom, 57

zoning regulations, 61–62, 83

zoom lenses, 48

BOOKS FROM ALLWORTH PRESS

Photography Your Way: A Career Guide to Satisfaction and Success
by Chuck DeLaney (paperback, 6 x 9, 304 pages, $18.95)

The Photographer's Assistant, Revised Edition
by John Kieffer (paperback, 6 ¾ x 9 ⅞, 256 pages, $19.95)

Business and Legal Forms for Photographers, Third Edition
by Tad Crawford (paperback, with CD-ROM, 8 ½ x 11, 192 pages, $29.95)

Photography: Focus on Profit
by Tom Zimberoff (paperback, with CD-ROM, 8 x 10, 432 pages, $35.00)

The Business of Studio Photography, Revised Edition
by Edward R. Lilley (paperback, 6 ¾ x 9 ⅞, 336 pages, $21.95)

ASMP Professional Business Practices in Photography, Sixth Edition
by the American Society of Media Photographers (paperback, 6 ¾ x 9 ⅞, 432 pages, $29.95)

Pricing Photography: The Complete Guide to Assignment and Stock Prices, Third Edition
by Michal Heron and David MacTavish (paperback, 11 x 8 ½, 160 pages, $24.95)

How to Shoot Stock Photos That Sell
by Michal Heron (paperback 11 x 8 ½, 160 pages, $24.95)

Photographic Lighting Simplified
by Susan McCartney (paperback, 6 ¾ x 9 ⅞, 176 pages, $19.95)

Mastering Black-and-White Photography: From Camera to Darkroom, Revised Edition
by Bernhard J Suess (paperback, 6 ¾ x 9 ⅞, 256 pages, $19.95)

Creative Black-and-White Photography: Advanced Camera and Darkroom Techniques, Revised Edition
by Bernhard J Suess (paperback, 8 ½ x 11, 200 pages, $24.95)

Mastering the Basics of Photography
by Susan McCartney (paperback, 6 ¾ x 10, 192 pages, $19.95)

Talking Photography: Viewpoints on the Art, Craft and Business
by Frank Van Riper (paperback, 6 x 9, 320 pages, $19.95)

Historic Photographic Processes: A Guide to Creating Handmade Photographic Images
by Richard Farber (paperback, 8 ½ x 11, 256 pages, $29.95)

Please write to request our free catalog. To order by credit card, call 1-800-491-2808 or send a check or money order to Allworth Press, 10 East 23rd Street, Suite 510, New York, NY 10010. Include $5 for shipping and handling for the first book ordered and $1 for each additional book. Ten dollars plus $1 for each additional book if ordering from Canada. New York State residents must add sales tax.

To see our complete catalog on the World Wide Web, or to order online, you can find us at *www.allworth.com*.